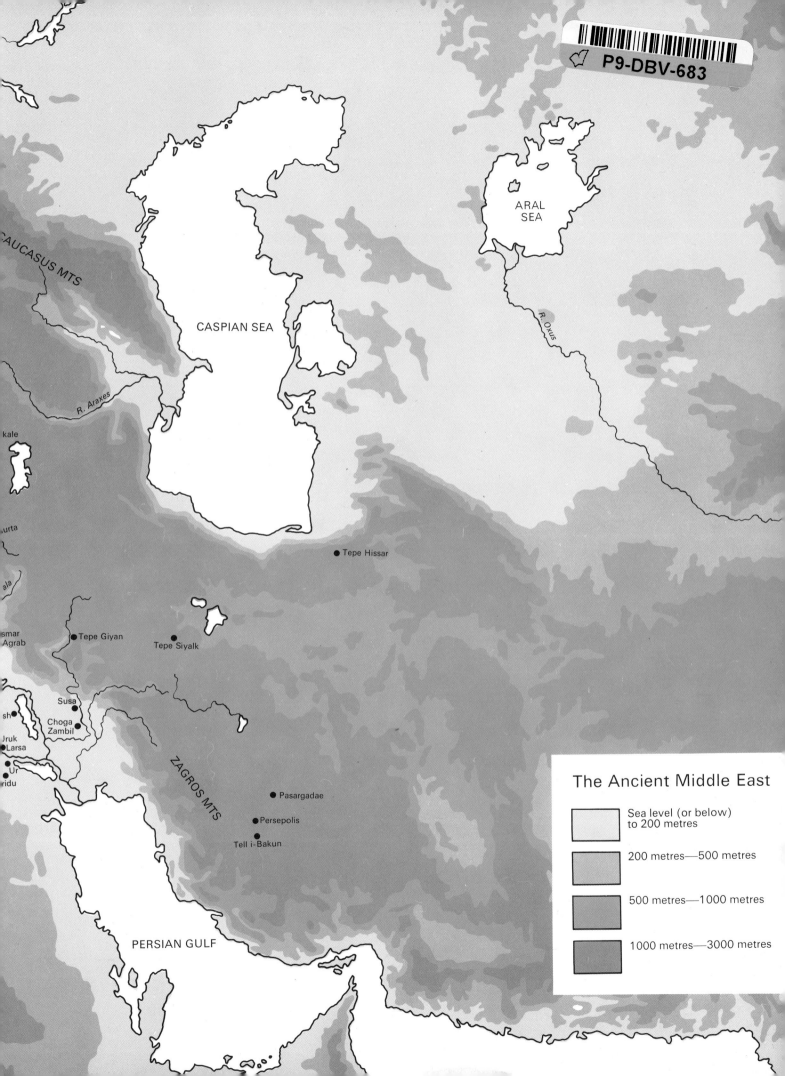

CAUCASUS MTS

ARAL
SEA

R. Oxus

CASPIAN SEA

R. Araxes

kale

urta

ala

Tepe Hissar

smar
Agrab

Tepe Giyan

Tepe Siyalk

Susa

sh

Choga
Zambil

Jruk

Larsa

Ur

ridu

ZAGROS MTS

Pasargadae

Persepolis

Tell i-Bakun

PERSIAN GULF

The Ancient Middle East

Sea level (or below)
to 200 metres

200 metres—500 metres

500 metres—1000 metres

1000 metres—3000 metres

The Ancient World

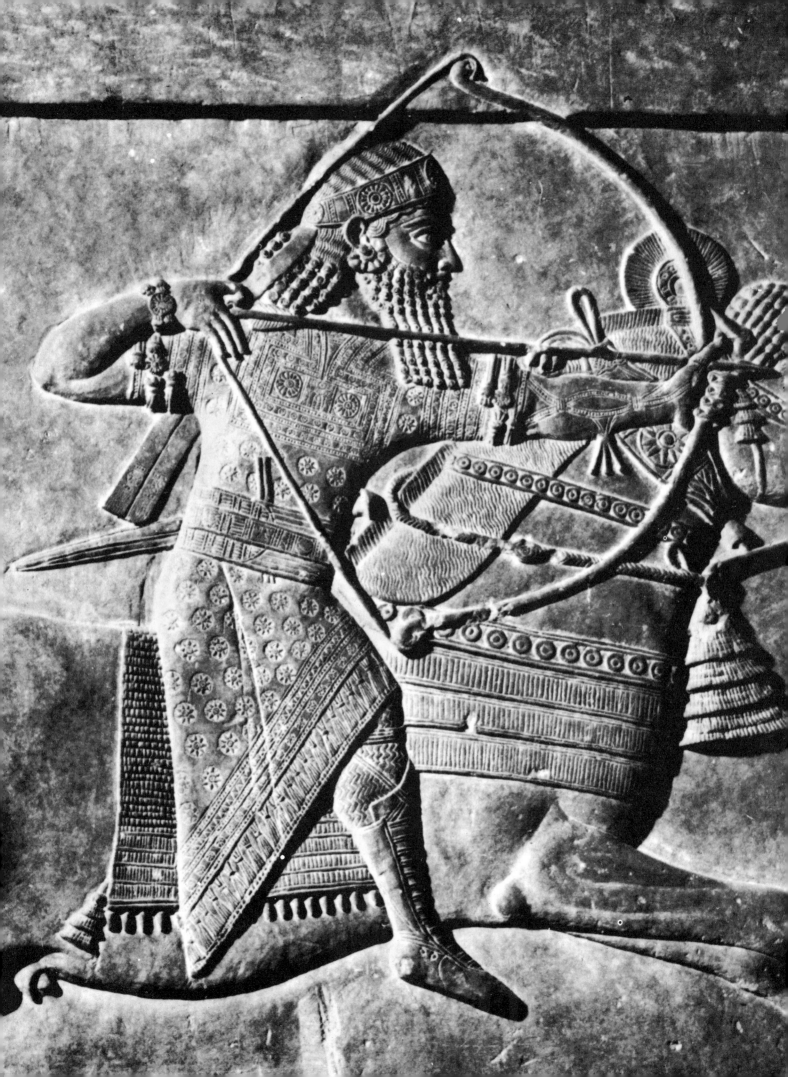

THE ANCIENT WORLD

GIOVANNI GARBINI

Professor at the Institute of Near
Eastern Studies, University of Rome

PAUL HAMLYN · LONDON

General Editors

TREWIN COPPLESTONE BERNARD S. MYERS
London *New York*

PREHISTORIC AND PRIMITIVE MAN
Dr Andreas Lommel, Director of the Museum of Ethnol-
ogy, Munich

THE ANCIENT WORLD
Professor Giovanni Garbini, Institute of Near Eastern
Studies, University of Rome

THE CLASSICAL WORLD
Dr Donald Strong, Assistant Keeper, Department of
Greek and Roman Antiquities, British Museum, London

THE EARLY CHRISTIAN AND BYZANTINE WORLD
Professor Jean Lassus, Institute of Art and Archaeology,
University of Paris

THE WORLD OF ISLAM
Dr Ernst J. Grube, Associate Curator in Charge, Islamic
Department, Metropolitan Museum of Art, New York

THE ORIENTAL WORLD
Jeannine Auboyer, Chief Curator, Musée Guimet, Paris
Dr Roger Goepper, Director of the Museum of Far
Eastern Art, Cologne

THE MEDIEVAL WORLD
Peter Kidson, Conway Librarian, Courtauld Institute of
Art, London

MAN AND THE RENAISSANCE
Andrew Martindale, Senior Lecturer in the School of
Fine Arts, University of East Anglia

THE AGE OF BAROQUE
Michael Kitson, Senior Lecturer in the History of Art,
Courtauld Institute of Art, London

THE MODERN WORLD
Norbert Lynton, Head of the School of Art History and
General Studies, Chelsea School of Art, London

PUBLISHED BY
PAUL HAMLYN LIMITED · DRURY HOUSE
RUSSEL STREET · LONDON WC2
FIRST EDITION 1966
SECOND IMPRESSION 1967
© PAUL HAMLYN LIMITED 1966
PRINTED IN THE NETHERLANDS BY JOH. ENSCHEDÉ EN ZONEN
GRAFISCHE INRICHTING N.V. HAARLEM

*Previous pages: Relief from the Palace of Assurbanipal at Nineveh,
showing the king shooting at lions. British Museum, London*

List of Contents

8 Introduction

9 Mesopotamia

The Sumerian Civilisation · The Study of Sumerian Art · Predynastic Architecture · Predynastic Sculpture · Predynastic Seals · The First Crisis of Sumerian Civilisation: Transitional Period · The Early Dynastic Period · Early Dynastic Architecture · The Background of Early Dynastic Sculpture · Regional Schools of Early Dynastic I Sculpture · Sculpture of the Early Dynastic II Period · Early Dynastic II Reliefs · The Minor Arts · The Akkadian Period (c. 2350–2150 BC) · Akkadian Sculpture · Akkadian Seals · The Neo-Sumerian Period (2150–1950 BC) · Neo-Sumerian Art · The Isin-Larsa and Old Babylonian Periods · Architecture and Painting · Sculpture · Old Babylonian Seals · The Kassite Domination · The Assyrians · The Neo-Assyrian Period · Assurnasirpal II · Shalmaneser III · Tiglath-pileser III · Sargon II and Sennacherib · Assurbanipal · Assyrian Painting · Assyrian City-Planning and Architecture · The Neo-Babylonian Period

70 Peripheral Areas

Early Palestine: Jericho · Early Anatolia · Early Iran · Iran and Mesopotamia · Proto-Elamite Art · Sumerian Influences · The Indus Valley Civilisation · Syria and Palestine in the Third Millennium · Syro-Palestinian Sculpture · Anatolia in the Third Millennium · The Rise of the Mountain Peoples in the Second Millennium · The Hittite Civilisation · Hittite Architecture and Sculpture · Mitanni · The Iranian Revival · Syria and Palestine in the Second Millennium · Syro-Palestinian Architecture · Syrian Sculpture · Syrian Minor Arts · Disruption and Partial Recovery · Syrian Architecture in the First Millennium · Syrian Reliefs · Phoenicia and Palestine · Phoenician Art · Luristan · The Persian Empire · Persian Art · Anatolia in the First Millennium · Syria and Palestine: the Final Phase · Phoenicia

111 Egypt

General Considerations · Predynastic Egypt: an Outline · Art at the Beginning of the Dynastic Period · Early Dynastic Architecture · Early Dynastic Sculpture · The Old Kingdom: the Pyramid Age · Old Kingdom Sculpture · Old Kingdom Reliefs · The Middle Kingdom: Historical Background · The Art of the Middle Kingdom · The Eleventh Dynasty · The Twelfth Dynasty · The Second Intermediate Period · New Kingdom Cosmopolitanism · The Early New Kingdom · Sculpture in the Reign of Queen Hatshepsut · The Reign of Tuthmosis III and after · New Kingdom Painting · The Amarna Revolution · The Later Amarna Style · Transition to the Nineteenth Dynasty · Theban Painting at the End of the New Kingdom · The Sculpture of the Ramesside Era · Transition to the Late Period · The Saite Dynasty · The End of Egyptian Art

167 The Expansion of the Art of the Ancient Middle East

Nubia · South Arabia · Ethiopia · The Phoenician Civilisation overseas · Punic Art

Colour Plates

1	View of the Nile, near Aswan	17
2	View of the Jordan, near Jericho	18
3	The Cedars of Lebanon	18
4	Ruins at Babylon	19
5	The ruins of Jericho	20
6	Neolithic tower at Jericho	20
7	Remains of the Early Sumerian temple levels at Uruk	21
8	The ziggurat at Uruk	22
9	The Step Pyramid of Zoser	23
10	The pyramids of Giza	24
11, 12	The Sphinx of Chephren, and detail	25, 26
13	The ziggurat at Ur	27
14, 15	The 'Standard of Ur'	28
16	Head of a bull decorating the front of a lyre, from Ur	29
17	Helmet of Meskalamidug from Ur	30
18	Fluted beaker from Ur	30
19	Offering stand from Ur	31
20	Vase in the Susa I style	32
21	Seated figure from 'Ubaid	49
22	Relief of Imdugud from 'Ubaid	50
23	Beaker from 'Ubaid	50
24	Gudea of Lagash	51
25	Wall-painting from the palace of Zirimlim at Mari	52
26	Vase from Khafajah	52
27	Jug from Alaca Hüyük	53
28	Stag standard from Alaca Hüyük	54
29	Disk standard from Alaca Hüyük	54
30	Jug from Kültepe	55
31	Vase from Conelle	56
32	View of temple ruins at Hattusas	57
33, 34	The Lion Gate, Hattusas, and detail	57, 58
35, 36	Sphinx from the Sphinx Gate at Alaca Hüyük	59
37	The rock sanctuary of Yazilikaya	60
38	Relief: procession of twelve gods, Yazilikaya	61
39	Relief: Tudhaliyas IV, protected by the god, Sarumma	61
40	Vase from Alalakh	62
41	Relief from Malatya	62
42	Statuette from Megiddo	63
43	Bowl from Ugarit	64
44	Silver plate from the Ziwiye treasure	81
45	Obelisk temple at Byblos	82
46	Ruins at Byblos	82
47	Terracotta plaque from Kish	83
48	Phoenician ivory from Nimrud	84
49	Syrian ivory panel from Nimrud	85
50, 51	Assyrian wall-paintings from the palace at Til Barsip	86, 87
52	The Ishtar Gate, Babylon	88
53	Detail from the façade of the throne room, Babylon	89
54	The ziggurat at Choga Zambil	90
55	View of Persepolis from the Gate-House of Xerxes	91
56	General view of Persepolis	92
57	The Palace of Darius, Persepolis	92
58	Relief from Persepolis	93
59	Ivory plaque from the Ziwiye treasure	94
60	Achaemenian rhyton, bowl and finials	95
61	Cup from Hasanlu	95
62	Achaemenian tombs at Naqsh-i-Rustam	96
63	Tomb of Artaxerxes II	96
64	Obelisk from Aksum, Abyssinia	113
65	View of Motye	114
66	The tophet of Tharros, Sardinia	114
67	Interior of the Valley Temple of Chephren at Giza	115
68	Rahotep and his wife Nofret	116
69	Jubilee pavilion of Sesostris I	117
70, 71	Reliefs from the pavilion of Sesostris I	118, 119
72	Statue of King Mentuhotep	119
73	The Colossi of Memnon	120, 121
74, 75	Temple of Queen Hatshepsut at Deir el-Bahri, and detail	122, 123
76	Middle colonnade at Deir el-Bahri	123
77	Court of Amenhotep III, Temple of Amon, Luxor	124
78	Colonnade of Amenhotep III, Temple of Amon, Luxor	125
79	Entrance pylons to the Temple of Amon at Karnak	125
80	Temple of Ramesses III at Medinet Habu	126
81	Relief from the temple at Medinet Habu	126
82	Vestibule of Kom Ombo	127
83	Head of Taharqa	128
84	The Valley of the Kings at Thebes	145
85	Wall-painting from the tomb of Itet at Medum	146
86	Wall-painting from the tomb of Ity at Gebelein	146
87, 88	Wall-paintings: tomb of Nakht, Thebes	147, 148
89	Wall-painting: tomb of Menna, Thebes	149
90	Ceiling painting: tomb of Khonsu, Thebes	150
91	Wall-painting: tomb of Ramose, Thebes	151
92	Wall-painting from a palace at Amarna	152, 153
93	Head of Nefertiti	154
94	The second mummiform coffin of Tutankhamen	155
95, 96	Wall-paintings from the tomb of Meye, Thebes	156
97	Wall-painting: tomb of Userhet, Thebes	157
98	Detail from a 'Book of the Dead'	158
99	Wall-painting: tomb of Pashedu, Thebes	158
100, 101	Wall-paintings from the tomb of Sennedjem, Thebes	159
102	Funerary stele of Nes-Khonsu-pa-Khered	160

	EGYPT	SYRIA-PALESTINE	ANATOLIA	MESOPOTAMIA	IRAN
BC 6000		*JERICHO*	*ÇATAL HÜYÜK*	*JARMO*	
			HACILAR		
5500					
5000				HASSUNA	BAKUN I SIYALK I
4500	FAIYUM 'A' and TASIAN			SAMARRA / HALAF	SUSA I
4000	BADARIAN AMRATIAN			'UBAID	SUSA I
3500	GERZEAN	*GHASSUL*			
				PREDYNASTIC	
3000	EARLY DYNASTIC		*TROY* / *BEYCESULTAN*	TRANSITION 2700	SUSA II and GIYAN IV
2600		*KHUERA*	*ALACA*	1st EARLY DYNASTIC	
2500	OLD KINGDOM			2nd EARLY DYNASTIC 2350	ELAMITE KINGDOM
	FIRST INTERMEDIATE	*MARDIKH*		AKKADIAN 2150	
				GUTI	
2000 1991	MIDDLE KINGDOM	*MARI* / *ALALAKH*	*KÜLTEPE*	UR III / ISIN-LARSA	ELAMITE KINGDOM
				DYNASTY OF BABYLONIA	
SECOND INTERMEDIATE 1570			HITTITE OLD EMPIRE		
1500	NEW KINGDOM	*UGARIT* / *HAZOR*	HITTITE NEW EMPIRE	KASSITE DYNASTY	
1190					
1085		Syro-Hittites			IRANIAN INVASIONS
1000	LATE PERIOD	Phoenicians Israelites	Phrygians Urartu	NEO-BABYLONIAN PERIOD	
		ASSYRIAN and BABYLONIAN DOMINATION			ELAMITE KINGDOM 612 / Persians
500	PERSIAN DOMINATION				

(Anatolia column, vertical: Amorite Kingdoms)
(Mesopotamia column, vertical: Assyrians)

Introduction

The numbers in the margins refer to the illustrations: heavy type for colour plates, italics for black and white illustrations.

At some time between perhaps a million and half a million years ago, the long history of man as we know him today began. For the greater part of this time man lived in a simple, primitive condition, dominated by the physical forces of climate and geography, struggling for a mere existence in his wandering search for food and shelter. Groups of people perished when they made a wrong decision, when intuition or instinct failed. Eventually, with the passage of thousands of years, in certain coincidentally favourable areas man learned, by slow experience, sufficient discipline to enable him to live in settled communities. He could raise a family in relative safety, grow crops, herd and breed animals, build structures for shelter and defence. At this stage in man's development the more complex and stable organisation of high civilisation became possible. Ignorance of the origins of natural phenomena and yet the awareness of an obvious pattern in nature led to a search for cause and responsibility, and from this the first real forms of religion emerge. The need for restricted activity and social responsibility within the unit led to law and kingship. Man had progressed from a primitive to a mature culture.

This book is concerned with the social and historical development of certain high civilisations, and with the forms of their artistic expression. The earliest politico-religious and artistic expressions of man within a mature culture are to be found in the region which is known today as the Ancient Middle East. This region stretches from Egypt and Anatolia in the West to the Iranian plateau in the East, extending southwards to embrace the Arabian peninsular. The geographical features of this vast area vary considerably. Two great river valleys cut through the deserts of the area, that of the Nile in Egypt and the 'two rivers' Tigris and Euphrates in Mesopotamia. (According to biblical tradition the latter was the Garden of Eden, the earthly paradise). Between the Tigris and Euphrates, following the fertile foothills of the mountain ranges in the north, is the 'Fertile Crescent'. It extends in an arc above northern Mesopotamia to Palestine through northern Syria and the Mediterranian coastal area (Phoenicia). Below this crescent is the Syro-Arabian desert and beyond it the plateaux of Iran and Anatolia, with chains of mountains running from east to west.

It was in these surroundings that the most ancient civilisations created by man were to develop. Originating along the river valleys, first in Mesopotamia and soon afterwards in Egypt and in India (along the Indus river), the cultures showed distinct cultural affinities in their predynastic phases. Thus in the earliest stages of the history of the Middle East the rivers were the centres of attraction. Nomadic peoples, who brought their herds to the valleys, learned how to channel the flood water and irrigate the land. This eventually led to the cultivation of grain on a commercial level. Grain surplus brought economic stability, and trade with poorer regions developed. Thus the growth of the city-state became a practical possibility.

But ethnic and cultural movements were not limited to the plains. East-west communication was possible also through the valleys in the north, a fact which has only recently been emphasised. In this way relations arose between Iran, Anatolia and the Caucasus which were to make their influence felt later when such peoples as the Hurrians, the Kassites and the Hittites descended from the north. These 'mountain peoples', generally of Indo-European tongue, were to give a new direction to the history of the ancient orient.

There is still no doubt, however, that the most creative impulses of the ancient middle-eastern civilisations developed along the Nile, the Euphrates and the Tigris; the Egyptians and the Sumerians were the first to develop powerful and complex political structures. But if it is true to say that similar conditions prevailed—the great rivers had to be harnessed to obtain a means of subsistence and then of power—beyond this the political and cultural development of the two races was markedly different.

Egypt always had a dual nature, the north and south, known respectively as Lower and Upper Egypt, having a tendency for independent government. This dualism was always kept in check by a strong central power, which maintained a more or less united Egypt under a single ruler the *pharaoh*, to whom were assigned divine powers and privilege. In Mesopotamia on the other hand political unity was rarely attained because of the strength of the individual cities. The city state, with theocratic ruler, was the typical political expression of Sumerians, just as the regional state was typical of Mesopotamia as a whole. The Sumerian ruler never assumed divine rights. He was the representative of the god on earth who would intercede with the god on behalf of the people.

The peripheral areas (Iran, Syria-Palestine and Anatolia) sometimes had powerful political structures such as the Hittite Empire in Anatolia and the Elamite state in Iran. On the whole however they were always in a weak political position, being dispersed over wide tracts of territory and thus easy prey for their more powerful and integrated neighbours, Mesopotamia and Egypt.

The civilisation of the Ancient Middle East seems to us to have a unity only because we view it from such a distance. In fact it varies greatly from region to region, the Sumerian civilisation differing not only from the Egyptian, but even from the Babylonian, its natural offspring. But the achievements of these civilisations were nevertheless parallel and there were certain exchanges between them. Writing with similar characters, appeared at about the same time, in Egypt (hieroglyphic), in Mesopotamia (cuneiform) and in Iran (proto-Elamite). In the Egyptian script a more lively decorative sense is evident, and in the graphic arts as a whole achievements varied from region to region, even if they shared their principal sources of inspiration. In a general evaluation one should remember that while Egypt, because of its geographical position, always remained faithful to herself, in language, art, religion and politics, the Asiatic regions had a continual succession of races and thus of languages, political structures and cultures. Egyptian art was unique in its consistency over a span of three millennia despite differing spiritual outlooks from one period to another. (The works of C. Aldred in England and S. Donadoni in Italy are fundamental to the understanding of the spirit of Egyptian art). The arts of Asia in contrast, suffered numerous interruptions and involvements one area with another, and remained on the whole at a lower level of accomplishment than Egypt.

We must constantly be aware, when examining a work of any early society that the criteria of excellence of those that produced it were different in kind from ours. For us art involves aesthetic appreciation as well as a consideration of its social, political or religious functions. We are irrevocably involved today with that indefinable quality which we call 'beauty'. It is our habit to relate all artistic manifestations from artefacts to architecture to our personal and transient idea of beauty. We apply this aesthetic judgement as much to the art of the past as to the productions of our own day. We look, for instance, at Egyptian sculpture assessing its qualities as a 'work of art'. It is important to remember, however, that aesthetic considerations were unknown to early societies. (In Greece, for example, there was no separate word for art). To the Egyptian or Sumerian, sculpture had a recognisable practical use in worshipping gods, celebrating victories or decorating a palace or a tomb. A separate concept of beauty would have seemed, if not incomprehensible, certainly irrelevant. If we introduce aesthetic considerations when looking at the 'art' of the Ancient Middle East—and it is impossible for us to avoid doing so—we must be careful not to ascribe our values to those who produced it so many centuries ago.

Mesopotamia

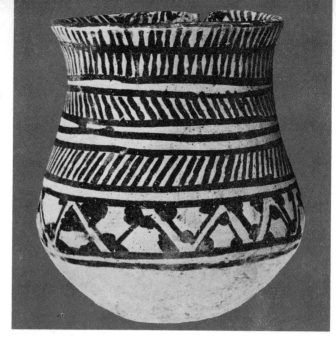

The territory of ancient Mesopotamia—the land of the two rivers—corresponds in the main to the modern Republic of Iraq. Mesopotamia is not defined by any strong natural boundaries and it shades off in the east to Iran, in the north to Anatolia, and in the west to Syria. (The art of these countries will be discussed in the following chapter: 'Peripheral Regions'). Mesopotamia proper presents a flat and undramatic appearance, the uniformity of which is only broken by the channels of the Tigris and Euphrates rivers and the surviving 'tells', or artificial hills gradually built up over many successive phases of urban habitation. The history of the earliest settlements in Mesopotamia can be traced through the pottery finds at such sites as Tell Hassuna, Samarra, Tell Halaf and Tell al-'Ubaid. But the true history of Mesopotamian civilisation and art begins only with the Uruk period, which seems to coincide with the coming of the Sumerians.

For convenience the history of Mesopotamian civilisation may be divided into a Sumerian and a Semitic epoch. The first (*c.* 3500–2350 BC) comprises a period of preparation, the predynastic period, and a classic flowering, the Early Dynastic period. The latter in turn is divided into three parts. The Semitic epoch began about 2350 BC with the dynasty of Akkad. After a short Sumerian revival at the time of the 3rd dynasty of Ur, Semitic predominance was re-established in the Old Babylonian period, continuing through the Kassite, Neo-Assyrian and Neo-Babylonian periods. Native rule in Mesopotamia was finally ended by the Persian conquest of Babylon in 539 BC.

THE SUMERIAN CIVILISATION

This civilisation was formed in southern Mesopotamia in the second half of the 4th millennium BC. In language (and probably also in racial make-up) the Sumerians were intruders in the ethnic complex of early Mesopotamia; they seem to have come from the Iranian highlands. Nonetheless they managed to fuse so successfully with the native population that this fact is now known only because of the existence of certain city names that do not belong to the Sumerian language. Although the Sumerians imposed their own language on the population, they adopted the established pattern of living that they found there and developed it further.

The unpredictability of the Tigris and Euphrates rivers required the building of dikes and the cutting of canals in order to guarantee a regular flow of water and check the disastrous inroads of floods. Irrigated in this way the rich alluvial soil of southern Mesopotamia became extremely productive. Without this regulation southern Mesopotamia —as is the case today—is reduced to steppes and reed swamps.

At first the Sumerians formed agricultural communities which lived mainly by tending cattle and sheep and by cultivating date-palms and grain. (The earliest Sumerian art clearly bears the imprint of this way of life). The Sumerian civilisation proper came into being as these com-

1. **Vase from Samarra.** Fired clay, painted. Staatliche Museen zu Berlin. The origins of the Samarra culture are still disputed. Possibly Iranian, it is paralleled by the Tepe Siyalk II ware. Named after a site on the Tigris, Samarra ware is found over a large area, even as far west as northern Syria. It is characterised by narrow bands filled with geometric ornament, and dates from about the first half of the fifth millennium BC. The culture of Samarra was preceded in northern Mesopotamia by that of Tell Hassuna, and was followed by the rich Tell Halaf culture.

2. **Female figurine from 'Ubaid.** Predynastic period. First half of the fourth millennium BC. Terracotta. h. 5½ in. (14 cm.). British Museum, London. Such figurines number among the earliest finds of the predynastic period. They sometimes depict a mother suckling a child. The lumps on the shoulders may represent tattooing. The wig is of bitumen. The 'Ubaid is the first prehistoric culture of southern Mesopotamia, whither it came from the Iranian plateau.

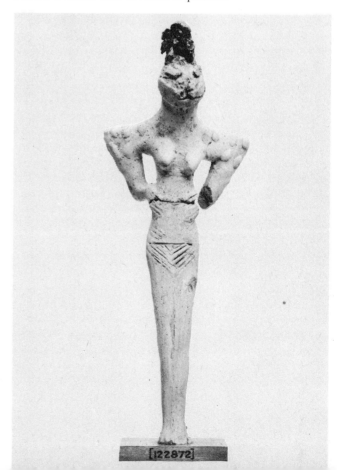

munities were gradually organised collectively to undertake the enormous public works needed for large-scale agriculture.

Organisation of this type calls for a strong central power and with the Sumerians this took a theocratic form. Thus the logical focus of Sumerian life and civilisation was the temple, the house of the god who rules the city. The high priest, the *en* who was assisted by a large college of subordinates, represented the god; he combined religious and political power. The *ensi*, or governor had a similar status. Only in a later phase of Sumerian history did political authority, embodied by the *lugal* or king, become independent of the temple. The political ideas and structure of the Sumerians developed in accordance with these basic economic and social facts. The ideal ruler was conceived as a peace-loving man always eager to build temples for the gods and to dig canals for his people. For the Sumerians this concept was far more than a humanitarian sentiment, it was a living reality, tremendously important for the formative period of their civilisation and destined to remain effective throughout the entire course of its history. Much later the Babylonians revived this ideal of kingship.

THE STUDY OF SUMERIAN ART

Unfortunately it is still hard to grasp the outlines of the early development of Sumerian art. The scarcity of surviving objects in a period stretching over a thousand years is a formidable obstacle. Moreover, the known works are unevenly spread over the various types and sites. To give only two examples, the great profusion of cylinder seals is paralleled by meagre finds in the other minor arts and the considerable remains of sculpture from Khafajah and Telloh (ancient Lagash) find no real counterpart in the archaeological discoveries from such important places as Ur and Uruk. A further complicating factor in the study of Sumerian art is uncertainty of chronology; eminent scholars have assigned many objects to very different dates. Last but not least is the inadequate development of art-historical scholarship concerning ancient western Asia; research has remained largely at the philological stage. Although there is no doubt that some studies in the field of style analysis such as those of Anton Moortgat and Henri Frankfort have increased our understanding, the general validity of such methods in the study of the art of the ancient Middle East has not yet been established.

If we compare Sumerian art with the achievements of the Egyptians at the same period of time, Sumerian inferiority in formal expression and stylistic accomplishment is unmistakable. The main explanation of the divergence between the arts of the two peoples probably lies in the difference between Egyptian and Sumerian artistic taste; but the environment that supplied their vital energies was also strikingly dissimilar. The disparity in quality is especially marked in the field of sculpture where the Sumerians often produced indifferent work. One of the reasons for this is that southern Mesopotamia, unlike Egypt, has no stone

readily available for carving. The short supply of imported raw material hindered the growth of guilds of artisans who could hand down their craft from father to son as happened in Egypt. When artistic inspiration flagged in Egypt technical skill often compensated. The absence of stone in Mesopotamia explains why the art of sculpture—as will be seen—was probably initially dependent on Egyptian models. For long ranking as one of the most typical expressions of Mesopotamian civilisation, sculpture in stone practically ceased to exist at the end of the Sumerian period. Babylonian sculpture is mostly executed in bronze.

PREDYNASTIC ARCHITECTURE

Sumerian art begins at Uruk, the biblical Erech, in the later centuries of the 4th millennium BC with a series of works that bear witness to the advanced civilisation of the city. Uruk is situated in lower Mesopotamia, to the east of the Euphrates. The condition of the river valley did not lend itself to elaborate building projects. The tall marsh reeds were suitable for making shelters for animals, but little more. No wood or stone was available. What was present in unlimited quantity was alluvial mud. Mud bricks, which appear to have been an earlier Iranian invention, were oblong, sun-dried, and set into a mortar of mud when walls were built. Largely because of its religious prestige, Uruk always remained one of the most important centres of the Sumerian world. To the early period belong two large sacred complexes, the precinct of the *E-anna* ('the house of the sky') and the so-called 'Anu Ziggurat' surmounted by the White Temple. The *E-anna* precinct contained a group of temples of which only the most important can be mentioned here. The Limestone Temple, which takes its name from the unusual construction material, has a plan in the form of a broad rectangle (100×255 ft.). In the centre is a big T-shaped room bordered at the sides and back by smaller chambers. A number of entrances pierce the two long sides of the building. Despite the use of stone in place of the brick that is found in most of the other Sumerian temples, this building keeps the wall buttresses characteristic of brick temples. These buttresses are a striking feature of Sumerian religious architecture and were even copied in Egypt. They were invented as a device to contain high wooden structures with thick and heavy masses of unfired clay. Later Sumerian architects made use of the buttresses to form an effective decorative element: the regular sequence of solid and void units served not only to break up the monotonous heaviness of the walls but gave them a kind of sculptural rhythm taking advantage of the effects of light. This architecture is severely symmetrical both in the distribution of interior space and in the three-dimensional treatment of the walls.

The Limestone Temple and a second temple coordinated with it but turned at an angle of ninety degrees are linked by a monumental courtyard with a short side that presents an imposing group of eight cylindrical columns and four half-columns standing on a platform.

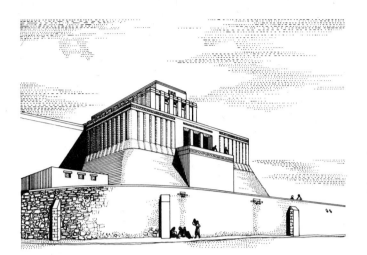

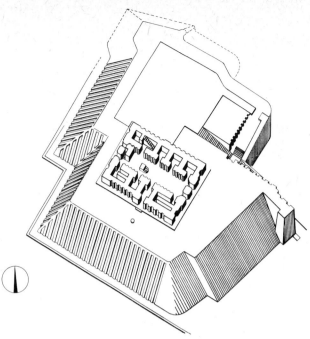

3. **Reconstruction of the temple at Eridu.** Predynastic
period. The oldest Sumerian religious structure has been found
at Eridu (modern Abu Shahrein). Built on an artificial platform
which anticipates the ziggurat proper, it had buttressed walls.
When excavated a quantity of fishbones were found on the
floor of the cella, and it has been suggested that the temple
was dedicated to Enki, the 'lord of the earth', later called by
the Semites Ea, the 'house of sweet waters'.

4. **Plan of the White Temple at Uruk.** Predynastic period.
c. 3200–3000 BC. The White Temple, so called because of its
whitewashed sides, surmounted the 'Anu ziggurat', the second
important predynastic sanctuary at Uruk. The central room is
flanked by five side rooms to the north-east. Entry was through a
door in the south-western side, leading through a vestibule
to the long cella. In one corner stood a platform or altar and,
a few feet in front, an offering table of brick with a semi-
circular hearth.

Our surprise at finding such columns in Mesopotamian
architecture is heightened by the colourful revetment of the
columns and the courtyard wall. Thousands of terracotta
cones of various colours are pressed into the plaster of the
wall surface so as to form patterns of zigzags and lozenges.
Once again the Sumerian architects succeeded in en-
livening the brick structure, here by means of eye-catching
geometric patterns. It is interesting to note that the designs
produced by the terracotta cones recur some centuries
16 later in the decoration of objects of the minor arts (musical
instruments, for example) and they survived until only a
few decades ago in rugs of the local bedouin tribes.

Uruk's other main religious complex, the Anu Ziggurat,
consists of an immense brick platform of slightly irregular
plan approached by steps. On the platform was a terrace
and at one side of this stood a building known as the 'White
4 Temple', which is rather different from the Limestone
Temple of the *E-anna* precinct. The White Temple also has
a rectangular plan, though it is less broad than the Lime-
stone Temple. The centre room is a simple rectangle and
the small side chambers are carefully grouped without
being strictly symmetrical. The system of projections and
recessions of the outer walls is treated on a broad scale;
within the temple the side chambers come into being
almost spontaneously through the large-scale application
of the same decorative principle. The siting of the temple
on a platform, a device that recurs in the oldest temple of
3 Eridu, is another leading characteristic of Sumerian reli-
gious architecture. Practically speaking, the elevation of
the temple above the surrounding plain might have arisen
both from the need to protect the building from the danger

of floods and from the cumulative effect of repeated re-
buildings and repairs leading to a gradual rise of the
ground level. But apart from these practical aspects the
building of temples on heights—the heights were necessa-
rily man-made owing to the absence of natural elevation
in this flat alluvial region—satisfied a deep-seated religious
need. The Sumerians conceived of the god as dwelling upon
a mountain; both literally and figuratively he stood on a
higher plane than man. This conception of deity, which
finds its architectural symbol in the creation of the 'high
temple' that heralds the true ziggurat of later times, shows
the beginnings of an awareness of the transcendent charac-
ter of the divine. It was deeply alien to the semi-nomadic
Semitic people who entered into relations with Sumerian
culture and who later settled in Palestine; in fact the
Biblical story of the Tower of Babel reveals the bewilder-
ment of the patriarchs before an exalted religious concept
differing fundamentally from that of the Semitic peoples
of the desert.

PREDYNASTIC SCULPTURE

The monuments of architecture that have been discussed
reveal an advanced state of artistic and cultural progress in
the formative period of Sumerian civilisation. These
buildings are matched by equally significant works of
sculpture. An outstanding piece is the so-called 'hunting
stele' from Uruk, a fragmentary pillar in granite showing a *5*
king during two separate episodes of a lion hunt. In the
main scene, which is rendered in larger scale, we see the
king drawing his bow against two wounded lions. The
secondary scene shows the same figure spearing a lion. The

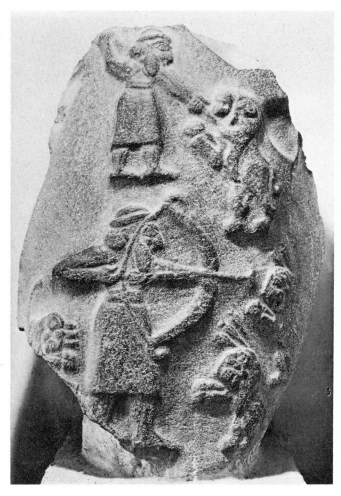

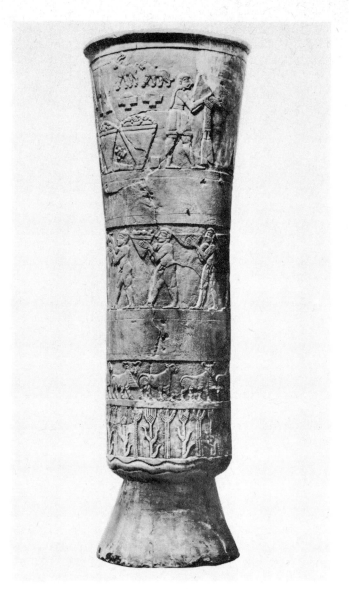

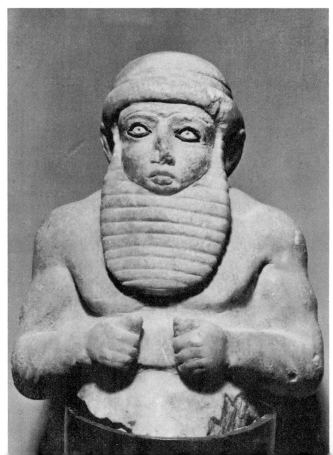

5 (above). **'Hunting stele' from Uruk.** Predynastic period.
c. 3200 BC. Granite. 30¾ in. (78 cm.). Iraq Museum, Baghdad.
This rare surviving fragment of early Sumerian sculpture
shows two episodes in a lion hunt. Above a king attacks the
animals with a long spear, below with a drawn bow. The scene
may have either an historical or a symbolic meaning.

6 (above, right). **Vase from Uruk.** Predynastic period.
c. 3200–3000 BC. Alabaster. h. 36 in. (92 cm.). Iraq Museum,
Baghdad. This elegant vase was found in the E-anna precinct
at Uruk. It celebrates, on the bands of its relief, the offering of
the fruits of the earth to the goddess of fertility. The sense of
volume evident here is also present in the sculptures
illustrated as figures 7 and 8.

7. **Statuette of bearded man from Uruk.** Predynastic
period. *c*. 3200–3000 BC. Alabaster. 7⅛ in. (18 cm.).
Iraq Museum, Baghdad. This early predynastic figure is one
of the first examples of Sumerian sculpture in the round. The
beard is clearly shown to be artificial. The eyes are of shell,
with pupils of lapis lazuli. This is the earliest example of the
typically Sumerian cult statue representing a king or
priest in prayer before a divinity.

meaning of this stele is uncertain, for it seems unlikely that the purpose was merely to record a royal hunting expedition. Perhaps it refers indirectly to some important military undertaking. However this may be, the resemblance of the scenes depicted to those on the 'hunters' palette' from the contemporary Egyptian predynastic period is striking.

An object of outstanding artistic interest also from Uruk is a cylindrical alabaster vase, slightly flaring at the top and with a conical base. The outside bears a decoration of bas-reliefs arranged in four registers. From bottom to top the friezes represent ears of corn, domestic animals, nude attendants bearing offerings, and finally the goddess Inanna receiving offerings before her temple. The ritual meaning of these scenes is clear: they commemorate the presentation of the fruits of the earth to the fertility goddess. The ceremony shows that at this time the people were primarily concerned with agriculture. A pastoral scene, with flocks beside the sheepfold, appears on the side of an alabaster trough also from Uruk, reflecting the same pre-occupation.

These examples constitute the most important relief sculptures of the period. They share an artistic style characterised by a close adherence to nature rendered with a sensitive understanding of volume. The figures are arranged on the surface with a sense of compositional balance that reflects the same love of order and solemnity which has been observed in the planning of the temples. One gains an impression of a society that is powerful, serene and self-assured.

The finest works of art of this period, however, are the sculptures in the round. Their background cannot yet be properly traced. They were preceded by a series of terra-cotta statuettes usually nude female figures, that belong to the 'Ubaid period. But there are no stylistic links between these clay statuettes and the later sculptures in stone, which show an altogether different conception, style and spirit. Thus it is hard to find forerunners of the great works of Uruk that are about to be discussed. What is certain is that they reveal a remarkable maturity of style that could only be the result of long periods of experimentation.

A group of stone statuettes of unknown origin survive, representing a nude man, bearded and with his hands on his chest. The date of these figures is uncertain, but their general form and stance suggest that they belong to the early predynastic phase. Moreover, they show a remarkable similarity to a male Egyptian statuette (now in the Ashmolean Museum, Oxford) from the predynastic period that represents a nude man, bearded, who wears a kind of codpiece characteristic of the earliest North African peoples. It is interesting to note that both in this Egyptian statuette and in the earliest Sumerian ones the beard is clearly shown as artificial. Despite the uncertain chronology, it seems likely that these are the earliest manifestations of Sumerian sculpture in the round and that they constitute a category of work ultimately inspired by Egypt. They prepare us for the masterpieces of this period, the bust

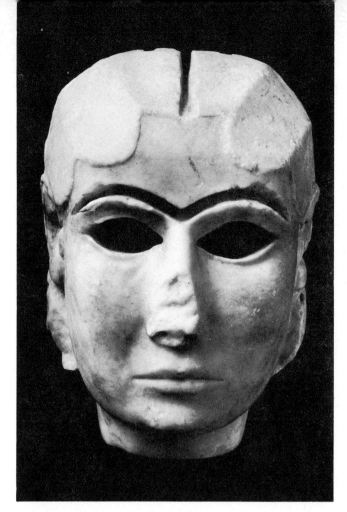

8. **Female head from Uruk.** Predynastic period.
c. 3200–3000 BC. White marble. $7\frac{7}{8}$ in. (20 cm.). Iraq Museum, Baghdad. This famous head, known as the 'Lady of Warka', shows a developed understanding of the problems of sculpture in the round. Possibly part of a complete figure representing a goddess, it is, however, flat at the back and provided with holes to attach it to a vertical surface.

of a king and the mask of a woman, both from Uruk. The male bust, discovered only a few years ago, shows a complete technical mastery and a superb artistic sense: the treatment of the unclothed body displays the same attention to volume that has been noted in the reliefs, but stylistically it is markedly superior. Similar qualities are found in the famous mask known as the 'Lady of Warka'. Here the extremely delicate modelling permits a subtle play of light around the eyes and mouth. The softness of the face and the static quality of the cheeks accentuate the intense expression of the mouth and the empty eye sockets, to produce a profoundly moving effect on the modern observer.

PREDYNASTIC SEALS

A summary of the earliest Sumerian art would be incomplete without mentioning that branch of craft production that was always to remain the most characteristic feature of Mesopotamian civilisation as a whole: the decoration of cylinder seals. Contrary to what occurred in prehistory and subsequently in Egypt and in the West, the Mesopotamian seal did not take the form of a stamp or die, but was cylindrical with decoration distributed all around the surface. The abundance of these small objects permits us to follow the course of artistic development better than

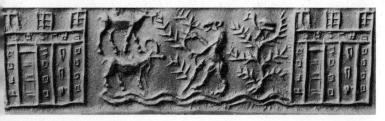

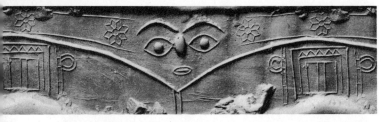

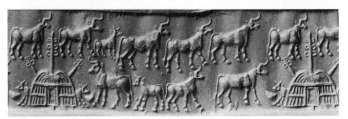

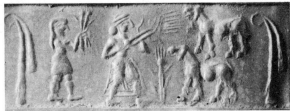

9a–e (left). **Predynastic cylinder seal impressions from Uruk.** Iraq Museum, Baghdad. Predynastic cylinder seals are remarkably free in their composition, and lively in manner. A variety of scenes shows *(a)* animals and a mythological figure before the walls of a temple, *(b)* the all-seeing eyes of the god, *(c)* offerings brought by land and water to a shrine, *(d)* a procession of animals of the sacred herd, three of them emerging from wooden byres, *(e)* animals being fed by two figures bearing twigs. Representations of buildings on cylinder seals *(c)* are important for they are our only source of knowledge of the actual appearance of structures otherwise known only from foundations.

11 (right). **Limestone tablet from Kish.** *c.* 3500 BC. Ashmolean Museum, Oxford.
12 (below, right). **Foundation tablet of Aannepadda.** *c.* 2600 BC. British Museum, London.
13 (far right). **Stele of Assurbanipal.** 7th century BC. British Museum, London. The development of writing from the early pictographs to a developed cuneiform script can be seen in these three examples of widely differing periods. Figure 11 shows the earliest known picture writing with a sign for a hand, a foot, a threshing sledge. Figure 12 shows the Sumerian form of the cuneiform wedge-shapes which initially were abstract versions of the earlier 'sign writing'. In figure 13 the script has acquired a new and very different form. With its sharp angles it differs from the elegant archaicising form used in Babylonia. This stele bears a fragment of the Gilgamesh epic in the later Assyrian version and contains a description of the Flood.

with the larger rarer works. (Students of classical art are confronted with a similar situation, for the evidence for Greek painting is derived almost exclusively from black- and red-figure vases). Not only do the earliest seals of Uruk show the same stylistic traits as those seen in the reliefs, that is, the treatment in terms of broad volumetric masses, the sense of free composition and a close adherence to nature, but the choice of subject-matter expresses the same under-lying attitude. The seals of Uruk display ritual and religious scenes in which the gods assume completely human form. Purely decorative friezes of domestic animals are also depicted. They include a motif of Egyptian origin, animals *88b* with long intertwined necks, possibly inspired by the giraffe, and finally scenes alluding to warfare with prisoners bound before the king.

THE FIRST CRISIS OF SUMERIAN CIVILISATION:
TRANSITIONAL PERIOD

The flourishing development of Sumerian civilisation and art which we have seen at Uruk in the last centuries of the 4th millennium BC was suddenly interrupted about the beginning of the 3rd millennium. There then began a period of Sumerian civilisation lasting some three centuries

which shows not only a decline in quality and quantity of works of art but also a far-reaching spiritual change. This period of crisis, which heralds the Early Dynastic period, is the first to be found in the course of Sumerian cultural development. At present we can only guess the reasons for this sudden check in the cultural progress of the country: perhaps there were political disturbances connected with the settlement of Semitic peoples, or, on the other hand, an internal crisis within Sumerian society may have arisen, provoked by some exceptional event. One's mind turns to the Sumerian legend of The Flood, which marks a division between the earliest dynasties of a mythological type and those of the period we term protodynastic. In any case, it seems that in the artistic sphere the transition from the Predynastic to the Early Dynastic period took place in stages.

Among the notable characteristics of the new proto-dynastic art, the strong expressionist tendency, the sense of movement and the dramatic figural presentation are to some extent anticipated in some predynastic works of the transitional period. Some stone vases decorated with carving in high relief that come from Uruk and Ur, reflect an artistic sensibility that is totally different from that seen, *14*

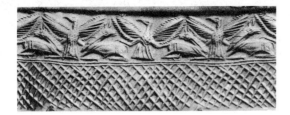

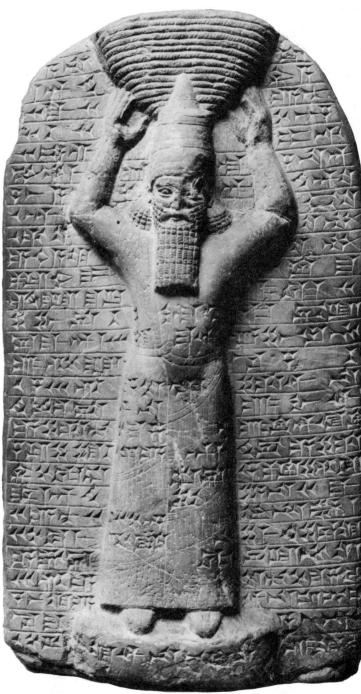

10 (left). **Cylinder seal impression of birds and animals.**
Transitional to Early Dynastic I period. *c.* 3000–2700 BC.
Louvre, Paris. This seal, in the so-called brocaded style, shows
figures almost dissolving into a sea of lines. The eagle-like
birds with wings and claws outstretched to protect the
antelopes probably represent a god, anticipating the motif on
the copper relief shown in plate 22.

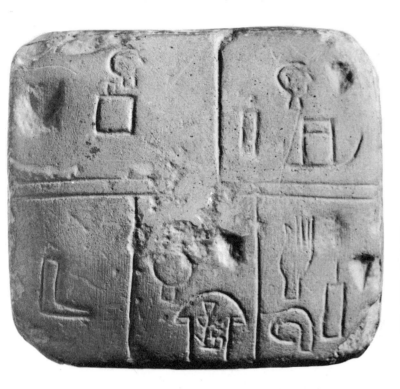

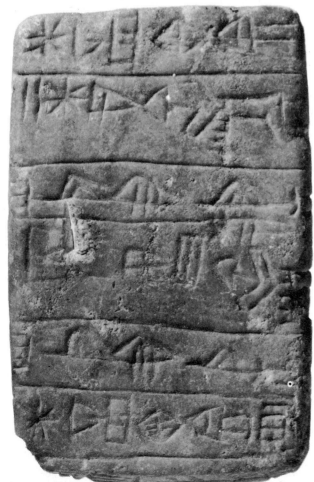

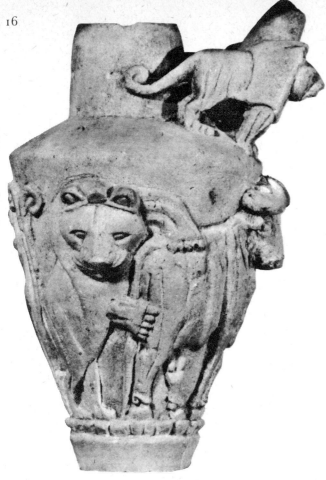

14. **Spouted jug from Uruk.** Transitional period.
c. 3000–2700 BC. Yellow limestone. 8 in. (20·3 cm.).
Iraq Museum, Baghdad. The rendering of the figures on this
jug is strikingly different from the ordered friezes in figure 6.
The treatment is more massive and dynamic. The lion struggling
with the bull almost obscures the function of the jug, and
reflects a preoccupation with the dramatic struggles of life.

15*a*, *b*. **Sin temples II and VIII at Khafajah.** Transitional
to Early Dynastic period. First half of the third millennium BC.
The successive rebuildings of the temple at Khafajah show a
development of a simple plan with a single cella *(a)* to a new
scheme with two cult rooms *(b)* and an irregular sequence of
chambers. Unlike the plan at Uruk (see figure 4) there is now
only one entrance and the temple is surrounded by a high wall.

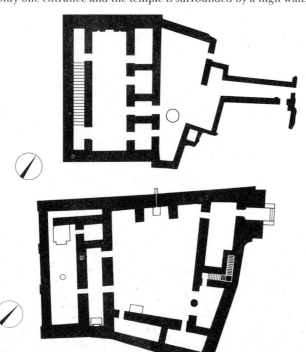

for example, on the alabaster vase with the religious scenes
illustrated earlier. Now one finds herds attacked by lions 6
and defended by a nude hero (the so-called 'Gilgamesh
motif'). A new attitude to the world has come into being:
man's struggle with his environment. In style these vases
do not compare with the earlier example; the figures do not
fit within the bounds of the vase but seem to suffocate it
with their mass and dramatic force. A whole new world is
announced.

THE EARLY DYNASTIC PERIOD

The art of the Early Dynastic period in Mesopotamia grew
from seeds already sown during the period of crisis in the
later Predynastic period. The break that arose then proved
to be lasting, and efforts were made to create a new artistic
language from elements taken from the most recent tradi-
tions. This transitional phase, linking the later predynastic
period to the Early Dynastic period, and corresponding
roughly to the first three centuries of the 3rd millennium
BC, is relatively barren. Seals are almost the only works of
art that have survived from this period. The seals are
mainly in the so-called 'brocaded style' in which the most 10
popular motifs of the old repertoire dissolve in a sea of
broken lines. The disregard for the integrity of natural
forms is a reflection of a new and intensely intellectual
attitude. This intellectualism was to find its full artistic
expression only later, but it emerged at this period through
a transformation of writing. The basic form of the original 11
pictographs was changed as the script evolved into a 12,13
rigorous system, which we know by the name cuneiform.
(This contrasts with Egypt where pictographic symbols
continued to be employed.) The process is closely related to
the development of seals; in the new script the units lose all
reference to reality and take on the abstract form of
geometrical designs, mainly of closed type (triangles,
lozenges, rectangles, lattices).

EARLY DYNASTIC ARCHITECTURE

The economic and political revival of Mesopotamia in the
Early Dynastic I period beginning about 2700 BC, is
reflected in a number of important public building
complexes in cities belonging to Sumeria or influenced by
her. The most characteristic structures are still the temples
and comparison of these with their forerunners shows the
(Continued on page 33)

1 (opposite). **View of the Nile, near Aswan.** The Nile has
always been the life-force of Egypt. With the retreat of the
northern ice-cap over Europe at the end of the last Ice Age
20,000 years ago, the drying up of the north African grasslands
forced the tribes of hunters to congregate in the fertile river
valley. In a now almost rainless country the regular annual
flood of the Nile was a constant renewal of hope to these people,
who formed the African substratum of Egyptian society. It was
their first measures to harness the Nile flood into dykes and
canals which resulted in organised communities.

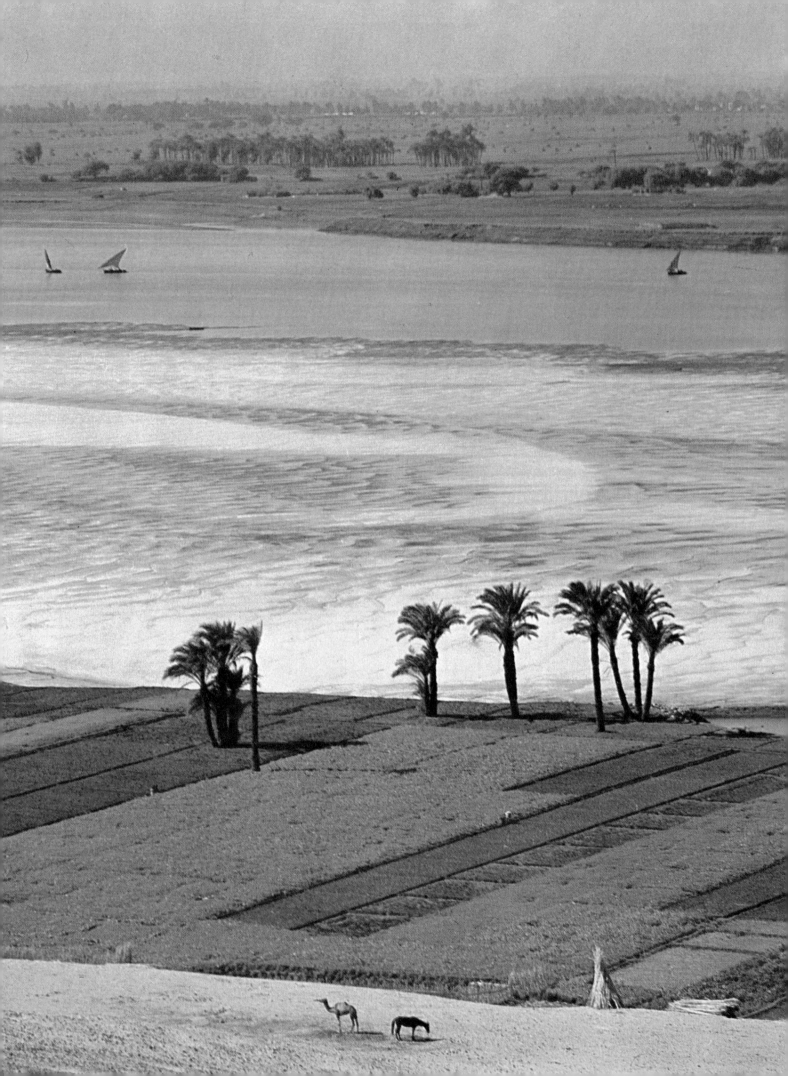

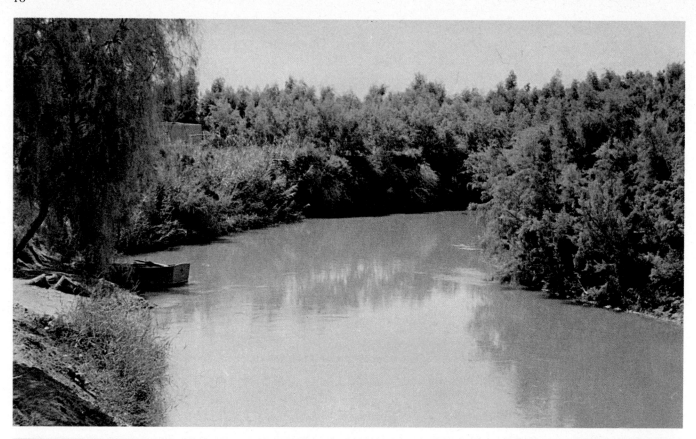

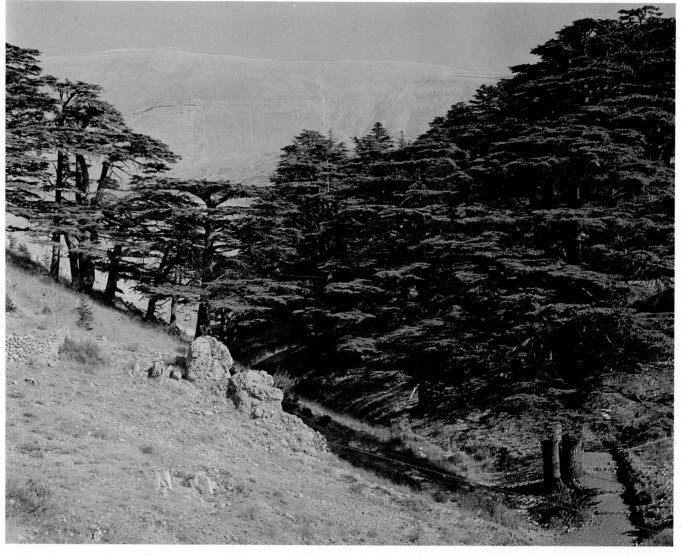

2 (opposite, above). **View of the Jordan, near Jericho.** The river Jordan is the main river of Palestine, flowing over two hundred miles from its source in the Anti Lebanon mountains through the Great Rift Valley to the Dead Sea in the south. Together with the river Orontes in the north it marks the eastern boundary between the agricultural coastal strip of Western Asia and the Syrian desert. Throughout history it has divided the settled from the nomadic populations and crossing the Jordan was always an event in the history of Israel.

3 (opposite, below). **The Cedars of Lebanon.** The famous cedars of Lebanon which once formed widespread forests on Mount Lebanon are now considerably reduced in number. This region was in ancient times the source of timber for the whole of the Near East from Egypt to Mesopotamia. The export of the prized timber made the area very prosperous. The Lebanon cedar is frequently mentioned in the Scriptures as an allegory of power, prosperity and longevity.

4 (below). **Ruins at Babylon.** Babylon first became important as the capital city of the early Babylonian kings of whom Hammurabi is the most famous. These remains however belong to its second great period which culminated in the massive building operations undertaken in the reign of Nebuchadnezzar (604–562 BC). Today only piles of bricks remain of what was one of the most splendid and famous cities of the ancient world. The prosperity of the Mesopotamian cities derived from the elaborate canalisation of the waters of the Euphrates and the Tigris. When this irrigation system was destroyed the deserts and swamps returned.

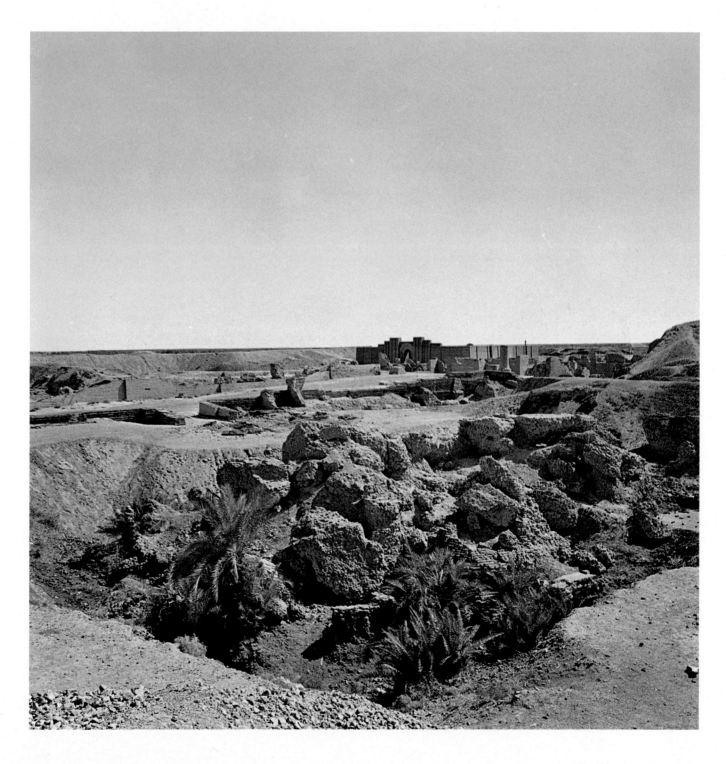

5 (right). **The ruins of Jericho.**
Situated in the desert of Judah, near an
oasis some 656 feet below sea level,
Jericho grew up around a powerful
spring. In the seventh millennium the
small Neolithic village developed into a
thriving city. The flimsy huts were
replaced by round houses built of mud
bricks, on stone foundations with floors
well below the level of the ground outside.
The spectacular fortifications were built
later: a stone wall five feet thick reaching
a height of over sixteen feet was built
within a deep trench.

6 (below). **Neolithic tower at Jericho**
(detail). The imposing circular stone
tower found within the fortifications still
stands some twenty-six feet high. The
inner staircase of twenty-eight wide stone
slabs leads to the top. At the bottom of the
steps a passage leads to a door at the
eastern side of the tower.

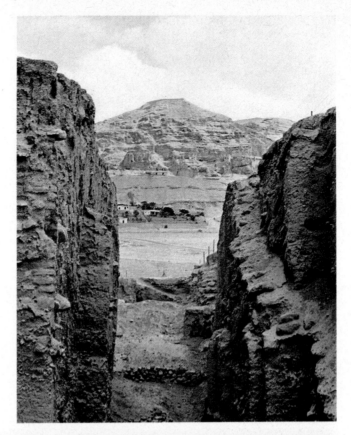

7. **Remains of the Early Sumerian temple levels at Uruk.** End of the fourth millennium. The city of Uruk (modern Warka) was one of the most important centres of early Sumerian civilisation. It is situated on the west bank of the old bed of the Euphrates, whose course now runs some miles to the east. By the second half of the fourth millennium Uruk was a thriving city with a perimeter wall measuring some five miles. The façades of the temples and public buildings were decorated with a mosaic of clay cones in contrasting colours and geometric patterns. These are the earliest remains in Mesopotamia of buildings on a monumental scale.

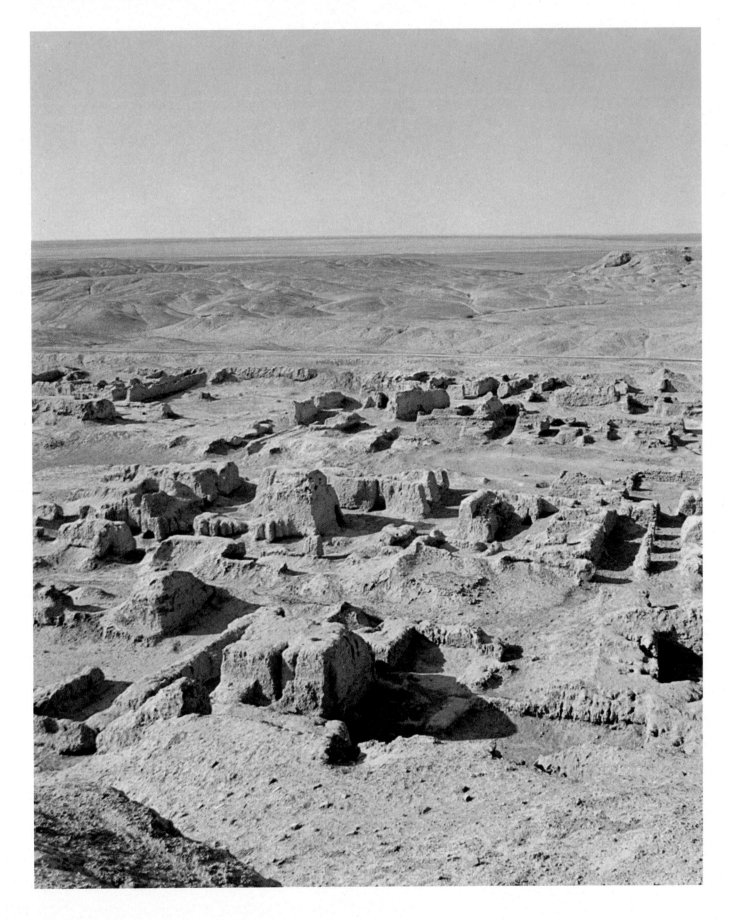

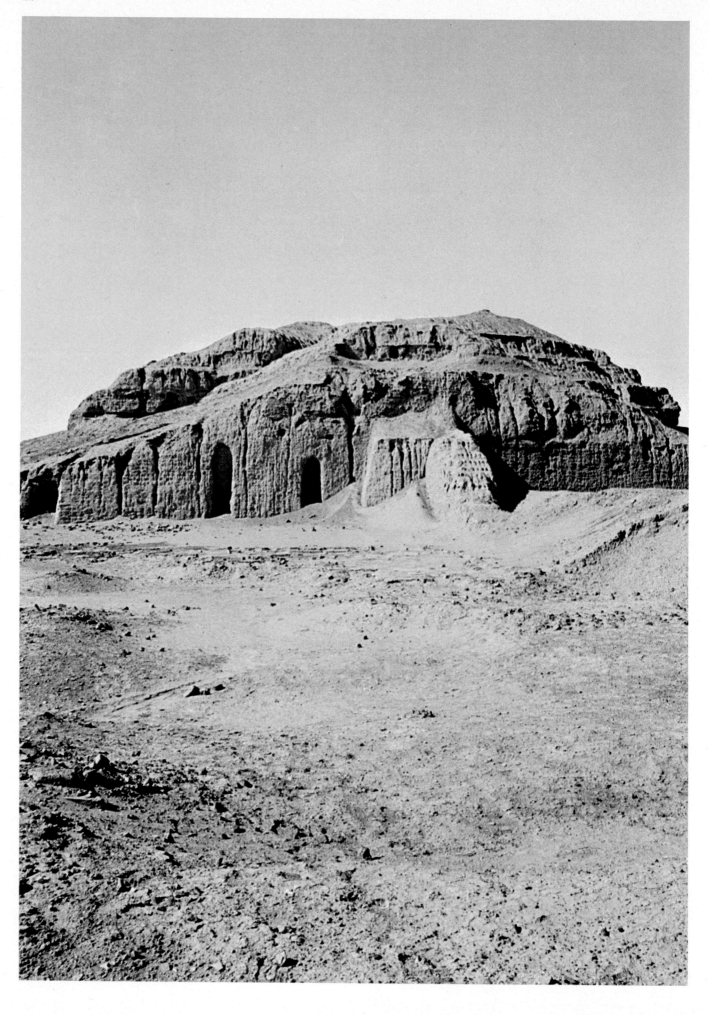

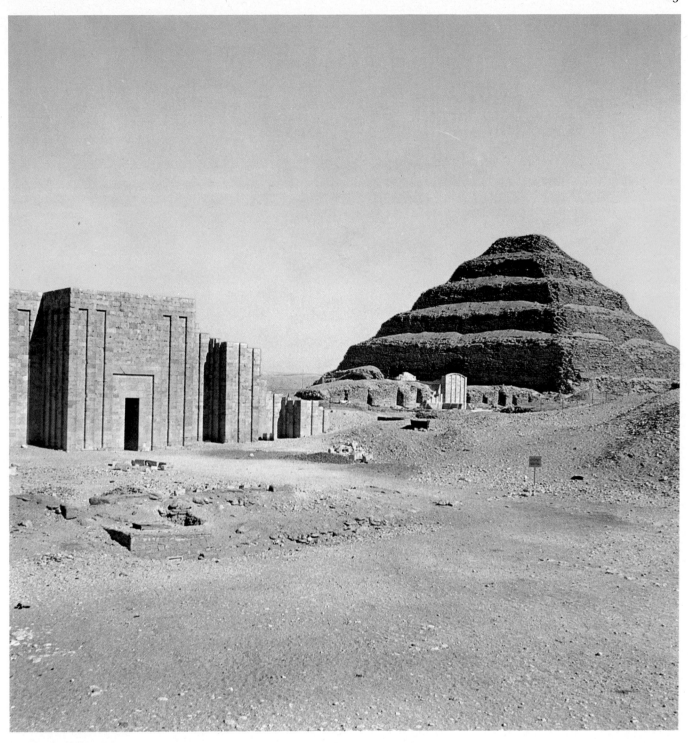

8 (opposite). **The Ziggurat at Uruk, seen from the north-east.** The city of Uruk was successively enlarged and rebuilt during the long course of its history from prehistoric times until the Parthian Empire of the 2nd century BC. The most imposing building of the predynastic period is the so-called ziggurat, an enormous artificial platform of irregular shape, measuring some 196 feet in width, built of mud bricks which were plastered over with clay. Above the platform stood the White Temple dedicated to the sky god Anu. The ramps which supported the staircases can clearly be seen in this view.

9 (above). **The Step Pyramid of Zoser at Saqqara.** Third Dynasty. *c.* 2650–2630 BC. The Zoser complex was built under the direction of the architect Imhotep as a funerary monument to the king. It is distinguished by its ambitious plan and dimensions, and also for the fact that stone was used here for the first time on a large scale. The pyramid itself, a six-staged tower 195 feet high, although resembling the ziggurat of the Sumerians, serves a different purpose. The function of the tower in Mesopotamia was to raise the chapel built upon its summit from a human to a celestial level. In Egypt the pyramid housed the dead; its height served to add splendour to the proportions of what was in effect an enclosure. The perimeter wall (shown to the left, and partly restored) was an articulated façade, echoing Mesopotamian practice. It enclosed the precincts of the pyramid comprising a mortuary temple, a festival court and other buildings.

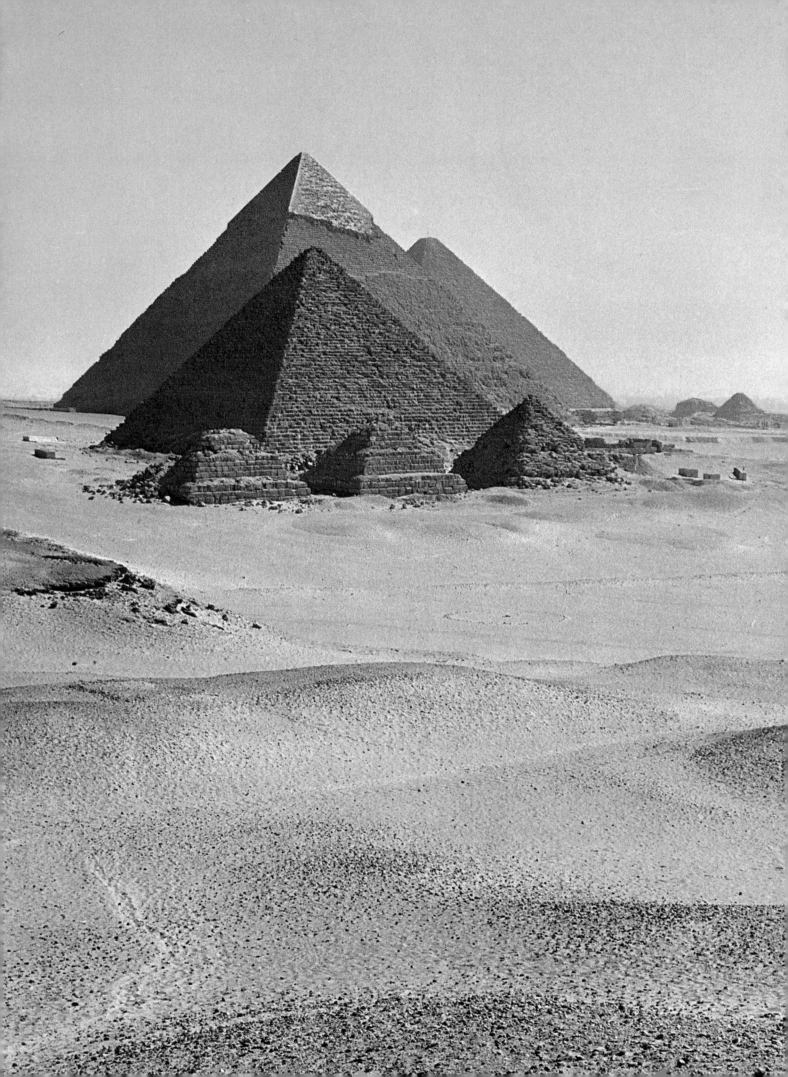

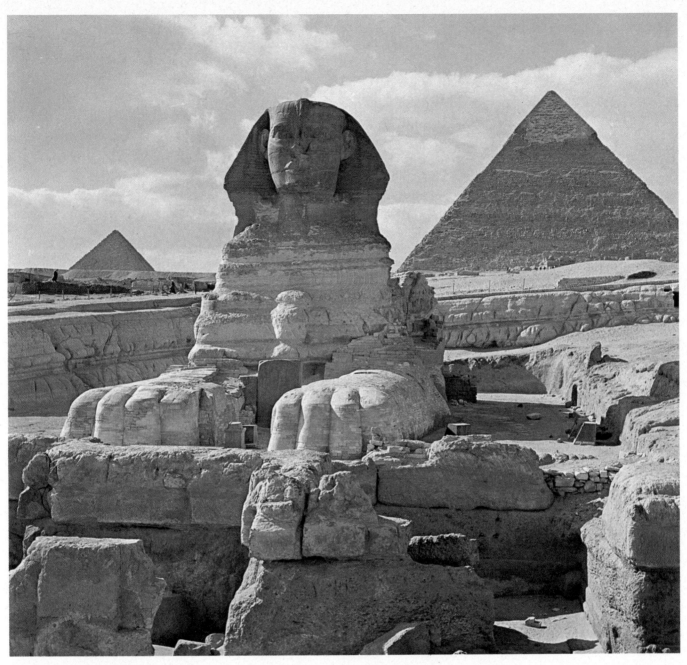

10 (opposite). **The pyramids of Giza from the south.** Fourth Dynasty. The pyramid of Chephren standing on higher ground in the centre, looks deceptively larger than the Great Pyramid of Cheops beyond it. The vizir Hemon, cousin of King Cheops, was responsible for the construction of the Great Pyramid, which took over two million large limestone blocks. The stone for the core was quarried on the spot while the finer limestone facing blocks were ferried from Tura across the river. The pyramid of Mycerinus, in front, is flanked by the small pyramids of three of his queens.

11 (above). **The Sphinx of Chephren.** Fourth Dynasty. h. 66 ft. (20·11 m.). The Great Sphinx lies next to the causeway which connected the pyramid temple of Chephren with the Valley Temple (see plate 67). The pyramid temple was situated close to the pyramid of Chephren within the girdle walls which enclosed the three Giza pyramids. The Valley Temple lay outside the wall near the fertile area reached by the Nile flood. Alike in the arrangement of their halls, the two temples served separate functions, connected with the final funerary rites of the dead ruler.

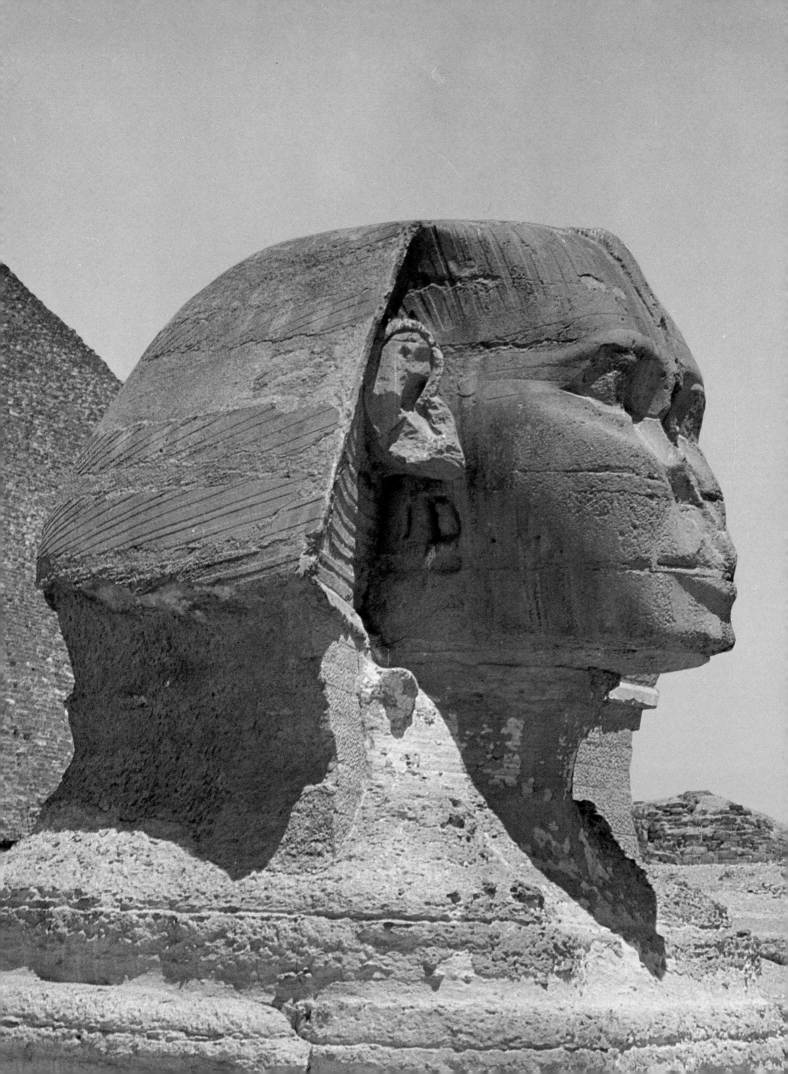

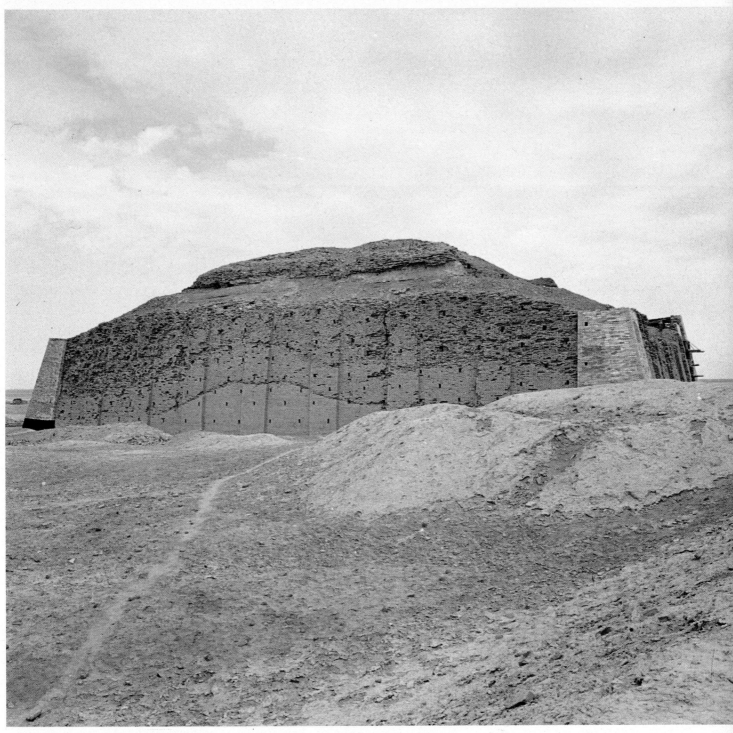

12 (opposite). **The Sphinx of Chephren**
(detail). Fourth Dynasty. Approximately
2500 BC. width of face 13½ ft. (4·10 m.).
The guardian Sphinx was fashioned out of
a knoll of rock left in the quarry where
the blocks were hewn for the Chephren
pyramid. It has the body of a lion and the
head of a human being in royal headdress.
Despite signs of weathering, recalling that
it has stood guard over the burial places
for many thousands of years, it still retains
the fascination it had for the Greeks who
took it as symbolic of everything
mysterious and enigmatic.

13 (above). **The Ziggurat at Ur.** Ur III
period. *c.* 2150–2050 BC. The imposing
ziggurat at Ur owes its fine state of
preservation to the fact that the entire
staged tower was given a brick facing. It
was built in the reign of Ur-Nammu,
founder of the Third Dynasty of Ur, and
was probably surmounted by a temple
dedicated to the moon·god Nanna, but no
traces of this remain. Approached by
three staircases, its sloping walls are
broken with shallow articulations. In this
view the holes in the brick casing can be
seen. These must have been incorporated
to stop the mud-brick core from cracking
during the rainy season.

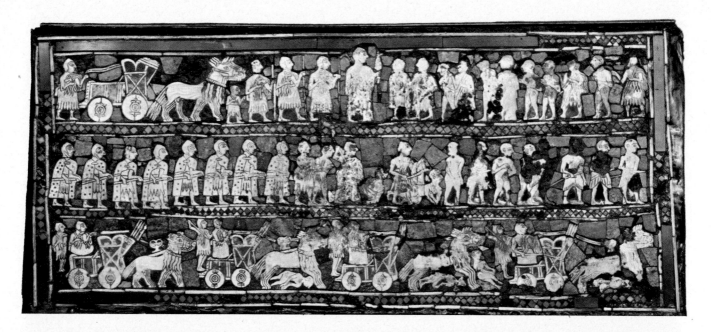

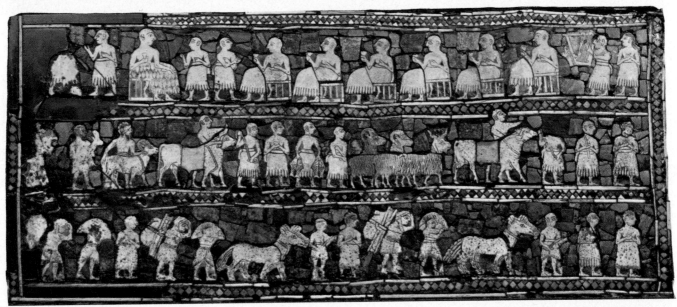

14, 15 (above). **The 'Standard of Ur'.**
Early Dynastic II Period. *c.* 2600–2400 BC.
Shell, red limestone and lapis lazuli inlaid
into a bitumen base. h. 8 in. (20·3 cm.).
British Museum, London. The so-called
'Standard' of Ur was found in one of the
earliest tombs of the Royal Cemetery. The
two panels are placed back to back in a
wooden frame at an in-slanting angle so
that the ends of the object are trapezoid in
shape. The upper plate shows scenes of
war. In the top register the king, who has
alighted from his chariot, receives
captives. In the centre a row of helmeted
lancers in heavy cloaks are shown left,
with vanquished enemies to the right,
while in the bottom register four chariots
drive across the bodies of the fallen. The
'Peace' side (lower plate) shows, first, a
banquet scene with seated courtiers
drinking with their king to the sound of

music. The lyre at the extreme right is
similar to the ones excavated at Ur (see
plate 16). In the centre, servants are
leading bullocks and lambs, and a central
figure holds a pair of fish in either hand. In
the lowest register we see men carrying
heavy bundles on their backs or leading
pairs of wild asses, perhaps the spoils of
war. The purpose of the standard is not
known, but it has been suggested that it
formed the sounding board to a musical
instrument.

16 (opposite). **Golden head of a bull
decorating the front of a lyre from Ur.**
Early Dynastic II Period. 2600–2400 BC.
Gold on a wood core. h. 11⅝ in. (29·5 cm.).
Iraq Museum, Baghdad. Stringed
instruments such as harps and lyres are
frequently illustrated in feasting scenes
on Early Dynastic seals, and several
examples were unearthed from the
Royal Cemetery at Ur. The soundboxes
are decorated with an inlay of
mother-of-pearl and lapis lazuli, similar to
that found on the 'standard' (plates 14,
15). The bull's head demonstrates the
high standards that the art of the metal-
worker achieved at this period, together
with an obvious delight in inlay work.

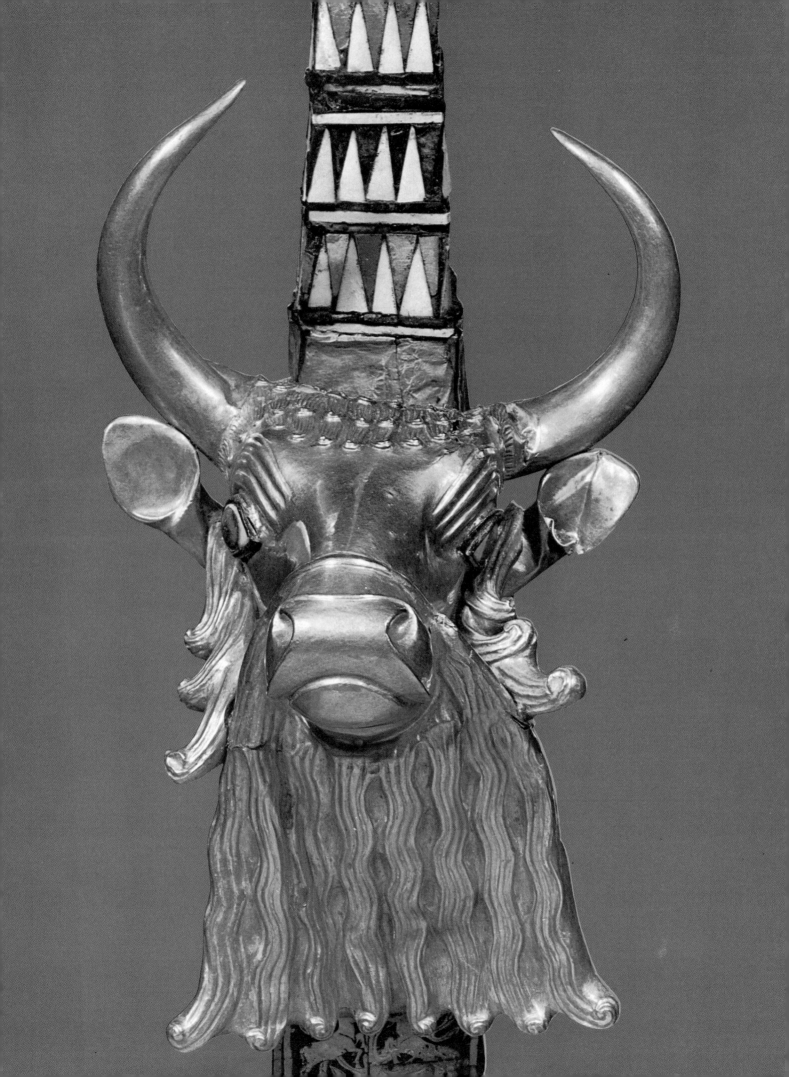

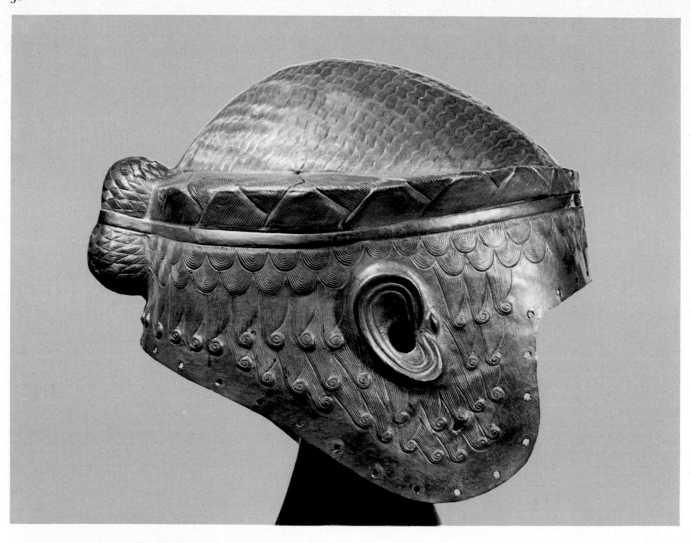

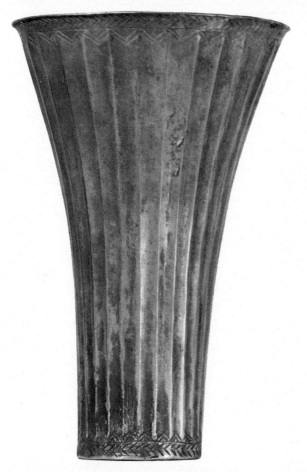

17 (above). **Helmet of Meskalamidug from Ur.**
Early Dynastic II Period. 2600–2400 BC. Gold. h. 9 in. (23 cm.).
Iraq Museum, Baghdad. This wig helmet has the ears and hair
skilfully modelled and engraved upon it, and was made from a
single sheet of gold. It was found in the royal tomb supposedly of
the prince Meskalamidug, together with a golden bowl,
weapons, and ornaments.

18 (left). **Fluted beaker from Ur.** Early Dynastic II Period.
c. 2600–2400 BC. Gold. h. 5¼ in. (13·5 cm.). Iraq Museum,
Baghdad. The simple lines of this graceful piece are characteristic
of the vessels found at Ur. It shows the skill of the Sumerians
in metalwork and the rich taste of the ruling class.

19 (opposite). **Offering stand from Ur.** Early Dynastic II
period. *c.* 2600–2400 BC. Gold, silver, lapis lazuli, shell and
red limestone. h. 20 in. (50 cm.). British Museum, London.
Often referred to as the 'ram caught in a thicket' and apparently
a fertility symbol, this strange figure was found in the great
death-pit at Ur. The ram is shown hobbled to the branches of a
flowering tree. The technique of building up a figure from so
many precious and contrasting materials reaches its apogee in
works such as this.

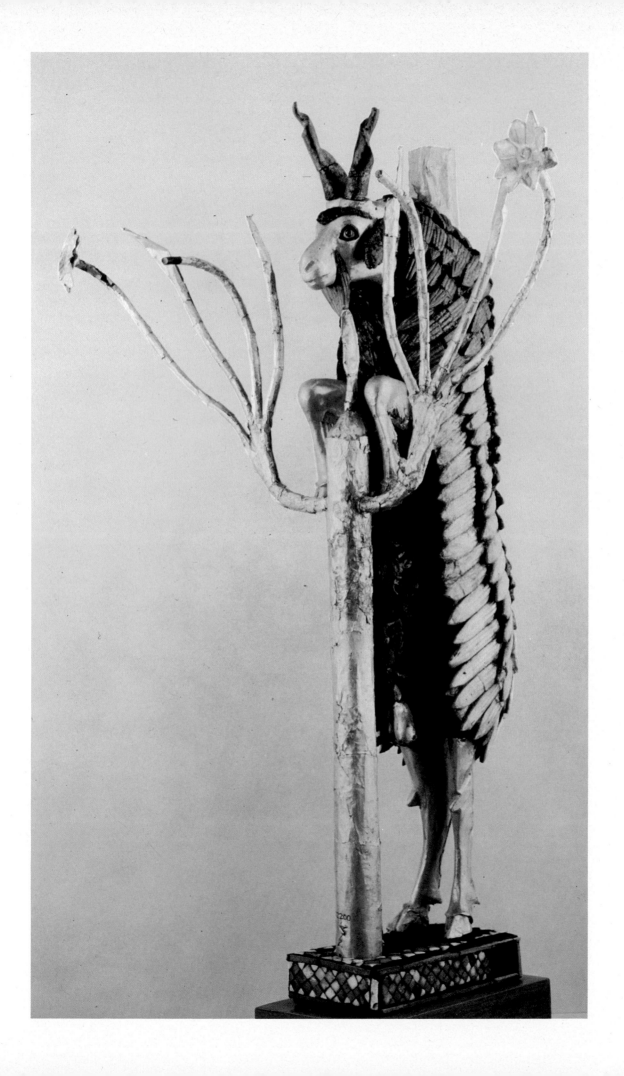

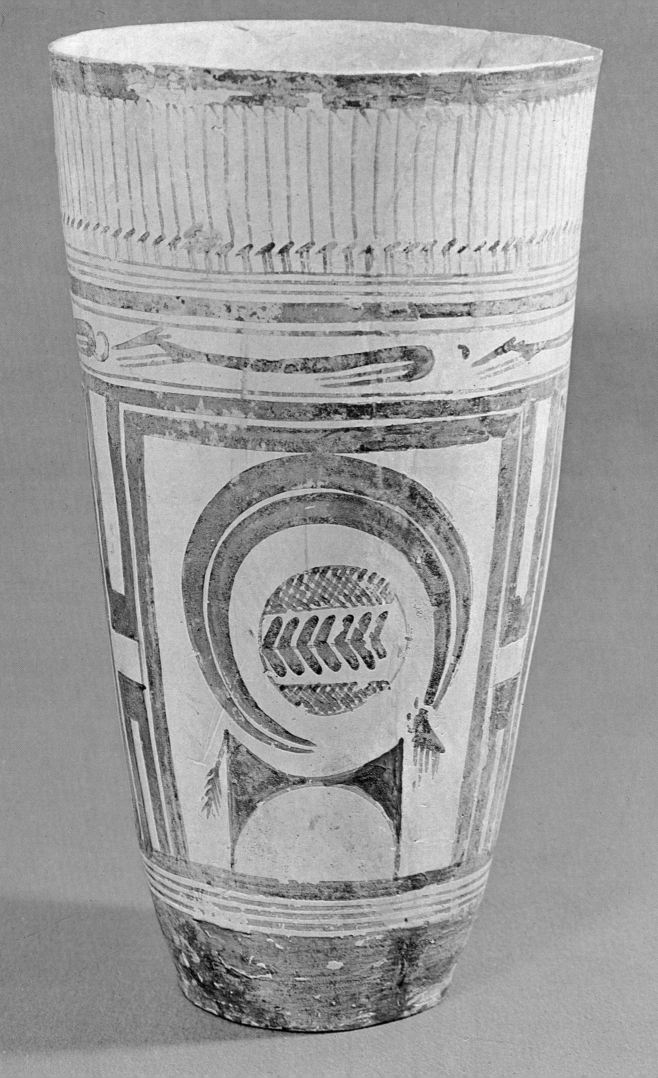

change that has taken place. The successive rebuildings of the Temple of Sin at Khafajah reveal a shift from a basically archaic plan (though provided with only a single entrance on one of the long sides), to a totally new scheme with two parallel cult rooms of unequal size preceded by an irregular sequence of chambers and courtyards. Perhaps the greatest innovation is the fact that the temple no longer rises upon a monumental platform constituting the ideal centre of the city, but is embedded in the urban mass, from which it is set off by a high wall. At other sites, such as Tell Asmar and Mari, the temple has a different plan—roughly square, with a large centre room accompanied by side chambers and chapels. Although the present state of research does not allow us to assume a common prototype, all these schemes do seem to share an interest in isolating the religious centre of the temple, the Holy of Holies, so as to make it almost inaccessible. This concept, which is diametrically opposed to that which governed the construction of the first Sumerian temples, heralds the Semitic temples built later in Syria with three successive rooms. This does not mean that the Mesopotamian temples of the 3rd millennium corresponded to a religious mentality influenced by Semitic culture. Rather it suggests that in this period all western Asia began to accept a concept of the relation between man and god that differed greatly from the faith of the 4th millennium.

Turning to the field of secular architecture, we find for the first time a large complex of buildings constituting a palace. Such a complex has been found at Kish, a city that became very powerful in the Early Dynastic I period. The palace of Kish is made up of adjoining clusters of structures. One of these clusters has a plan that was to be typical of Mesopotamian secular architecture: a big central courtyard with rooms distributed around the sides. Here too the complex is enclosed by a massive outer wall, forming a neat rectangle. Adjacent to this complex is a somewhat smaller one, of uncertain use, in which the most striking feature is a row of four brick piers. Although direct evidence has not survived, it is likely that this period saw the erection of the first city walls, a means of defence that was previously neglected in Sumeria.

THE BACKGROUND OF EARLY DYNASTIC SCULPTURE

Sumerian sculpture in the round shows a good deal of uniformity of type. Apart from some animal figures, mainly cattle, sculpture has only one theme: the offerer or worshipper, who may be a man or woman, in an attitude of

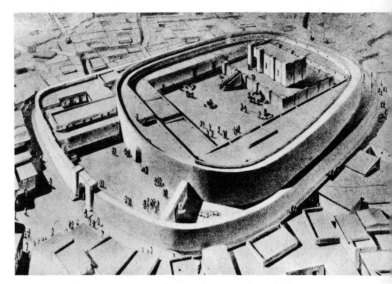

16. **Reconstruction of the temple complex at Khafajah.** Now that the temple was no longer isolated on a platform as at Eridu (figure 3) and Uruk (figure 4) the sanctuary had to be set off from the city in an alternative way. Two irregular oval walls protected the sacred area. The shrine is built according to the old buttressed principle.

prayer before the god. Usually shown standing, these figures are occasionally seated, but kneeling worshippers are rare. This narrow range is explained by the aim of the Sumerians in creating statues; the main if not the exclusive purpose was to provide the temples with a permanent 'population' of kings, priests and local notables. Thus the Sumerian statue was intended to perpetuate the presence of the faithful in the temple with their continuing prayers to the god. This religious origin of sculpture explains certain features of its appearance that differentiate Sumerian work from the Egyptian statues of the Old Kingdom. Inasmuch as it was destined to be placed in a tomb and not to be seen by the living, the Egyptian statue had its own inner justification, for it embodied the living essence of the deceased. This is the source of the potent vitality of the Old Kingdom figures. But the Sumerian statue, though almost invisible in the dark recesses of the temple in which it was placed, always presupposed a dependence upon the deity in whose house it stood. The justification of the Sumerian statue thus lay outside itself in the religious and magical bond linking it to the god. It is therefore easy to explain not only the prominence of such iconographical details as the joining of the hands on the chest in prayer, but also the emphatic gaze, which was firmly focused upon the god. Reflecting the expressionistic tendency of the art of this period, the face began to exert an absolute dominion over the statue as a whole.

After a break in the artistic record that lasts for several centuries (there is only a statuette from Khafajah depicting a woman in prayer, of rather rough workmanship and somewhat older than the statues that are about to be mentioned), archaeologists have found a great quantity of

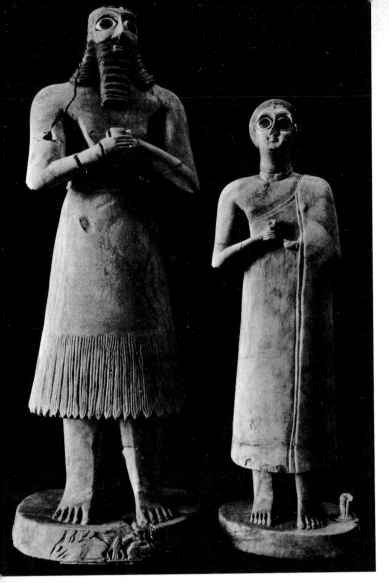

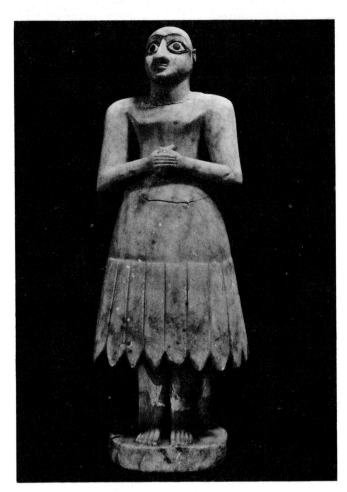

17. **Statues of worshippers from Tell Asmar.**
c. 2700–2600 BC. Veined gypsum. h. 28¾ and 23¼ in.
(72 and 59 cm.). Iraq Museum, Baghdad. Statues like these
were placed on the ledges of a sanctuary. A group of ten such
figures were found at Tell Asmar, all representing worshippers.
These two, however, are larger in size than the others, and have
sometimes been thought to depict a god and goddess. In their
hands they bear goblets, and on the base of the male statue is a
relief showing the god Imdugud.

18. **Statue of a bald priest from Tell Asmar.**
c. 2700–2600 BC. Veined gypsum. 15¾ in. (40 cm.).
Iraq Museum, Baghdad. This priest of Abu (the god to whom
the temple of Tell Asmar was dedicated) was found with the
group of cult statues mentioned in figure 17. Less intense in
expression, it displays a preoccupation on the part of the
sculptor with geometric form and effects of light.

sculpture, with some unusual features that should be noted.
The uneven distribution of this work is striking. The statues
of the Early Dynastic I period (*c.* 2700–2600 BC) come
mainly from border regions: the area of the Diyala river
(Tell Asmar, Khafajah, Tell Agrab) and Tell Khuera in
Syria. The land of Sumer has yielded statues in quantity
only at Nippur; an isolated example comes from Umma.

In the following period (Early Dynastic II: 2600–2350
BC) outlying regions still dominate: the Diyala area again
(though less examples survive), Mari in Syria, and Assur
in the north. But the centre of Sumeria now provides a good
many pieces as well, from Lagash, from Adab, from Ur,
'Ubaid, Nippur and Uruk. It is hard to attribute this
distribution merely to the chances of excavation. There can
be no doubt, however, that in the Early Dynastic period
Uruk was no longer the cultural capital that it had been in
the predynastic period. Moreover, the figural art of
Sumeria was largely governed by well diffused standards

of uniformity, as is proved by the close similarity of statues
coming from sites that are far apart geographically,
especially at the beginning of the Early Dynastic period.
Stylistically, the most important development is the
complete disappearance of the naturalistic trend that
characterised the early predynastic period. The statues of
the Early Dynastic I period appeared in an atmosphere still
strongly imbued with the expressionist and intellectual
tendencies that emerged in the transitional period, (3000–
2700 BC). At this time certain guidelines for the further
development of Sumerian art seem to have been fixed.

The uniformity of type, iconography and, within certain
limits, of style that prevails throughout the sculpture of the
Early Dynastic I period has caused it to be regarded as
making up a single style, sometimes termed the abstract or
Mesilim style, a claim that has some justification. But it is
important to bear in mind that 'abstract' is not a very
precise term, for it can be applied to works executed in very

different styles. Moreover, to attribute a single style to works produced in different places during a period lasting about a century means on the one hand to give too much stress to the influence of certain prototypes, and on the other to obscure the characteristics of certain other examples that have retained an individuality within the bounds of a broader current of taste and thought. For these reasons it is well to pass briefly in review the regional schools of Early Dynastic sculpture.

REGIONAL SCHOOLS OF EARLY DYNASTIC I SCULPTURE

The oldest Early Dynastic statues share certain iconographic features with the predynastic works that preceded them. The stylistic differences, however, are marked. As we have observed, the naturalism, the interest in narrative and the predilection for large volumetric masses give way to an expressionist tendency, in which a preoccupation with volume is rejected in favour of tonal contrasts. Such contrasts are achieved through the play of light in the finer works, while in the coarser ones it is brought about by crudely painting some parts of the statue's surface.

The most homogeneous group of Early Dynastic I sculptures comes from Tell Asmar (ancient Eshnunna). It *17* represents a crowd of worshippers with long garments arranged so as to expose the upper part of the body. As a rule the men wear long beards with hair reaching down to *18* their shoulders; sometimes they are bald. The women are wrapped in a long tunic which leaves the back and the right arm bare. A concern for geometric form—particularly noticeable in the case of the male figures—is certainly apparent. But what draws the eye particularly is the intense expression on the faces. The statue of a bald priest is less distracting from this point of view because of its abstract linear quality and the careful handling of light.

In the large body of sculpture from Khafajah it is possible to identify several stylistic trends. Some works are entirely free of the geometric emphasis of Tell Asmar and are marked by a crude realism that is not backed by sufficient technical skill. Other works show a strong geometrical commitment, itself rather crude, with stylised women's skirts ressembling inverted tumblers. A third group of figures, however, shows greater mastery of form with an expressive use of curved lines, and a careful treatment of the masses; the finest example of this type is the Urkisal statue.

Apart from the realism that links them to some works from Khafajah, the sculptures of Tell Agrab demonstrate a special feeling for the soft modelling of the face. Of the other cities only Nippur and Tell Khuera in Syria have yielded a reasonable number of works for this period. These show some local peculiarities but always within the broad trends of the period. Finally some bronze statuettes, mostly found in the Diyala region, reproduce some of the features of the stone sculpture, but are distinguished by a greater freedom of expression. This suggests that the Sumerian sculptor was more at ease working in metal than in stone.

SCULPTURE OF THE EARLY DYNASTIC II PERIOD

In the Early Dynastic II period (2600–2350 BC), sculpture shows considerable change. It has already been observed that the old centres of the Diyala region were on the wane, and now we see the advance of new centres, such as Mari and Lagash, that produced work of much vivacity and richness. Although some innovations occur in the accepted formula for the rendering of the figures (statues of seated figures and of couples appear more frequently; fashion favours the flounced woollen skirt), the most pronounced *19* change is a stylistic one. The basically expressionist trend of the Early Dynastic I period gave way to stress on volume and a heightened realism. As has been mentioned, these tendencies were already noticeable at Khafajah, but now they became dominant, informing a whole new atmosphere that was developing in Mesopotamia. The crisis following the predynastic period had been weathered and Sumerian man regained confidence in his own value, which he sought to express in monumental form. The basic aspiration of this period was for monumentality, expressed in sculpture through volume and in relief through historical narrative. No longer confined to the role of offerer before the divine majesty and no longer obsessed by the power of implacable natural forces, Sumerian man took possession of the earth once more. He remained faithful to the gods, while embarking on the conquest of foreign lands. In this almost heroic atmosphere, which reached its full height in the Akkadian period, art regained the powerful qualities it had possessed at the beginning of the predynastic period and developed them further.

The artistic schools that flourished in the cities of the Diyala region reflected these new trends only partially: they gave up the exaggerated geometry and expressionism, but they were little concerned with the new sense of volume and mass. (That these centres underwent an eclipse in the Early Dynastic II period is convincingly borne out by the fact that statues were fewer, and less carefully executed). In Sumeria proper the limited number of surviving works are unusually powerful and expressive. This suggests the existence of an active centre of production that had not yet come to light. The most important of these works is probably a statue found at 'Ubaid, the so-called 'Kurlil'. Only the *21* head and the upper bust of this crouching figure are worked in detail. This work certainly cannot be called realistic, yet its abstraction is of a completely different type from that of the Early Dynastic I period. The head is so strong that the whole statue takes on a monumental dimension.

The most prolific and vital work of the Early Dynastic II period is found outside Sumeria, at Mari on the Euphrates. Here we see figures of men and women which, while sharing the sensibility, have an inventiveness and lively expression not found in Sumerian works. The male figures have an almost superhuman quality and the female ones radiate *19* such grace and spirit as to surpass any of their Sumerian competitors. It is undeniable that Mari offers something new, probably under the stimulus of nearby Syria.

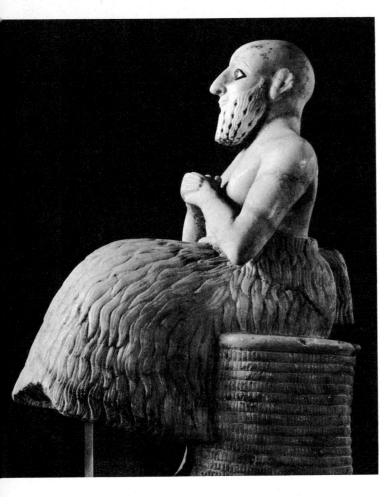

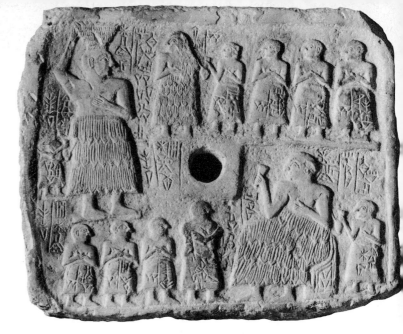

20. **Votive plaque of Urnanshe from Lagash.** Early
Dynastic II period. *c.* 2600–2350 BC. Limestone. 15¼ in.
(40 cm.). Louvre, Paris. Urnanshe, ruler of Lagash, is shown
carrying a basket of mud on his head to mould the first bricks
of a new temple. Below he celebrates the completion of the work.
Although rather crudely carved, this relief is interesting in
constituting a basis for the development of the historical relief.

19 (left). **Seated statue of Ebih-Il from Mari.** Early
Dynastic II period. *c.* 2600–2350 BC. Alabaster. h. 20⅝ in.
(52·5 cm.). Louvre, Paris. The statues from Mari on the
Euphrates, outside Sumeria proper, display a liveliness not
found in Sumerian works. This figure of the superintendant
of the temple at Mari is outstanding. The decorative treatment
of the beard and tufted skirt in no way detracts from the
monumentality of the figure.

EARLY DYNASTIC II RELIEFS

In the Early Dynastic II period the evidence of sculpture
in the round is supplemented by that of relief carving.
Besides the maces, which include one of Mesilim of Kish in
which the repertory of the late predynastic period recurs,
there are numerous rectangular slabs in terracotta.
Although the exact purpose of these slabs is unknown, they
are almost certainly connected with religious observances.
The slabs are variously decorated with a ritual banquet
served by rows of offering bearers and scenes of battle.
Later in the Early Dynastic II period appear scenes in
20 which the king, attended by his family, carries a basket of
bricks for the building of a temple. These slab scenes are not
remarkable as art; rather their interest resides in the fact
that they constitute a basis, both in form and in subject-
matter, for the development of the historical relief. The
scenes on the slabs are divided into registers and sometimes
the figure of the god or king is shown in a larger scale.
Unfortunately only a single example of historical relief has
been recovered from this period, the victory stele of King
21 Eannatum of Lagash (sometimes known as the 'stele of the
vultures'). Both sides of this fragmentary stele bear reliefs
punctuated by inscriptions and representing respectively
several episodes of a battle (the king at the head of his
troops, the heap of slain enemies) and the god Ningirsu
holding a mass of enemies fast in a net. The narrative skill
of the stele is noteworthy, but the key point is that for the
first time we find a visual account of historical event. As has

been noted above, the outlook of Sumerian man was
profoundly transformed in this period. This is the time in
which Lugalzaggisi, King of Umma, created a transitory
empire that was shortly to fall into the hands of the Semitic
King Sargon. Thus Mesopotamian civilisation passed from
the urban to the imperial phase. Although this develop-
ment was finally achieved under Semitic rule, their work
would have been impossible without the great advances
previously made by Sumerian society. The art of this period
clearly reflects this historical process.

THE MINOR ARTS

Our account of Early Dynastic art would be incomplete
without a brief mention of the minor arts. Pride of place
belongs to the glyptic art of seal carving, which paralleled
the other arts in figural range and style. After the phase of
crisis marked by the brocaded style, the scenes depicted on
seals document the forging of a new tradition and style.
Formerly restricted to stylised figures of animals and geo-
metric decoration, subject-matter was now enriched with
religious and mythological scenes: first the hero's struggle 22
with the beasts, then, along with this motif, scenes of sacred
banquets and mythological scenes of uncertain meaning.
The style also underwent a significant transformation. The
linear quality and disorder of the brocaded style gave way
in the first protodynastic period to an incipient feeling for
the wholeness of the figure set within well defined composi-
tions that are carefully balanced. These tendencies were

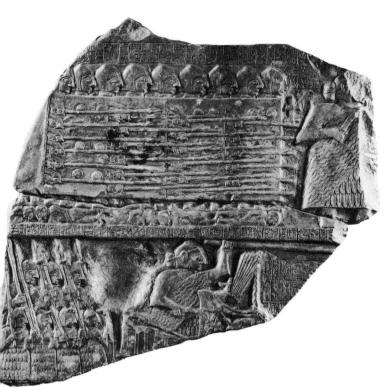

21. 'Stele of the Vultures' from Lagash. Early Dynastic II period. *c.* 2400 BC. Limestone. h. 71 in. (180 cm.). Louvre, Paris. This fragment of the victory stele of King Eannatum of Lagash shows the king leading his heavy infantry to war, across the bodies of fallen foes. Below he appears in his war chariot raising a spear in his left hand. In another fragment, vultures devour the heads of his enemies—hence the name that the stele has acquired.

22a, b. Early Dynastic cylinder seal impressions. 2700–2350 BC. British Museum, London. After the 'brocaded' seals of the transitional period (see figure 11) Early Dynastic seals display an ordered composition and a feeling for three-dimensionality in the figures. Here we see *(a)* animals and mythological creatures and *(b)* a banquet scene.

accentuated in the following Akkadian period, which was increasingly preoccupied with a feeling for depth and carefully calculated rhythmic effects in the figures. In this realm the Akkadian artists continued in masterly fashion the process set in motion in the later Early Dynastic period.

The technical perfection achieved by the workshops of the Early Dynastic II period is amply illustrated by the sophisticated splendour of the objects found in the so-called royal tombs of Ur. In the largest of these burials over seventy retainers were sacrificed to accompany the king on his journey to the next world. This was a very prosperous *23* period and the perfection of the metalwork has assured the fame of such pieces as the cups, the helmet and the gold **17,18** sword, as well as the bull heads decorating the front of the **16** stringed instruments. The masterpiece of this metalwork (though it does not fall in the category of 'minor arts' in any true sense of the term), is the big copper relief from 'Ubaid **22** showing the lion-headed eagle Imdugud holding with his claws two stags placed back-to-back. But the creative vigour and technical ability of this period of Sumerian art appear also in intarsia, whether with small stones (the lively scenes on the musical instruments and the two standards), in mother-of-pearl (the Mari figurines) or in **14,15** cut-out figures (the 'Ubaid frieze with a pastoral scene).

THE AKKADIAN PERIOD (*c.* 2350–2150 BC)

The lengthy process of artistic reconstruction and development carried out in the three centuries of the Early Dynastic period and intensified in its last phase found its ripest expression in the Akkadian period. For these two centuries Mesopotamia was unified under the Semitic dynasty founded by Sargon with its capital at Agade (Akkad). Although until quite recently scholars had assumed that the domination of Semitic rulers produced a break with the tradition of Sumerian art, though a happy one, it is now clear that the art of the Akkadian period is the finest flowering of the genius of Sumerian art. In the artistic field the Semitic domination was only secondary. While moving directly along the path indicated by Early Dynastic works, Akkadian art can boast a far-reaching realisation of the most original and fruitful trends of the earlier period. The essential factor is the appearance of a more flexible mentality, less preoccupied by religious fears and more concerned with the everyday world. To suggest a parallel with later times, the Akkadian period was for Mesopotamia what the 15th century was for Italy and the 16th century for Europe as a whole.

AKKADIAN SCULPTURE

If architectural remains are negligible, sculpture is represented by pieces of the first order. Unfortunately few works have survived from this period, but their high quality and interesting characteristics, though they make us regret what has been lost, do illuminate the artistic tendencies of the age. The fact that some of the finest works of the Akkadian period have been found at Susa in Iran,

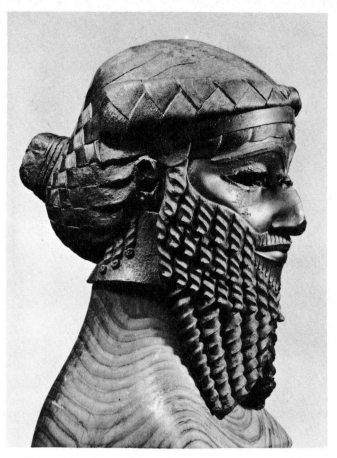

23. **Silver vase of Entemena.** Early Dynastic II period. 2600–2350 BC. h. 13¾ in. (34·9 cm.). Louvre, Paris. This outstanding example of the Sumerian silversmith's art was found intact at Lagash (modern Telloh). It depicts the lion-headed eagle god Imdugud with a pair of lions. This subject also appears on the relief from 'Ubaid (plate 22), and on the base of the larger statue illustrated as figure 17.

24. **Bronze head from Nineveh.** c. 2350–2150 BC. h. 14⅜ in. (36·6 cm.). Iraq Museum, Baghdad. This famous example of Akkadian sculpture, possibly representing Sargon, expresses a new idea of kingship. The proud head has a dignity and nobility hitherto unknown. The hair is bound in the Sumerian fashion, plaited, wound round the head and gathered in a chignon (see the wig-helmet illustrated as plate 17).

where they had been taken as spoils by the Elamite kings who were several times victorious in Mesopotamia, shows how much prized these works were by later generations. Among the statues are a headless figure from Assur and the lower part of a statue of Manishtusu, the son of Sargon. The striving for monumentality, foreshadowed in the Early Dynastic II period, is well captured in the statue of Manishtusu which shows the spiral movement found in the Early Dynastic statue of Urkisal. This figure witnesses the artist's final victory over the static quality of archaic tradition. This mastery of formal expression appears in an extremely refined and even slightly academic form in the magnificent bronze head from Nineveh, where the minute descriptive detail and the carefully adjusted symmetrical composition attenuate the force that is found in other works, such as the stele of Naram-Sin. This last is possibly the masterpiece of all Akkadian art. With the roughly pyramidal form, the clear triangular composition of the scene, the subtle stylisation of the landscape elements, the ascending movement of the soldiers and the helmeted figure of the king shown larger than the other figures, the stele of Naram-Sin shows an extraordinary power of stylistic synthesis. Its elegant, though somewhat cold formal traits are never simply inert. Similar narrative features, sustained by an unfailing sense of form, are found in other reliefs (un-

fortunately fragmentary), showing battle scenes. They recall some features of what is perhaps the greatest monument of Roman figural art, the Column of Trajan. But these Mesopotamian works lack the piety, the profoundly human quality of reverence, that gives the Roman work its supreme value. It seems that even in its most successful achievements Middle Eastern art cannot speak to us directly.

AKKADIAN SEALS

As might be expected the fullest documentation of Akkadian art is provided by the seals, which are particularly fine. The impressions taken from seals serve not only to confirm and clarify some of the formal traits that can be observed in other arts, but also present a world of images which has since vanished in the 'major' arts but which remains of great interest for an understanding of Akkadian culture. On the formal level one finds in seals, apart from the renewed feeling for nature, a tendency to carefully balanced, preferably symmetrical composition. This emphasis on the formal elements of the scenes is confirmed by the new importance given to the inscriptions that are sometimes included on the seals for practical reasons. The inscription, normally enclosed in a cartouche, is now inserted into the composition itself and therefore may be considered

25 (left). **Stele of Naram-Sin, King of Akkad.** *c.* 2300 BC. Red sandstone. 78¾ in. (200 cm.). Louvre, Paris. Naram-Sin, wearing the horned helmet of divinity, stands alone before a stylised mountain, one foot resting on slain enemies. A tree below indicates a wooded area. Soldiers ascend a mountain path. This stele was so valued in antiquity that the Elamites later carried it to Susa as part of the spoils of war, adding an inscription which can be discerned along the peak of the mountain.

26*a, b* (below). **Akkadian cylinder seal impressions.** 2350–2150 BC. British Museum, London, and Iraq Museum, Baghdad. The seals of the Akkadians reflect the same masterly sense of composition as was evident in the stele of Naram-Sin. Mythological scenes such as this, though prevalent, cannot be explained because of the loss of contemporary literary texts.

as a design element of equal importance to the figures. This is a continuation of the process begun on the Stele of Vultures, where the written text had a place of its own and was not just added to the scene like a caption.

Even more important is the repertory of themes found in seals. The traditional subjects (mainly the hero's struggle with wild beasts) are treated almost exclusively as decorative motifs for the elaboration of elegant compositions in which the religious and magical meaning, though still present, is of secondary importance. Unfortunately the mythological subjects cannot be adequately interpreted owing to the loss of literary texts from this period. Scenes of unmistakable mythological content are depicted with a richness of detail that implies an enjoyment of description for its own sake. Sometimes the incidents in these stories turn towards the marvellous, as in the case of the myth of Etana, the shepherd who was seized by an eagle and carried to heaven. (The myth of Etana is a distant forerunner of the Greek story of Ganymede).

THE NEO-SUMERIAN PERIOD (2150–1950 BC)

The high development of Akkadian culture was shattered by the invasion of the Gutians, an Iranian people. They invaded the northern part of Mesopotamia, and from this base sought to carry on the imperial policies of the dynasty of Sargon, but their efforts were not notably successful. In the field of art they contributed very little, for the Gutians were a backward people capable of only the clumsiest efforts at imitation. Seemingly untouched by the Gutian invasion, southern Mesopotamia underwent a political revival, which for a time enabled the third dynasty of Ur to exert a temporary sway over western Asia. At this time, however, we find a strange new phenomenon, especially noticeable at Lagash: the artists, who in their formal traditions were the direct heirs of Akkad, broke free and returned openly to models from the Early Dynastic period. Sumerian civilisation, hard-pressed by the political and ethnic domination of the Semites, fell back wearily on its own resources. The Sumerians repudiated the worldly splendour of the Akkadian period in order to withdraw into their ancestors' world of tranquil piety. This is indeed surprising. Although it finds an outward parallel in the crisis that attended the fall of the Old Kingdom in Egypt, it is not easy to explain the failure to take advantage of a chance of renewal, for similar circumstances in Egypt led to the foundation of the Middle Kingdom. The deeper reasons may lie in the exhaustion of the Sumerian stock itself, still the essential ingredient in the creation of new cultural forms just as it had been in the crisis at the end of the predynastic period. A massive invasion of Mesopotamia by

the Semitic Amorites began in the last centuries of the 3rd millennium. The political instability resulting from the fall of the Akkadian empire and the earlier dominance of the indigenous Semitic element had already taken their toll. Now the invasion of the Amorites led to a quick Semiticisation of the country. This was accompanied by a progressive cultural decline, despite the newcomers' efforts to preserve the existing Semitic heritage.

NEO–SUMERIAN ART

Notwithstanding the basic spiritual exhaustion the neo-Sumerian period was still creative in the visual arts. In architecture the ziggurat was the essential form. The ziggurat derives from the archaic temple erected on a plat-form and consists of a series of superimposed terraces—in this period three—surmounted by a temple. The structural elements and the sites chosen for this type of building by Urnammu, the first king of the third dynasty of Ur to undertake the building of ziggurats, clearly reveal the spirit of the new architecture. Nostalgia for the past is unmistakeable, either because the ziggurats were built in places where the archaic terrace temples had stood or because they harked back to these buildings in structure. Still, the work of the Akkadian period had not been in vain. It passed on a strong sense of monumentality and a demand for clarity and symmetrical distribution of structural elements. Nonetheless, the Sumerian ziggurats preserve a clear indication of their ultimate origin. By adhering to a type of building in which the original artificial mound is always recognisable, they avoided the intellectual abstraction of the Egyptian pyramids.

In sculpture the tendencies of the neo-Sumerian period are particularly clear in the many surviving statues of Gudea, the *ensi* or king of Lagash, which are only part of what must have been an enormous production. In the first place one must note the abandonment of the type of the royal statue as it was conceived in the Akkadian period in favour of a return to the figure of the faithful temple worshipper. Naturally the return to older forms is reflected in a style, which shows its Akkadian lineage. There is an unmistakable feeling for effects of light. Certain details stand out, such as the feet or the arch of the eyebrows. Finally, one should not fail to notice how the apparent naturalism of some statues (as seen in the slightly academic formalism of the bronze head from Nineveh) conceals a delicate feeling for abstraction. This abstraction appropriately conveys the metaphysical longings in Gudea's make-up; his deep religious piety is proved by many inscriptions.

Religious motifs predominate in relief carving, as might be expected. The damaged steles of Gudea and Urnammu show the kings in an attitude of worship before the god. This period sees the entry of a new religious formula, that of the worshipper introduced by his divine sponsor to a greater god, a scheme to be repeated endlessly in later times.

Finally, the difference between Neo-Sumerian seals and the Akkadian ones is striking. The rich mythological sub-

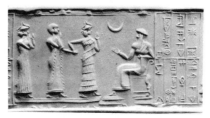

27. **Neo-Sumerian cylinder seal and impression.** *c.* 2150–1950 BC. British Museum, London. This scene shows a worshipper being presented by a divine sponsor to a great god who is seated on an elegant throne. The script is now adjusted into neat columns.

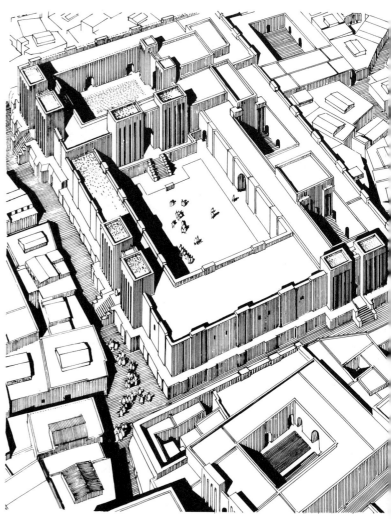

28. **Reconstruction of the temple of Ishtar-Kititum at Ischali.** Isin-Larsa period. *c.* 1950–1850 BC. The temple of Ischali belonged to the independent kingdom of Eshnunna, which was one of several independent city states which grew up after the fall of the Third Dynasty of Ur, and before the unification of the whole country under the Amorite, Hammurabi. To reach the shrine of Ishtar from the courtyard the worshipper mounted the staircase and turned right inside the entrance, to face the deity.

ject matter suddenly disappears altogether. Stylistically, however, the best examples among the seals keep to tried and tested compositions. The vertical schematism of the figures, which closely parallel the sculptures, is skilfully adjusted to the dense columns of script, which in this period begin to occupy much of the available surface of the cylinder. At times the empty space between the various figures acquires an independent value in the composition. The script continues to play an essential role, though with a changed emphasis.

THE ISIN-LARSA AND OLD BABYLONIAN PERIODS

The end of Neo-Sumerian power in Mesopotamia was followed by the emergence of local, mainly Semitic, dynasties. (Isin-Larsa period *c.* 1950–1850 BC). Outstanding among them was Babylonia, which again unified Mesopotamia under its rule. This process, which lasted from the end of the third to about the middle of the second millennium BC, sealed the fate of Sumeria as a political and ethnic force, though of course the Sumerian achievement was the indispensible basis for Babylonian civilisation. We must examine a little more closely what is meant by the term 'Babylonian civilisation'. Its most characteristic feature is the use of a Semitic language, though one much enriched by Sumerian loan words. Babylonian religion remained basically Sumerian, or rather Mesopotamian, despite the fact that some of the gods were given Semitic names; for example, Inanna became Ishtar. The liturgical language was Sumerian, and Sumerian too the name of Babylonia's national god Marduk.

Real Semitic predominance only came about as a result of the disruptive invasion of the Amorites, a semi-barbaric people coming from Syria. Although they brought several incidental cultural features, including their god Amurru, and certain intellectual attitudes of their own that differed from those of the Sumerians, in the main the Amorites could only assimilate the existing civilisation. The result was that instead of revitalising Mesopotamia as the Hyksos had revitalised Egypt, the Amorites prolonged the agony of the break-up of Sumeria for several centuries without contributing any essential innovations.

ARCHITECTURE AND PAINTING

Architectural remains from this period are scarce. At Tell Harmal near Baghdad archaeologists have found the ruins of a city with regular streets and large houses, perhaps of semi-palatial type. At Ishchali on the middle Tigris the most important monument is the temple of Ishtar Kititum, a big complex on a rectangular plan enclosing three different sanctuaries. By far the most important remains, however, are those of the royal palace at Mari on the upper Euphrates. Covering an area of about 660 × 400 ft., the Mari palace comprises a spacious series of rooms grouped around two large courtyards and some other small ones. The palace reached its final form through successive en-

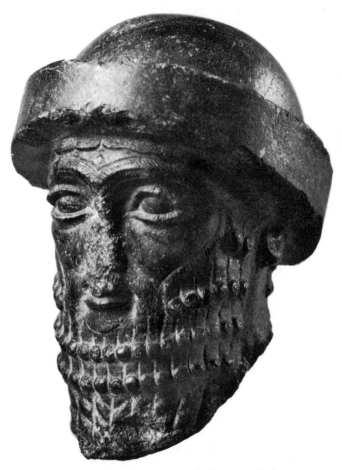

29. **Head of a prince from Susa.** Isin-Larsa period. 1950–1850 BC. Diorite. 5⅞ in. (15 cm.). Louvre, Paris. Once thought to be a portrait head of Hammurabi (18th century BC), this sculpture is now considered earlier in date. Compared with the formal statues of Gudea (see plate 24) the work is more impressionistic in character. It was found in Susa having been taken there from Babylon as booty.

largements, but these did not hide the original shape based on a loose principle of agglomeration. The two large courtyards led respectively to the throne room and to an official and sacred area. The walls of some rooms and of one courtyard were embellished with paintings and some interesting fragments of these have been recovered. One panel shows scenes of sacrifice, while a second one, divided into two scenes, depicts a royal investiture and the figures of gods. Yet another panel reveals a goddess amidst a landscape of trees and fantastic animals. These three panels are just about all that is left of Mesopotamian painting in the second millennium, but their cogent style suggests the existence of established schools drawing upon a long tradition. Apart from the costumes of the figures, the fragments with the scenes of sacrifice derive from the Sumerian-Akkadian tradition starting from the stele of Eannatum, with the figures in rows and the king shown in much larger scale than other men. The two-scene panel, which is of cult type, points instead to the iconographic formulas developed in the Neo-Sumerian period and

42

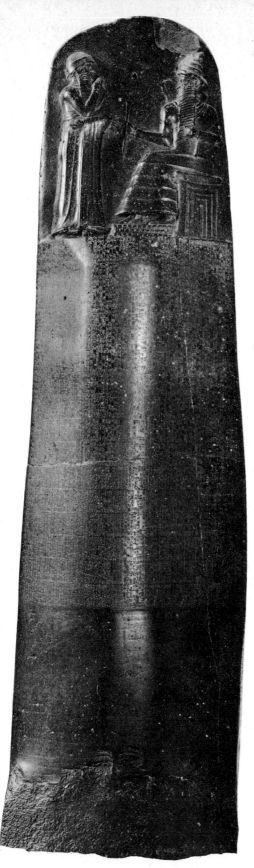

30a, b. **Stele of Hammurabi.** Old Babylonian period.
18th century BC. Basalt. 88⅝ in. (225 cm.). Louvre, Paris.
Hammurabi, King of Babylon and 'law giver' is shown before
the sun god, Shamash, who holds the ring and staff in his hands.
On the shaft of the stele, in minutely engraved cuneiform script,
is the famous 'Code of Hammurabi', which is the first known
of the so-called 'codes'. We now know of several codes which
pre-date Hammurabi's. They in fact represent a literary genre
which had started in the Sumerian period, and which described
the social ideals of the ruler in a literary form.

widely diffused under the Old Babylonian Empire. The
third panel is interesting because of its mixed character,
which admits Egyptian motifs (note the two figures beside
the palm and the form of the flower of a tree). The Egyptian
influence must have come by way of Syria, as the spiral
motif framing the scene suggests.

SCULPTURE

In the field of sculpture we have, for the Isin-Larsa period,
statues from Mari and Eshnunna, though the latter group
was actually found at Susa in Iran where they had been
taken as spoils of war. Although these works are still
dependent on Neo-Sumerian tradition, they show qualities
of their own, which can be discussed under two different
headings. On the one hand, masses are accentuated and
the figures tend to become stiffer (Eshnunna statues and
statue of Ishtup-Ilum from Mari); on the other, there is a
kind of graceful calligraphy that lends itself to minute
attention to details of costume and the beard (Mari statues
of Puzur-Ishtar and Idi-Ilum). A place apart belongs to
the very fine male head from Susa (perhaps an import from 29
Babylonia), which was formerly identified as Hammurabi
but which seems to be earlier in date than that king. In this
work the academic stiffness of the beard is counter-
balanced by the interest in the face, which is marked by
strong furrows emphasised by the play of light. The relief
incised at the top of the famous stele of Hammurabi in the 30
Louvre unfortunately has scarcely any artistic value: it is
coldly stylised and altogether lifeless. A surviving statue of
a goddess from Mari, however, is originally conceived
with an effective use of chiaroscuro.

A less imposing genre much advanced at this period is
the production of terracotta figures from moulds. These 47
objects are probably connected with folk cults. They show
a variety of subjects: animals, musicians, gods and unusual
mythological compositions.

OLD BABYLONIAN SEALS

Seal carving from the Old Babylonian period has two
noteworthy characteristics. First, there is a certain revival
of the iconography bequeathed by ancient Sumeria, 31
breaking into the uniform texture of the Neo-Sumerian
tradition. Secondly, the artists imported such Syrian icono-

31. **Old Babylonian cylinder seal impression.**
c. 18th century BC. British Museum, London.
This Old Babylonian seal carving has a cruder, less vigorous
character than the preceding Neo-Sumerian work. It was to be
surpassed by the contemporary Syrian and later Assyrian
craftsmen. Here a man with a mace, accompanied by a
suppliant goddess, stands before Nergal, the god of pestilence
and death. He holds a triple-headed mace. The inscription
reads: 'Apil-Sin, son of Silli-Ishtar, servant of the
god Nin-Shubar'.

32. **Detail of temple façade at Uruk.** Kassite period.
c. 1600–1100 BC. Staatliche Museen zu Berlin. This temple was
built by the Kassite king Karaindash at the end of the 15th
century BC, and dedicated to the mother goddess, Inanna.
The outer walls were constructed of moulded bricks with niches
enclosing the figures of gods. Here a deity holds the 'flowing vase'
from which issue streams of water (see plate 25).

graphic features as the god Amurru, the motif of the cow
nursing its calf, sphinxes, etc. In the great majority of
cases, however, the varied figural repertoire is handled
clumsily, without reaching the narrative vivacity and
compositional finesse of earlier times.

THE KASSITE DOMINATION

The Kassites, having first settled in Elam, conquered
Babylonia and established themselves there. The Kassite
rule in Babylonia, which lasted through much of the
second half of the second millennium (*c.* 1550–1150 BC),
was a truly creative period, notwithstanding the low
estimate placed on it by some scholars. Unlike the Amorites
who were satisfied with an impoverished Sumerian herit-
age, the Kassites infused new life into Babylonian culture
and this is particularly evident in the field of art. The
Kassites were responsible for an architectural revival which
left significant traces at Dur-Kurigalzu, the capital founded
by King Kurigalzu in the 14th century, and also in the
ancient city of Uruk, as attested by the small but original
temple of Inanna built by King Karaindash. The outside
walls of this building were constructed of terracotta slabs,
forming alternate projections and recessions following
Sumerian practice. But the recessions displayed reliefs of
gods, also in terracotta, while the projections had a linear
motif evidently of religious inspiration. This predilection
for terracotta, which is paralleled at the same time in Susa
in Iran, appears in some sculptures of Dur-Kurigalzu
depicting a bearded male head (with remains of paint in
red and black) and a lioness. The liveliness of these sculp-
tures makes impressive contrast with the cold stiffness of
Old Babylonian statues.

A characteristic feature of Kassite Babylonia is the
kudurru, a type of boundary stone bearing figures and
inscriptions. In a way the *kudurru* may be regarded as the
outgrowth of steles such as the one of Hammurabi in the
Louvre, but there is no doubt that the Kassite *kudurrus*
amount to a new departure. Approximately cylindrical in
shape, *kudurrus* have a surface covered with religious
symbols and texts. The anthropomorphic presentation of
the god, previously dominant in Mesopotamia, became
relatively rare without disappearing altogether. The
surface of the stone was usually divided into strips dis-

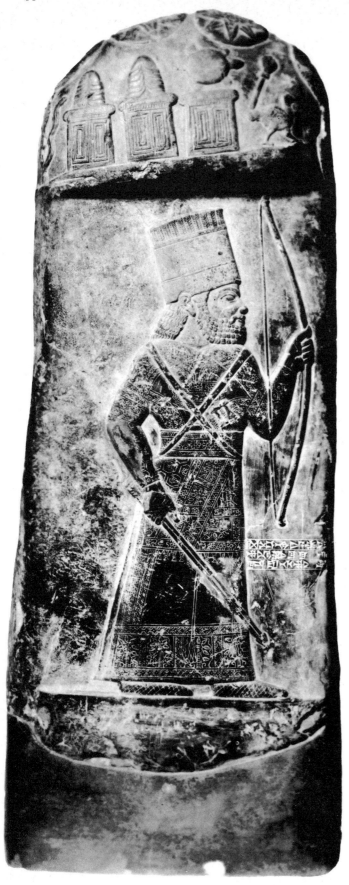

33. Boundary stone of Marduknadinakhe. Kassite period.
c. 1100 BC. British Museum, London. Kassite boundary stones,
known as *kudurrus*, bore the reliefs of gods to protect the
boundary, or of kings who guaranteed possession of the land to
the owner. Many reliefs of a religious character were depicted,
but gods were represented almost exclusively by symbols.

playing the divine symbols; in some instances the text is
framed. This feeling for compositional clarity and for
careful arrangement of planes recurs in the art of seal
carving; the traditional Neo-Sumerian type of the wor-
shipper standing before a god and accompanied by a
panel of writing, yields in the Kassite period to a hieratic
composition dominated by an elongated figure, isolated in
space and flanked by columns of writing.

THE ASSYRIANS

During the Kassite period in Babylonia a new people
emerged in northern Mesopotamia, the Assyrians. But the
first uncontestably Assyrian art works come from the
Middle Assyrian Period in the second half of the second
millennium. They are not particularly numerous, but
enough is left to give an idea of the maturity and in-
dependence reached in a Mesopotamian region previously
under the cultural control of southern Mesopotamia and
later part of a northern culture which spread from Anatolia
to Iran. The change is evident in architecture: the temple
of Sin and Shamash in Assur, built by Assur-nirari I
in about 1500 BC already shows features that recur in the
later temple of Anu and Adad in the same city: a double
sanctuary, with two cellas flanking a big courtyard, and
two ziggurats. The temple of Assur at Kar-Tukulti-
Ninurta, the capital built by Tukulti-Ninurta I, in the
13th century, consists of a cella surrounded by smaller
rooms and adjoining a ziggurat. The regular appearance of
the ziggurat in Assyrian sanctuaries betrays the importance
attached to it in Assyrian architecture and religion as a
separate element considered indispensable to the proper
functioning of the temple. Also important is the widespread
adoption in this period of the stepped pinnacle surmounting
the top of the wall. This is a very old Iranian motif occasion-
ally found in India and Syria as early as the third millen-
nium, but only adopted for common use in Assyria at this
time and then exported to Anatolia, Syria and Palestine,
ultimately reaching Arabia. As for sculpture, several reliefs
must be mentioned. One shows a figure—probably King
Tukulti-Ninurta—in two separate episodes of adoration
before the symbol of a god. Another, from the top of a
broken obelisk, shows a king holding some prisoners on a
leash. Other fragments of sculpture show war scenes. These
few objects are of great importance because they prove the
existence of narrative relief even at this early phase of
Assyrian art. Narrative relief must be considered a western
contribution, for similar reliefs had already appeared on
the walls of the Hittite city of Malatya. 41

But Middle Assyrian art shines most brilliantly in the
art of seal carving. Turning away from the Babylonian 34
tradition in favour of a repertory of Mitannian (Syrian)
origin, Middle Assyrian seals rapidly developed very
original style and iconography in which the harmony of
the composition, the modelling of the figures, and the
liveliness of the scenes reach heights unknown in Mesopo-
tamia since the Akkadian period.

34. **Neo-Assyrian cylinder seal impression.** *c.* 1000–700 BC.
British Museum, London. The scene depicted here is similar
to that shown on the relief in figure 37. The king, supported by
winged, eagle-headed genii approaches a sacred tree. Above
hovers the god Assur in a winged sun disk, a motif with Egyptian
connotations, which also occurs in Achaemenian reliefs.

35. **Statue of Assurnasirpal II from Nimrud.** 883–859 BC.
Limestone. h. 41¾ in. (106 cm.). British Museum, London.
This coldly formal statue of the king bears an inscription giving
his name, title and victorious campaigns. He holds a curved
crook-axe and a sceptre, royal attributes which are markedly
similar to those of the Egyptian kings (see plate 94). This is in
no sense a personal portrait. The head is impassive and the
features generalised.

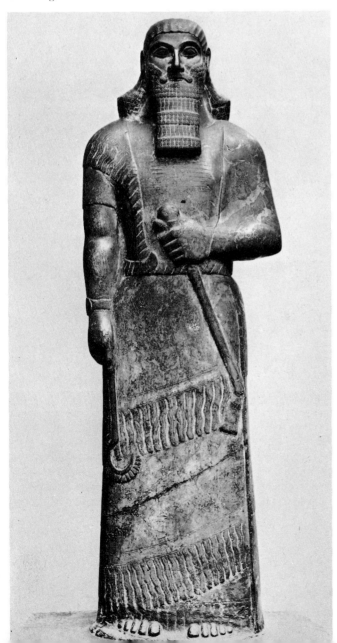

THE NEO-ASSYRIAN PERIOD

Assyrian art of the later or Neo-Assyrian period (*c.* 1000–
612 BC) can be largely identified with the art of the great
palaces built by those kings who were more vigorous or
successful than the others in the conduct of imperialistic
wars. The last four centuries of Assyrian history were not
always glorious; they were marked by fairly long periods in
which no significant work seems to have been produced.
But this was not, as appears at first sight, simply an age of
cruel wars, but also a time of historical transformation and
spiritual ferment when the stage was being set for the dis-
appearance of a venerable civilisation that had flourished
for millennia and the birth of a new world that was to be
enriched by the contributions of men and ideas from both
east and west. The periods of silence that fell between the
more vigorous reigns with their feats of arms and great
building enterprises were only pauses after which the
interrupted development continued. The victorious kings
could count on the services of artists with enormous skill in
carrying on the tradition, even though this might have been
interrupted for several decades. This is a particular strength
of the Assyrian spirit, which for the first and last time after
the Sumerian period created the basis for a unified and
controlled artistic development, despite the apparent
monotony of the subject-matter.

Naturally there was no lack in Neo-Assyrian art of a vast
production of objects of the minor arts and of individual
pieces which reflected the taste of the court. These con-
stitute the base uniting the whole field of the visual arts and
strong links were formed with neighbouring cultures. But
this work never reached the level of achievement created
for the king. The great rock-carved reliefs of Bavian and
Maltai commissioned by Sennacherib (704–681 BC) show
the king with two gods and a row of seven deities standing
on animal 'attributes'; these two scenes are repeated many
times. Although the type goes back to the rock-carved
prototypes of Anatolia and Elam, these reliefs add little to
the evidence provided by the decoration of the royal
palaces. The rare statues in the round, including one of
Assurnasirpal II, two of gods, and one of Shalmaneser III, *35*
are notable only for their academic correctness. Recalling
North Syrian counterparts, they are carefully worked in
the engraved parts of the hair and the beard, but they offer
no interest beyond the treatment of particular details. An
amber statuette in the Boston Museum of Fine Arts is
exceptionally attractive because of the soft modelling,
which again points to the North Syrian region, as do also
the details of the decoration of the pectoral worn by the
figure.

The best examples of seal carving, which do not always
maintain the high level set in the Middle Assyrian period,
show a similar interest in narrative detail. Generally
speaking, however, the bodies have lost their solid form,
being rendered with rapidly executed lines and with the
drill. This is the same sharp and linear dryness that
characterises the inscriptions of this period. The composi-

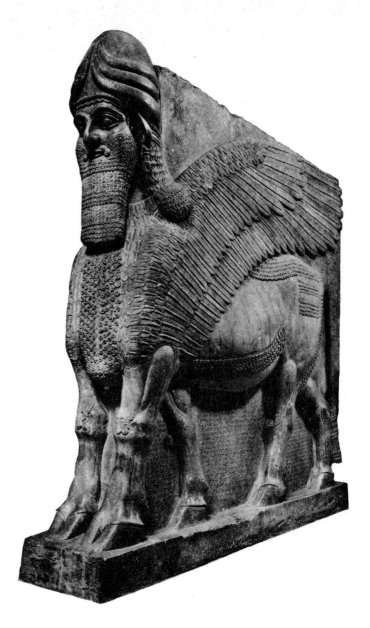

46 tions appearing on Neo-Assyrian seals mostly represent gods (the armed Ishtar) and cult scenes, often in the presence of the king. But there are also many scenes of struggle against winged monsters, a theme that was to be continued under the Achaemenian Persians. It seems to be closely bound up with the religious feeling of the period, which was preoccupied with the struggle between good and evil. While a modest number of Assyrian reliefs show varied and often clumsy attempts to naturalise a foreign genre, the production of tiles, enamelled vases and metal objects identifies Assyrian art as a cultural manifestation of the plateau, linked on the one hand with the Mitannian heritage and on the other with the future achievements of the Persians.

ASSURNASIRPAL II

Having briefly reviewed the average products of Assyrian art, let us turn to the grander work done for the great kings. Neo-Assyrian art comes into its own in the reign of Assurnasirpal II (883–859 BC), whose statues have already been mentioned. This king erected a large palace in Nimrud (ancient Kalkhu), a city he largely rebuilt. The palace belongs to the Mesopotamian tradition of clusters of rooms arranged around courtyards, but they follow an innovation met for the first time under Adadnirari I (13th century BC), that is the grouping of rooms in a corner of the great courtyard. (This may be the source of the design of the Palestinian royal palaces of the first millennium). The walls of the public areas were faced with big stone slabs bearing reliefs, while the entrance to the palace was flanked by enormous

36 figures of human-headed, winged bulls carved in the round and in relief. These figures, which were intended to ward off evil forces, are executed in the same spirit as the statues. They show a minute attention to linear detail, an affectation perhaps, but in their huge scale they achieve an effect of great power, which must have been enhanced by the design of the setting as a whole. The lions flanking the entrance to the temple of Ninurta at Nimrud are much livelier, despite the minute treatment of detail and the

75 script that covers the bodies. They descend from Anatolian and North Syrian models.

The reliefs that decorate the lower part of the walls of the palace of Assurnasirpal can be divided into two classes. One

37 group shows the king, accompanied by winged genii, performing some religious rite, or the beneficent genii, of which there are several different types, might appear alone. The other group narrates episodes from the king's

38 military campaigns and his hunting expeditions. It is curious that while the first group usually has a closely packed inscription which passes over the figures about half way up the slab, in the second group the inscriptions, which function as captions, are placed on projecting strips that divide the scenes into registers. Apart from the general differences in composition—the reliefs with religious scenes show a single scene per slab while the narrative slabs accommodate several scenes in registers—the two

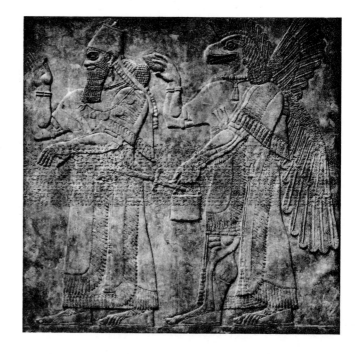

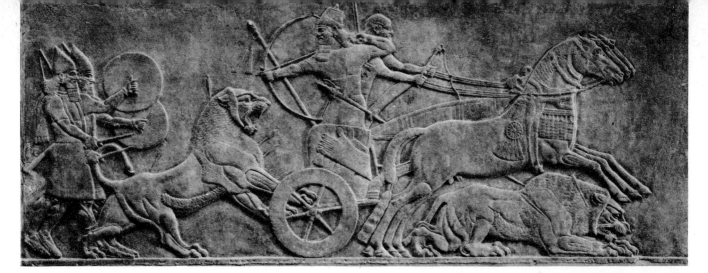

38 (above). The Lion Hunt of King Assurnasirpal.
883–859 BC. h. *c.* 36 in. (93 cm.). British Museum, London. This
relief, also from Nimrud (see figure 37), shows the king drawing
his bow at a lion. Hunting episodes such as this are much freer
both in composition and in movement than the religious scenes.
The lion hunt motif had a religious and symbolic meaning in the
ancient Middle East. It lasted from the fourth millennium BC
(stele from Uruk, figure 5) until Sassanian times. The king
personified the good, vanquishing the powers of evil.

**36 (opposite, above). Winged human-headed bull from
Nimrud.** Period of Assurnasirpal II. Alabaster. h. 10 ft. 4 in.
(3·14 m.). British Museum, London. This colossal figure guarded
a doorway of Assurnasirpal's palace at Nimrud. It marks the
climax of Assyrian relief-carving in its majestic power and
minute attention to delicate detail.

**37 (opposite, below). Relief from the North-West Palace of
Assurnasirpal at Nimrud.** 883–859 BC. Alabaster. h. 7 ft. 2 in.
(2·18 m.). British Museum, London. Part of a ritual relief
showing the king approaching a sacred tree, accompanied by an
eagle-headed genius, who bears offerings. An inscription
describing the king's victories runs right across the centre of
the slab.

40 (below). Detail from the bronze gates of Balawat.
Reign of King Shalmaneser III. 858–824 BC. h. of strip 10½ in.
(27 cm.). British Museum, London. During excavations at the
Assyrian city site of Balawat, the casings for two pairs of doors
were discovered. The most famous pair, of which a detail is
shown here, depicts, in long narrow strips, episodes from the
king's military expeditions.

39 (above). Soldiers crossing a river. (See figure 37 for
date and provenance.) Scenes from which the king is absent
achieve a greater vivacity and are perhaps more attractive to
modern eyes. Here soldiers are shown crossing a stream on
inflated skins. Note the stylisation of the river which
contrasts with the lively execution of the figures.
In fact everything is depicted with strict adherence
to fixed rules.

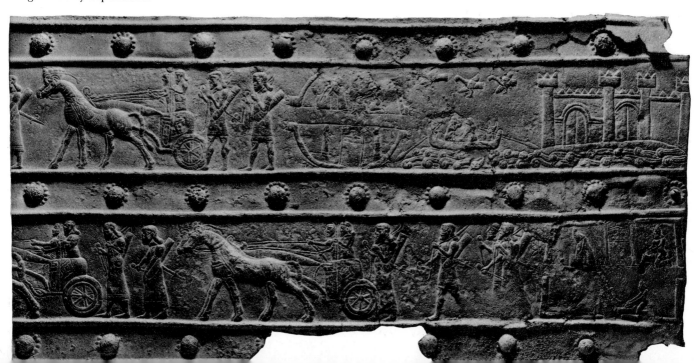

groups differ markedly in style. In the first group the lines indicating contours and internal divisions are sharp and precise, while the figures are stiff and hieratic. This is the atmosphere breathed by the cult statues, with their correct and careful treatment. In the narrative scenes, however, the contour line softens and the relief becomes more plastic: the movements of the figures seem free and unconstrained. These scenes have an astonishing vivacity; there are sieges, battles, and triumphal parades of chariots and prisoners. Some episodes, such as the scene of soldiers crossing a river, are described with a combination of richness of detail and a close attention to composition. The explorers are carried across the water on inflated skins, and the waves are elegantly stylised. When the king appears in a scene the figures stiffen and the composition becomes cold, so that in the hunting scenes only the animals seem really alive and independent of the human figures that attack them.

The unheralded appearance of relief art of such high quality in Assyria calls for an explanation, which unfortunately cannot be entirely satisfactory. The historical relief which had disappeared from Mesopotamia in the time of the Akkadian dynasty makes it necessary to regard the Assyrian relief either as an original creation or as a derivation from some other country. Now it is true that fragments of historical scenes were already attested to the end of the second millennium in Assyria. One piece of evidence is the 'White Obelisk', which some scholars assign to the time of Assurnasirpal II, while others date it earlier, to the reign of Assurnasirpal I (11th century BC). Apart from some details of costume that speak in favour of the earlier dating, it is the type of composition used on the obelisk that is of importance here; the scenes are divided into eight registers, and within a single register events follow without separation. A single figure may be cut off by the corner of the obelisk; a scene may appear without any relation to what precedes and follows; the direction of movement may change abruptly. Obviously the artist had difficulty in integrating a body of iconographical themes, which had many points in common with that of Assurnasirpal II, into a single unit. But if we turn to the Broken Obelisk that certainly belongs to the reign of Assurnasirpal II it is evident that the hesitations and naiveté of the White Obelisk have disappeared: the composition is fully integrated. This proves that a precedent for the reliefs of Assurnasirpal II already existed in Assyria. Here, however, the position is the same as with the North Syrian reliefs: the thematic repertory existed earlier, but not the technique of relief itself. The most likely solution is that the Assyrians borrowed from North Syria and Anatolia the idea of decorating the palace with reliefs, exploiting for this purpose the thematic repertory already in their possession and eventually enriching it with western motifs. In this way we can explain iconographic resemblance between the Assyrian reliefs and the historical reliefs of New Kingdom Egypt. It is hard to imagine direct connection; the

common elements may be explained by a parallel derivation from the Syrian and Anatolian world. Once this has been said, however, the fact remains that the Assurnasirpal reliefs were undoubtedly the work of exceptionally highly skilled artists, who succeeded in expressing something genuinely new and important in the materials that tradition and the culture of the time had supplied.

SHALMANESER III

Assurnasirpal II's successor, Shalmaneser III (858–824 BC) built a great deal at Assur, including the wall surrounding the city, but no mural reliefs have survived from his reign. Instead there are two monuments that, despite their differences, tell us a good deal about the new artistic tendencies that were developing. These are the so-called 'Black Obelisk' and the bronze doors of Balawat. The Black Obelisk, the latest instance of a type that goes back to the second millennium and which probably was the closest forerunner of the wall reliefs, distributes the scenes in five tiers. The scenes extend across the whole width of each face so that a completely consistent division of space is achieved. Despite the clarity of such scenes as those of the foreign kings—including Jehu of Israel—in abject prostration before the Assyrian king, the sharp separation of the scenes has acted as a check on the artists' imagination and the same scene often recurs on several sides. An opposing tendency comes to the fore in the bronze gates from Balawat, which are divided into twelve long and narrow bands containing narrative reliefs. Here we find not only the transposition of the wall-relief technique into a different medium, but the length of the bands obliged the artists to integrate the figures and thus to present complex narrative episodes. Often the artist dealt with the problem by creating long rows of almost identical figures. In other instances he used the enthroned king or another seated person as a focus to unite two halves of the relief. From the narrative point of view the designer of the doors lacked the inventive powers reflected in the reliefs of Assurnasirpal, but in one respect the doors of Balawat do signal an advance on the art of the earlier period: the artist shows great interest in landscape settings when the action requires them. The army's crossing of rivers on inflated skins, the exploration of the mountain source of the River Tigris, the depiction of the city of Tyre built on an island—many opportunities are provided for the artist to display his narrative skill. The device of show-

(Continued on page 65)

21 (opposite). **Seated figure from 'Ubaid.** Early Dynastic II Period, c. 2600–2350 BC. Basalt, with traces of paint. h. 14¾ in. (37·5 cm.). British Museum, London. This figure is one of the most important works of sculpture of the Second Dynastic period. It has a strength and a monumentality new to Sumerian art. Like the contemporary figures from Mari the arms are placed across the chest and the hands clasped in an attitude of worship. Once thought to portray Kurlil, a 'warrior chief of Uruk', it probably does not in fact represent that ruler, whose name was actually inscribed on another piece of sculpture.

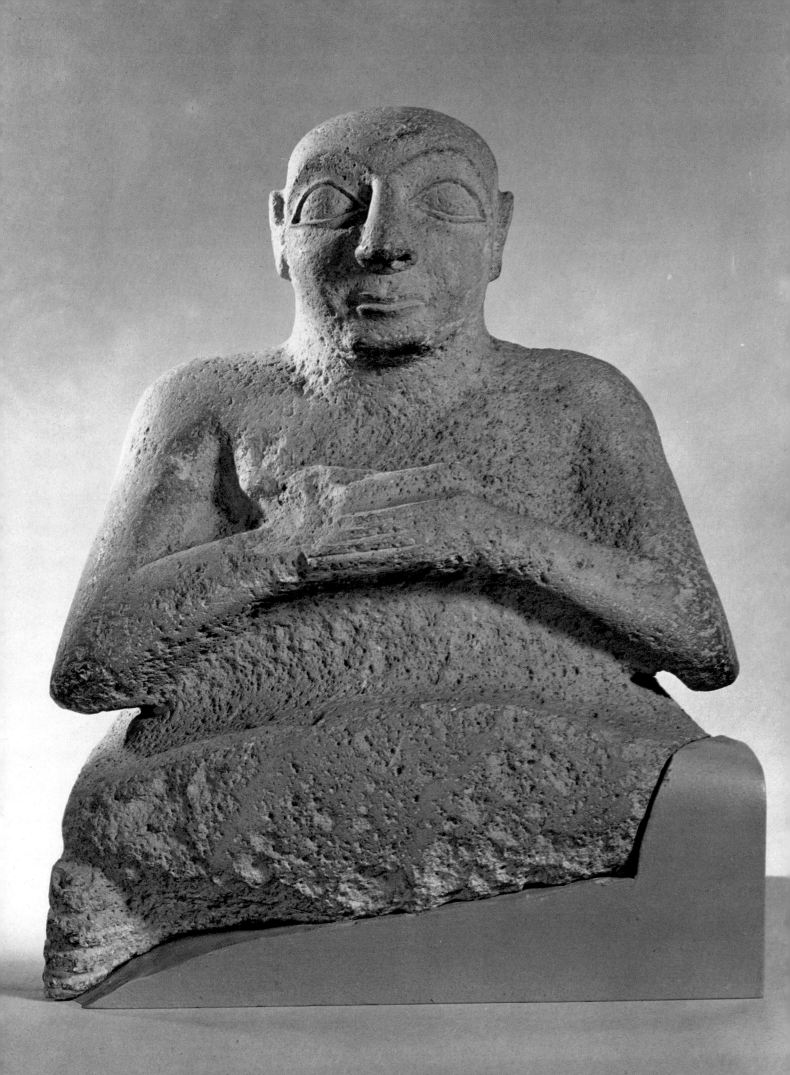

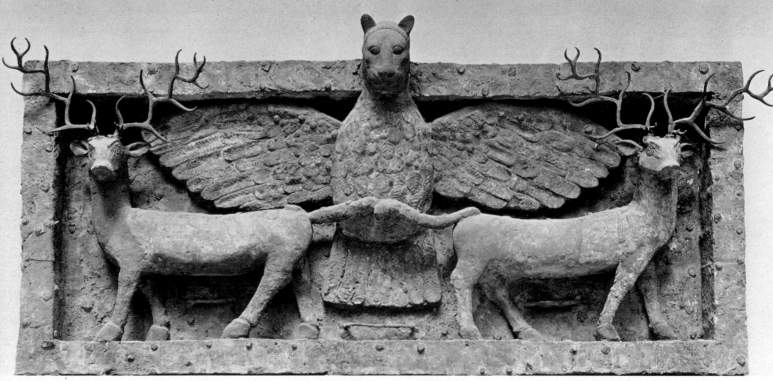

22 (above). **Relief of Imdugud from 'Ubaid.** Early Dynastic II Period. *c.* 2600–2400 BC. Sheet copper on a wooden core. w. 7 ft. 9¾ in. (238 cm.). British Museum, London. Imdugud, the benevolent lion-headed eagle of Sumerian mythology, is shown with wings outspread, protecting two stags. In this 'heraldic' composition the Sumerian artist sought to increase the power of the sacred eagle by duplicating the object of its care. The relief was probably placed above the entrance to a temple.

23 (below). **Beaker from 'Ubaid.** Predynastic period. Early fourth millennium BC. Painted pottery. h. 6¾ in. (17 cm.). British Museum, London. 'Ubaid pottery, of which this beaker is a typical example, was characterised in its late phase by dark geometric patterns on a light ground. It is hand made, and contemporary with the Susa I pottery (see plate 20). Comparison between the two vessels points to an infinitely more refined character in the Iranian decoration.

24 (opposite). **Gudea of Lagash.** Neo-Sumerian period. *c.* 2150–2050 BC. Diorite. h. 29 in. (73·6 cm.). British Museum, London. French excavations at Lagash (modern Telloh) have recovered a number of statues of Gudea, the governor or *ensi.* He is always depicted as a devout man, and such texts as have been recovered confirm this. These sculptures belong to the period of Sumerian 'renaissance'. One cannot but be impressed by the quality of the modelling in such hard intractible material.

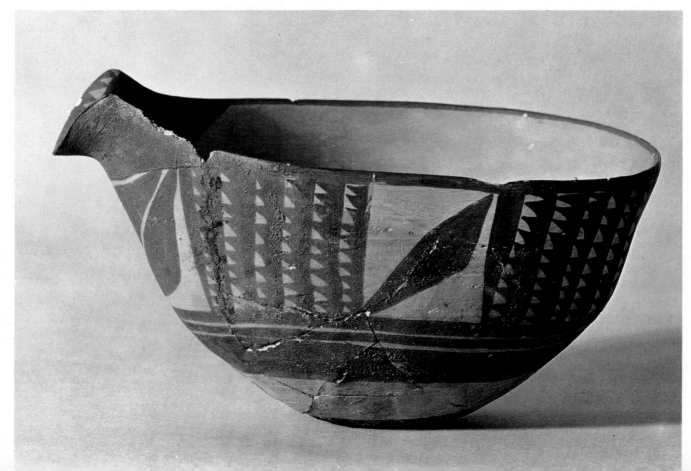

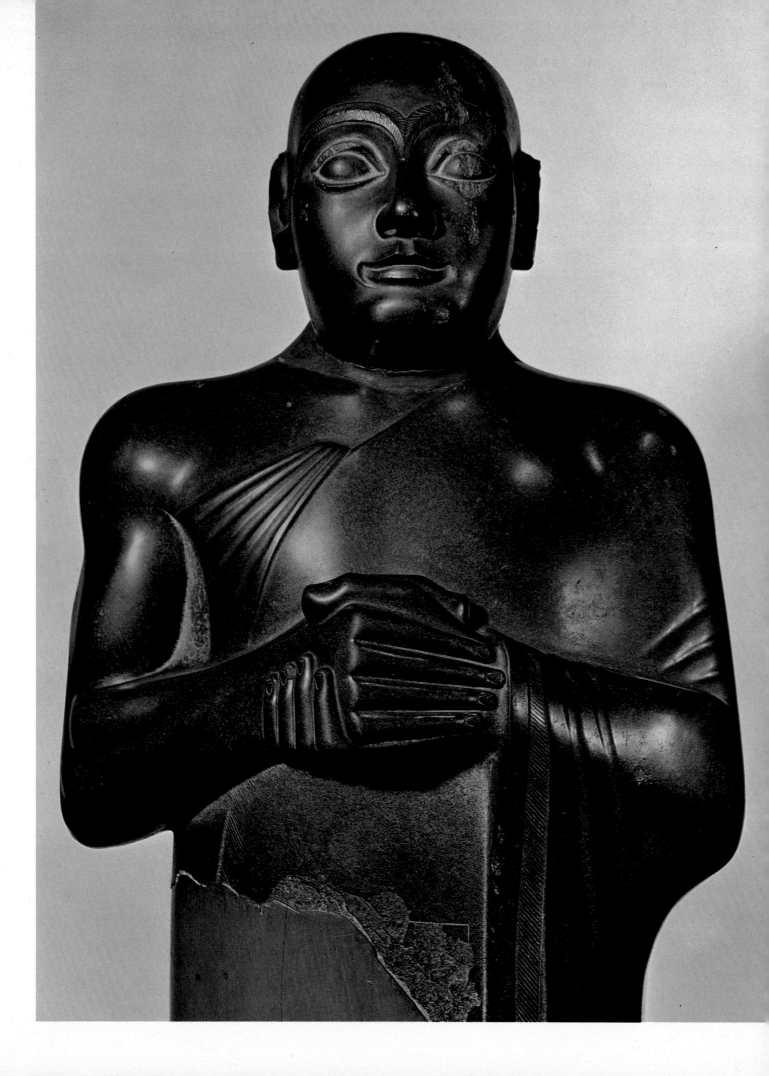

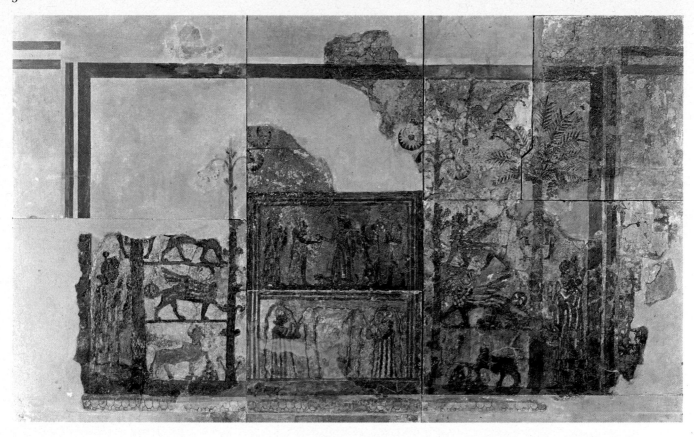

25 (above). **Wall-painting from the palace of Zirimlim at Mari.** *c.* 2040–1870 BC. Paint on plaster. h. 5 ft. 7 in. (1·7 m.). Louvre, Paris. One of the earliest surviving Mesopotamian wall-paintings. On the left mythological creatures beside a sacred tree. In the centre (above) the king before the goddess Ishtar, and (below) deities holding vases from which issue streams of water. To the right is a delightful narrative detail with two figures climbing a date palm.

26 (left). **Vase from Khafajah.** Early Dynastic Period. Beginning of the third millennium. Painted pottery. h. 12 in. (30 cm.). Iraq Museum, Baghdad. An example of the so-called 'Scarlet Ware', in which animals and human figures in orange-red appear on a pale yellow ground. This pottery testifies to the existence of a separate cultural unity shared by Elam and eastern Mesopotamia, even after the growth of the Sumerian civilisation in southern Mesopotamia. By the middle of the third millennium, however this peripheral area was to be drawn completely into the Sumerian cultural orbit.

27. **Jug from Alaca Hüyük.** *c.* 2400–2200 BC. Gold. h. 6 in. (15·3 cm.). Archaeological Museum, Ankara. Little is yet known of the Bronze Age people of Alaca Hüyük, (probably the Hattites), who preceded the Hittites into Anatolia. The rich finds from their tombs testify to a long familiarity with metalwork techniques, and they may have links with the Caucasus. They knew how to solder, inlay, and hammer precious metals and also produced repoussé reliefs. The decoration of their gold vessels is always geometric, fluting and zig-zag lines being the most favoured patterns.

28 (left). **Stag standard from Alaca Hüyük.** *c.* 2400–2200 BC. Bronze inlaid with silver. 20½ in. (52 cm.). Museum of Archaeology, Ankara. Among the finds at Alaca Hüyük were many 'standards', so called because it is supposed that these bronzes were inserted into the top of long poles.

29 (below). **Disk standard from Alaca Hüyük.** *c.* 2400–2200 BC. Bronze. h. 9¼ in. (23·3 cm.). Museum of Archaeology. Ankara. The sun disk standards are without precedent in the history of the Near East; many were found in the royal graves at Alaca Hüyük.

30 (opposite). **Jug from Kültepe.** 18th century BC. Clay with red-brown slip. h. 13¾ in. (39·8 cm.). Museum of Archaeology, Ankara. Tall tapering vessels with beak-like spouts were being produced in Anatolia from the end of the third and into the second millennium BC. This pottery known as Alishar II ware appears to be connected with a culture in northern Anatolia, and examples have been discovered at Kültepe, an important Assyrian trading centre.

31. **Vase from Conelle.** Beginning of the second millennium BC. Greenish pottery. h. 11⅞ in. (30 cm.). Archaeological Museum, Ancona. This vase belongs to the Pre-Apenninic culture which flourished in central Italy at the beginning of the second millennium BC. The shape of the vase and its decoration clearly derive from Balkan and Anatolian models. The culture of Conelle (a site near Arcevia) and similar ones in Sicily, Sardinia, and at Almeria in Spain testify to the presence of an Oriental migration of warriors or shepherds in southern Europe at this period; they introduced the use of bronze into these regions.

32 (upper). **View of temple ruins at Hattusas.** Hittite Imperial Period, 1400–1200 BC. The Hittite capital of Hattusas was built on a rocky plateau, not far from the modern Turkish village of Boghazkoy. It was strongly fortified, with city walls following the contours of the hillside, upon which towers were placed at regular intervals. Within the city limits the remains of five temples and the walls of a royal palace have been found.

33 (below). **The Lion Gate, Hattusas.** Hittite Imperial Period. 14th century BC. The most striking architectural feature of Hattusas is the elaborate perimeter wall four miles in circuit. The famous Lion Gate guarded the south-western approach. The animals are carved from enormous blocks of stone, and are among the outstanding sculpture of the Hittite Imperial period. (See next page.)

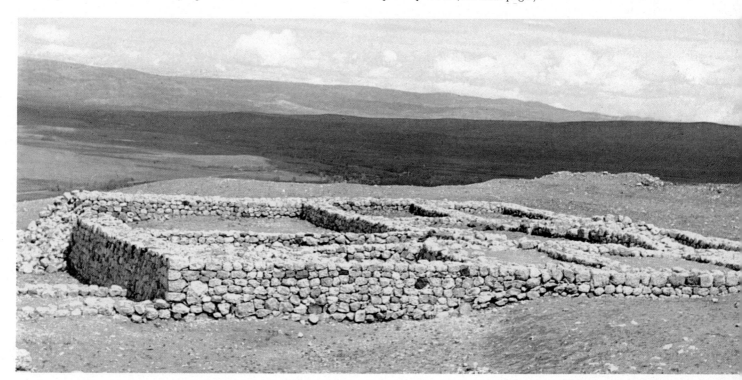

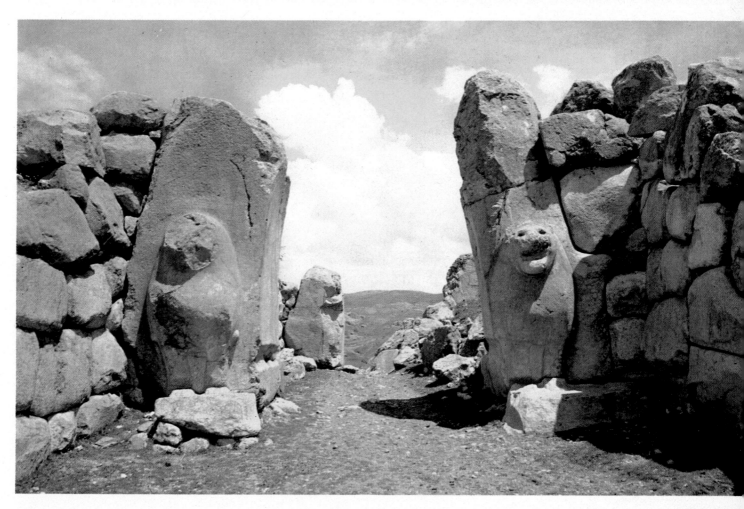

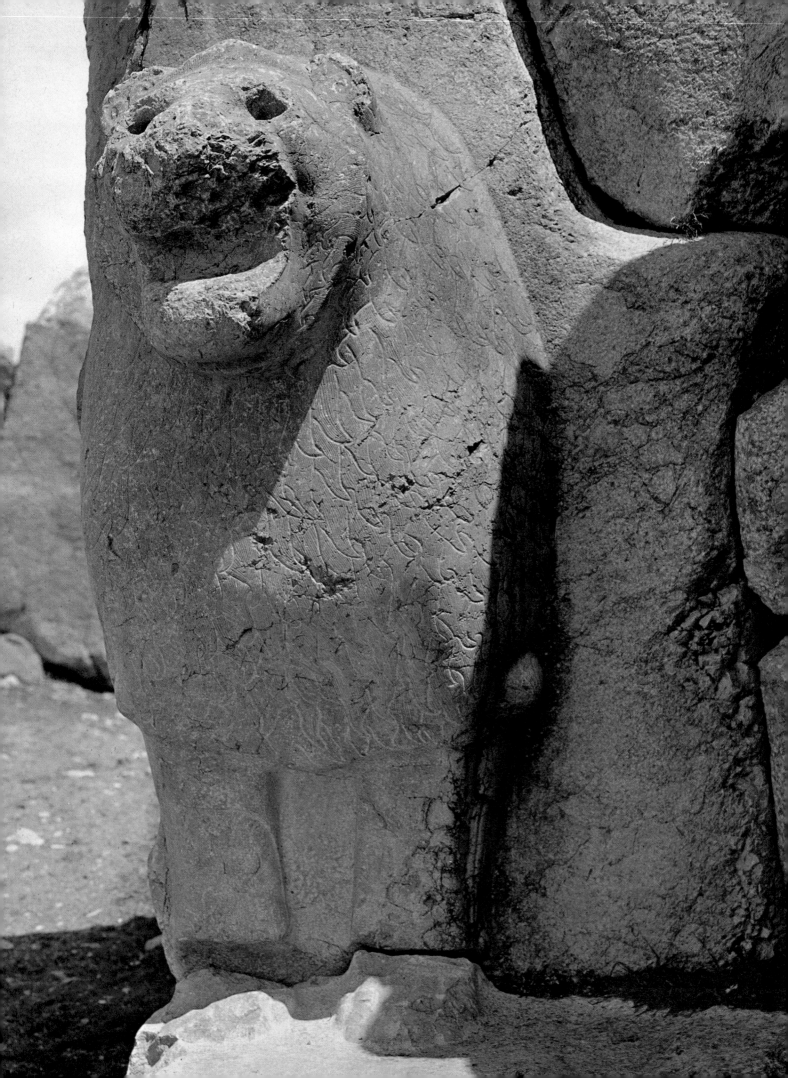

34 (opposite). **Detail of the right-hand lion in plate 33.**

35, 36 (right and below right). **Sphinx from the Sphinx Gate at Alaca Hüyük.** Hittite Imperial Period. Middle of the 14th century BC. The Sphinx Gate, like the Lion Gate at Hattusas, guarded the entrance to the city. It was built over the Early Bronze Age tombs described in plates 27–29. The sphinx motif probably reached Anatolia from Egypt via Syria, but it is transformed from a male symbol into a female one. If the idea of guardian creatures originated in Mesopotamia, it was developed by the Hittites in a monumental way which was to find echoes in Assyria centuries later.

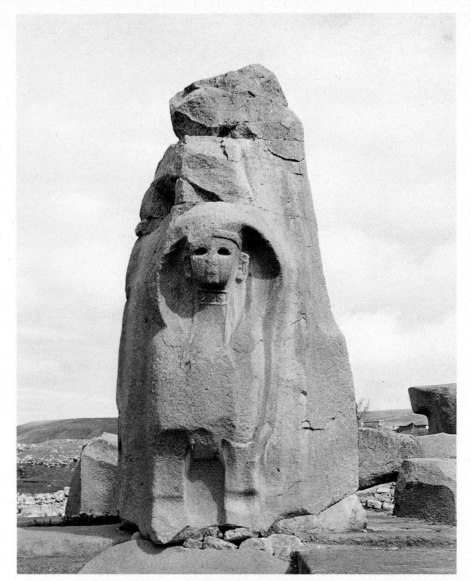

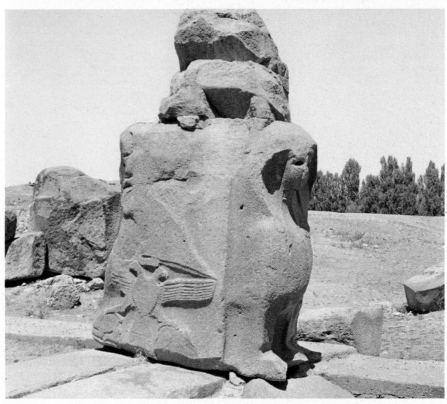

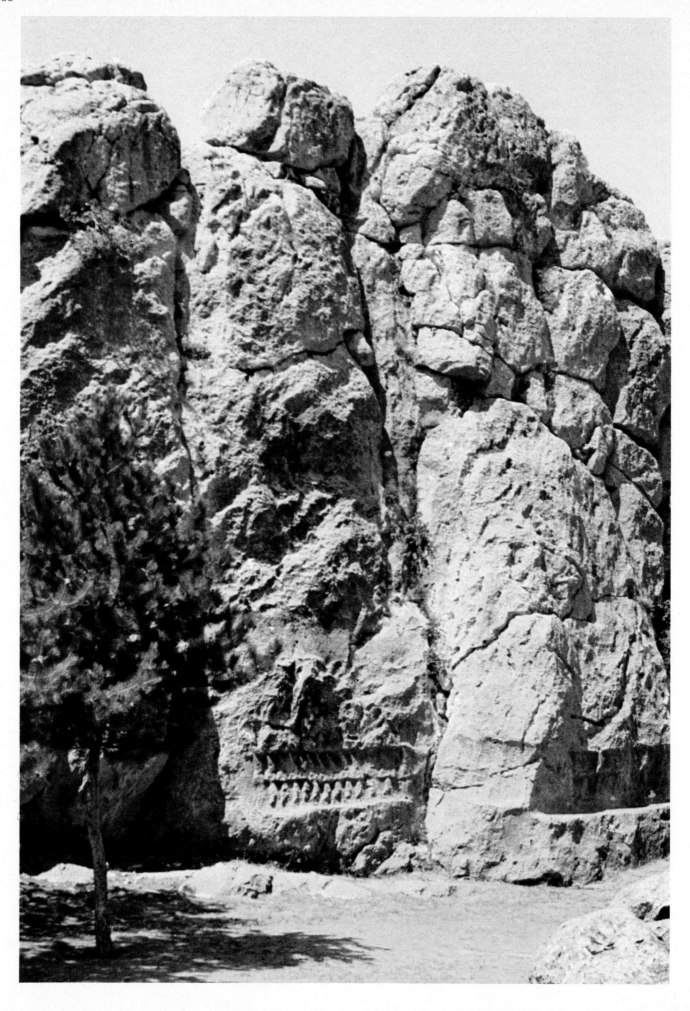

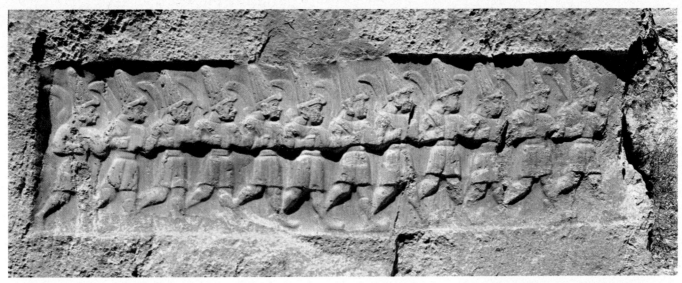

37 (opposite). **The rock sanctuary of Yazilikaya.** Hittite Imperial Period. *c.* 1350–1250 BC. About two miles to the north-east of Hattusas, on the site of a natural spring, lies the impressive rock sanctuary of Yazilikaya. Deep clefts in the limestone made a setting for religious cult ceremonies. The two main recesses or chambers are carved with numerous reliefs of gods, goddesses and kings. Before the opening into the sanctuary to isolate and protect the inner chambers were a gate-house and a temple. Passing

through the temple the observer would suddenly be confronted with two great processions numbering some seventy figures converging from the side walls to the back of the first chamber.

38 (above). **Procession of twelve gods, Yazilikaya.** Hittite Imperial Period, *c.* 1350–1250 BC. h. of figures 30–34 in. (*c.* 80 cm.). This relief from the inner chamber shows twelve warrior gods armed with scimitars and wearing tall conical hats.

39 (below). **King Tudhaliyas IV, protected by the god Sarumma (Sharma).** Hittite Imperial Period. *c.* 1250 BC. The Hittite religion was characterised by a remarkable tolerance. In their texts they refer to the 'thousand gods' of their realm, and they probably absorbed local Anatolian cults into their elaborate polytheism. In this relief Sharma holds in protective embrace King Tudhaliyas IV, whose name is given in the cartouche above.

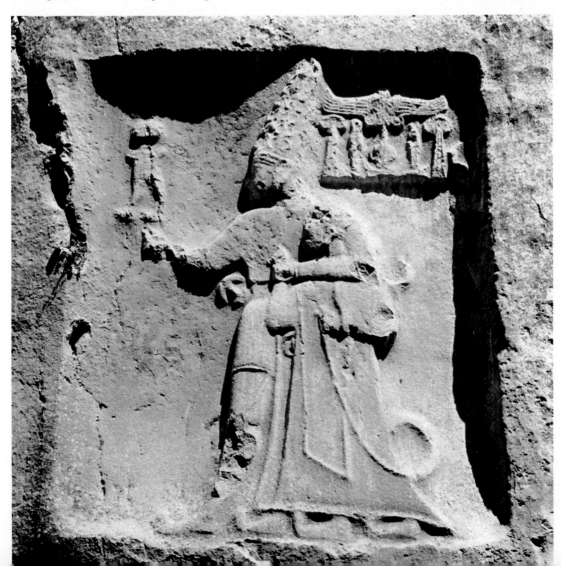

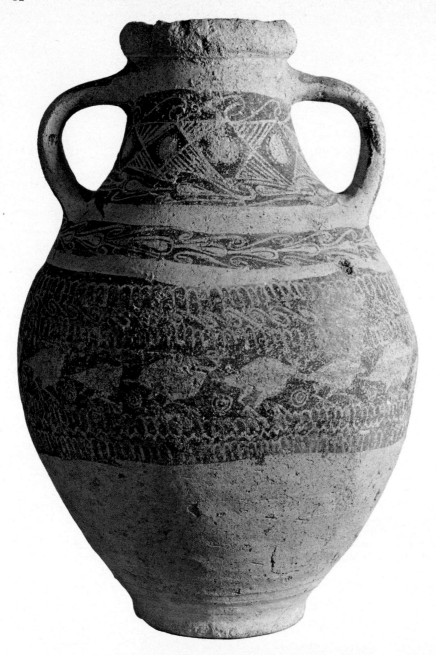

40 (left). Vase from Alalakh.
c. 1500–1200 BC. Painted fired clay.
h. 13⅛ in. (33·3 cm.). British Museum,
London. The state of Mitanni was
created by the Hurrians towards the
middle of the second millennium BC. It lay
to the north-west of Syria in the upper
Euphrates valley. The most characteristic
known elements of Mitannian art are
reflected in their cylinder seals and
pottery. Various Syrian sites, including
Alalakh on the Orontes and Nuzi, have
produced attractive pottery with elegant
white motifs of birds and plants painted
on a dark ground.

41 (below). Relief from Malatya.
850–700 BC. Limestone. h. 21⅝ in.
(55 cm.). Archaeological Museum,
Ankara. Although destroyed in most of
Anatolia, the Hittite tradition survived
for a long time in northern Syria. Close
to the upper Euphrates, Malatya (ancient
Melidi) seems to have been a particular
guardian of the Hittite culture. This
orthostat relief shows a bowman preparing
to shoot a second arrow into the rearing
lion. A second rider holds the reins of the
chariot taut. A dog runs along beneath
the horses' hooves.

**42 (opposite). Statuette from Megiddo,
Palestine.** *c.* 1350–1200 BC. Bronze
covered with gold. Oriental Institute,
Chicago. Syrian art in the second
millennium presents us with certain
contradictions. On the one hand their
metalwork (see plate 43) testifies to a high
level of craftsmanship. Their sculpture
on the other hand has a naive simplicity,
and the metal statuettes show no great
development from the ones that had been
made during the third millennium. It
seems clear therefore that their best work
derived from foreign models. This statuette
probably represents a ruler of Megiddo.

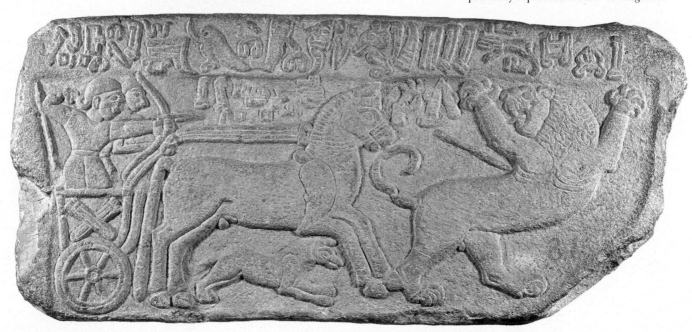

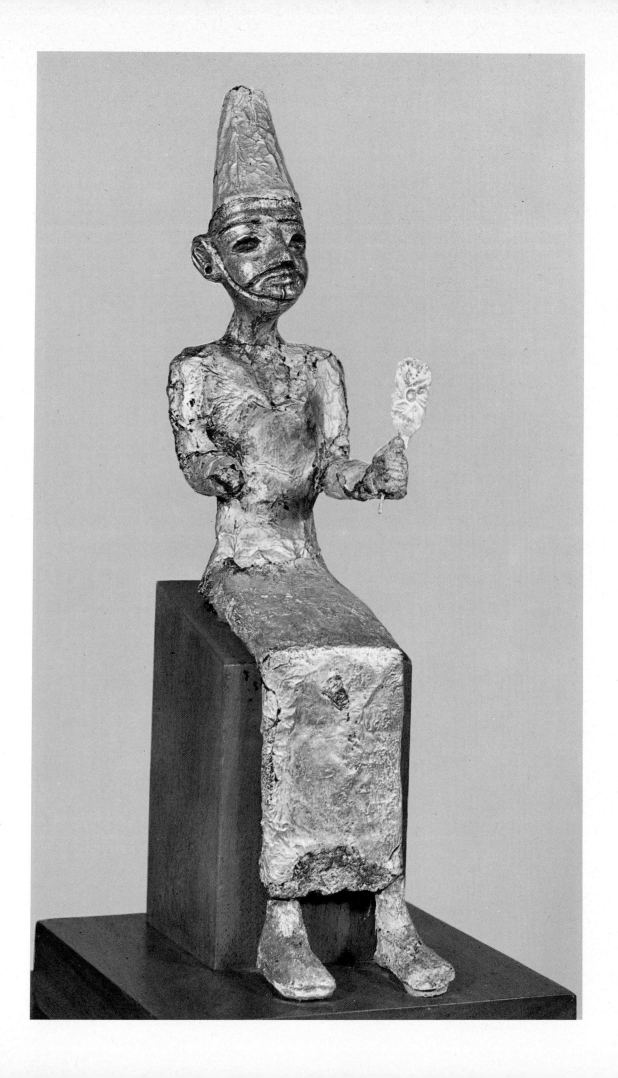

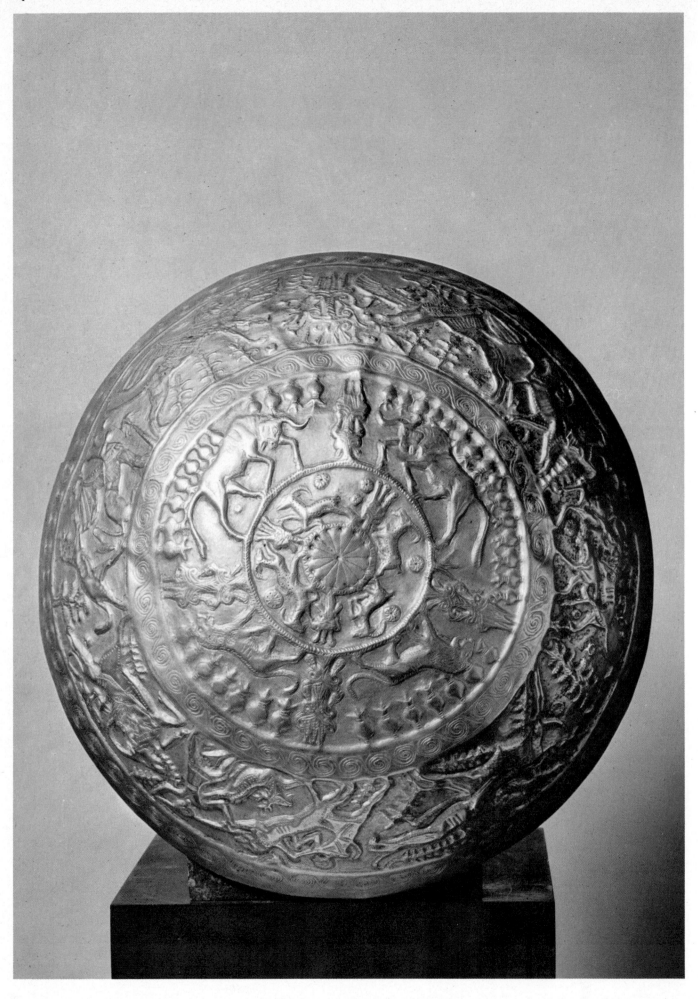

ing the sources of the Tigris as 'windows' opening from the mountains is original and attractive.

TIGLATHPILESER III

After Shalmaneser III there is an eighty-year gap in the record of Assyrian art until the reign of Tiglathpileser III (745–727 BC), whose reliefs from the palace of Nimrud are known to us from a few fragments. Although the subject-matter is not unusual (the conquest of cities and battles with the Arabs), the reliefs of Tiglathpileser show a great novelty in the conception of space. Particular sectors delimited by strips of inscriptions are not filled completely, even with landscape elements, as had happened earlier. This means the achievement of an organic conception of space, no less real for being unconscious. A single band may contain figures that are unrelated to one another, or at least apparently so. Unless one supposes that the different planes and dimensions indicate a rudimentary perspective (which is difficult to maintain), one must imagine that between one figure and another there is no 'space', but only a surface that could, if desired, be filled with another motif. This assumption is borne out by a relief showing a besieged city before which soldiers carry booty, which they could only have obtained after the city had fallen. Nearby are soldiers rendered in a larger scale making a breach in a wall that is not connected to the city, while over this wall we see the defenders fighting. It is difficult to escape the impression that the artist combined successive phases of the narrative, fitting them in where he had room.

SARGON II AND SENNACHERIB

The reliefs commissioned by Sargon II (721–705) to decorate the palace built in the new capital he founded, Khorsabad (the ancient Dur-Sharrukin, 'city of Sargon'), are divided (like those of Assurnasirpal II) into two groups. Some show the king with his retinue, others hunting and similar outdoor scenes. In the huge scene of courtiers, which is over nine feet high, the figures are all represented with the same faces and the same gestures. But their succession in ordered and solemn rows with the garments and insignia carefully indicated, effectively conveys an impression of the majesty of the king. In other reliefs, which follow the paths laid out by earlier narrative tradition, we find instead the

43 (opposite). **Bowl from Ugarit** (modern Ras Shamra). 14th century BC. Gold. diameter $6\frac{3}{4}$ in. (17 cm.). Aleppo Museum. Egypt exercised a strong influence on Syria during the second millennium BC, and it is probable the Syrian metalworkers learned their fine technique from Egyptian craftsmen. This small repoussé bowl is decorated in concentric bands. In the outermost band, scenes of lion hunts are depicted together with winged mythical beasts. In the second band, two bulls and two lions are separated by stylised trees bearing pomegranates. Gazelles and goats surround the central rosette. Here a certain lack of sophistication is evident in the poor compositional balance.

41. **Relief from the palace of Sargon at Khorsabad.** Neo-Assyrian. 721–705 BC. Alabaster. h. of detail *c.* 38 in. 96·5 cm.). Louvre, Paris. This detail shows wood being transported by sea. The heavy timber is supported on the prow of a rather fragile-looking boat. The figurehead is carved as a horse's head.

42. **Relief from the palace of Sennacherib, at Nineveh.** 704–681 BC. British Museum, London. In this scene slaves are dragging a colossal statue to the palace. The formality of the royal reliefs is altogether absent in this lively narrative detail.

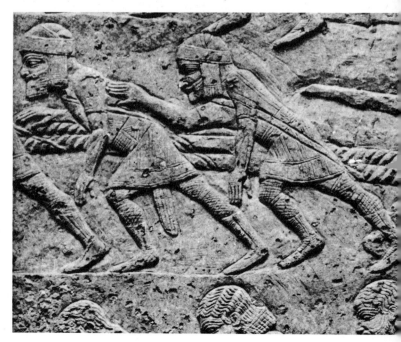

first coherent application of the concept of space as it had begun to emerge at the time of Tiglathpileser III. In the scenes showing the transport of wood by sea the artist has deliberately superimposed rows and groups of figures to suggest several planes of recession in depth.

This feeling for perspective and for landscapes with figures, (hunters among trees and workmen being ferried across a river), is more prominent in the reliefs of Sennacherib (704–681). In the reliefs of the palace of Nineveh (modern Quyunjik) the figures never appear against a blank background; they must be picked out from a setting of trees, mountains, or reedy marsh-land. When a well defined background is lacking, various details are supplied to link the figures to their settings. But the reliefs of Sennacherib merit attention for other reasons. The scenes are observed with a new attention to human detail. Sometimes the artist picks out a spontaneous gesture and then firmly fixes it with a narrative device from his stock in trade. Figures are commonly repeated in series, but they are imbued with an impulse born of a sympathy for suffering humanity. In the rows of prisoners pulling a colossal statue one man wearily leans his palm on the shoulder of the figure before him. And among the slaves shifting stones over rugged terrain under the surveillance of armed guards one tugs at the clothing of the slave walking beside him. We note the sympathy shown for a family hiding in a boat amongst the reeds and the drama of the wild flight of a horse with soldiers in pursuit towards a swamp that suddenly appears in its path. In these reliefs Assyrian narrative art reaches its peak. The understanding of working in depth is often accompanied by a superb sense of design. The mark of human sympathy is evident in the presentation of the terrible events that were the obligatory themes in this official art. These features are not found in the later Assyrian reliefs of Assurbanipal (668–626), which follow different paths.

ASSURBANIPAL

Assurbanipal's palace at Nineveh is rich in scenes of war. The increase in descriptive detail, emphasised by the short inscriptions that identify the subject-matter, is of great value because it provides information about costumes, peoples and ancient cities, but it cannot be said to add artistic merit. Assurbanipal's artists vary between strict adherence to the system of tiered registers, (which had not been discontinued even in the time of Sennacherib), and broader composition spreading over several registers. The handling of battle scenes acquires almost baroque effects, with the corpses heaped in mounds, the Assyrian soldiers harrying and killing, and the dead and dying contorted in diverse positions. But this world in which cruelty is the universal rule occasionally evoked sympathy from the artist. If his attention is sometimes fixed on the rows of prisoners, it may be that his sympathy lay with this weak but appealing segment of humanity. One feature certainly demonstrates sensitivity—the representation of abandoned

41

42

44 (opposite). **Wild asses hunted with mastiffs.** Detail of a relief from the North Palace of Assurbanipal at Nineveh. 668–626 BC. h. 21 in. (53 cm.). British Museum, London. This poignant rendering of animals in flight suggests a sympathy on the part of the sculptor with the fate of the wild asses. The animals are carved with an extraordinary subtlety. This is one of many hunting scenes which decorated the walls of Assurbanipal's palace.

43 (below). **The capture of Susa.** Relief from the palace of Assurbanipal at Nineveh. 668–626 BC. British Museum, London. In the centre the sculptor has shown the city on the banks of a river almost as if it were a plan. Its houses and streets, and the palm trees outside the perimeter walls can be clearly distinguished. Below Elamite women and children are marched into captivity. In the water dead and dying horses mingle with broken chariots.

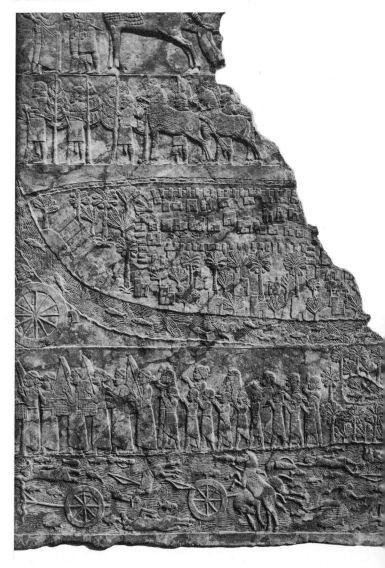

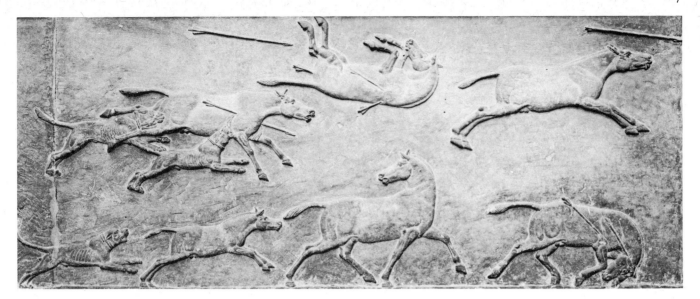

cities. One relief depicts the city of Susa, surrounded by rivers and with its houses spread among trees, then an Elamite sacred wood with its shrine and altar on the top of a wooded hill eroded by little brooks. The contrast between these deserted places and the columns of wretched prisoners is a moving illustration of the heartbreak of exile.

The Assyrian artist was nevertheless compelled to hide his human feelings when reporting the official campaigns and ceremonials of the king. This attitude finds its most complete expression in the royal hunting scenes in Assurbanipal's palace at Nineveh. In a lively descriptive setting provided by the crowd of people who have gathered on a hillock to watch the spectacle and the ranks of soldiers making a cordon of safety, the king's fierce hunt unfolds, culminating in a libation over a heap of slain lions. In accordance with the tradition established by Assurnasirpal, the figure of the king—in a chariot, on horseback, or on foot—always keeps his courtly and measured stiffness; he seems almost lifeless. But this attitude changes when the artist carves the figures of the animals, slain or in flight, and the groups of servants preparing for the hunt. These scenes show remarkable artistic quality. The relief is very low, being almost reduced to a delicate contour, but the modelling, which is so gently indicated, is revealed by the play of light. That the lowness of the relief was a calculated ingredient of the style is confirmed by the discovery of a small clay model, apparently a sketch, which is worked in much higher relief. In this sketch the figures themselves are flattened in preparation for the accepted low relief rendering which would be carried out in the finished work.

After the achievements of the reign of Sennacherib, there could be no further progress along these lines. Assurbanipal's artists repudiated the background altogether, substituting for it an empty plane to be filled only in the observer's imagination by the tensions and relationships connecting the various figures. These figures, even of the servants, now live their own lives. Skilfully grouped, they are distinguished one from another by small but revealing details. In the figures of animals, which court tradition permitted to be shown in a greater variety of attitudes, the artist gave rein to his best qualities, revealing his technical mastery of lyrical composition that still remained within the prescribed bounds of his art.

ASSYRIAN PAINTING

The creation of wall reliefs was paralleled by paintings employing the same formal devices. Apart from some fragments from the palace of Sargon at Khorsabad, which form part of a purely ornamental composition, we have some remains from a provincial palace at Til Barsip, which probably date from the reign of Tiglathpileser III. Familiar themes from the reliefs are found here: court scenes and sea battles. The figures are drawn with a thick contour line and they take on a colourful richness through the contrast of the blacks and reds against the whitish background.

Some votive steles, executed in bas relief and belonging to various reigns, again depict the figure of the king in the character of victor over enemies or as the great priest.

ASSYRIAN CITY-PLANNING AND ARCHITECTURE

The most satisfactory idea of Assyrian city-planning and architecture comes from the ruins of the city of Khorsabad, founded by Sargon II and left unfinished after his death. Approximately square in plan and surrounded by a wall with seven gates, Khorsabad's most important buildings are grouped together on the north-west side, which has only one gate instead of two. These buildings stand on an artificial terrace and in their turn are surrounded by a wall of their own, so that they form a kind of citadel. Some of the gates have a monumental entrance, usually flanked by huge winged bulls with human heads and occasionally by the gigantic relief figure of a hero strangling a lion—the ancient Gilgamesh motif. The royal palace, which was accompanied by a ziggurat and a complex of temples, had two main entrances, of which one was equipped with towers and sculpture, including as many as twelve winged bulls with human heads. Organised around two immense courtyards, the several parts of the palace present a regular plan, thus revealing the same predilection for clear distribution that is seen in the plan of the city as a whole. An interesting feature is the throne room, comprising a long rectangular space with the entrance at the centre of one of the long sides. Placed on a monolithic platform with a sculptured base, the throne rose at the centre of the short side as the spectator faced right from the entrance. This follows the arrangement of Assyrian temples and thus underlines the sanctity of the king. Among the other build-

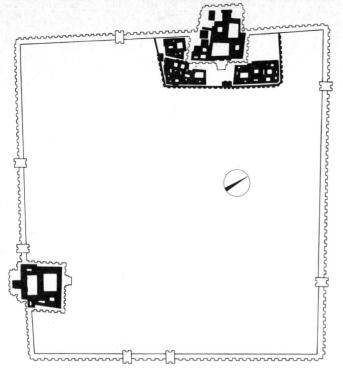

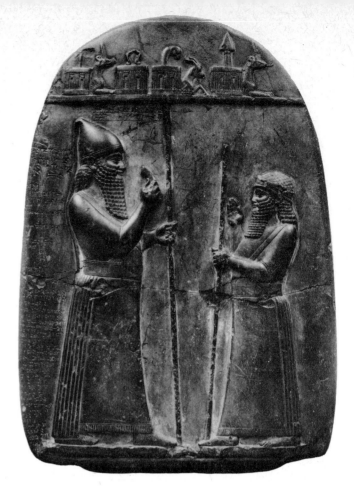

45. Plan of the city of Khorsabad. 8th century BC. The city of Khorsabad was dedicated in 706 BC, shortly before the death of its founder, Sargon II. Approximately a square mile in area, it had two main concentrations of buildings. At the northern edge of the town was the citadel, which enclosed within its inner wall the royal palace, a complex of temples, a ziggurat and foreign embassies. A similar fortress protected the southern entrance to the town.

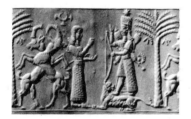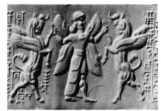

46a, b. Late Assyrian cylinder seal impressions. 9th–7th centuries BC. British Museum, London. Assyrian cylinder seals seem to have played some part in religious rituals, particularly those of the New Year Festival when the kings sought divine protection for themselves and their people. In *(a)* the goddess Ishtar is shown standing on her animal attribute, bearing a bow, arrows and other weapons. In *(b)* a winged genius with the curly Assyrian beard stands between two confronted winged bulls.

47 (above). Stele of Mardukpaliddina. Neo-Babylonian period. *c.* 721–703 BC. Black marble. h. 18½ in. (46 cm.). Staatliche Museen zu Berlin. The Neo-Babylonian boundary stones are in the tradition of Kassite art, and have scarcely any affinities with Assyrian sculpture (see figure 33). The rounded form and the greater depth of the relief recall the stele of Hammurabi (30).

49 (opposite). Reconstruction of the main temple precinct at Babylon. Model in the Staatliche Museen zu Berlin. The precinct of the city god Marduk is surrounded by buttressed walls. Within is a low temple structure with two square courts. The vast five-tiered ziggurat, the biblical 'Tower of Babel', is surmounted by a small sanctuary following earlier Sumerian practice.

ings of Khorsabad one should note the so-called Palace F, which lies on the other side of the city. This has a porticoed entrance with column bases of bulbous form well known from North Syria. Palace F is in fact an imitation of the *hilani*, as Sargon admits himself in an inscription: 'Before the gates of the palace I have built a portico following the example of the Hittite (i.e., North Syrian), which is called *bit-hilani* in the Amorite (i.e., western) language'.

Assurbanipal was the last great king of Assyria. A little more than a decade after his death the allied Babylonians and Medes destroyed Nineveh (612 BC), extinguishing the Assyrian power forever.

THE NEO-BABYLONIAN PERIOD

The fall of the Assyrian Empire sealed the fate of Assyrian art, which was too closely linked to the court and its needs to be able to survive independently. Although Assyrian art left some traces in the later art of other regions and peoples, this was due to the widespread diffusion of certain standards of craft production. Babylonia was left as the last upholder of Mesopotamian culture and in some ways her history parallels that of Egypt in the late period. We have seen how the Kassite rule brought a phase of cultural and artistic renewal for Babylonia. Unfortunately the re-establishment of national dynasties that survived for several centuries up to Babylon's fall to the Assyrians meant the final extinction of any hopes of cultural revival. The Babylonia of the first millennium, which the Greeks respected as the home of wisdom, was actually little more than a museum in which age-old traditions, especially those of Sumeria, were assiduously collected, studied and preserved. When it did not meekly follow the Assyrian

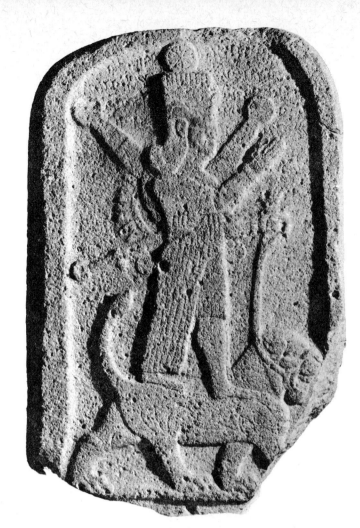

48. **Relief from Tell Ahmar.** 8th century BC. 48 in. (121 cm.). Louvre, Paris. This relief shows the goddess Ishtar standing on a lion which she holds on a rein. Above her crown is the star, which was one of her attributes. This piece shows affinities with North Syrian work, rather than Assyrian influence which was so much nearer home, yet affected their art less strongly.

which the ruling family belonged, inherited the imperialistic policies and power of the Assyrian Empire. Under Nebuchadnezzar II this power was expressed in the form of monumental architecture. But even today power and ambition do not always guarantee artistic success. The use of glazed bricks bearing figures of symbolic animals—lions, bulls and a kind of griffon—to decorate the Ishtar Gate and the processional street of Babylon amounted only to a large-scale application of a principal already known in Kassite times. Further, the huge buildings of Chaldean Babylonia—the famous ziggurat known as Etemenanki which forms the basis of the story of the Tower of Babel, the temples, and the royal palace with its famous 'hanging gardens', which archaeological excavations have revealed to be disappointingly modest—present no innovations comparable to the Assyrian achievements. An exception is the arrangement of the throne room. As in Assyria the Babylonian scheme imitated that of the temple, but now the throne is found at the centre of one of the long sides, preceded by a long cella. The principle of theophany replaces the Assyrian idea of the hidden god as the main influence in the concept of kingship.

Apart from architecture, archaeological finds for the Neo-Babylonian period are meagre. This suggests that the splendid buildings whose ruins are still to be seen must have contained furnishings that were looted or destroyed. The fact that we do not have a single statue is possibly due to the fact that from the Kassite period onwards, Babylonia preferred sculpture in metal which was an easy prey to looters. (Herodotus records a gold statue of Marduk that was carried off by Xerxes, and Diodorus Siculus mentions three gold statues also looted by the Persians). A few stone reliefs and terracottas serve to illustrate the recourse to archaic motifs from the Neo-Sumerian and Old Babylonian periods. Just as in Saitic and Ptolemaic Egypt, the principle of the revival of the antique is victorious. All the Chaldean kings, especially the last, Nabonidus, were zealous restorers of ancient buildings in the old style; they took particular pride in recovering the foundation texts of the Sumerian kings. In the relief of Nabuapaliddin we even find the 'presentation scene' characteristic of the Neo-Sumerian period.

Babylonian art, unlike that of Assyria, did not meet a violent end. The process of decline—which in reality had begun as early as the beginning of the second millennium BC, and which the Kassite domination had temporarily halted—continued into the Chaldean period, despite much pomp and outward show. The decline was accelerated in the Achaemenian period, when for the first time in three millennia the cultural and spiritual hegemony of western Asia belonged once more to the Iranian plateau. By the Hellenistic period Nineveh was only a memory and Babylon, like medieval Rome, was largely given over to fields and gardens.

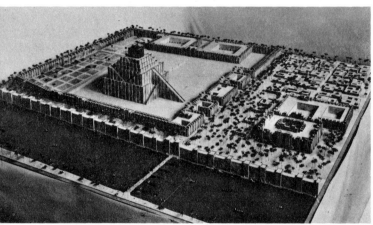

lead, the art of this period, which is still little known, seems to have continued in the wake of the Kassite tradition. Among its products are some late boundary stones bearing the figures of kings—this is an innovation not found among the Kassites—which derive from Assyrian practice but are stylistically quite varied, being executed with a softer line and gentler modelling.

In a Babylonia that had shut itself off from the outside in order to contemplate its past glories, the barbarian Aramaeans succeeded to power a few years before the fall of Nineveh. Like the Amorites of the second millennium, the Aramaeans had little culture of their own. But they sought to assimilate the indigenous culture and to play an active political role. The Aramaeans succeeded in imposing their language on the country. The Chaldean dynasty, so called from the name of the Aramaean tribe to

Peripheral Areas

The extensive area discussed in this section forms an immense arc of highlands embracing Mesopotamia from the Persian Gulf in the south east to the Mediterranean in the west. Although the peripheral regions are not homogenous, they are characterised by the absence of a central river system such as those found in Mesopotamia and in Egypt and by a general predominance of hills, mountains and plateaux. Ancient Anatolia, which corresponds to modern Turkey in Asia, adjoins Mesopotamia to the north and moreover the sources of the Tigris and Euphrates rivers are found in Anatolia. Syria and Palestine, which will be regarded as one unit occupy the intermediate area between Egypt and Mesopotamia; culturally the Syro-Palestinian region was influenced in turn by both of the two great civilisations of the ancient Middle East. Iran is much the largest of the peripheral countries, and although Elam in the south west was closely linked to Mesopotamia, the plateau areas of central and northern Iran often enjoyed considerable cultural independence.

In this book we are primarily concerned with the great traditions of Middle Eastern civilisation that began in the fourth millennium BC. At this time the 'Urban Revolution', as it has been called, permitted men to develop the first systems of writing and public administration. The resulting concentration of wealth stimulated the production of great works of art. Recent discoveries in Palestine, Anatolia and Iran, however, have provided spectacular evidence of the immediately preceding stage of human civilisation in the ancient Middle East; our account of the peripheral regions must therefore begin with these.

EARLY PALESTINE: JERICHO

As early as the 7th millennium BC, the Jericho settlement took on the dimensions and status of a city surrounded by a proper wall. An imposing Neolithic tower survives, containing an interior staircase giving access to the top; the tower is built of stones of considerable size, and even now measures some 26 feet high. It has been suggested that the obvious prosperity of Jericho depended principally on flourishing trade connections. Hunting and fishing could not be the basis of the growth of the city, and even if agriculture must have been practised to feed a community of two thousand people, some other source of wealth must have existed. Jericho was well placed for commercial enterprise; it commanded the resources of the Dead Sea whence such useful products as salt, bitumen and sulpher could be obtained. Obsidian, nephrite and other greenstones from Anatolia, turquoise from Sinai, and cowries from the Red Sea have been discovered at the site, which gives some indication of its probable far-reaching commercial contacts.

Apart from their advanced building techniques, the people of Jericho were accomplished sculptors. Terracotta figures have been found which show some ability, but by far the most interesting find in the field of sculpture has been the human skulls which, probably for religious

5,6

50

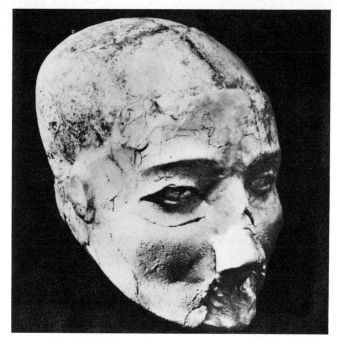

50. **Plastered skull from Jericho.** Seventh millennium BC. Amman Museum, Jordan. Ten such skulls have been discovered during excavations at Jericho. The plaster is skilfully modelled upon the skull to represent human features, and the eye sockets are set with cowrie shells. Probably relating to an ancestor cult, some of the skulls preserve traces of paint.

51. **Mother Goddess figure from Çatal Hüyük,** Anatolia. Early sixth millennium BC. Baked clay. h. 3⅝ in. (9·2 cm.). Archaeological Museum, Ankara. One of the cult figurines of the goddess of fertility found in a Neolithic shrine at Çatal Hüyük. The hair is wrapped round the back of the head. The nose and ears are in relief but the eyes indicated only by a slight hollowing of the clay. This is the earliest testimony of the cult of the Mother Goddess in Anatolia which was to continue until Roman times.

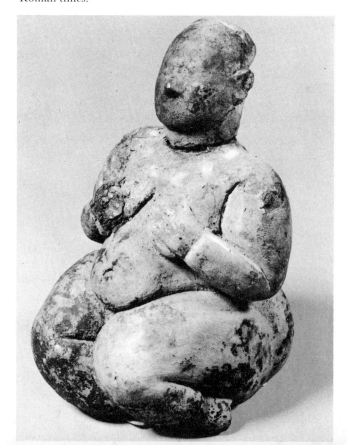

52. **Mother Goddess from Hacilar,** Anatolia. *c.* 5700–5600 BC.
Baked clay. h. 4⅛ in. (10·5 cm.). Archaeological Museum,
Ankara. Somewhat later in date than the Çatal Hüyük example
(figure 51), this figurine has pronounced thighs, buttocks and
upper arms. The eyes are incised. Terracotta figurines of this
kind were widespread in the ancient Middle East from the
Mediterranean to India.

reasons, were covered with a fine gesso to reproduce human
features. The refinement of the modelling of these heads
can only partly be explained by the underlying bone
structure; the subtle rendering of the features permits one
to regard them as true sculpture. They also give a good
idea of what the inhabitants of Jericho looked like.

EARLY ANATOLIA

Religious requirements lie behind the earliest art of Ana-
tolia, which comes from Çatal Hüyük in southern Turkey.
Here, within various stages of rebuilding, a number of
religious structures have been found the earliest of which
date from the first half of the 7th millennium BC. There are
six sanctuaries with walls decorated with reliefs and paint-
ing. The reliefs usually depict long-horned bull's heads of
various sizes and with differing degrees of stylisation. The
paintings of Çatal Hüyük which were brought to light only
recently by the English archaeologist James Mellaart are
the first known examples of Middle Eastern wall painting.
The earliest of these are mostly of geometric type, though
one should not overlook a scene showing small headless
men surrounded by enormous birds with comb-like wings.
The later paintings—dating from the late 7th millennium
—present, among other subjects, deer-hunting and dancing
scenes. Executed in red, pink and occasionally in black on
a cream pinkish-white ground, the male figures have a
surprising freedom of movement, the delicate outlines
accentuating their vitality. The female figures, however,
which are painted in white, are fleshy and heavy.

Within the sanctuaries numerous stone and terracotta
female figurines have been found chiefly representing
single figures, although a few examples are in pairs. This is
the first appearance of the typically Anatolian cult of the
Mother Goddess which was to persist until the adoption of *51*
Christianity. The goddess is shown as a young woman, a
woman giving birth to a child, or as an old woman. In some
cases the breasts are stressed, and usually there is a fullness
to the figure suggesting fecundity.

The finds at Hacilar in south-western Turkey, where the
earliest levels belong to the first half of the 6th millennium
BC, are slightly later in date, but closely parallel to those of
Çatal Hüyük. Hacilar has also yielded female figurines, *52*
often with protruding buttocks. Such figures occasionally
retaining traces of painting. But the most important
artistic discovery of Hacilar is the pottery. This is the first
appearance of ceramics in the western part of the Middle
East and it has been suggested that southern Turkey is one
of the two centres from which, in about 6000 BC, the art of
pottery was diffused throughout the ancient world. Only
future excavations can confirm or refute this hypothesis of a
double origin of ceramics—the Zagros mountains of Iran
compete with Turkey for the honour—but scholars agree
that while the ceramics of Iranian origin found their chief
area of expansion in Mesopotamia and the Syrian high-
lands, the Anatolian ceramics radiated towards the Syro-
Palestinian region and especially towards south-eastern

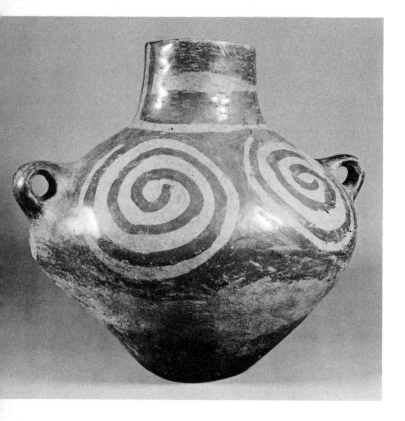

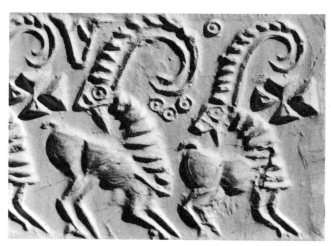

54 (above). **Proto-Elamite cylinder seal impression.**
End of the fourth millennium. British Museum, London.
These stylised goats with long curving horns are designed in a
frieze rather than confronted in the Mesopotamian manner.
Proto-Elamite motifs were imitated in Mesopotamia.

53 (left). **Terracotta jar from Hacilar.** End of the sixth
millennium BC. h. 13$\frac{3}{8}$ in. (34 cm.). Archaeological Museum,
Ankara. This jar is characteristic of the pottery of the late
Hacilar period which was decorated in white on red or red on
white. This example is painted with spirals.

Europe. The painted pottery of the Hacilar II period
(c. 5500–5300 BC), represents the climax of the ceramic art
in early Anatolia. Painted in red on a cream ground, the
patterns are geometrical combinations of spirals, triangles
or lozenges. Collar-necked vessels with tubular handles or
lugs, oval cups, and shallow dishes have been unearthed in
quantity, and a painted pot in the form of a seated goddess
survives.

EARLY IRAN

The first painted pottery of the Middle East appeared
towards the end of the 6th millennium in the easternmost
regions; at Tell-i Bakun and Tepe Siyalk on the Iranian
plateau, and at Tell Hassuna in Mesopotamia. The
diffusion of this pottery, which at first displays only a simple
geometrical decoration with bands and then adds triangles
and lozenges, proceeded from east to west. This initial
phase, was succeeded at about the beginning of the 5th
millennium by a more advanced product, the pottery of
Tepe Siyalk which parallels the Samarra pottery of Meso-
potamia already mentioned. The Iranian potters, whose
favourite forms include cups and broad beakers, began to
employ extremely stylised designs of animals, especially
birds and stags, reduced to a linear abstraction of almost
geometric type.

With pottery the Iranian and Mesopotamian figural
conventions spread westwards, reaching Syria and part of
Anatolia. This fact is of great importance because it pre-
supposes the existence of close trade and cultural relations
across a large area, as well as the adoption by diverse
peoples of the most advanced cultural forms as they were
created from time to time by more highly developed or
better organised peoples.

IRAN AND MESOPOTAMIA

In the later 4th and 3rd millennium BC Sumeria set the
pace for the cultural advance of all western Asia. Conse-
quently the arts of the various countries of the region shared
a common dependence on the art of lower Mesopotamia.
Certain areas, nevertheless achieved some originality of
feature and quality, in fact the existence of such variations
is a natural consequence of the rapid spread of a high
civilisation with an enthusiasm for bronze in vast areas that
had hardly emerged from the neolithic stage of cultural
development. In this process Sumeria provided the vital
spark—far more than Egypt, which had a more limited
sphere of influence.

To turn to a concrete example of Iran's creative depen-
dence on Mesopotamia, archaeologists have found that the
Susa 'branch' of 'Ubaid culture has a distinctive physiog-
nomy of its own. Although Susa pottery is directly linked
to the Mesopotamian 'Ubaid wares it exhibits interesting
characteristics of its own. The tall, elegant chalices and
cups are characteristic of Susa. Their decoration, which is
in brown over an opaque yellow base, comprises chiefly
very stylised animal figures (birds and stags following
normal Iranian practice), but these figures have the
particular merit of being skilfully arranged on the body of

the vase to bring a harmony to the decoration in which the abstract treatment of the figures strikes a note of unusual refinement.

It must not be forgotten, however, that in many ways Sumerian culture overlapped that of Iran, especially its western region, Elam. The prehistoric cultures of northern Mesopotamia (Tell Hassuna, Samarra, Tell Halaf) were closely linked with what was being done in Iran but this is partly true of the southern ones as well ('Ubaid, Eridu). In northern Mesopotamia, where Sumerian culture was mainly effective as an import and therefore less deeply rooted, the connections with the Iranian plateau—as well as with Anatolia—are obvious. In the south, however, where Sumerian culture arose as a native product, the extinction of earlier links with Iran created the basis for a detached dialogue between the two countries.

Thus although Mesopotamia was usually the senior partner with Iran, a give-and-take relationship appeared: politically and culturally the two countries influenced one another by turns. The big cultural break in Mesopotamia between the 'Ubaid period and the following predynastic phase had a counterpart in Elam, where the painted pottery of the Susa I style disappeared, giving way to a new phase that clearly paralleled the earliest civilisation of Sumeria. Proto-Elamite civilisation, has many traits that recall Sumeria. It too created a distinctive script, which scholars are gradually deciphering. Cylinder seals were in common use and it has been suggested that they were actually invented on the Iranian plateau. But some regions of Iran stood apart from this cultural interchange with Mesopotamia; finds at Tepe Giyan, to take one instance, prove the continuing vitality in the third millennium BC of a type of pottery derived from the Susa I ware.

PROTO-ELAMITE ART

Iranian architecture of the third millennium is practically unknown to modern archaeologists, but Proto-Elamite sculpture is represented by some pieces that merit close attention. Apart from the clay statuettes of obese nude women with stressed sexual attributes, there are some limestone sculptures—figures of women, a man with a vase, an ape—that recall the earliest works of the Sumerian protodynastic period, though they must be regarded as essentially provincial in inspiration. Several interesting pieces, however, have come to light in recent years. They represent a standing man whose head shows a certain similarity to Sumerian works, but the rest of the figure is completely different. The body looks as if it were covered with scales and the torso is clothed in a garment made up of horizontal strips. These pieces reflect an interest in the monstrous that appears again in the seals. Unfortunately these statuettes are the only ones yet discovered that represent the early stage of Elamite sculpture in an aspect that is not overshadowed by Sumerian work.

As in Mesopotamia the Iranian cylinder seals are filled with elaborate designs. In both countries the seals depict groups and rows of animals, but monstrous creatures are more typical of Iran. Proto-Elamite seals generally surpass their early Sumerian counterparts in richness of theme, suggesting a more active imagination; the monsters depicted are more grim than could be visualised by the people of the plain.

Unlike Mesopotamia, 3rd-millennium Iran produced a good deal of painted pottery. At Susa the break in continuity resulting from the disappearance of Style I was followed by a new trend, Style II, with a figural repertoire consisting mainly of birds, sometimes with comb-like wings. The Susa II Style was imitated at Tepe Giyan, where the vessels sometimes have a narrow decorated strip on the shoulder. But eastern Iran favoured a polished monochrome pottery of its own, using elegant, slender forms deriving from metalwork objects.

SUMERIAN INFLUENCES

In the second half of the third millennium the originality of Proto-Elamite art yielded to outright imitation of Sumerian models, apparently in response to the invasions of Elam by the kings of Akkad. The huge figure of the victorious king towering over his enemies, so splendidly realised in the stele of Naram-Sin, now appears in Iran, though it migrates from the stele to the monumental setting of a rocky mountainside. This is a category of art that deserves to be emphasised, for it anticipates by several millennia one of the most characteristic features of Achaemenian and Sassanian Iran. By this time it had long since been absorbed into the artistic sensibility of the peoples living on the plateau north and east of the valley of the two rivers. The rock-carved reliefs of Yazilikaya in Anatolia are another instance of the theme, this time in the west.

Sculpture in the round also points to Sumerian models, as in the statue of the goddess Inanna dedicated by King Puzur-Inshushinak (23rd century BC). Several centuries later, a pair of steles from Susa present imitations of the common Babylonian motif—seen in the Hammurabi stele—of the king before the sun god: Iran's dependence on Mesopotamian art was to continue for most of the 2nd millennium.

THE INDUS VALLEY CIVILISATION

Iranian art of the third millennium, especially in vase decoration, had a strong influence on areas farther east; the prehistoric cultures of the Indus Valley in West Pakistan, which are known to have had close trade links with the land of Sumer, have features that indicate direct or indirect borrowing from the Iranian-Mesopotamian cultural unit. An example of this is the building technique in unbaked bricks. In vase decoration—always the best available clues to the art of early civilisations—the influence of models from Iran (especially Susa, Giyan and Siyalk) can be traced at Quetta from the fourth millennium, and at Kulli, Rana Ghundai and Harappa in the third.

The cultural links between the Indus valley and the

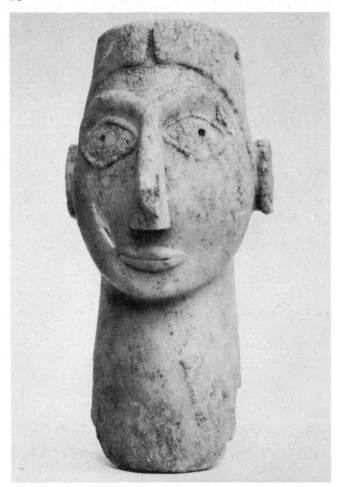

55. **Head from Tell Brak.** *c.* 3000 BC. White alabaster.
7 in. (17·8 cm.). British Museum, London. One of the earliest
known pieces of North Syrian sculpture, this head is boldly
modelled and has the prominent nose and wide eyes of the
copper figures in figure 56. Like the famous 'Lady of Warka'
(figure 8), the head is flat at the back and grooved for attachment
to a flat surface. Nevertheless it is quite independent of the
Sumerian tradition and marks the beginning of Syrian sculpture
in the round.

contemporary societies farther west were severed in the
second millennium BC by the invasion of a new people,
apparently the Indo-European-speaking Aryans, who
destroyed the Indian prehistoric civilisation. At almost the
same time other invaders, also partly Indo-European, were
shattering the states established in Iran and Mesopotamia,
thus weakening the basis of Sumerian civilisation.

SYRIA AND PALESTINE IN THE THIRD MILLENNIUM

We must now turn to an area that lies west of the centres of
civilisation that we have been discussing. In the third
millennium BC, the Syro-Palestinian region (comprising
what is now Syria, Lebanon, Israel and Jordan) had not
advanced beyond the threshold of history, even if there is
evidence of a time in the Chalcolithic period when Palestine
had a rich culture of its own (the paintings of Teleilat
Ghassul, and the ivories of Beersheba). So far as we know,
it had not even developed a script of its own. But this
does not mean that the region stood at a low level of
cultural development. The region had to withstand
political pressure coming from both Egypt and Mesopota-
mia for the rulers of those countries were attracted by the

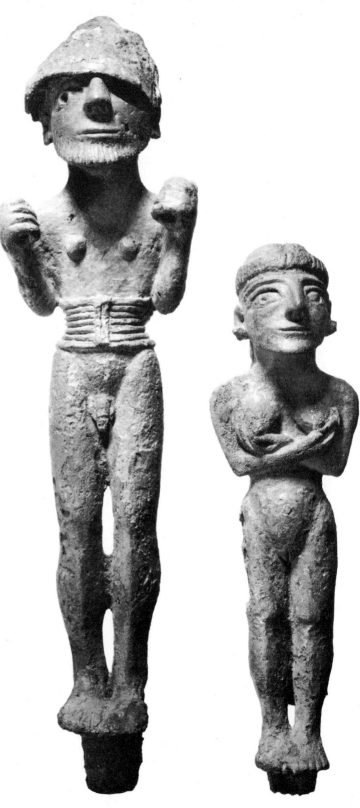

56. **Copper figures from Tell el-Judeydeh.**
c. 2900 BC. h. 7½ and 5¼ in. (19 and 13 cm.). Oriental Institute,
Chicago. Six metal statuettes were discovered at the
Tell el-Judeydeh site in northern Syria. They probably represent
worshippers. The figures clearly represent Syrian people; the
man wears the broad belt, and tall conical hat or 'helmet'.
Wide-eyed and tight-lipped, they have lively alert expressions.

57 (above). **Fragment of sculpture from Tell Mardikh.**
End of the third millennium BC. Basalt. h. 12¼ in. (31 cm.).
Aleppo Museum, Syria. This fragment, which was part of a
ritual basin, was found at Tell Mardikh in 1964, and is one of
the few surviving examples of Syrian art of the third millennium.
The recent discoveries have led archaeologists to suppose that
there flourished in Syria, particularly during the second half of
the millennium, a culture which, while owing much to Sumeria,
developed certain peculiarities of its own. This was the culture
which was introduced into Babylonia a little later by the
Amorites, and forms the springboard of Old Babylonian art.
The fragment shows the head of a mythical bull-man.

possibilities of expansion offered in Syria and Palestine.
Inhabited by various linguistic groups (including a large
proportion of the Semitic peoples conventionally termed
Canaanites), Syro-Palestine was unable to present a unified
front to the advances of the two high cultures of the period.
But these Semitic peoples were clever in selecting the
sources most useful to them. Local cultures grew up with a
pronounced flavour, but detached from both Egypt and
Mesopotamia. Although we do not yet know enough of
Syria and Palestine in the third millennium, some broad
outlines are clear. In the first half of the third millennium
Syria was in the orbit of Sumerian culture (Tell Khuera).
Shortly after the middle of the third millennium many
large towns were founded, which were then destroyed
around 2000 BC by the Amorite invasion. In the second
half of the millennium there were various phases of direct
Mesopotamian rule (first under Lugalzaggisi King of
Uruk, then Sargon, then the third dynasty of Ur). These
periods of foreign rule expose the political weakness of the
region, but they also suggest that it was economically
important enough to repay the trouble of conquest and
administration.

SYRO-PALESTINIAN SCULPTURE

The most important aspect of the art of Syria and Palestine
in the third millennium BC is sculpture. Although this
derived largely from Mesopotamia, the artists succeeded in
infusing their models with a new spirit. At Tell Brak some 55
carved stone heads have been found which show total
independence from Mesopotamian models of the con-
temporary transitional period. This originality becomes
particularly noticeable towards the middle of the millen-
nium, when the links between the two regions were
particularly close. Cities like Tell Khuera and Mari,
though belonging to Syria geographically, in practice
formed part of the larger Mesopotamian cultural orbit.
But the art of Mari cannot be entirely equated with
Sumerian taste and this suggests that they were capable of
resisting imported forms, even those of such a superior
culture as Sumeria. The statues of Mari display a liveliness, 19
a fullness and a subtle vein of humour missing from
Sumerian work. These traits, which are probably to be
associated with a sensibility that can be called 'Mediter-
ranean', recur in some reliefs recently discovered by Italian
archaeologists at Tell Mardikh, which reveal a stylistic 57

maturity hitherto unsuspected in third-millennium Syria. Previously known works, whether they follow Mesopotamian models or attempt a more independent approach are of poorer craftsmanship.

This period also saw the appearance of a variety of metal statuettes intended as votive gifts; the best examples come from Tell el-Judeydeh. Seals are of the Mesopotamian cylinder type though some stamp seals have also come to light. The geometrical designs and animals on the cylinder seals are inspired by Sumeria, but sometimes a more original design solution appears, heralding the splendid Syrian seal art of the second millennium BC.

ANATOLIA IN THE THIRD MILLENNIUM

Despite the exciting discoveries of recent years, it is not yet possible to obtain a clear general picture of civilisation in Anatolia during the third millennium. We must therefore be satisfied with observing some revealing individual factors. Archaeologists have excavated three main sites for this period: Troy in north-western Anatolia, Alaca Hüyük on the central plateau and Beycesultan near the Maeander River. The notorious complexity of the cultural map of Anatolia is apparent even at this period. While the culture of Troy is linked to the Balkan region—together with the famous jewellery from the so-called 'Treasure of Priam', Troy shows the first instances of a characteristic building with two or three successive rooms, known to Homer as the megaron—the objects found in the royal graves of Alaca Hüyük point rather towards Iran. The people of the Bronze Age city of Alaca Hüyük buried their ruling families in a series of tombs, thirteen of which have been found. The treasures in the tombs include objects of religious significance, and private possessions of the dead, such as jewellery and gold vessels. The high quality of the metalwork is surprising and so far has not adequately been explained. What is certain is that this Bronze Age people were of an advanced technology and had a sophisticated aesthetic sense. Outstanding among the finds at Alaca Hüyük are the metal 'standards', so called because they are designed to be fixed into the end of long poles. Some take the form of pierced disks decorated with flowers and birds, others are simple animal figures, a stag being a favourite subject. The figures are of bronze, occasionally inlaid with geometric patterns in silver. Jewellery found in the tombs included necklaces of gold and precious stones, bracelets and an earpendant. The obvious familiarity with metalwork technique points to a close contact with a mining area, probably the Caucasus.

Finally the discovery of marble idols at Beycesultan with marked geometrical stylisation of the female form has provided a link with a culture that was beginning to flourish in the Cycladic Islands of the Aegean Sea. Thus the cultural connections of the three main Anatolian centres of the third millennium point in three different directions.

In order to grasp the full importance of Anatolia we must remember that the routes followed by the peoples entering

58. **Lion rhyton from Kültepe.** 18th century BC. Fired clay, painted. 7 in. (17·8 cm.). Louvre, Paris. This vessel, found at the Assyrian trading settlement of Kültepe, is an example of 'Cappadocian' ware. It was probably intended for a ritual libation ceremony and is decorated in black on a grey slip with lively patterns. The spout is at the back of the lion's open mouth.

Anatolia from the east did not follow the path of the Mesopotamian plain, but crossed over the uplands moving north of Mesopotamia from east to west. This explains why Anatolia shares many cultural features with Iran that are closely connected with Central Asia and especially with southern Russia. As early as the third millennium some decorated vases found at Maikop (the Kuban region north of the Caucasus) show a combination of Anatolian elements with others that seems to foreshadow the 'animal style' of the Scythians.

Another aspect of Anatolia's importance lies in its role as transmittor of civilisation to the west. Not only did Cycladic civilisation derive from Anatolia, but that of Crete and the Maltese Tarxien probably owed much to Anatolia in their formative periods. Indeed all the bronze and iron age cultures of Europe may be traced across the Aegean to Anatolia. Small groups of well-organised adventurers attracted westwards from Anatolia by the lure of farm land and mines, took with them skills of pottery and metalwork. The Aegean and Anatolian example lies behind such Italian mainland cultures as Remedello, Rinaldone, Gaudo, and Conelle, the Sicilian Serraferlicchio, Castelluccio and Piano Conte, the Sardinian

Anghelu Ruju and San Michele, and the Iberian culture of Almeria. This is abundantly proved by the vase shapes, 31 (such as that found at Conelle), the collective chamber tombs, and the use of such symbols as horns and the double spiral.

THE RISE OF THE MOUNTAIN PEOPLES IN THE SECOND MILLENNIUM

While southern Mesopotamia, Elam and to some extent the Syro-Palestinian region were heirs of Sumerian culture in the first half of the second millennium BC, much of western Asia was developing along different lines, owing to the appearance of new peoples. During the last centuries of the third millennium and the first centuries of the second new and dynamic ethnic groups entered the area from the east and north-east. Not especially numerous but well organised, they settled in areas where old cultures had flourished: first the Hurrians in northern Mesopotamia and Syria pushing the Hyksos into Palestine and Egypt, then the Kassites in southern Mesopotamia and the Hittites in Anatolia. All these peoples, though differing a good deal in language and culture, shared elements in common: the use of the horse and of the war chariot, and a refined metalwork technique. All settled in the highlands and for this reason some modern scholars refer to them collectively as the 'mountain peoples'. Unlike the Gutians and the Semitic Amorites who preceded them, these peoples not only disturbed the political and cultural life of the regions into which they came, but historically were to bring a new direction and unity to the civilisation of the ancient Middle East.

THE HITTITE CIVILISATION

The Hittites, 'the sons of Heth' as the Old Testament called them, have been the subject of conjecture and controversy since the first archeological discoveries of the nineteenth century. At the height of their power they possessed one of the strongest empires in the ancient world, even challenging the might of Egypt. Yet in spite of the documents we now possess, the numerous clay tablets discovered in their capital city Hattusas (modern Boghazköy), little is known of their early history. It is assumed that they entered Anatolia in stages, gradually assuming overlordship over successive areas. Certainly they did not sweep across the country in one dramatic mass migration. It also seems clear that they did not impose a ready-made culture on a subject people, and indeed took over some local beliefs and practices.

If the historical circumstances surrounding the Hittite settlement in Anatolia, and the characteristics of the art of that period are not yet fully understood, certain aspects at least have been clarified. At the end of the third millennium, and the beginning of the second, for example, much of Anatolia was producing a particular type of pottery characterised by tall, tapering forms with beak-like spouts, with a brownish-pink surface. This pottery, known as Alishar II ware, seems to be connected with a culture in 30 northern Anatolia; it later acquired, as 'Cappadocian ware', a decoration of painted geometric forms, sometimes with the addition of animals. This is the culture which was 58 encountered at the beginning of the second millennium by a colony of Assyrian merchants at Kültepe in central Anatolia. At this period, too, clay vessels were made in the shape of animals, which, though less sophisticated to our eyes than the elegant Alishar II beakers, have a charming naturalistic quality. In the south of the country a somewhat different culture existed. Finds at Beycesultan again point to the fact that at this period the Hittites had not drawn the country into their cultural web, for the pottery is again different in style. A sanctuary and a large palace of Syrian type discovered there also show originality. As has been suggested, little survives from this first phase of Hittite art. But when the empire emerged with its capital at Hattusas towards the end of the 18th century BC, its craftsmen could clearly draw on an established art tradition, fusing motifs of local origin with impulses from Mesopotamia which reached them via Syria, and so brought in their train Egyptian elements.

The art of the New Empire (c. 1450–1190 BC), when the Hittite domination spread rapidly over Anatolia and much of Syria (where it came in contact with an expanding Egypt), is better known. But since the important remains are limited to three centres—the capital, Hattusas, still being excavated; the open-air sanctuary of Yazilikaya nearby; and the walls of the city of Alaca Hüyük—it is not yet possible to trace a direct line of artistic development. Thus 'Hittite art' for us means an assortment of works, some of them very fine indeed, but not linked in an organic series.

HITTITE ARCHITECTURE AND SCULPTURE

If it were true to say that Hittite art finds its most eloquent expression in architecture, it would also be misleading. Architecture for the Hittites was not merely the practical task of establishing the limits to a building or a city, it was also sculpture, and the reliefs and figures which enliven their walls and palaces form an indissoluble part of those buildings. This fusion of the two arts is an original Hittite contribution which they were to pass on first to Syria, and then to the Assyrian world.

The five buildings excavated in Hattusas and generally 32 identified as temples give some idea of the variety and inventiveness of Hittite planning. But to study monumental architecture, we must turn to the walls of Hattusas and Alaca Hüyük. Built of huge blocks of stone, these walls reveal an excellent understanding of military strategy. The gates, which are of the *tenaille* type especially suited to defensive purposes are most characteristic; they consist of enormous stone blocks forming an entrance on a parabolic plan. The entrances are flanked by reliefs intended to ward 33,34 off evil forces (this feature perhaps reflects a Mesopotamian 35,36 precedent), and for a certain distance on either side of the

59a, b. The Warrior Gate, Hattusas. 14th century BC.
h. 78¾ in. (200 cm.). Archaeological Museum, Ankara.
The Warrior, or King's Gate guarded the eastern entrance to
the Hittite capital city of Hattusas. The figure of a god protector
is carved in high relief, projecting so far that the head is about
three-quarters modelled. The curious mixture of profile and
frontal view is disturbing in that it produces ambiguities, such
as in the slanting of the battle axe which appears to be bending
inwards at the waist. In *(b)* the gate jamb is shown *in situ*,
skilfully interlocking the masonry walls. The sculpture has now
been removed to the Ankara Museum.

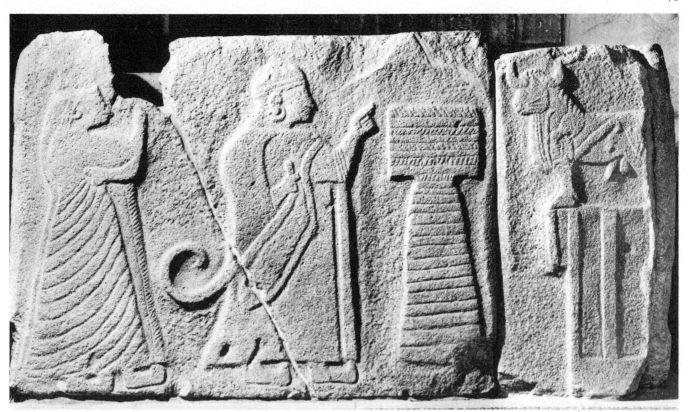

60. **A king and queen making a libation before a bull.**
Orthostat relief from Alaca Hüyük. 14th century BC. Basalt.
h. 49⅝ in. (126 cm.). Archaeological Museum. Ankara. This
relief faced one of the towers protecting the Sphinx Gate at
Alaca Hüyük (see plates 35, 36). The figures are in low relief,
standing flat against a background which has been chiselled
away, and the details of the garments are incised rather than
modelled. The king wears the robes of a priest—the long cloak,
curving staff and shallow cap. From the point of view of quality
this relief is only an echo of the court art of Hattusas, where the
ablest craftsmen were at work.

gates the lower part of the outer face of the wall is decorated
with slabs carved in low relief. This enlivenment of the
plain stone faces with a sculptural frieze recurs later in
typical Syro-Hittite work, in which the lower part of the
wall is also made up of sculptured orthostats. (Still later the
practice was to be re-echoed in the Greco-Oriental trend
seen in the sculptured lower drums of the columns of the
temple of Artemis at Ephesus). The reliefs found at the sides
of the Hittite gates show a limited range of subjects:
sphinxes (Hattusas and Alaca); lions and a warrior god
(Hattusas). These figures carved out of great blocks of
stone seem to spring out of the rock at the observer. It is
tempting to seek for Egyptian or Mesopotamian precedents
for figures; certainly there were some, but they provided
only a starting point, which the Hittites transformed to
express a totally new idea.

To illustrate this new sculptural departure, let us
examine the figure of the warrior god carved in low relief
on a jamb of the King's Gate at Hattusas. The figure,
helmeted and wearing a short kilt, is depicted in profile, but
the bust is turned around to a frontal position following a
principle often found in the ancient Middle East. It is
interesting to observe how the artist has dealt with the
abrupt transition of planes; the handle of the axe appears
strangely curved, as does the short sword inserted in the
belt. Such distortions are to be explained, not by the
peculiar shape of the Hittite weapons, but by the artist's
rather naive effort to bind together the two separate aspects
of the body, the frontal and the profile. In the front view the
axe blade and the hilt of the sword are naturally placed in a
plane parallel to that of the bust. Their continuation, how-
ever, if straight, would have suggested that the axe and the
sword were held in an almost vertical position, rather than
an oblique one. For this reason in the lower sections the
weapons take on the position that is required by the profile
position, so that their form appears bent to the observer.
Finally, one notes how the blade of the sword appears
turned forward, rather than being hidden by the figure as
would be more logical.

Carved on the rock face of an open-air sanctuary not far
from the capital, the reliefs of Yazilikaya depict rows of
gods, usually standing on animals and accompanied by
religious symbols. Sometimes a king appears with a god
shown to larger scale. Apart from their formal interest, the
reliefs of Yazilikaya have value as documents for the
understanding of the Hittite aesthetic. Here again the rock
face is divided and brought into focus by the sculptural
strips which embellish it.

The last group of sculpture from the Hittite New Empire
consists of a series of orthostats with relief decoration from
Alaca Hüyük, where they decorated the lower part of walls
beside the Gate of the Sphinxes. Royal hunting scenes and
sacrifices are shown: the relief is low and without internal
modelling, the details being indicated by mere lines. But

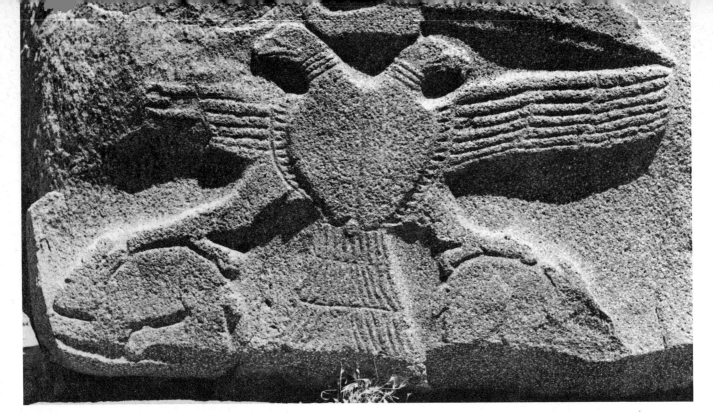

61. **Double-headed eagle gripping two hares.** Relief from the side of the Sphinx Gate at Alaca Hüyük. 14th century BC. At Alaca Hüyük a number of artistic streams meet. The sphinx itself is of Egyptian origin though it has acquired a Syrian character in the rendering of the headdress. The double-headed eagle on the inside of the gate is a Sumerian motif. It is carved in the same technique as the orthostat of figure 60.

they have considerable documentary value. In their originality it is clear, on the one hand, that this kind of art was peculiar to Anatolia, and on the other, that these works must have been created by drawing on lost models, perhaps located in the Hittite capital of Hattusas. More important, they pave the way for the reliefs to be found later in the North Syrian sites of Carchemish, Malatya and Zincirli, and perhaps also in Assyria.

MITANNI

Towards the middle of the second millennium the powerful kingdom of Mitanni arose, adjoining Assyria to the northwest. Mitanni was the only state created by the Hurrians. The political domination exercised by Mitanni over Assyria brought with it considerable cultural influence, more evident in later effects than in immediate impact. While we know little of the art of Mitanni—the Mitannian capital of Washukkanni, together with Agade, is the only great city of the ancient Middle East that has not been located—we can recognise that when Assyrian art had begun to flourish about the 14th century it appears essentially separate from the southern Sumerian and Babylonian tradition. On the other hand, the links connecting the new Assyrian art with the western culture complex, or rather with the complex of the mountain peoples, (who were also found to the east), are unmistakeable. It would fly in the face of the historical evidence to deny that the source of the new cultural status of Assyria lay in the political and cultural tutelage imposed by the Hurrite Mitannians.

At present the characteristic elements of Mitannian art emerge most clearly in craft work: pottery and seals. The pottery is unique in western Asia during the historical period. After a long predominance of monochrome wares, with only occasional geometric decoration, various sites in Syria—from Alalakh to Nuzi—yield a pottery decorated with elegant white motifs on a black background. There are bands of spirals, rosettes, stylised birds, and geometric motifs: occasionally these are supplemented by more ambitious compositions of elegant plants. The origin of this pottery, which fuses a Syrian and Anatolian repertory of motifs with other elements evidently derived from the Aegean, poses a serious problem, for the Minoan models that seem to lie at the root of this development had gone out of use several centuries before the appearance of the Mitannian pottery.

In contrast with the Hittite Empire, where the stamp seal predominates, Mitanni adopted the Mesopotamian cylinder seal. Mitannian seals show several original motifs; the repertoire consists mainly of griffins, winged animals, sacred pillars, stylised trees of life, winged disks and

(Continued on page 97)

44 (opposite). **Silver plate from the Ziwiye treasure.** Late 7th century BC. Diameter *c.* 14 in. (35 cm.). Archaeological Museum, Teheran. This engraved silver plate was found in a hoard of gold and silver objects near Sakkiz in Iranian Azerbaijan. The three animal motifs arranged in concentric circles are typically Scythian; the stylised bird of prey with its curved beak, the running hare, and the lynx-like creatures which are either shown on all fours or in an upright position in opposed pairs. The lynx and the hare appear on other objects from the same treasure.

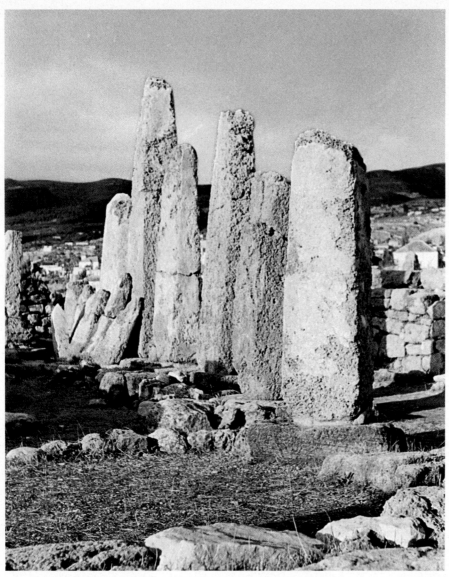

45 (left). **Obelisk temple at Byblos.**
46 (below). **Ruins at Byblos.** The port of Byblos came into prominence as early as 2700 BC, as the principal town to export the cedarwood from the Lebanon. At the beginning of the second millennium, under the resourceful kings of the Twelfth Dynasty, Byblos virtually became a vassal state of Egypt. From 2000 to 1800 BC fine examples of Egyptian craftsmanship entered Syria and exerted a strong influence over the local metalworkers and sculptors. Gifts from the Pharaohs have been found in the tombs of the Byblite kings. The obelisk temple which dates from about 1900 BC clearly derives from Egyptian example. This also was dedicated to the sun god, but at Byblos the obelisks were erected in lines within a rectangular enclosure, which was not the practice in Egypt.

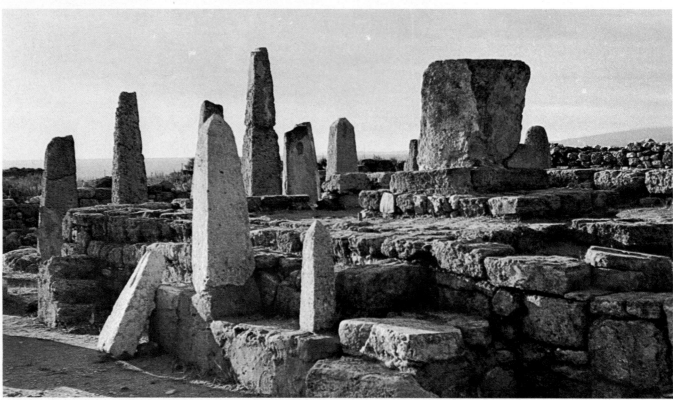

47. **Terracotta plaque from Kish.**
Old Babylonian. *c.* 1800 BC. h. 4 in.
(10 cm.). Ashmolean Museum, Oxford.
This relief shows a bearded god holding
a sceptre in each hand. Many terracotta
figures and plaques were produced at this
period showing musicians, mythological
figures, and gods. Such objects were
probably associated with folk cults.

48 (below). **Lioness attacking an Ethiopian boy in a papyrus grove.** Last quarter of the 8th century BC. Ivory overlaid with gold, and encrusted with lapis lazuli and cornelian. h. 4 in. (10·2 cm.). British Museum, London. This ivory was found, with others, in the palace of Assurnasirpal at Nimrud. It is one of a pair, thought to have decorated a piece of furniture. Phoenician and Syrian ivories were exported and have been found over a large area. This exquisite ornament is one of the finest examples of Phoenician workmanship, and is unusual in its naturalistic rendering of a narrative scene.

49 (opposite). **Ivory panel from Nimrud.** Syrian. 9th–8th century BC. h. *c.* 4 in. (10 cm.). This ivory was found in the North-West palace of Nimrud, together with a number of other pieces which seem to have been parts of a single decorative scheme. The beardless youth, clad in a costume based on that of the Egyptian kings, grasps the stalk of a tree formed by a giant lotus flower. The right hand is raised in adoration to the sacred tree.

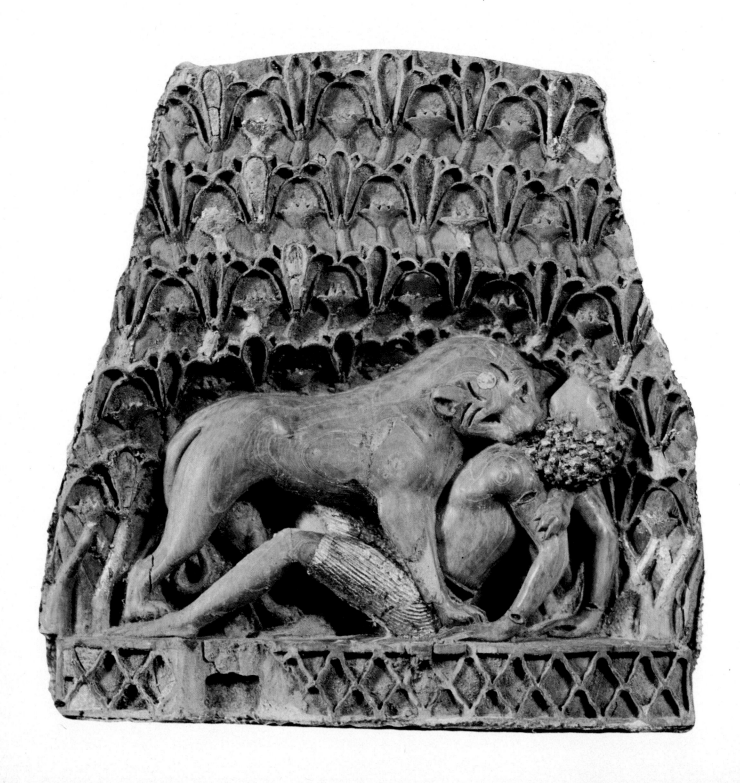

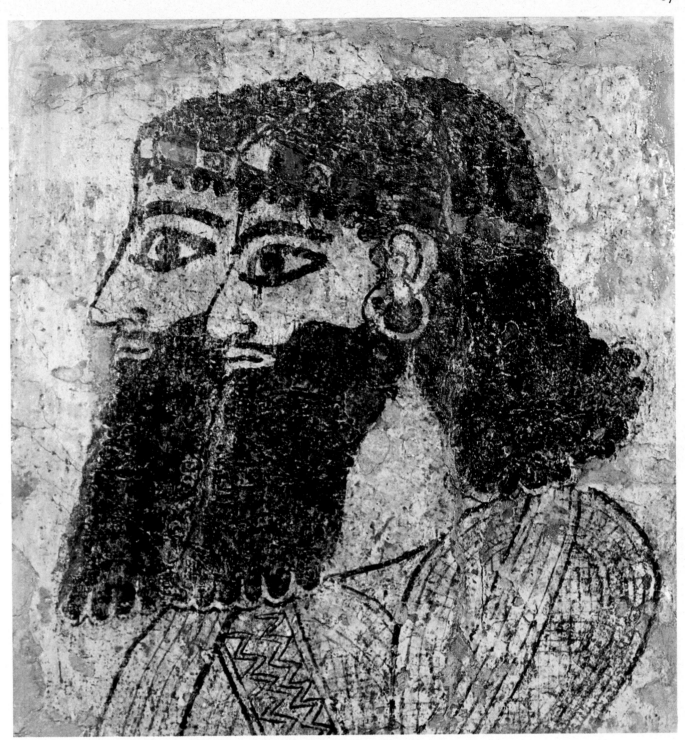

50 (opposite). **Warship with oarsmen and warriors.**

51 (above). **Two official dignitaries.** Neo-Assyrian. Probably reign of Tiglath-pilesar III (744–727 BC). Painting on plaster. 29¾ in. (75·6 cm.). Aleppo Museum. These fragments of painting were found in the palace of the governor at Til Barsip on the Euphrates. The left-hand fragment depicts a sea battle, the boat being rowed with long oars. One figure can clearly be seen at the helm, while above another helmeted and bearded warrior stands at the look-out. On the right two official dignitaries are shown in profile. They are dressed in formal court apparel with headbands, earrings and embroidered robes. The painted heads with the thick black outlines make a powerful pattern against the whitish background.

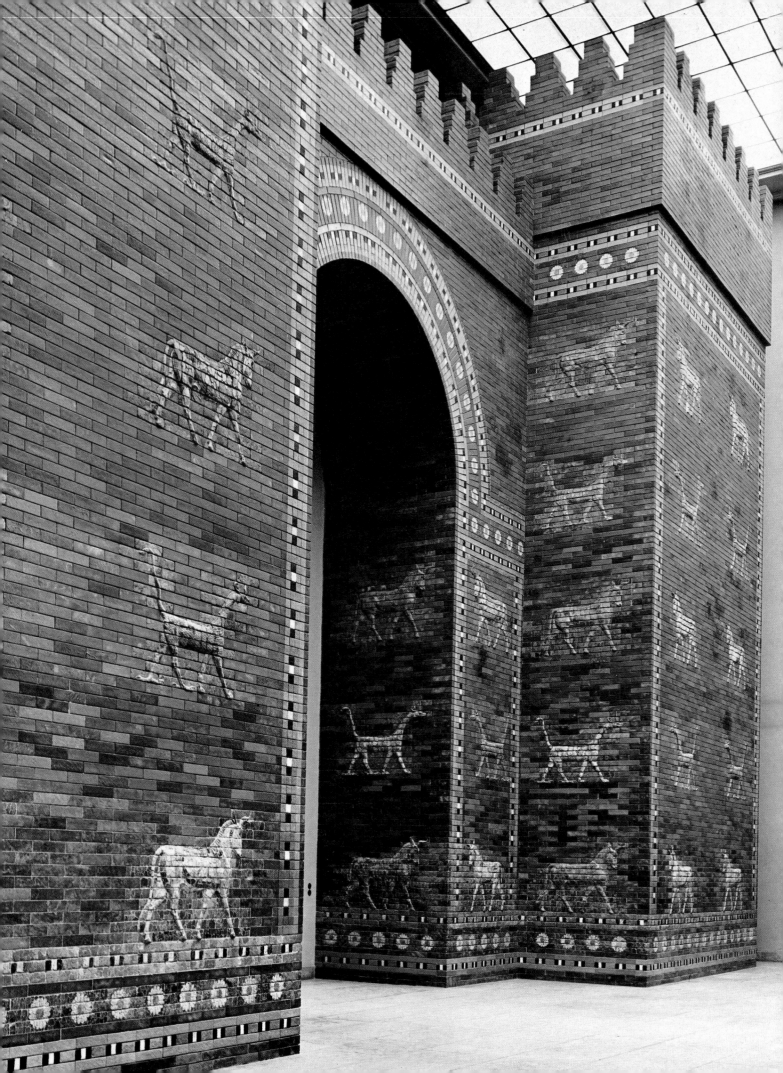

52 (opposite). **The Ishtar Gate, Babylon.** Glazed brick. 47 ft. (14.30 m.). 53 (below). **Detail from the façade of the throne room at the palace of Babylon: polychrome lion.** Reign of Nebuchadnezzar II, (604–562 BC). Staatliche Museen zu Berlin. The main gates into Babylon and the side walls of the Processional Way were faced with glazed bricks in rich colours. The heraldic animals were first modelled on a rectangular panel of clay. While still soft, the panel was cut up into separate small bricks, which were glazed, fired and then reassembled on the façade. The great crenellated walls must have presented a dazzling sight; the technique so impressed the Achaemenians that they imported Babylonian craftsmen to produce similar effects on the walls of Susa.

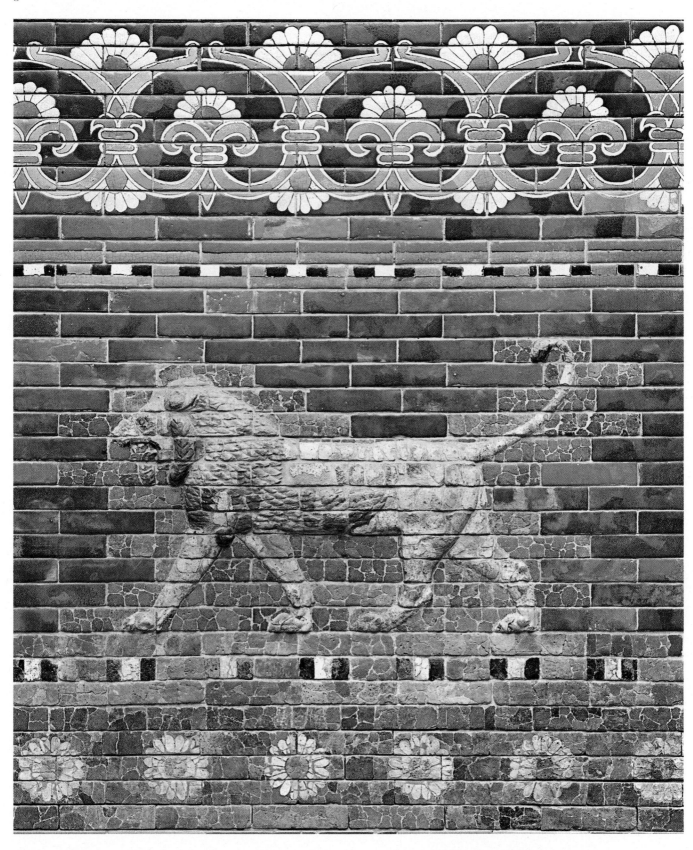

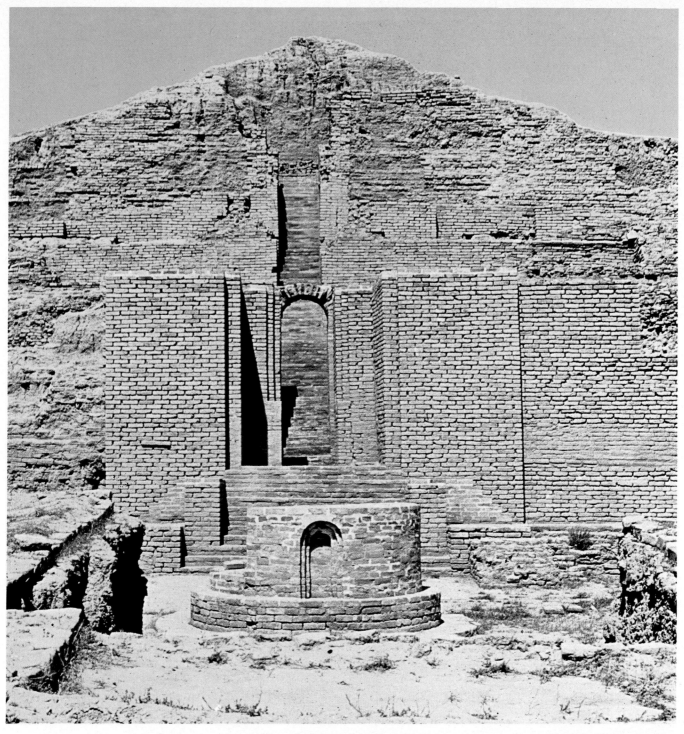

54 (above). **The Ziggurat of Choga Zambil.** 13th century BC. The eastern-most example of this typically Mesopotamian structure, the ziggurat at Choga Zambil dates from the 13th century BC, and was probably built by King Untash-Khuban. His capital city (ancient Dur Untashi, 'city of Untash') lay in western Iran, not far from Susa. This ziggurat is one of the best preserved examples; three of the original five staircases remain.

55 (opposite). **View of Persepolis from the Gate-House of Xerxes.** 518–460 BC. Entrance to the city was by a gate-house which was guarded on the inner side by a pair of human-headed bulls. In the middle foreground is the staircase leading to the audience hall of Darius I, the columns of which still stand. Beyond is the palace of Darius (see plate 57).

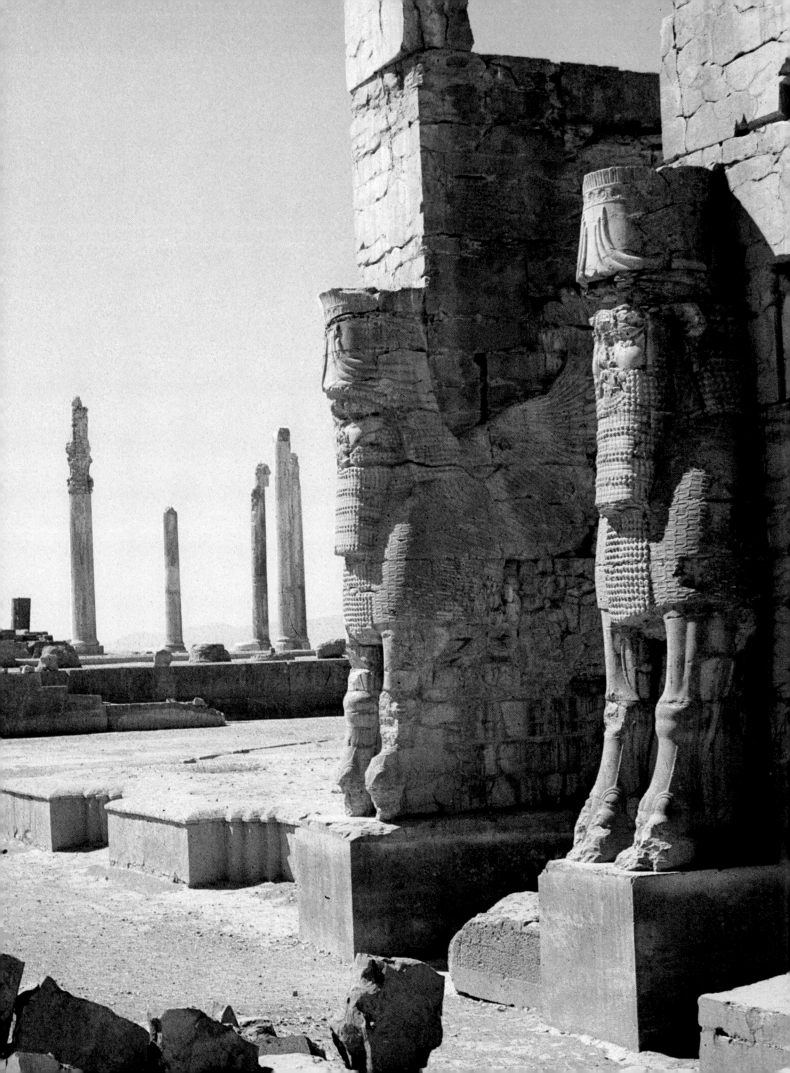

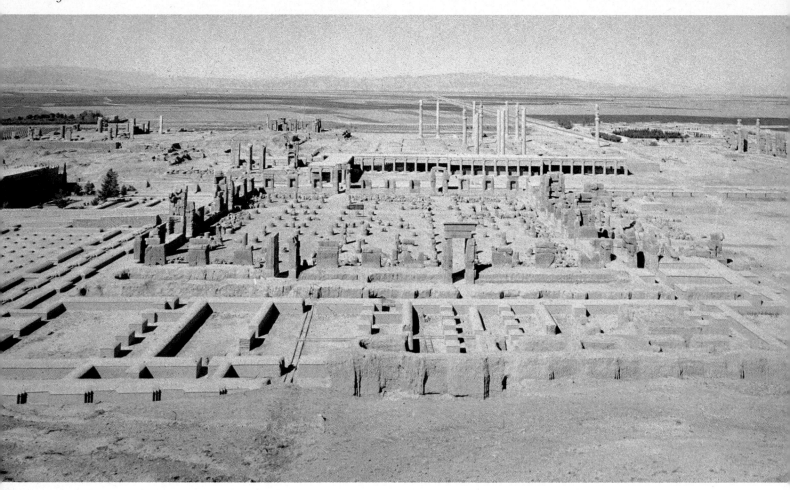

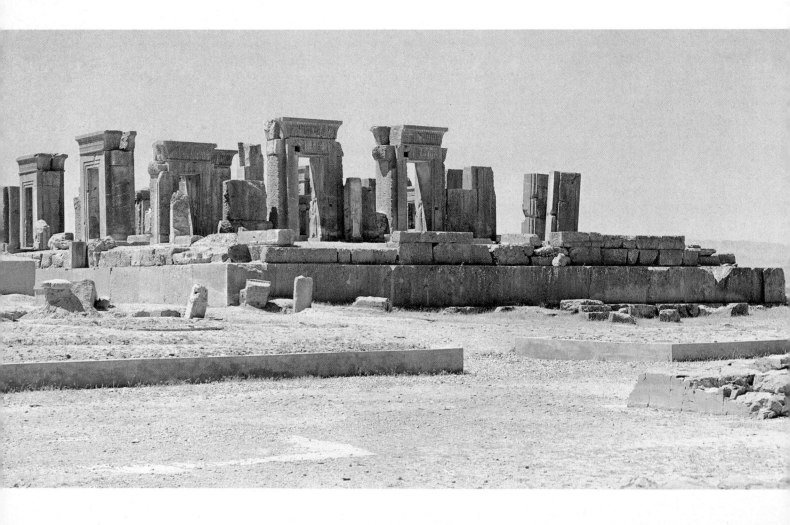

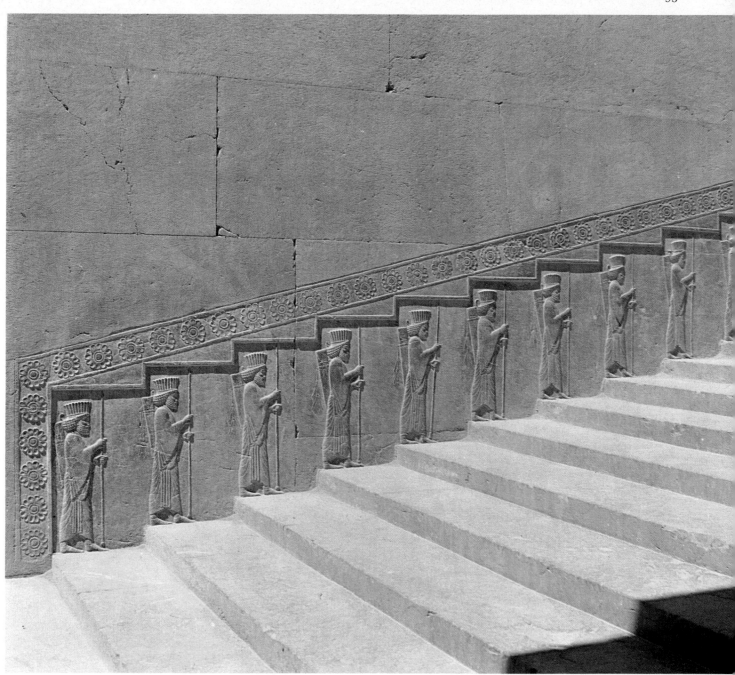

56 (opposite, above). **General view of Persepolis.** The city of Persepolis was built during the reigns of three successive kings, Darius I, who began it in 518 BC, through the reign of Xerxes and into that of Artaxerxes I, *c.* 460 BC. It was constructed on an artificial platform bordered to the north and east by mountains. In this view, looking north-west, the Throne Hall of Xerxes (the Hall of a Hundred Columns) is in the middle distance, and to the left the columns of the Audience Hall can be seen behind the palace of Darius.

57 (opposite, below). **The Palace of Darius, Persepolis.** The massive door and window frames of the palace are well preserved. They are constructed not of four separate pieces as in Egypt and Greece, but were carved sometimes from a single block of stone or even of unequal parts, three-quarters of the rectangular frame being in one piece, completed by a further block. The brick walls have now disappeared.

58 (above). **Detail from the staircase leading to the Audience Hall of Darius I.** 518–460 BC. This great staircase is entirely faced with reliefs, showing long lines of 'immortals', foreign tribute bearers, courtiers, and other dignitaries. The object of the decoration was on the one hand to demonstrate the power of the king, and on the other to indicate the diversity of people who comprised the empire. Darius employed Ionian craftsmen to carve the reliefs at Persepolis, which have nevertheless acquired a certain oriental stiffness. The narrative incidentals of Assyrian relief carving are absent, and the figures appear almost frozen into immobility.

59. **Ivory plaque from the Ziwiye treasure.** 9th–8th century BC. h. 5⅞ in. (15·2 cm.). Archaeological Museum, Teheran. This plaque, which is Assyrian in style if not in workmanship, is divided into three registers. In the upper part a man fights with a lion. In the second register three typically Assyrian bearded figures follow one another in procession, and in the lower damaged part is a struggle between a man and a bull. The plaque is part of the large treasure found in Iranian Azerbaijan, near Sakkiz, which also included the silver plate illustrated as plate 44.

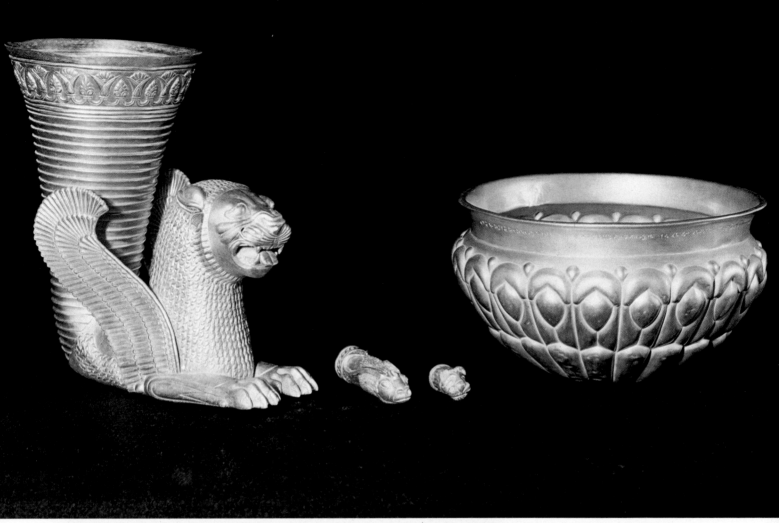

60 (above). **Rhyton cup, bowl and finials from an unlocated Achaemenian treasure.** 5th century BC. Gold. Archaeological Museum, Teheran. In all the Persian metalwork one notices a particular fondness for the animal form, and a skilful adaptation of the form for decorative uses. This exquisite winged-lion rhyton, discovered only in 1955, is one of the finest examples of Achaemenian metalwork. The gold bowl bears a cuneiform inscription round the rim which confirms its royal provenance.

61 (left). **Cup from Hasanlu, Iranian Azerbaijan.** *c.* 900 BC. Gold. Archaeological Museum, Teheran. Part of the 'treasure of Hasanlu', this gold repoussé cup, although showing some Assyrian influence, is profoundly original in its decoration. A whole series of mythological episodes are represented which as yet cannot be explained. The cup is thought to be Scythian.

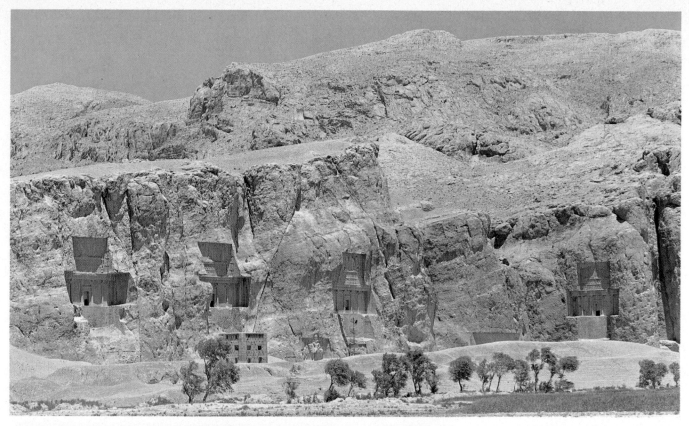

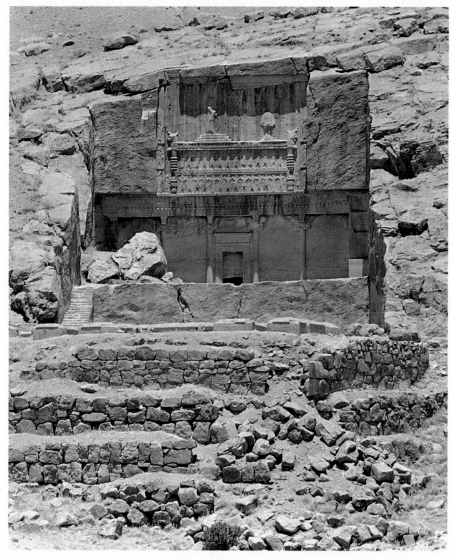

62 (above). **Achaemenian tombs at Naqsh-i-Rustam, near Persepolis.**
63 (left). **Tomb of Artaxerxes II.**
From the time of Darius, all the Achaemenian kings were buried in rock-cut sepulchres at Naqsh-i-Rustam near Persepolis. There are four similar tombs. The façades, approximately sixty feet wide, are each faced with four columns, with a central doorway. Above the entrance is a frieze with two rows of figures. Surmounting this is the figure of the king standing before an altar. Near the tombs is a fire temple consisting of a small square tower with a single room. The Achaemenians are said not to have built imposing temples for public worship although three single-roomed sanctuaries survive, of which the Naqsh-i-Rustam fire temple is one, and a temple has recently been found in eastern Iran. It seems that they worshipped their god Ahura Mazda in the open air, for the altars known to us are in the country, some distance away from city or shrine.

palmettes. There are also some figural scenes such as that of the slaying of the demon Humbaba, a motif known in Mesopotamia as early as the third millennium and which returns later in a relief from Tell Halaf. In composition a pyramidal arrangement is often favoured.

Outside the field of the minor arts, Mitanni has left few remains: a piece of wall painting from Nuzi shows metopes with alternating palmettes, bulls' heads, and a female head motif (possibly derived from the common Egyptian Hathor type); and terracotta sculpture representing animals, or vases with human faces.

THE IRANIAN REVIVAL

In the Iranian plateau, or at least its western part, the second half of the second millennium witnessed a political and cultural revival. The most important architectural remains of this period have been found at Dur-Untashi (modern Choga Zambil), a city founded in the vicinity of Susa by the Elamite king Untash-Khuban. Apart from a sacred area with the remains of four small temples, archaeologists have found a huge five-stage ziggurat. This is the easternmost example of this type of monument and probably the best preserved. In structure, however, it differs considerably from its Mesopotamian counterparts, notably in the fact that access was internal. Susa has yielded terracotta relief work similar to that seen in the Kassite temple of Karaindash at Uruk. The relief figures, however, spread out over a more extended surface, while the recessions in the wall are slight. Also noteworthy is the presence of a closely packed inscription in a band over the relief. This shows how far script had progressed at this period to become an integral part of the composition. It is instructive to know that when the Elamite king Shutrukna-khunte modified the stele of Naram-Sin, which had been caried off to Susa as a spoil of war, he added an elegant inscription along the mountain depicted before the Akkadian king. A group of statues suggests the existence of an excellent local tradition of metalwork, which may also go back to Mesopotamia. Among these the masterpiece is the headless figure of Queen Napirasu, consort of Untash-Khuban. The skirt of the figure is covered with a closely packed Elamite inscription again pointing to the decorative use of script in works of art.

SYRIA AND PALESTINE IN THE SECOND MILLENNIUM

During the earlier part of the second millennium, Syria escaped almost unscathed from the cultural shifts caused by the movement of the mountain peoples. This is surprising, for these peoples were ultimately to found a state there. In this period Syrian art continued the policy it had followed in the second half of the third millennium, borrowing and reworking the motifs imported from Mesopotamia. Since Mesopotamian culture underwent a steady decline in the first half of the second millennium, Syrian work, especially seal carving, often surpassed its models.

62. **Mitanni cylinder seal impression.** 14th century BC. British Museum, London. The Hurrians, who settled in the northern Syrian plains, were newcomers to the ethnic complex, like the Hittites in Anatolia and the Kassites in Babylonia. Their rulers were Indo-Europeans who founded the state of Mitanni. They did not develop a distinguishable art of their own, although certain elements are recognisable on their seals and pottery. This seal is divided into two registers, but the composition is freer, the motifs not being bound closely by the space which surrounds them. Typical Mitannian elements are the sacred tree, the griffin, and the pillar of life. The guilloche is Syrian.

63. **Statue of Queen Napirasu from Susa.** Middle Elamite. Mid-13th century BC. Bronze. 4 ft. 2¾ in. (129 cm.). Louvre, Paris. This magnificent bronze statue is the finest surviving example of Elamite metalwork. The figure was cast in two stages: first an outer shell about 1¼ in. thick was made which was then filled with metal. The inscription on the skirt gives the name of the subject, who was the wife of King Untash-Khuban. A curse threatens anyone who attempts to destroy or steal the statue. This work exemplifies the high standards of metalwork of the period. It was probably as a result of Elamite influence that the most important statues of gods in first-millennium Babylonia were cast in metal—bronze or gold.

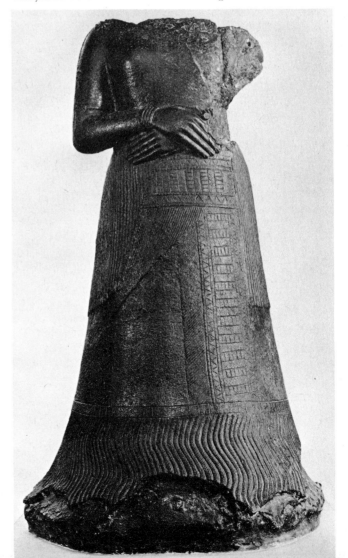

Historically, this means that the destruction of many cities by the invasion of the Amorites in about 2000 BC failed to halt the development of Syrian civilisation. Once the Amorites were established in the surviving cities they were quite content to adopt a superior civilisation. The craftsmen could carry on as before under their new patrons.

SYRO-PALESTINIAN ARCHITECTURE

In trying to understand the cultural position of Syria and Palestine we must bear in mind that one of the fields in which independence from neighbouring civilisations is most evident is architecture, the art most closely linked to local geographical conditions and consequently best placed to resist foreign pressures. Of interest are three Palestinian buildings of the third millennium BC of uncertain use found at Tel Gat, Ay and Megiddo. The first two possess a room articulated with regularly placed piers, preceded by a big courtyard. At Alalakh on the northern coast of Syria, the remains of a palace of the beginning of the second millennium BC have been discovered, with large brick columns that reflect Mesopotamian practice and, what is more important, a typically Syrian temple. Comparison with a small clay model discovered at Tell Sulaymiyya suggests that the temple consisted of a fore-structure with altar and staircase followed by a cella or sanctuary placed several yards higher. If this reconstruction is correct we have a building that is not paralleled in any other region of the ancient Middle East.

The architecture of Syria continued to display marked originality. The most important building of this period, the palace of Yarim-Lim at Alalakh (18th century BC), is quite different from the roughly contemporary and larger palace of Mari. A courtyard divides the Alalakh palace into two wings, one intended for official use with large regular rooms, the other containing the living quarters. The domestic wing had a second storey with wooden columns standing on basalt bases. This palace ranks as the first example of a kind of princely dwelling that was typical of Syrian architecture, and was later to be taken over by the Assyrian kings. The essential feature is the *hilani*, a broad audience hall, with columns at the entrance, opening into a large antechamber. Orthostats revet the lower part of the walls of the more important rooms, just as in the later Hittite and Assyrian buildings. It is interesting to note that in some respects the palace of Yarim-Lim recalls the palaces of Beycesultan in Anatolia and those of Minoan Crete.

Syrian religious architecture of this period is represented by several temples. Three examples at Ugarit consist of a courtyard with an altar from which one passes successively **46** into a pronaos and cella. A temple in Byblos has two courtyards, one behind the other, of which the second is higher **45** and contains the cella and many obelisks of different sizes. Another temple at Byblos, which survived intact into Roman times, comprised three consecutive rooms, preceded by a courtyard containing colossal statues of seated gods together with kings shown in the attitude of an Egyptian pharaoh.

The architecture of Palestine presents a somewhat different picture. Egyptian hegemony rules out royal palaces such as that at Alalakh. Nonetheless, a number of cities, including Jericho, Shechem, Megiddo and Tell Beyt Mirsim, had princely dwellings that amounted to enlarged versions of the local private houses. More characteristic of Palestine, however, are the city walls whose outer face is sloped, while the *tenaille* gates recall those of the Hittite **59** empire.

Turning to the second half of the second millennium, the most important building is the Syrian palace of Niqmepa at Alalakh (late 15th century). It follows the type of the earlier palace of Yarim-Lim with some changes: a staircase leads up to the porticoed entrance from which one proceeds immediately to the interior of the palace. The plan of the building is regularised so that it becomes almost square with a predominance of large, wide rooms. This palace represents an intermediary stage between the Yarim-Lim palace and the *hilani* characteristic of the first millennium. In a second phase of construction the palace was enlarged through the addition of a second wing on the east side and a row of rooms on the north side. Unlike the Mari palace where the later enlargements are not at first evident, Niqmepa's palace segregates the added parts by giving them their own perimeter walls even where they adjoin the earlier construction.

Religious buildings are numerous and varied in this period. A temple at Alalakh has rooms that are broader than they are deep just as in the contemporary palace of Niqmepa. The Alalakh temple resembles the earliest temple at Byblos in having three consecutive rooms, but the forecourt is missing. With minor alterations this type persists for a long time. In Palestine the temple at Lachish reflects the shift from the archaic type, which has a rectangular room with central piers and the entrance on the long side, to a new scheme probably inspired by Egyptian models: a square room with central piers opens onto a small sanctuary placed slightly off axis. Similar temples were built at Beth Shean by order of the pharaohs Amenhotep III and Ramesses II.

SYRIAN SCULPTURE

The development of Syrian sculpture in the second millennium reflects clearly the special position occupied by the region's art. In the third millennium Syrian sculpture had either depended more or less upon Sumerian art (works from Mari and Tell Khuera) or else, while showing some independence, was of poor quality. In such a vital artistic milieu one would expect either that an accomplished independent style would be developed within the framework of a figural art of Sumerian type, or that a local and independent growth would acquire a finesse of its own. Of these two possibilities only the first was fully realised, as is shown, for example, in seal carving. Except when they **68**

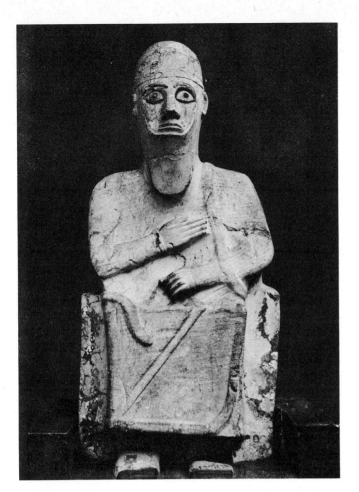

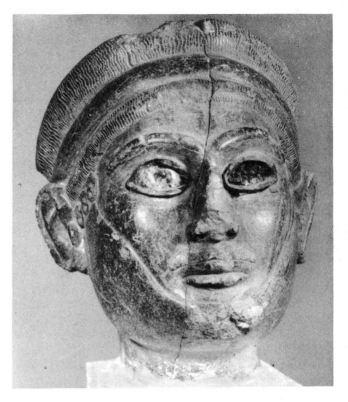

64. **Idrimi, King of Alalakh.** Middle Syrian. 15th century BC. Whitish stone figure, basalt throne. h. 41 in. (104 cm.). British Museum, London. This rather primitive-looking sculpture is principally of interest for the long inscription engraved upon it. The many vicissitudes of the king's career (including seven years of exile in Canaan) are enumerated, culminating in a successful expedition against the Hittites as a vassal of the Mitanni. The booty he collected enabled him to set up a court, where he reigned for thirty years.

65. **Yarim-Lim (?) of Alalakh.** *c.* 1750 BC. h. 6½ in. (16 cm.). Hatay Museum. This striking head perhaps representing the King of Alalakh betrays a sureness of touch on the part of the Syrian sculptor which is totally lacking in the statue of Idrimi (figure 64). It is contemporary with the reign of Hammurabi with whom King Yarim-Lim was in correspondence. One of the finest examples of Syrian sculpture of the second millennium, the head bears witness to the existence of a mature artistic tradition in Syria which had absorbed the technical knowledge of late Sumerian craftsmen.

were directly influenced by nearby cultures, the local production never succeeded in rising above a modest craft level. Some small idols from Alalakh, a stele from Abu Ireyn, the so-called 'colossus' of Byblos (an imitation of the standing pharaoh type) are disconcertingly primitive. The same criticism applies to the later well-known statue of 64 King Idrimi from Alalakh. Despite the liveliness in the handling of the head, the Idrimi figure exposes the disadvantages resulting from a contradiction between the attempt to achieve monumentality and the flat surface treatment of the piece.

The picture becomes less bleak when one turns to the male head from Alalakh (18th century BC), thought to 65 represent King Yarim-Lim himself, which is exceptionally fine. The broad modelling of the face contrasts with the minutely worked strands of hair and is set off by the emphasis on the eyebrows, the eyes and the mouth. Another male 66 head, from Jabbul, has a generally Syrian look, but is completely different in style from the Yarim-Lim subject. The vertical emphasis, the roughness of the features fitfully picked out by the light and the slight indication of a furrow

over the mouth suggest a conscious reworking of Egyptian models of the Middle Kingdom, such as the statues of Sesostris III and Amenemhet III. It seems clear that whenever Syrian artists strove to rise above the level of craft competence they turned to foreign models which they reworked in their own fashion, though without disguising the source. Thus the relatively advanced artistic workshops in the service of the courts took their models from outside, while the more humble craftsmen were hindered from forging an expressive idiom of their own. The best confirmation of this is to be found in the metal statuettes. This branch of art already existed in the third millennium and was continued in the second. The seated figure of a king 42 from Megiddo, while possessing a certain naive charm, has none of the sophistication or bravura that one would expect of court art. Such figures were made of bronze and encased in a gold sheath, hammered on to the bronze core.

At this period Syrian artists developed a type of decorative stele edged with a border and carved in low relief. The example illustrated comes from Ugarit (modern Ras 67 Shamra). It depicts a weather god holding a spear. The

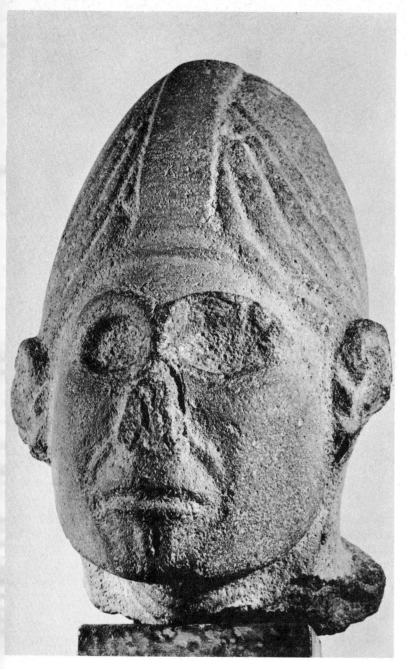

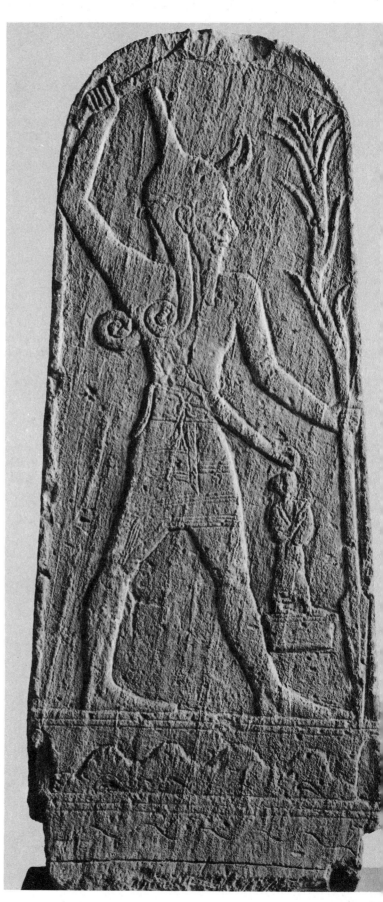

66 (above). **Head of a deity from Jabbul.** *c.* 1800 BC.
Basalt. h. 13⅜ in. (34 cm.). Louvre, Paris. This striking head,
although generally Syrian in feeling, is notably different in
execution from the Yarim-Lim head (figure 65). Comparison
with the statue of Amenemhet III (figure 103) suggests an
Egyptian influence. Although damaged, the piece has
unmistakeable force.

67 (right). **Stele of a weather god from Ugarit.**
14th century BC. h. 57 in. (144 cm.). Louvre, Paris. The weather
god was a major deity in the Syrian pantheon. But if the
subject-matter is Syrian the attitude of the god, with his raised
mace, recalls the pose of an Egyptian king overcoming his
enemies. The part profile, part frontal rendering of the slim
figure is also Egyptian, but he wears the Syrian horned
headdress of divinity, and from his spear tongues of lightning
appear. The wavy line at the bottom of the stele may indicate
the mountainous region where the god resides.

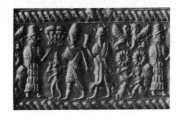

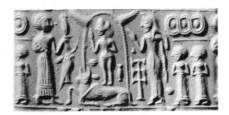

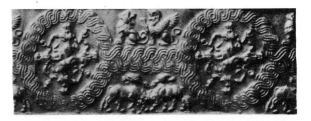

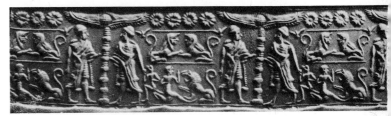

attitude, the slenderness of the figure and other features clearly derive from Egyptian example, while the costume has affinities with Anatolia. Egyptian elements also appear on Palestinian steles.

An important monument from the last centuries of the second millennium is the sarcophagus of King Ahiram, found at Byblos. It is inspired by Egyptian models (as the arts of Byblos generally are), but its sides are decorated with reliefs in the Syro-Palestinian manner, anticipating the style of the later Syro-Hittite reliefs.

SYRIAN MINOR ARTS

One of the best and most original branches of Syrian art of the second millennium is seal carving. Although the art goes back to the Chalcolithic period in Syria, the real flowering of seal carving begins in the 18th century and lasts for several hundred years. The Syrian seals, which adopt the Mesopotamian cylinder type, have a repertoire that shares some elements with the Old Babylonian seals, but local motifs also occur—divine and human figures, religious and purely ornamental motifs—together with Egyptian features. Despite the varying sources of the motifs Syrian seal carving achieved a unity and coherence that distinguish it from the contemporary Mesopotamian production. Syrian originality is particularly noticeable in the feeling for composition and the vigorous postures of the figures. The surface of the cylinder is arranged in registers, often set off by a *guilloche* motif. These traits are common in the work of northern centres (Alalakh, Aleppo), but they also occur in the south (Hazor). Elsewhere different schools developed. Ugarit preferred a linear treatment in which the isolated figures were deprived of all relief; Egyptian motifs were more common. In the second half of the millennium the south, where the northern school had had less influence and foreign models (including some from Cyprus) were better known, developed an independent style in which a taste for ornament was dominant. This is revealed in the arabesque motifs and the predilection for animal figures, either in rows or carefully arranged in groups. Palestine has yielded many scaraboid seals, especially of the Hyksos type, with a spiral decoration deriving from the Aegean.

The latter half of the second millennium saw the appearance of a branch of art destined to have a great future: ivory carving. The technique goes back to prehistoric times, but only under the stimulus of New Kingdom Egypt did Syria develop able craftsmen in this medium. Both iconography and style betray unmistakable Egyptian leanings, but just as with their seal carving so with ivories, the Syrian artists found an opportunity to forge an essentially independent tradition based on a strong feeling for ornament. Finally, this period saw the development of another craft speciality that was to enjoy much success later: gold and silverwork. A gold plate and cup from Ugarit, an Egyptian-looking pectoral from Byblos, a plaque from Tyre decorated with hunting scenes, animals and mythological creatures. In the

68a–d. **Syrian cylinder seal impressions.** *(a)* British Museum, London. *(b) (c) (d)* Staatliche Museen zu Berlin. Syrian cylinder seals, while borrowing motifs from Egypt and Mesopotamia, achieved none the less an individuality and high quality of carving which were all their own. The bull-man *(b)* occurs in seals from the Ur III period. The pillar of life *(d)* is also seen on Mitannian seals and the sphinx motif is of course Egyptian. But the disposition of the figures in friezes separated by rosettes and guilloche strips or roundels is a Syrian contribution.

69 (below). **Sarcophagus of Ahiram, King of Byblos.** 13th century BC. h. without cover 32 in. (80 cm.). Louvre, Paris. The scene depicted on the side of this Phoenician sarcophagus is a funerary feast in the Egyptian manner in which offerings are brought to the dead ruler. He is seated on a splendid throne in the form of a winged lion, and in the frieze above is a design of lotus buds. The lions at the base are comparatively crudely modelled. The relief recalls a similar scene on a contemporary ivory from Megiddo, and heralds an iconographic convention to be found on later Syro-Hittite reliefs. The sarcophagus, made in the 13th century, was used for King Ahiram in the 10th.

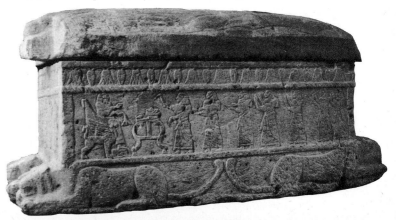

first millennium BC luxury objects of ivory and coloured glass, of gold and of silver were to bring the Syrian craftsmen great fame, and an extensive trade in such pieces developed.

DISRUPTION AND PARTIAL RECOVERY

The art of Syria in the second millennium, which we have examined in the light of both its originality and its dependence on Mesopotamian and, later, Egyptian models, was severely disturbed through the invasion of the 'Peoples of the Sea', who entered western Asia in about 1200 BC, destroying the Hittite Empire, sacking Ugarit and other Syrian cities, and driving the Egyptians back to the Nile delta. In the ensuing confusion new Semitic peoples, the Aramaeans and the Hebrews, settled in Syria and Palestine. The cultural effects of these events were considerable. Apart from some lingering survivals in Malatya, Hittite culture simply disappeared. The influence of Egypt was drastically curtailed. Syrian culture, which had been fairly uniform throughout the region, broke up into regional groups. This happened because the important cities which gave the lead had disappeared, and also because of changes in the ethnic structure of the country. A unified but delicately modulated national fabric gave way to three distinct regions. (1) North Syria was divided among relatively powerful and independent city states characterised by a population that mingled Hittite and Hurrian stocks with the new Aramaean element. The culture became altogether detached from the age-old Mesopotamian tradition; its true affinities now belonged with the mountain peoples. In the long run this North Syrian culture had excellent prospects for independent development. (2) Phoenicia succeeded in preserving its roots in the tradition of the second millennium. But the altered political situation, both in the hinterland, which was dominated by the as yet uncivilised Aramaeans, and in the Mediterranean, where the fall of the Mycenaeans had left the field open to others, created a real gap between Phoenician culture and that of the hinterland, despite the common origins of the two groups. Strong maritime ties with Egypt meant that Egyptian influence in the arts was to develop once more. (3) Palestine advanced from a provincial backwardness closely dependent on Egypt to a lively intercourse with its northern neighbours, first with Phoenicia and then with North Syria as well.

In evaluating the art of these areas it is essential to remember their historical background. There is no point in looking for original masterpieces from Palestinian craftsmen who were intent on imitating Phoenician work as far as their powers permitted. Nor should we expect vigorous pioneering in Phoenicia itself, which was wholly absorbed in its commercial interests; Phoenician art consists almost entirely of luxury items useful for trade. For fine and significant work we must turn to the art of North Syria. Not only was the tradition of the second millennium preserved here through very troubled times, but the disappearance

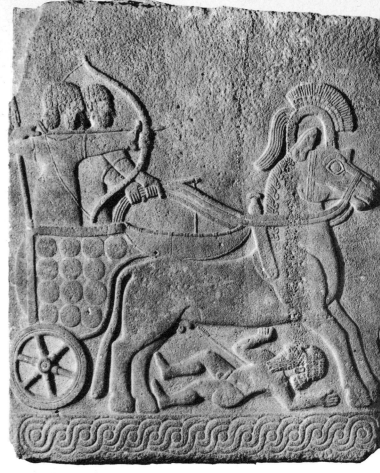

70. **Orthostat relief from Carchemish.** Beginning of the first millennium BC. Basalt. h. *c.* 69 in. (175 cm.). Archaeological Museum, Ankara. Carchemish was more closely associated with the Hittite Empire than any of the other North Syrian cities. The orthostat reliefs recall the Hittite ones from the point of view of technique. The subject-matter, however, is new and was to be employed later by the Assyrians, who particularly favoured scenes with battle chariots.

71. **Orthostat relief from Tell Halaf.** 9th century BC. Basalt. h. 36 in. (60 cm.). Aleppo Museum, Syria. The palace of Kaparu at Tell Halaf was elaborately decorated both with free-standing sculpture and orthostat reliefs. This detail shows three supporters of a winged sun disk, and recalls a motif common on Mitannian seals. The figure of the bull-man belongs to a Syrian tradition reaching back to the reliefs of Tell Mardikh at the end of the third millennium (see figure 57).

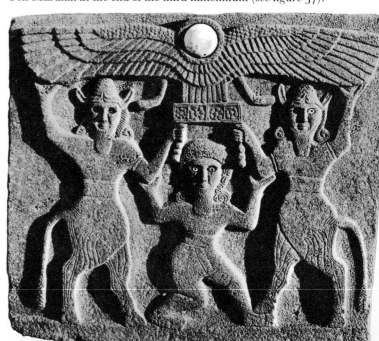

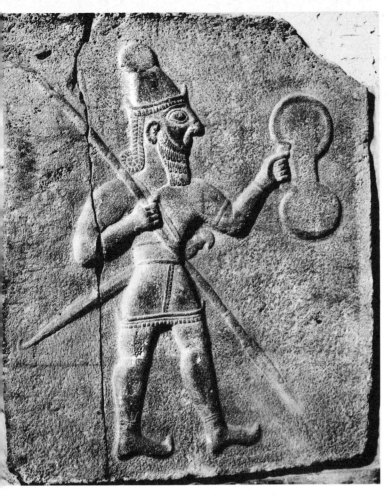

72. **Warrior from Zincirli.** *c.* 850 BC. Basalt. h. 56 in.
(142 cm.). Staatliche Museen zu Berlin. The sculptors at
Zincirli included some deities among their reliefs. Here a
warrior god is shown in Hittite dress, with tall hat, short kilt and
pointed shoes. The relief is perhaps less successful than those
found at Carchemish.

73. **Orthostat relief from Karatepe.** *c.* 750 BC. Basalt.
This detail from the reliefs of the south portal shows a procession
of musicians bearing cymbals, harps and pipes. Karatepe was a
small fortress on the edge of the Taurus mountains. If the reliefs
of Karatepe do not compare favourably with those of other
Syro-Hittite towns, their subject-matter is full of interest.
Note the harp with a rounded front, which is a Greek shape.
In antiquity itinerant groups of musicians visited many courts.

of the Hittite and Mitannian states left the way open for the
development of prosperous cities whose princes were
zealous patrons of art.

SYRIAN ARCHITECTURE IN THE FIRST MILLENNIUM

In the early part of the first millennium Syrian architecture
witnessed the flowering of a type of princely palace known
as the *hilani*. The distinctive feature of this is an audience
hall that is wider than it is deep, a relationship that is
reflected in the plan as a whole. Before the audience hall
stands a similar antechamber with a porticoed entrance
approached through a flight of steps. This building type is
the product of a long development which we have examined
in an early stage in the palace of Yarim-Lim and which can
be regarded as an independent Syrian contribution to the
art of the mountain peoples. Examples of *hilani* have been
found at Zincirli, Tell Halaf, Tell Tayanat, and Sakçegözü.
In these buildings the columns of the portico, which must
have been made of wood, stood on stone bases consisting of
pairs of animals, usually lions. The lower part of the walls
had orthostats bearing relief carvings following earlier
Hittite practice. It is clear that although the themes
depicted on these orthostats point mainly to Syrian motifs
found in the minor arts of the second millennium (above all
in seals), their projection to the monumental scale of relief
could not have taken place without the Hittite precedent.

SYRIAN RELIEFS

The character of North Syrian reliefs varies considerably
from one city and period to another. The earliest are the
reliefs on the so-called 'Long Wall of Sculpture' at Carche-
mish which can be dated to the second half of the 10th
century BC. These depict figures of gods, seen frontally and
in profile, and warriors mounted on chariots. The reliefs of *70*
the 'Herald's Wall' at Carchemish are somewhat later, and
are mainly given over to gods in the form of monsters. Still
later is the 'Royal Buttress' (9th century), which displays
scenes from the life and court of King Araras. In view of the
uncertain chronology of many of the Carchemish sculp-
tures, it is not yet possible to trace the stylistic development
of these works. In any case the reliefs are characterised by
the repetition of figures (compare the reliefs of Hittite
Yazilikaya), clarity of contour lines, and a method of **38**
giving depth to the figures through the use of overlapping
planes. This fondness for relief and for figures emerging
from the background recurs in the sculptors' treatment of
the Hittite script. Unlike most of the other scripts of an-
tiquity the characters are rendered as reliefs rather than
incisions. This technique continues in the Aramaic in-
scriptions of the North Syrian cities, under unmistakable
Hittite influence.

After Carchemish, the reliefs of the other North Syrian
cities seem rather provincial. At Zincirli the figures are
enervated and the faces repetitive, but at Tell Halaf the *71*
figures have a bodily fullness and a liveliness that verges on
the grotesque. At Karatepe the diversity of the earlier *73*

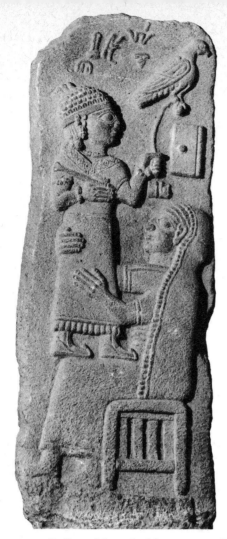

74. Funerary stele from Marash. 8th century BC. Basalt.
h. 29½ in. (75 cm.). Louvre, Paris. Funerary steles are extremely
rare in the ancient Middle East. The most important group
comes from Marash, and are a source for our knowledge of
Syrian religious practices. This stele shows the scribe
Tarhunpiyas standing upon the knees of a seated woman. In
one hand he holds a stylus and in the other a falcon.

tradition was preserved. Because of certain distinctly
41 Hittite motifs, the Malatya reliefs are uncertainly dated.
Their style, however, suggests that they are contemporary
with the reliefs of the other cities. Finally, the reliefs of
72 Sakçegözü and some others from Zincirli should be
mentioned because of their clear traces of Assyrian in-
fluence. Despite their apparent sophistication however the
Assyrianising reliefs are dull and mechanical.

These reliefs should be related to a large group of steles
that share their iconography and style and so demonstrate
the wide diffusion of this type of sculpture. The steles of
74 Marash which are of high quality are also of exceptional
interest as being the only ones in western Asia to be in-
tended for funerary use. In the large quantity of sculptures
in the round two main trends can be identified. The first
is characterised by a concern for volume and monumen-
tality, whereas with the second group attention is drawn
rather to surface texture, by means of delicate lines and
soft modelling. Examples of the first trend are the lost
statue of the god Atarlukas from Carchemish and the statue
of Hadad from Zincirli; the second appears in the monu-
mental head from Carchemish, a head found recently at
Malatya, and (with some exceptions) the architectural

statues from Tell Halaf. A place apart is occupied by the
statue of a king from Malatya, in which the cold and
calligraphic handling of the head reveals the reliance on
Assyrian models, while in the rendering of the body with its
elegantly pleated garment, the calligraphic trend is tem-
pered by a feeling for monumentality. Finally, the lion
figures, which have great power, can be regarded as **75**
symbolising this whole phase of sculpture. Executed in a
great variety of styles, they all hark back to the lion gates of
Hittite Imperial cities.

Our survey of the North Syrian art of the beginning of the
first millennium would be incomplete without reference to
ivory carving. This branch of art, which developed in the
last centuries of the second millennium in a number of
centres, including Ugarit and Megiddo, now gained wide-
spread popularity. The Phoenician schools proper were pa-
ralleled by at least one North Syrian school, which recent
discoveries have located in the city of Hama. By comparison
with Phoenician ivories the North Syrian ivories in the
Loftus Group from Nimrud now in the British Museum **49**
show two distinctive qualities: a more varied iconography,
partly explained by the influence of themes from reliefs,
and a technique of carving in greater depth.

PHOENICIA AND PALESTINE

The general artistic situation of Phoenicia and Palestine in
the early part of the first millennium is very different from
that of North Syria, even though, as has been mentioned,
the two regions share a common background. To some
extent the scarcity of material from the southern regions
can be explained by the lack of excavation in the big
Phoenician cities of Tyre and Sidon. More fundamental,
however, was the effect of various historical factors. The
Phoenicians were primarily involved with seagoing trade,
while in Palestine there was a prejudice against figural
representation. Moreover the influence exercised over the
two countries by Anatolian and Assyrian cultural traditions
was weaker. Such factors contributed to the partial isola-
tion of Phoenicia and Palestine (now more closely linked to
one another thanks to the relaxation of Egyptian pressure)
from the stimulating activities of the northern cities.

PHOENICIAN ART

Practically nothing remains of Phoenician architecture of
this period, though we know from literature of the rebuild-
ing of various temples in Tyre. Some idea of this architec-
ture can be gleaned from the Biblical description of
Solomon's Temple in Jerusalem, which was built by
Phoenician workmen, and it is interesting to note that the
plan repeats the Syrian scheme of three consecutive rooms.
Another instance of this plan is a temple at Tell Tayanat
adjacent to the royal palace just as at Jerusalem, but
erected a little after Solomon's Temple. Several other
princely dwellings are found in Palestine: at Samaria,
Megiddo and Ramat Rahel. These palaces share a com-
mon plan (a big courtyard with the buildings grouped in

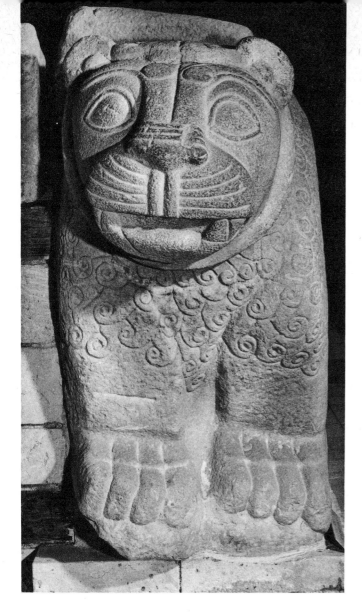

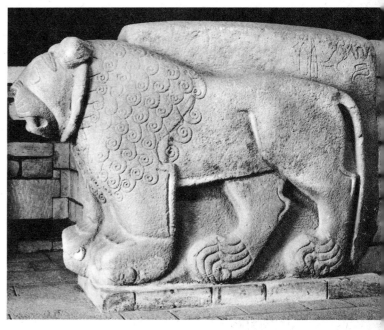

75*a, b*. **Lion Gate from Malatya.** 9th century BC. Basalt.
h. 51½ in. (131 cm.). Archaeological Museum, Ankara.
The guardian lions of Malatya derive directly from the earlier
sculptures at the gates of Hattusas (plates 33, 34). They are
typically Hittite with the fleshy ears, wrinkled nose and
hanging tongue. The use of lions as guardians spread from
Anatolia and North Syria to many parts of the ancient
Middle East. Some centuries later guardian figures occur at
el-Ula (ancient Dedan) in Central Arabia.

one corner), building technique (casemates in the outer walls) and architectural decoration (large volute capitals of the proto-Aeolic type borrowed from Phoenicia). These capitals are carved on one side only and fixed against the walls of the courtyard. In North Syria the city walls have the *tenaille* type of gate.

The almost complete lack of sculpture in the round and in relief is disappointing. Two sculptures from Amman in Jordan are at present unique. Palestine has yielded a good many crude little figurines in terracotta, usually representing female figures standing on columnar bases, in which the head is made from a mould. But widespread opposition to the depiction of the deity, which was not limited to Palestine but extended partially also to Phoenicia, restricted this kind of work to relatively unimportant folk craft.

By contrast the great expansion of Phoenician trade promoted the production of luxury goods, including textiles (all unfortunately lost), coloured glass imitating Egyptian models, ivories, and important work in precious metals, such as cups and plates in silver and bronze. The wealth of Egyptian iconographic features and the ornamental character of the composition give a degree of unity to this work, which in all likelihood was not limited to

Phoenicia itself, but was also practiced in Cyprus and in the North Syrian cities. Although there is some doubt about this, the qualities of some of the cups found at Nimrud in Assyria seem to parallel the ivories, which would make them an independent North Syrian branch of metalwork. From the artistic point of view however, the most successful Phoenician products are the ivories. Here too the themes represented are mainly Egyptian (gods and sphinxes), but there are also instances of the reworking of such Syrian motifs as the figure of the cow nursing its calf, the head of a woman at a window, various types of griffon, palmette and volute capital. Used to decorate furniture, these ivories were sometimes overpainted and enriched by inlaying other materials, as in the two examples from Nimrud, one of which represents a female face and the other an Ethiopian attacked by a lioness in a papyrus swamp.

48

The seal carvers of this period finally abandoned the Mesopotamian cylinder-type in favour of the Egyptian scarab and the Anatolian stamp seal. Numerous Egyptian motifs are employed (especially religious subjects and sphinxes), but there is no lack of griffons, lions, goats, heraldic animals and cult scenes—in short the familiar repertoire of the minor arts. A unique find is a painted

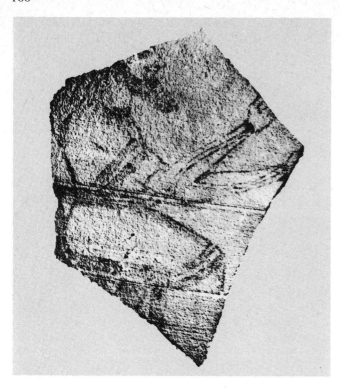

76. **Painted sherd from Ramat Rahel.** 7th century BC.
4⅞ in. (12·5 cm.). Fired clay. Department of Archaeology, the
Hebrew University of Jerusalem. This pottery fragment
represents an enthroned man. The work is probably
Phoenician, although the inspiration is Assyrian. The subject,
probably a king, is shown with arms outstretched and is
perhaps receiving tribute. This, with a further fragment also
from Ramat Rahel, is the only extant example of
Syro-Palestinian painting of the early first millennium.

77. **Bronze ornament from Luristan.** c. 900 BC. h. 12 in.
(30 cm.). Louvre, Paris. The rich and varied collection of
bronzes which have been discovered in northern Luristan
belonged to the tribes of mounted nomads from the plains of
Central Asia. The piece illustrated is a pole top. It shows a
hero between two beasts whose outward-curving shapes form
an open disk. Below the same subject is repeated but with two
bird heads flanking the head of the human figure.

76 sherd from Ramat Rahel representing an enthroned man,
probably a king. The style suggests an Assyrian model
transmitted via Phoenicia (note the type of beard), where
similar figures are found on seals. In the eighth and seventh
centuries BC, Phoenician and North Syrian crafts were
largely imitated in Anatolia, Cyprus and Greece, where
the so-called 'orientalising' art flourished which was to
spread over the whole Mediterranean area.

LURISTAN

Turning once more to Iran we find that the flowering of the
art of Elam in the 13th and 12th century BC was not destined
to last long, for this period saw the gradual infiltration of
new peoples from the Caucasus and Central Asia who
brought about an eastward shift of the cultural fulcrum of
the Middle East. At the end of the second millennium and
the beginning of the first the most important art produced
77 in Iran was the famous 'Luristan bronzes'. Widely scat-
tered tombs in Luristan, which is located north of Elam,
have yielded thousands of bronze objects, usually horse
trappings (cheek-pieces, bits, bridle ornaments, etc.), but
also swords, axes, and decorative pieces such as vases. These
were the finery of warlike nomads, moving frequently on
horseback from one grazing ground to another. Although
we have no all-inclusive name for this wandering popula-
tion (it includes the Cimmerians, the Scythians and the
Medes), its connection with the groups living in the plains

of southern Russia and Central Asia is clear. The themes
depicted on the bronzes are often connected with Mesopo-
tamian mythology; much of it for example relates to the
Gilgamesh legend, the hero who overcomes the beasts.
There are also confronted animals and such stylised motifs
as the rosette and the tree of life. But this whole world of
images was adjusted to express a sense of fantasy, free from
any interest in naturalism, and governed instead by careful
laws of composition (the pairing of figures horizontally and
vertically a concern for symmetry). In other words, the art
of the Luristan bronzes is allied to the so-called 'animal
style' which spread triumphantly through all of inner Asia,
from western Russia to Mongolia, and which found its
most characteristic expression in the objects preserved in
the famous frozen tombs of Pazyryk in Siberia.

Strongly influenced by Assyria but still linked to the art
of Central Asia are the treasures of Ziwiye and Hasanlu.
Probably the earliest among these objects are two repoussé
vases, one in gold and the other in silver, from Hasanlu in *61*
Iranian Azerbaijan. The surfaces are covered with relief
scenes with unknown mythological figures. Although there
are some Assyrian echoes, these reliefs remain profoundly
original in conception and subject matter. The many rich
objects from the Ziwiye treasure—bracelets, plaques, *44*
pectorals a large silver plate embossed in gold—belong to
the end of the 7th century. Although anticipating Achae-
menian art, the guiding spirit is still Assyrian.

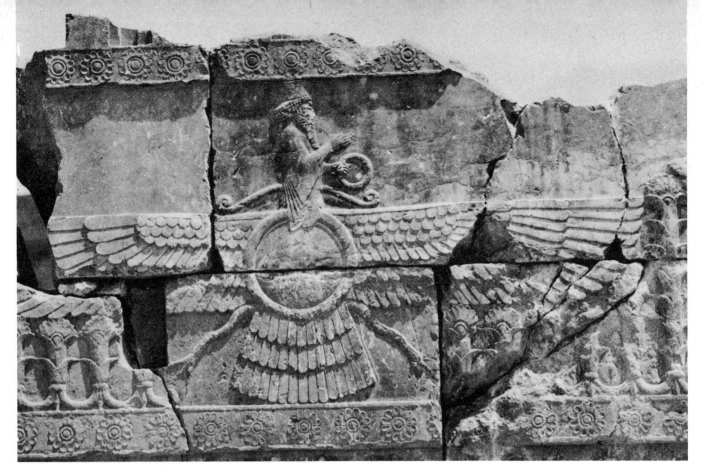

78. **Relief of Ahura Mazda at Persepolis.** 5th century BC.
This relief of the Achaemenian god Ahura Mazda, shows him
riding a winged sun-disk, like the Assyrian god, Assur.

The motif also occurs at Naqsh-i-Rustam and at Bisutun. But
while the iconography is Persian (with Assyrian precedents)
the carving was undertaken by Ionian craftsmen.

THE PERSIAN EMPIRE

From the mid-6th to the mid-4th century, western Asia and
Egypt formed one vast empire ruled by the Persian house
of the Achaemenians. Then in 330 BC the Middle East fell
under Greek cultural domination. It is tempting to
regard the Achaemenian Empire as the last manifestation
of the whole preceding cultural experience of the Middle
East, but this was not so. The empire of Cyrus indeed
belongs to the same line as those of Nebuchadnezzar,
Sargon II, Hammurabi, Sargon the Great, Lugalzaggisi—
but with a difference. The vital centre of civilisation now
lay not in Akkad or Babylonia or even Iran, but in Athens.
The Achaemenian kings did not achieve a cultural renewal
which they no doubt sought. Egypt contributed the
hypostyle hall and the sphinx, Assyria human-headed bulls
and reliefs, and Babylonia glazed tiles, but these features, so
productive in the past were now empty of meaning. The
Persians themselves were the bearers of a new spirit: a
religious and political concept of life that differed pro-
foundly from the ideas that had obsessed the Middle East
for millennia, and this new spirit could not be expressed in
old forms. Any attempt to find an exciting vigorous synthe-
sis of all the great styles of past ages was doomed to failure,
as was Alexander's later attempt at cultural fusion.

Nevertheless, the new spirit introduced by the Persians
did not disappear with their empire and their art. It was
deeply rooted in the consciousness of the people and
provided them with a bastion to repel the spiritual expan-
sion of Hellenism. The Parthians, who overthrew the
Greeks and became the true successors of the Achaeme-

nians, created the first authentically Persian art. Thus the
historical development begun under Cyrus did not end
with Darius III but continued into Sassanian times.

PERSIAN ART

Seen in the light of this larger perspective Achaemenian art
loses the interest that attaches to the great adventures of the
human spirit. However unique, evocative and stylistically
refined it may sometimes be, no true creative inspiration is
sustained. Ugo Monneret de Villard has justly remarked of
Achaemenian art that 'it was not an art that contained
even embryonically the outlines of a new and glorious
future, but the concluding episode of the age-old traditions
of the ancient Middle East. The burning of Persepolis by
Alexander's followers was not the holocaust of a living
culture, but the funeral pyre of a wraith.' To be sure the
huge building complexes of Pasargadae, Susa and Perse-
polis are not lacking in grandeur. The ruined palaces on
artificial platforms, with their vast many-columned halls 55, 56
and great sculptured monoliths guarding the entrances still
give an awesome impression of imperial power. The sacred
character of the monarchy is emphasised everywhere in the
references to Ahura Mazda, who is depicted in Assyrian
fashion as a bust borne by a winged disk. At Persepolis, the 78
stepped pinnacle, which among the Iranians clearly pre-
serves its original character of a religious symbol, emphasises
the cosmic idea of the city. The reliefs decorating the sides
of the staircases with their long rows of dignitaries and 58
tribute bearers and with the symbolic scenes of battles 81
against monsters, serve at once to convey the power of the

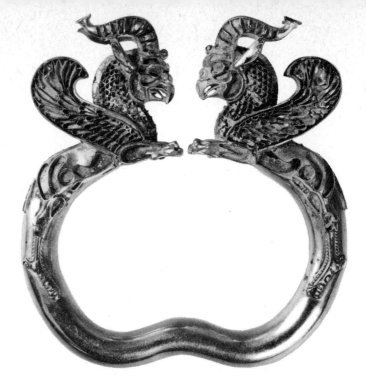

king and to exalt the fearless champion who overcomes the forces of evil. In this way the Assyrian theme of the king who slays the lion in single combat serves to symbolise the struggle between good and evil. This religious aspect of Achaemenian art is expressed repeatedly. Persian dependence on the Assyrian art of relief, is unmistakable, but the workmanship is Greek, as is proved not only by the handling of the drapery, but also by an explicit statement in the dedicatory inscription which lists the contributions of the various provinces of the empire to the realisation of the building. The enormous many-columned halls owe their inspiration to Egypt, but the concept that governs the disposition of the columns is quite different. The capitals are unusual: in accordance with a very old Sumerian and Elamite tradition they gain an extra, symbolic dimension *80* through the introduction of the fore-parts of animals (bulls and horses). Assyrian iconography again prevails in the reliefs set up near the gates. Sometimes, however, eclectic figures appear, such as the winged genius of Pasargadae that combines Assyrian and Egyptian features. Another difference separates the Persepolis reliefs from the Assyrian ones: the king is now shown in larger scale than the other figures.

62,63 The rock-carved royal tombs of Naqsh-i Rustam emphasise one of the most attractive aspects of Achaemenian art. Deriving from traditional Iranian rock reliefs, this branch of art is now enriched by an architectonic conception disposing the figures in space against a stately background of columned halls. (Later the Sassanian kings were to revive this distinctive kind of relief). A particularly attractive aspect of Persian art is its metalwork. Many precious *79* objects in gold and silver have survived intact: armlets, *60* vases, a lion-head rhyton, a silver fish, as well as jewelled daggers and belts. All these show an accomplished technique and an obvious delight in ornament for its own sake.

ANATOLIA IN THE FIRST MILLENNIUM

The fall of the Hittite Empire, though it led to the formation of city states in eastern Anatolia that depended culturally and politically upon North Syria, left a political vacuum in the central plateau that was soon filled by newcomers, the Phrygians. But this people failed to create a strong state and the development of a noteworthy art among them was delayed for a long time after their immigration into the region. The earliest Phrygian monuments belong to the 8th century. In spite of a number of recent finds Phrygian art remains little known. Its outstanding characteristic is the strong taste for ornament reflected in the precise decoration employing geometric motifs. Of this type are the carved rock faces at 'Midas City', and the inlay of a wooden throne found in a princely tomb at Gordion, the Phrygian capital. Love of ornament, the use of tumulus tombs, and certain pottery types are all features that link the Phrygians to the nomads who appeared in Iran at the end of the second millennium. Just as in Iran, so the newcomers in Anatolia were influenced by the existing art,

79 (above). **Armlet from the Oxus treasure.** 5th century BC. Gold. h. 5 in. (12·3 cm.). British Museum, London. This armlet would originally have been encrusted with precious stones. It displays two confronted griffins—a favourite Persian motif—and is a triumph of the metalworker's art. Similar armlets are being offered by the tribute bearers of figure 80.

81 (opposite). **Syrian tribute bearers.** Relief from the stairway of the Tripylon at Persepolis. 5th century BC. The magnificent stairway to the Tripylon is decorated with friezes showing tributaries from many parts of the Empire. Here Syrian emissaries bring objects of precious metal—vases, bowls and armlets—to the king.

80 (below). **Double-bull capital from Susa.** 464–358 BC. Louvre, Paris. This capital came from the throne room of the palace of Darius at Susa. It represents a unique contribution by Achaemenian artists. The top half is formed by a pair of bulls so that the beams are supported at two points. Below the fore-parts of the animals is a double volute. Grandiose and bizarre to our eyes, these capitals *in situ* must have been an amazing sight, mounted on painted, many-fluted columns.

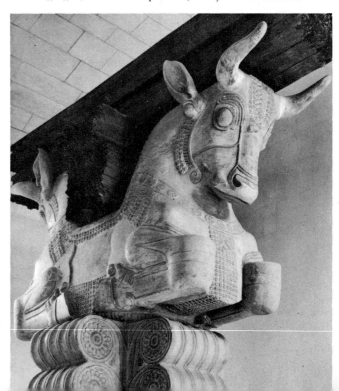

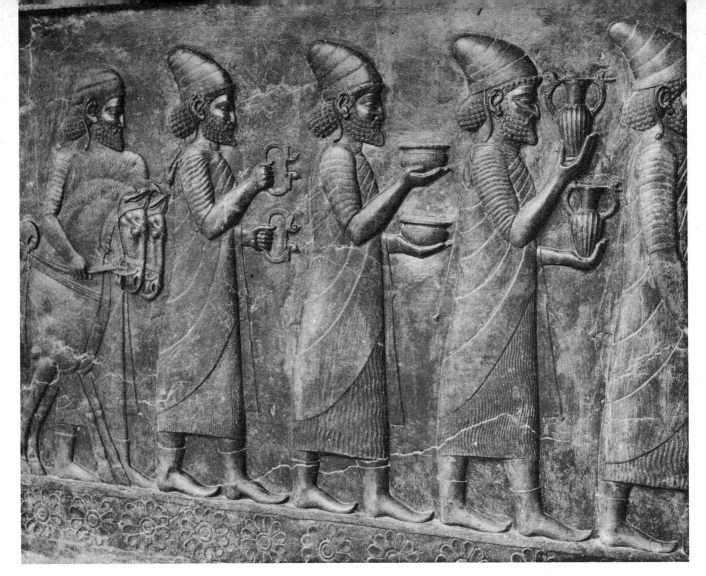

particularly in the field of iconography. Thus, for example, the painted terracottas of Pazarli show a lively local adaptation of Assyrian motifs—confronted goats separated by the tree of life—and Greek motifs—centaurs and warriors recalling those depicted on Mycenaean pottery. A statue recently found at Boghazkoy, which represents the goddess Cybele flanked by a pair of flute-players, reveals a degree of Ionian influence, even though the drapery type repeats formulae found in Syrian seals of the second millennium, while the high cylindrical cap is a purely Anatolian motif.

The art of central and western Anatolia gradually fell more and more under Greek domination. The tendencies initiated in the Phrygian period were taken up by Lydian and Lycian artists. But these were provincial workmen, translating a great foreign culture into local terms without striking any particularly memorable note of their own. In the last analysis this is the same historical process of borrowing that led to the formation of the art of the Hittite Empire, but the difference is that political conditions in the earlier period were such as to promote the creative recasting of foreign cultural influences. How far Anatolia was capable of resisting the process of Hellenisation that was ultimately to prevail is shown in the way they retained certain religious themes. In the first century BC, the enormous tumulus erected by King Antiochus I of Commagene, which is richly decorated with statues and reliefs showing the king accompanied by various gods, displays an

unusual fusion of Greek and Oriental elements on a base that is rooted partly in Mesopotamian, partly in Hittite tradition.

In the early centuries of the first millennium BC, the powerful kingdom of Urartu in north-eastern Anatolia with its capital at Tushpa (modern Toprakkale) was able to hold its own against the might of Assyria. The finds at Toprakkale, and especially the more recent ones at Karmir-Blur (ancient Teshebani) near Lake Sevan, have given substances to the allusions in Assyrian annals and reliefs. The most important aspect of the art of Urartu lies in its metalwork, including such fine pieces as the cauldrons decorated with figural appliqués and the helmet of King Argishti, which bears repoussé reliefs of Assyrian type. These are provincial imitations that in some ways recall the repoussé reliefs of the Hasanlu vases. The fame of the Urartu metalwork was enormous: it was exported and imitated in Greece, penetrating even as far as Etruria. But the destruction of the Urartian state at the beginning of the 6th century by the Scythians put an end to this flourishing art.

SYRIA AND PALESTINE: THE FINAL PHASE

The subjection of Syria and Palestine to Assyrian, and later Babylonian rule brought with it destruction of the cities and mass deportation of the people. Under these crippling blows the art of North Syria and Palestine was annihilated, while that of Phoenicia revived only later. This

82. **Terracotta reliefs from Pazarli.** 8th century BC.
Archaeological Museum, Ankara. These fragments found at
Pazarli in Anatolia, not far from Hattusas, are the work of
Phrygian artists who decorated their buildings with glazed
terracotta plaques. The subject-matter derives from Greek art.

83. **Bronze cauldron and tripod from Altintepe.**
8th century BC. Archaeological Museum, Ankara. The state
of Urartu had its capital at Tushpa (modern Toprakkale) on
Lake Van. Urartu was renowned for its metalwork, which
was traded over a large area, even reaching Etruria. This
magnificent cauldron is decorated with bulls' heads.

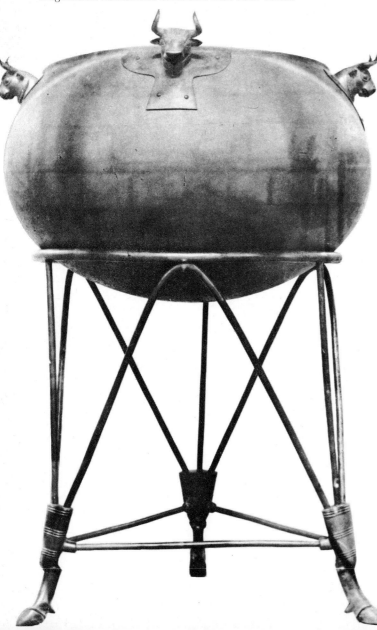

situation can be explained if we look at the historical back-
ground. The art of the cities of Syria and Palestine was a
court art; with the destruction of the cities its *raison d'être*
vanished. Moreover, the violence of conquest crippled the
country's economy. When things began to return to
normal during the Persian period the local traditions had
been stifled for too long to be renewed. A tentative artistic
tradition grew up, borrowing types and motifs from the
more fortunate cultures of Greece and Persia. Thus began a
process that though long pursued was never to be com-
pletely accomplished: the Hellenisation of Syria. But
Persian craft work too, spread many motifs, some of them
Assyrian in origin, but with its depleted political and
artistic vigour there was to be no distinctive Syrian art in
the first millennium BC.

PHOENICIA

The destiny of the Phoenicians, as during the previous
invasion of the 'Peoples of the Sea', was altogether different.
Their cities were important as trading centres and their
economic revival was fostered by the Achaemenian kings
who needed a Mediterranean fleet. The Phoenician cities
recovered rapidly and commercial and cultural contacts
could be resumed. However, there had been a real inter-
ruption and the Phoenicians were obliged to refresh the
springs of their inspiration abroad. Although they bor-
rowed Persian and Cypriot motifs, a time-honoured source
lay near at hand in the art of Egypt. The use of Egyptian
motifs was now an established tradition in Phoenician art.
It was further encouraged by the fact that Egypt was
joined politically to Phoenicia in the gigantic Persian
empire in which a constant flow of troops and merchants
welded firm links between Asia and Africa. Thus the 6th
century saw a new current of Egyptian influence in Phoe-
nicia that even affected architecture, which had previously
followed North Syrian models: the sanctuary of Marathos
is an obvious imitation of the Egyptian shrine. Also
Egyptian is the practice of burial in anthropoid sarcophagi
in which the bodily form of the deceased is modelled on the
cover. At first these are purely Egyptian in type, but later
they were brought into line with the prevailing Greek
tendencies. Even in the earlier period Greek motifs had
gradually insinuated themselves into Phoenicia. But as in
Syria and Palestine, here too a kind of underground
pattern of allegiances persisted among the common
people, particularly in religious matters (note the compari-
son with Anatolia). Thus old traditions were carried along
and brought to the surface at unexpected places; the plan
of the Roman temples of Syria shows an archaic concept
dressed up in Hellenistic finery. Furthered by a consciously
anti-western religious attitude, these trends found their true
home in the redoubt of Parthian Iran. They also nourished
such distinctive art forms as those of the Nabataean Arabs
and of Palmyra. In a new cultural setting age-old Mesopo-
tamian and Syrian motifs mingled side by side with
curiously transformed Greek elements.

Egypt

GENERAL CONSIDERATIONS

The appearance of the Nile Valley on the map suggests a sinuous tropical plant with the Delta as the flower and the Faiyum region as a bud. As one descends the Nile from the Sudan, Egypt proper begins at the first cataract. Four-fifths of the remaining length of the river is occupied by Upper Egypt, a narrow corridor of fertile soil hemmed in on either side by steep cliffs and desert. The delta, or Lower Egypt, is broad and flat, but at its edge one finds the same contrast between the rich alluvial soil whose fertility is maintained by irrigation and the endless desert waste. Rainfall is very sparse in Egypt and agriculture is entirely dependent on the yearly flooding of the Nile. For this reason Herodotus rightly called Egypt 'the gift of the Nile'.

Climatic conditions were not always as they are now. In palaeolithic times North Africa was much wetter, but as the ice cap retreated from Europe, North Africa began to dry up, forcing the hunter peoples who lived there to settle along the banks of the great river. Gradually they formed larger communities and established the political institutions needed to assure irrigation for farming. In time these communities coalesced into provinces or *nomes*, each with its own cultural and religious peculiarities. The nomes themselves were grouped into the two lands of Upper and Lower Egypt. Even after the uniting of the whole country at the beginning of the dynastic period, awareness of the distinction between Upper and Lower Egypt persisted.

Egypt's geographical situation had important cultural and political effects. The relatively broad area of cultivation in the north, the Delta or Lower Egypt, and the immensely long region of Upper Egypt in the south were joined by geographical necessity, and these two regions tended to follow separate paths, or more often, to dominate one another by turns. The political unity of Egypt was an outgrowth of this alternating preponderance of north and south. Thus a kind of political dualism lies at the root of the historical development of ancient Egypt. This dualism was promoted by ethnic and cultural contrasts. In the north the nearness of Asia, with its more advanced techniques, was strongly felt. Southern Egypt, however, was the gateway to an Africa still dominated by a hunting and grazing culture. But Egypt was neither Africa nor Asia. It was 'the two lands', the dynamic synthesis of two fundamental attitudes, the contrast of which is of abiding significance. The lively fantasy, the love of symbolism and the peculiar religious sense of Egypt always appear in history purified and distilled so as to reach a mature humanity. In the last analysis this humanity is closer to our own sensibility than the sometimes excessive abstractness of the civilisations of western Asia. Paradoxically, the concept of the Kingdom of the Dead as a meaningful goal of human existence made it possible for the Egyptians to accept life in all its variety.

It is customary to divide Egyptian history into thirty-one dynasties, a system of chronology worked out by Manetho, an Egyptian priest of Roman times. Modern scholars group the most important of these dynasties, when Egyptian civ-

84. **Predynastic pottery bowl.** First half of the fourth millennium BC. Diam. *c.* 7⅝ in. (19·4 cm.). Museum of Fine Arts, Boston. This red ceramic bowl of the Amratian culture is decorated with stylised hippopotami and a geometric border. The motif is typically African.

85. **Wall-painting from Hierakonpolis.** Predynastic period. *c.* 3200 BC. Egyptian Museum, Cairo. This wall-painting from a Gerzean tomb at Hierakonpolis shows boats and hunting scenes with lions. The ground is painted yellow over a black area around the base, and the individual figures are black, white and reddish brown. These motifs are typical of the Gerzean culture, but there are also certain Asiatic suggestions.

ilisation was flourishing, into four main periods: the Old, Middle and New Kingdoms, and the Late Period. These four periods were separated from one another by intervals of anarchy and confusion. The long era of preparation which culminated in the unification of Egypt is known as the Predynastic period.

The most important factor in the social organisation of the dynastic period is the position of the pharaoh or king. The pharaoh was regarded as a living god, second to no one in heaven or on earth. Some scholars have stressed the affinities between the divine kings of Egypt and the priest-kings of modern tribal communities in West Africa, both presumably stemming from the prehistoric chieftains of North Africa. It is assumed that these early societies were strongly matriarchal and that the royal mandate descended in the female line. This would account for the frequent brother-and-sister marriages in dynastic Egypt and also for the fact that several queens ascended the throne in their own right, the most famous of these being Hatshepsut in the New Kingdom. However this may have come about, the absolute power of the Egyptian pharaoh is in striking contrast to the relative subordination of the typical Mesopotamian ruler, who regarded himself as a mere agent of the god who held actual power over the state.

In practice, of course, the pharaoh depended on a large body of officials to execute his will. These officials became accustomed in their native regions to handing down their titles from father to son. Consequently the separatist tendencies of the nomes were free to develop and the pharaoh's authority could thereby be undermined. Moreover, in later times, the wealth and strength of the priests, who regarded themselves as the true guardians of Egypt's age-old traditions, gradually increased, and they were sometimes in a position to wield considerable power.

Egyptian art is characterised by a preference for stone, unlike Mesopotamia where the absence of stone quarries favoured techniques more appropriate in other media. With some justification scholars have spoken of the 'cubic' character of Egyptian sculpture as contrasted with the 'cylindrical' emphasis of Sumerian work, where the artists were more effective in metal. It is not surprising that when (in the protodynastic period) the Egyptians sought for a time to imitate the buttress construction of the Sumerians they translated it from brick into stone. But the fashion quickly passed leaving no permanent effects and opening the way to original inventions more in agreement with the native temperament.

Political unity played a decisive role in the historical development of Egyptian art. The standards laid down at the pharaoh's court became the model for all Egypt; outside their canons there was room for little more than a provincial folk art.

PREDYNASTIC EGYPT: AN OUTLINE

After the Neolithic (c. 5000 BC) and Chalcolithic (c. 4000 BC) phases, the early 4th millenium saw the appearance of the southern Amratian culture, characterised by a fine, red, polished, ceramic ware decorated with white lines. The scenes depicted on these pots are typically African—hippopotami and stylised plants. Somewhat later (c. 3600 BC) the north gave birth to the Gerzean culture, which had its centre in the Faiyum region. The pottery of this culture has a reddish brown decoration on a light ground that depicts a teeming world of men and animals, as well as long boats bearing a kind of altar. The vigorous Gerzean culture spread throughout Egypt, overlaying the southern Amratian culture. It thus anticipates Egypt's later unification as a single kingdom. *84*

In the last centuries of the 4th millennium BC, while in Egypt the Gerzean culture was issuing into the early dynastic period and in Mesopotamia the al 'Ubaid culture was evolving into the first predynastic phase of Uruk, the two countries, hitherto isolated from one another, established contact. Continuing westwards Mesopotamian culture reached Egypt, strongly influencing the character of the late Gerzean and early dynastic periods. While Mesopotamia showed a gradual, steady progress until it finally emerged in the full light of history, Egypt was radically transformed in a relatively short time. Although it seems certain that Mesopotamian influences acted as a catalyst, a full explanation for this sudden advance of civilisation in Egypt is not yet available. Several unmistakeably Mesopotamian elements appear in Egypt at the end of the predynastic and the beginning of the early dynastic periods: architecture in brick, buttressed buildings, cylinder seals and the theme of the hero flanked by two animals (the Gilgamesh motif). Egyptian elements found in Mesopotamia are less important: vase forms, the motif of animals with long necks intertwined, and possibly the practice of carving stone figures of rulers. *88*

ART AT THE BEGINNING OF THE DYNASTIC PERIOD

There is no clear break between the art of the late predynastic period and that of the early dynastic period. At the most important site of the transitional period, the Upper Egyptian capital of Hierakonpolis, the various strands that came together at the end of the predynastic period are interwoven. At the same time there emerge the characteristic styles and motifs of the ensuing early dynastic period (1st–3rd dynasties: c. 3100–2600 BC). A wall-painting found in a tomb at Hierakonpolis is a remarkable *85*

(Continued on page 129)

64 (opposite). **Obelisk from Aksum, Abyssinia.** 4th century AD. This strange obelisk is a characteristic monument of the early Ethiopian civilisation which flourished in the 4th century AD. In form it derives from Egyptian example, known in Ethiopia through contacts with the Nubian Kingdom of Napata. Its decoration, however, with the series of stylised doors points to South Arabian models.

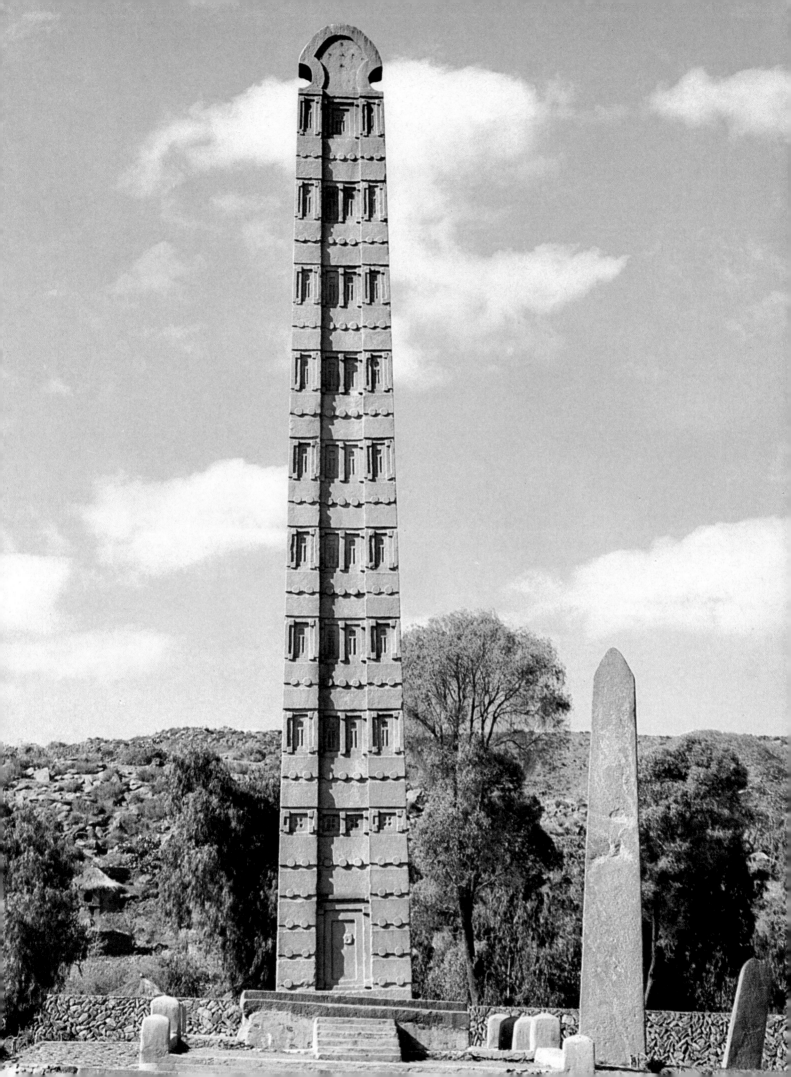

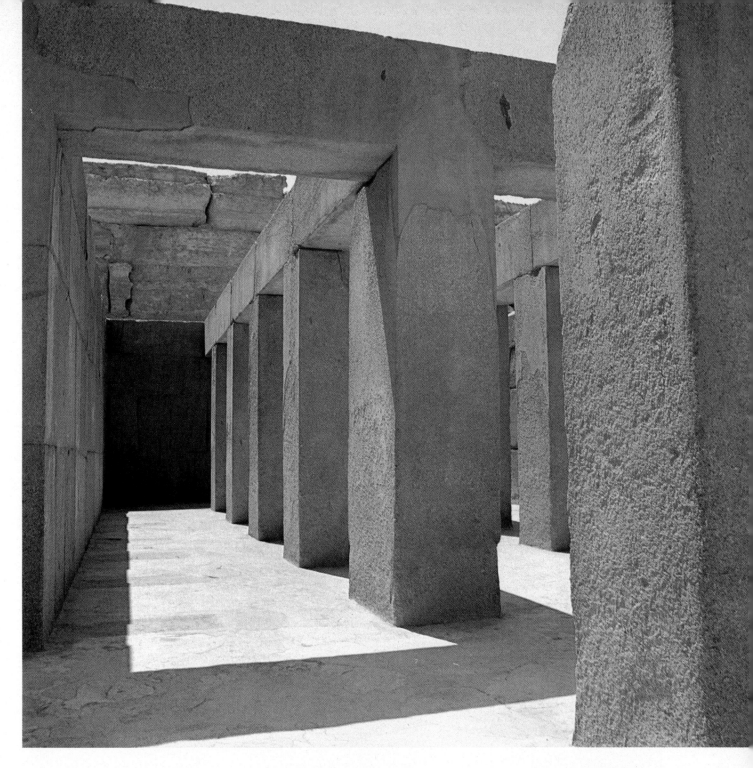

65 (opposite, above). **View of Motye.**
Motye, a small island west of Sicily, was
the site of a thriving Phoenician colony,
founded at the beginning of the first
millennium BC. In this view the northern
gate can be seen, though the walls
probably date from a later period. Motye
was the most important Carthaginian city
in the Sicilian area. It was destroyed by
Dionysius of Syracuse in 397 BC.

66 (opposite, below). **The tophet of
Tharros, Sardinia.** Tharros was a
Phoenician city on the west coast of
Sardinia. Its strong Carthaginian
influence is demonstrated by the existence
of this *tophet*, a sacred area where children
and small animals were sacrificed to the
gods Baal Hammon and Tanit. The ashes
of the victims were placed in urns which
can clearly be seen in this view. Votive
steles were also found during excavations.
When this photograph was taken they still
remained buried in the sand.

67 (above). **Interior of the Valley
Temple of Chephren at Giza.** Fourth
Dynasty. The Valley Temple is the best
preserved of the ancillary buildings at
Giza, and is built of massive blocks of
limestone faced with slabs of polished red
granite. The pillars were cut from
monoliths of red granite, and light filtered
on to the alabaster floor through oblique
openings cut in the top of the walls where
they met the granite roof. Statues of
Chephren were placed at intervals along
the hall, some of which still survive.

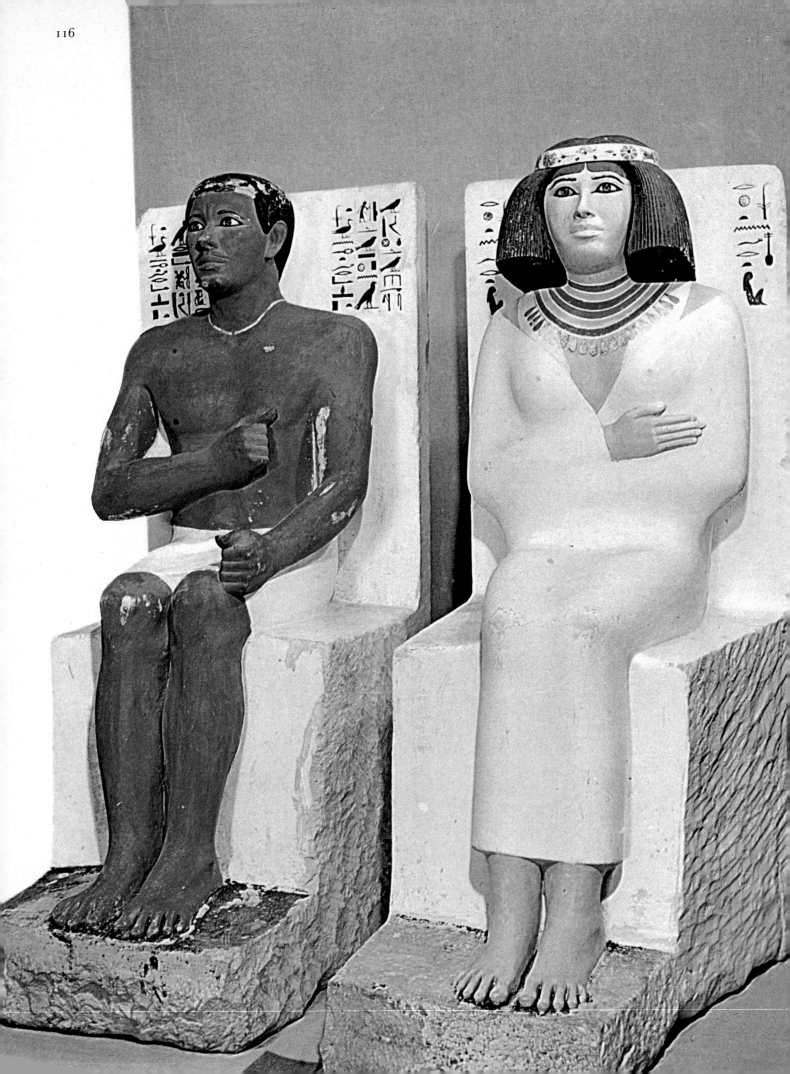

68 (opposite). **Rahotep and his wife Nofret.** Fourth Dynasty. 47¼ in. (120 cm.). Cairo Museum. The painted limestone statues of Rahotep, son of King Snefru, and Nofret his wife were found in Rahotep's tomb at Medum. They are seated on cube-shaped thrones, the backs of which bear inscriptions giving their names and titles. Rahotep was high priest of Heliopolis and commander of the army;

he is depicted with his right hand against his chest and his left hand on his thigh. The colouring of the figures is conventional, reddish-brown for the man and a creamy yellow for the woman. Nofret's femininity is accentuated by the colourful necklace and headband. The dramatic effect is enhanced by the inlaid eyes.

69 (below). **Jubilee pavilion of Sesostris I.** Twelfth Dynasty. c. 1940 BC. The small pavilion or chapel of Sesostris I has recently been reconstructed at Karnak. Almost all its limestone blocks were recovered from the foundation of the pylon of Amenhotep III. Standing on a raised platform, the pavilion was approached by ramps on two sides. Low balustrades linked the outer pillars, and inside four pillars surrounded the throne used by the king for jubilee ceremonies. These pillars are decorated with reliefs of high quality (see plates 70, 71).

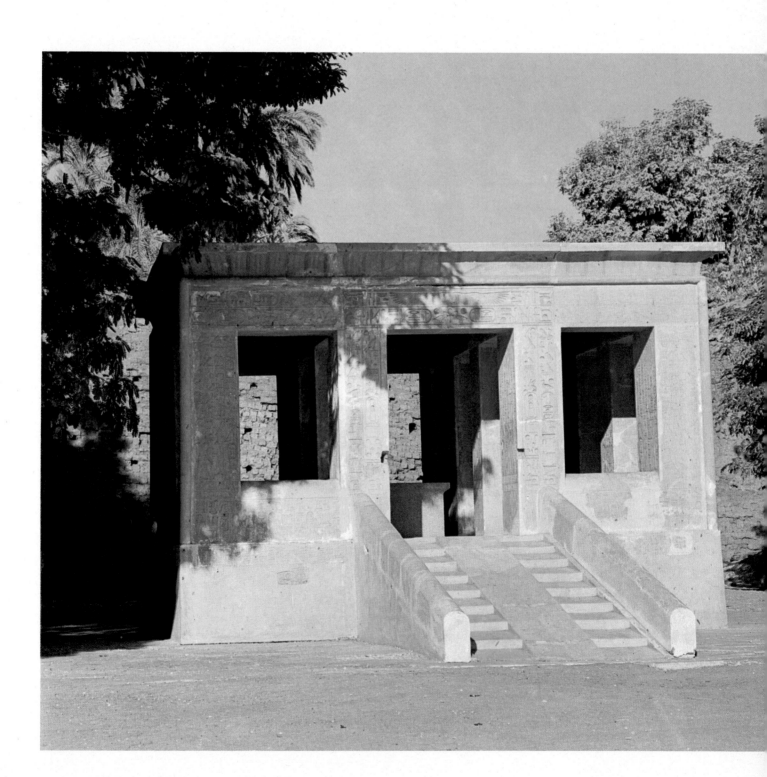

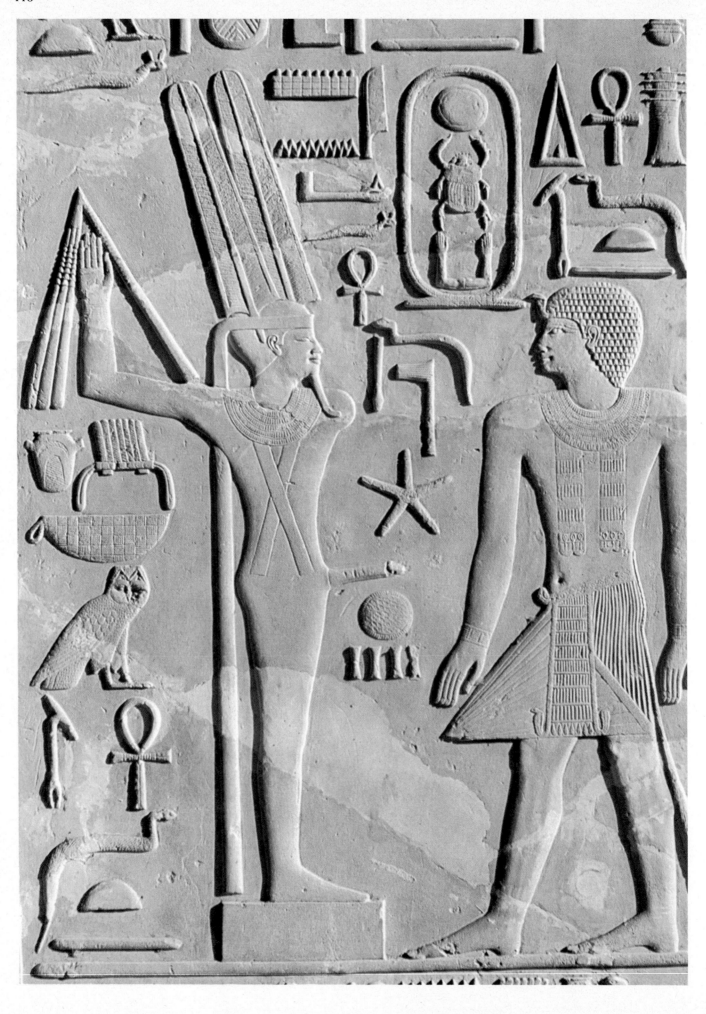

70, 71 (opposite and below). **Reliefs from the pavilion of
Sesostris I.** Twelfth Dynasty. *c.* 1940 BC. Details from the
pillars of the pavilion. Plate 70 shows the king, to the right,
before the god Amon in the form of Min, holding the flail, the
symbol of kingship. Plate 71, from the north-east corner pillar, is
a similar scene of the king dedicating a sacred emblem to Amon.

72 (right). **Statue of King Mentuhotep.** Eleventh Dynasty.
c. 2050 BC. 72 in. (182 cm.). Cairo Museum. The sandstone
statue of King Nebhepetre Mentuhotep was discovered in an
otherwise empty tomb near the king's mortuary temple at
Deir el-Bahri at Thebes. Slightly larger than life, the powerful
figure wears a white jubilee robe, and the Red Crown of
Lower Egypt.

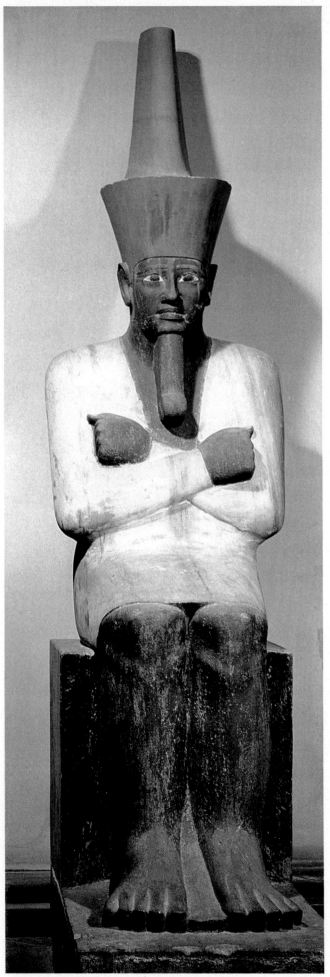

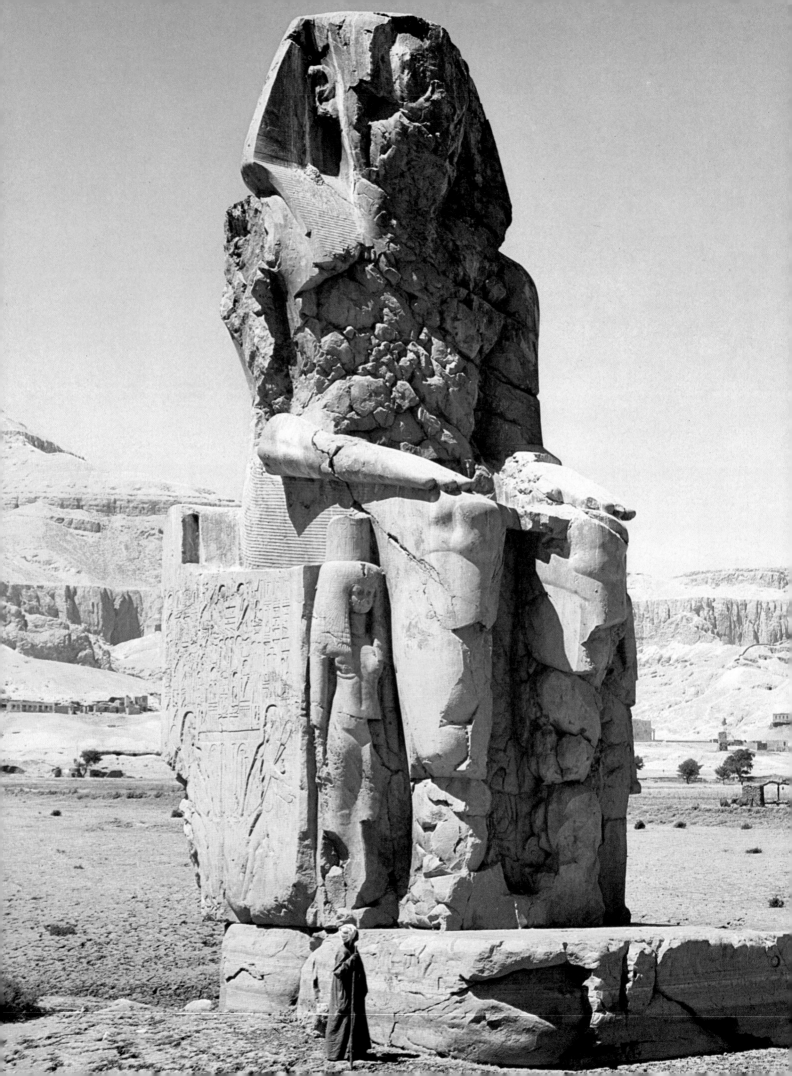

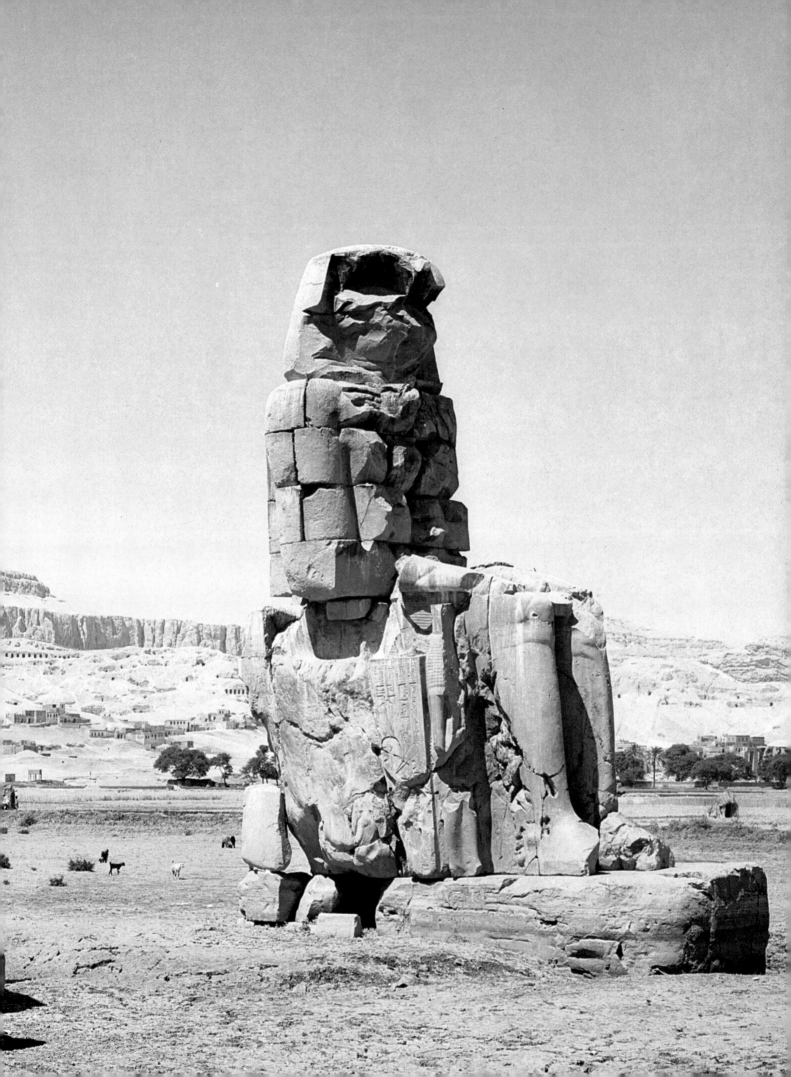

73 (previous pages). **The Colossi of Memnon.** Eighteenth Dynasty. These two enormous royal figures dominate the Theban plain, giving an indication of the vast scale of the funerary temple of Amenhotep III nearby, of which only a few ruins now remain. Originally over sixty-eight feet high, the colossi were carved from quartzite brought over four hundred miles from the Red Mountain quarry near Heliopolis. In Classical times they were considered one of the most impressive sights in the world.

74 (below). **Temple of Queen Hatshepsut at Deir el-Bahri.** Eighteenth Dynasty. *c.* 1480 BC. This mortuary temple was designed for Queen Hatshepsut and her father Tuthmosis I by her favourite, the architect Senmut. Built at the foot of the sandstone cliffs on the western bank of the Nile at Thebes, the limestone temple faces east towards the temples of Karnak and Luxor on the opposite bank. Hatshepsut's temple is similar in design to the Middle Kingdom temple of Mentuhotep nearby, but dispenses with the pyramid in the

forecourt. The need for greater secrecy and protection for the body of the dead ruler meant that the royal tombs were channelled into the rock behind the temples. Queen Hatshepsut's temple consists of two deep terraces within a walled enclosure. The terraces are reached by ramps and have colonnades to the left and right. The uppermost terrace has two rows of columns running round it, and a central sanctuary cut into the cliff dedicated to Amon. There were also shrines to Hathor depicted as the goddess of the dead, and to Anubis.

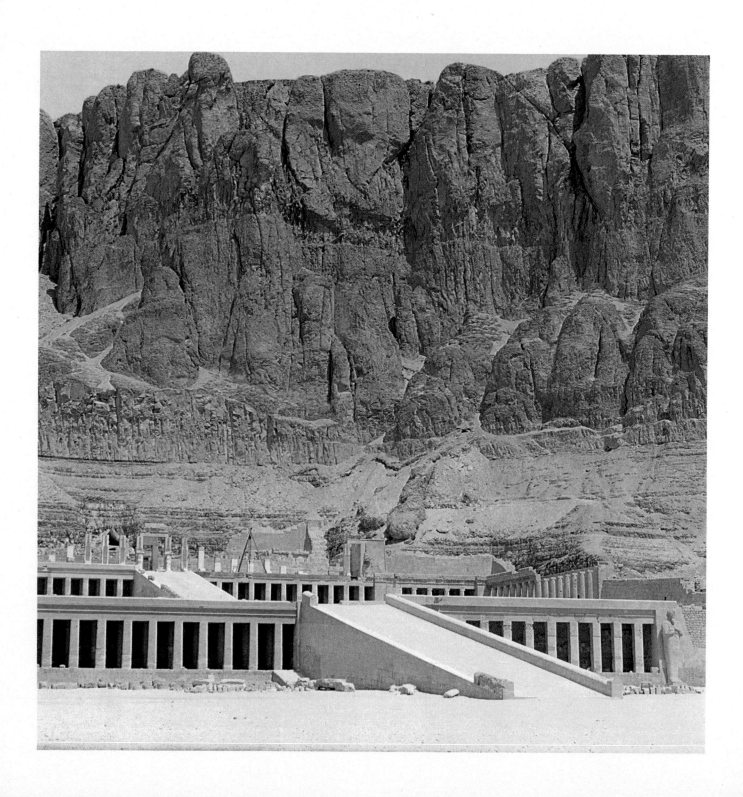

75. Sculptural detail, Deir el-Bahri.
Eighteenth Dynasty. *c.* 1480 BC. Hathor-headed pillar from the Hathor shrine on the left, south side of the first terrace at Deir el-Bahri.

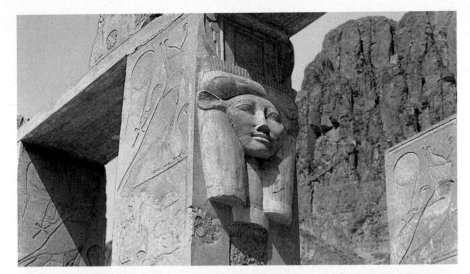

76. Middle Colonnade at Deir el-Bahri. Eighteenth Dynasty. *c.* 1480 BC. A view along the middle colonnade on the south side of the second terrace of the temple. All the colonnades at Deir el-Bahri are decorated with reliefs among which are the famous series recounting Queen Hatshepsut's expedition to Punt.

77 (above). **Court of Amenhotep III, Temple of Amon, Luxor.** Eighteenth Dynasty. *c.* 1400–1360 BC. The temple at Luxor was dedicated to Amon-Mut-Khons. The court of Amenhotep III was surrounded on three sides by two rows of columns. On the fourth, southern, side is a vestibule of four rows of eight columns. The papyrus-bundle columns are among the most beautiful examples in Egypt of the plant column: a stone shaft of bound plant stalks topped by a cluster of papyrus buds. The play of light and shade in the court and the subdued light in the vestibule accentuate the progression towards the darker sanctuary containing the image of Amon.

78 (opposite, above). **Colonnade of Amenhotep III, Temple of Amon, Luxor.** Eighteenth Dynasty. *c.* 1400–1360 BC. The colonnade, 174 feet long, is composed of seven papyriform columns at either side. The massive, imposing columns are 74 feet high and have open papyrus capitals. This may have been intended as the basis of a hypostyle hall.

79 (opposite, below). **The entrance pylons to the Temple of Amon at Karnak, with the avenue of rams.** In the time of Ramesses II, the temple of Luxor was connected with the temple at Karnak by a paved avenue flanked by ram-headed sphinxes. A similar avenue led from Karnak to the temple of Mut, and another to the quayside, seen in this view. This pair of entrance pylons was the last of six pairs to be constructed during the building of the temple by successive rulers, and dates from the Ptolemaic period. Every year the idol of Amon was taken in a sacred bark up the Nile from Karnak to Luxor for the jubilee festival.

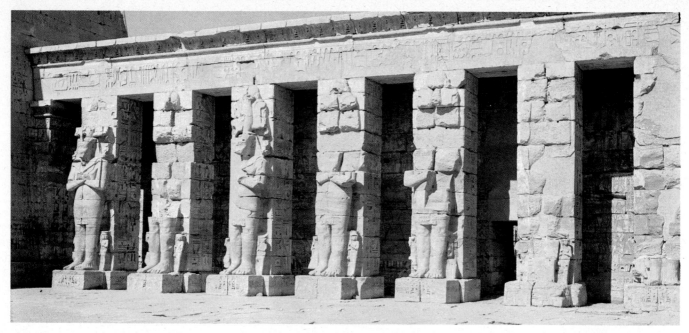

80 (above). **Temple of Ramesses III at Medinet Habu, Thebes.** Twentieth Dynasty. *c.* 1190–1160 BC. On the north side of the first court of the temple, colossal statues of the king as Osiris stand against the pillars. Similar in plan and size to the Ramesseum built by Ramesses II, the temple at Medinet Habu on the western bank of the Nile included in its complex a palace, administrative buildings, military quarters, store-rooms, gardens and pools.

81 (below). **Relief from the temple at Medinet Habu** (detail). Twentieth Dynasty. *c.* 1190–1160 BC. A life-size figure of King Ramesses III hunting wild bulls, from the sandstone sunk relief on the rear wall of the first pylon. The influence of painting on relief carving is seen in the way the bulls are partially concealed behind the rushes, and in the creation of a naturalistic setting which connects the row of the king's archer attendants with the main scene.

82 (opposite). **Vestibule of Kom Ombo.** Ptolemaic period. *c.* 145 BC. The picturesque temple at Kom Ombo was erected as a twin sanctuary to two gods, the crocodile-headed Sobek, and the falcon-headed Haroeris. The ten pillars of the double vestibule have richly decorated 'flower bunch' and palm-frond capitals.

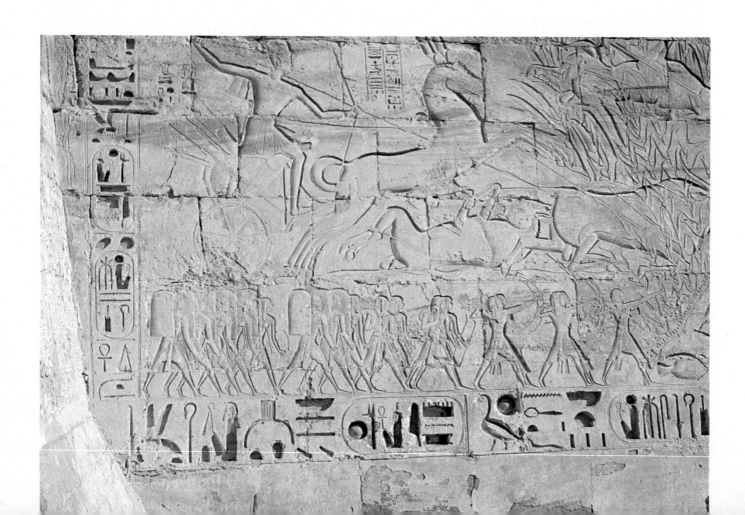

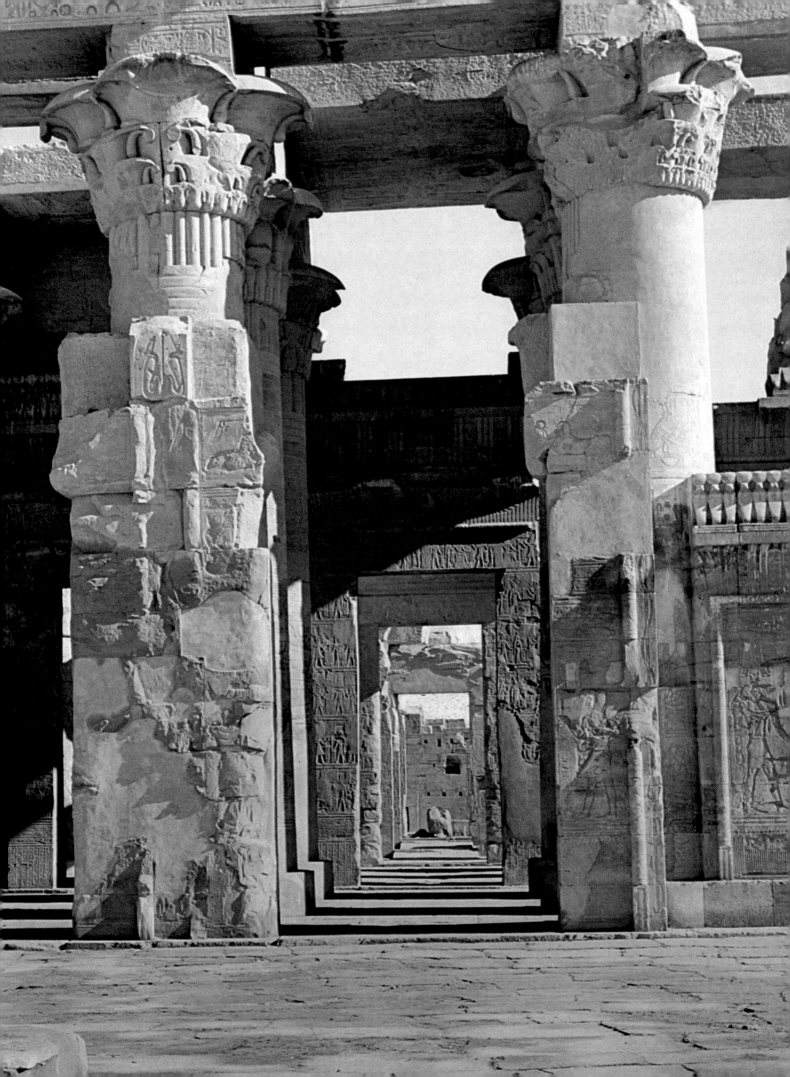

83. **Head of Taharqa.** Twenty-fifth Dynasty. Black granite. h. 13¾ in. (35 cm.). Egyptian Museum, Cairo. The remarkable sculpted head of the Nubian King Taharqa (*c.* 690–666 BC) is all that remains of a standing figure. The forcefully modelled negroid features are an indication of the racial origin of the Nubian leader. The Nubians rejected the somewhat effete taste of the New Kingdom, and strove to return directly to the classical sources of the Old Kingdom. Their sculptors were less preoccupied with the effects of light and more concerned with volume and realism.

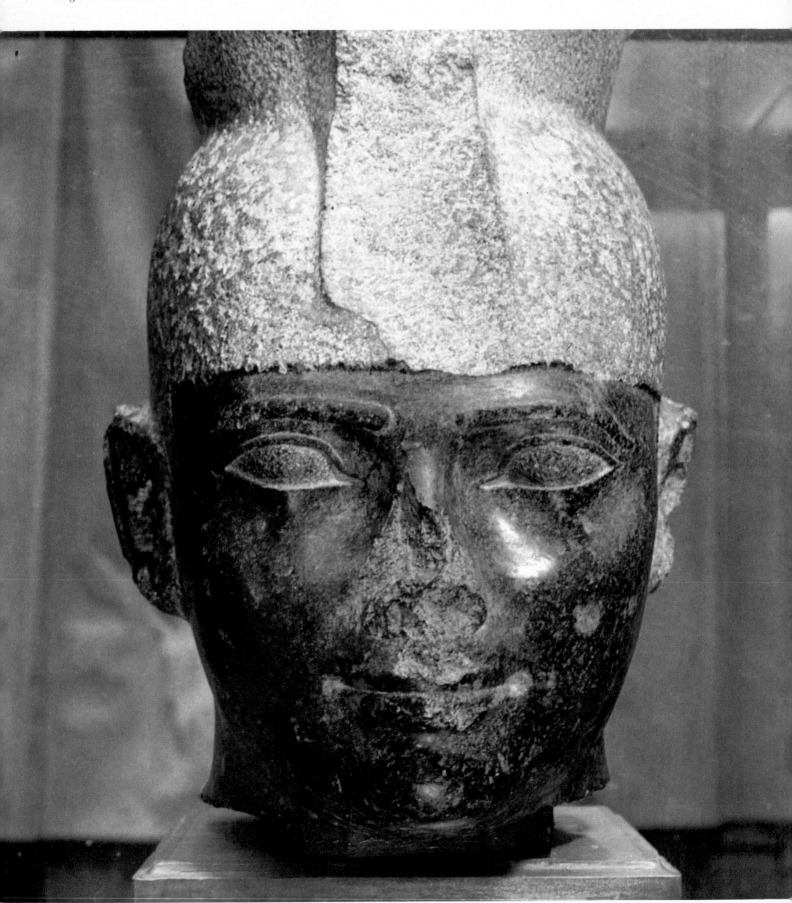

example of late predynastic art. The vast surface displays a loosely arranged ensemble of separately conceived scenes. This work belongs to a phase of stylistic freedom in which the artists were still unaware of the problem of space; compared with later works the scenes seem almost to float in mid air. The range of themes found in these paintings anticipates all the main features of the early dynastic art of Egypt. The motifs include the crescent-shaped boats familiar from Gerzean pottery, goats with long curved horns, and a standing figure flanked by two confronted animals. This last feature is clearly of Sumerian origin; it recurs in *86* an even more emphatic form in an ivory knife handle from *85* Gebel el-Arak. Moreover, the Hierakonpolis painting boasts several battle scenes. These include duals between individual warriors which in some cases may be regarded as successive episodes of the same story, as well as the figure of a warrior brandishing a mace so as to strike three conquered enemies who are rendered in smaller scale. This last is the earliest instance of a theme that was to be typical of Egyptian dynastic iconography and was ultimately to be exported to western Asia.

85 The themes of the Hierakonpolis painting recur, often in more advanced form, in other monuments of this period, *87,88* such as the Oxford, Narmer and Hunters' palettes. Narmer is usually identified with Menes, the first known pharaoh of the dynastic period and his palette provides a key for the understanding of much later Egyptian art. The old jumble of scenes is replaced by a clear division into horizontal registers, the heights of which correspond to the relative importance attributed to the scenes contained within them. Further, the strip dividers serve as base lines which firmly anchor the figures; the 'floating quality' of predynastic art is banished. The appearance of several hieroglyphs on the *88* palette shows the close connection between writing and art in Egypt. The two were perfected simultaneously at just this time and they were always to be closely interrelated. Having examined some of the leading stylistic qualities of this art we must now pay some attention to its content. For the first time in history, the predynastic Egyptians employed images to record actual events. The hard-fought battles that led to the unification of the 'two lands' are concretely reflected in the monuments that have been examined and the addition of the hieroglyphic name of the king shows a conscious effort to narrate history found only later in Mesopotamia. The emphasis on the pharaoh, whose exalted rank is appropriately symbolised by the fact that he is so much bigger than the other figures, heralds the rise of the art of monumental sculpture in the first dynasty.

EARLY DYNASTIC ARCHITECTURE

The kings of the first dynasty moved their capital from Hierakonpolis to This near Abydos, also in Upper Egypt. Archaeologists have uncovered cemeteries at Abydos, but these consist of cenotaphs only, the actual burials being in the north at Saqqara near Memphis. The cemeteries and the scenes depicted on monuments tell us something about

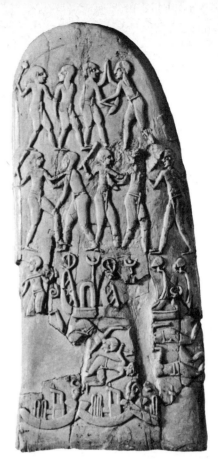

86. **Ivory knife handle from Gebel el-Arak.**
Predynastic period. *c.* 3200 BC. h. of knife 11 in. (27·9 cm.). Louvre, Paris. The ivory handle of this flint knife is carved on both sides with scenes of warfare and hunting. The side illustrated shows figures of two different warring groups, slain warriors, and ships of both foreign and native type.

87. **Small decorated palette from Hierakonpolis.**
Late Predynastic period, *c.* 3150 BC. Slate. h. 17 in. (43 cm.). Ashmolean Museum, Oxford. The Oxford palette is smaller than the Narmer palette (figure 88). It is carved on both sides with a pair of *canidae* (possibly hyenas) embracing a scene of real and imaginary animals. Among them a person dressed as a jackal plays a wind instrument.

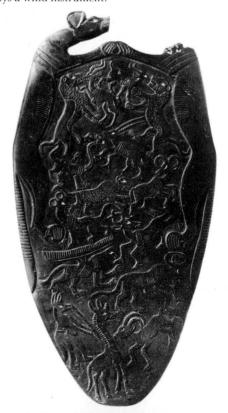

the earliest Egyptian architecture. The ordinary tombs, known by the Arabic name of *mastaba* (bench), take the form of a low truncated pyramid with one or more rooms inside. A more complex form, which at least in the exterior treatment seems to imitate secular buildings, appears in the royal tombs. These large structures of rectangular plan, with their various inner chambers placed at different depths, are built of unfired brick. The outside is enlivened by a series of buttress-like projections and narrow recesses. Thus they are a clear imitation of Mesopotamian architecture even as far as the material used. This indentation of the walls with alternating zones of light and shade, appealed for a time to the southern love of colour. But a tradition that was completely alien to Egypt could have no long-term prospects of success.

9 The critical phase of this architecture is represented by the step-pyramid built by Imhotep for the famous 3rd-dynasty pharaoh Zoser at Saqqara. Imhotep, who is the first architect known to history, was famous in later times as a paragon of wisdom. The step-pyramid, which was created by superimposing six *mastabas* of decreasing size, reveals a striving after grandeur fully realised by the imaginative use of existing forms. The greatest novelty lies in the fact that stone construction is widely used here for the first time. This meant the abandonment of a material hallowed by centuries of use but found to be inadequate for the needs of a fast growing society.

In the 3rd dynasty the capital was moved to Memphis in the north and this shift coincides with the advance signalled in the Zoser monument. The South Egyptian love of ornament is everywhere apparent in Zoser's funerary complex: the walls of the chapels are revetted with half-columns, sometimes fluted and sometimes ending in capitals

in the form of a papyrus blossom. But because this monument stands at the borderline separating two stages of culture, it also serves as a significant pointer towards later practice. The smooth and elegant surface of the high walls, delicately accentuated by the slender half-columns, is already far from the massive niched faces of Mesopotamian tradition. The heavy black and white effect has been rejected in favour of a surface almost devoid of shading, foreshadowing the geometrical purity of the Fourth-dynasty pyramids of Giza. **10**

EARLY DYNASTIC SCULPTURE

The early dynastic period saw the appearance of the first monumental sculpture. A comparison of one of the two nearly identical surviving statues of the pharaoh Khasek- **89** hem (2nd dynasty) with a predynastic statuette in Oxford **90** shows the enhanced importance given to the figure and concept of the king in early dynastic Egypt. The statues of Khasekhem are considerably less than life-size and not much larger than the predynastic piece, but they radiate a powerful, though incompletely realised impression of monumentality—a quality altogether absent in the predynastic figure. The attitude of the enthroned pharaoh, **89** the strong characterisation evident in the side view where the apparent depth of the statue is increased, the greater attention to facial features—all these are typical of royal statuary of the period. In fact they reappear in almost ex- **90** aggerated form in an image of Zoser himself. In this piece **91** the head is treated in an expressionistic manner (though the torn eye-sockets are the result of damage in modern times), while the rest of the body almost merges with the inert mass of the throne, which dominates the side view. Like the funerary monument of Zoser, this statue ap- **9**

88a, b (opposite). **Palette of King Narmer from Hierakonpolis.** First Dynasty. *c.* 3100 BC. Slate. h. 26 in. (66 cm.). Egyptian Museum, Cairo. *(a)* The reverse shows King Narmer wearing the White Crown of Upper Egypt, brandishing a mace and slaughtering a foe. Above is the falcon god Horus. *(b)* The obverse shows the king in the Red Crown of Lower Egypt in procession, a central design of two serpo-pards with intertwined necks, and, in the bottom register, the king as a bull breaking down a township. The king's name appears at the top between two Hathor heads.

89 (below). **Basalt statuette.** Predynastic period. *c.* 3300 BC. 15¾ in. (40 cm.). Ashmolean Museum, Oxford. This figure of a man or a god, generally ascribed to the Predynastic period, is of unknown date and origin. Comparison with the portrait statue of King Khasekhem (figure 90) shows a certain rigidity in this finely sculpted piece. This type of statue was probably the inspiration for the Sumerian temple statues (see figure 7).

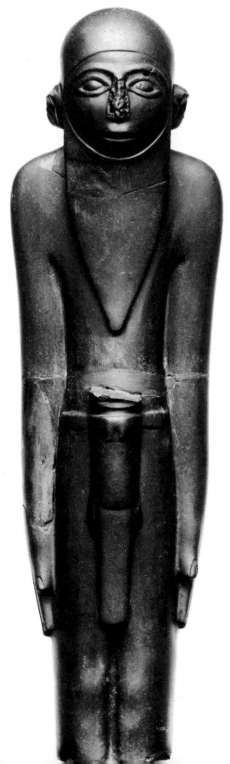

proaches the limits of the expressive resources of early dynastic art.

Relief sculpture also displays qualities that we may justifiably term expressionist, though it must be borne in mind that no allusion to modern art movements is intended: as used here, the term implies a formal simplification designed to heighten the emotional impact on the observer. In the figures of conquered enemies carved on the bases of the statues of Khasekhem the vivacity of movement is so 89 successfully captured that we forget their unnatural posture, and the incongruity of finding such decorative figures on a monument which aims at sombre majestic grandeur. It should be remembered that the loose but supple postures of the prisoners were already present in the late predynastic period (compare the lower part of the back of the Narmer 88 palette), so that after the close of the early dynastic period this theme could easily be integrated into the normal decorative repertoire. Another aspect of the expressionist trend occurs in a female figure depicted on a funerary stele of the 2nd dynasty from Saqqara; the slender body is weighted down with an enormous mass of minutely detailed coiffure. An exception to this general tendency is a work that has been regarded as a masterpiece of early dynastic art, the stele of Djet, the Serpent King of the 1st dynasty. This work excels in its delicate balance of clear and simple forms.

THE OLD KINGDOM: THE PYRAMID AGE

The 4th dynasty (2600–2480 BC) marks the beginning and the culmination of the art of the Old Kingdom. At this time the stylistic devices accumulated in the early dynastic period were completely revised, the older modes being replaced by a different style corresponding to a changed outlook. The immediate representation of reality yielded to a more detached and abstract treatment. The great works of art of the period were to achieve a perfection of form that was to provide a firm point of reference for the future.

In architecture the typical expression of this artistic concept is provided by the three colossal pyramids of Giza 10 built by the pharaohs Cheops, Chephren and Mycerinus. 11,12 The crystalline simplicity of these structures was the product of a long period of experimentation. Ever since their completion they have symbolised the enduring presence of Egyptian civilisation. The abstract rationalism of this architecture, which is normally restricted to purely geometrical forms of expression, is also found in quite different buildings, such as the pillared hall adjacent to the pyramid of Chephren. Here space is marked off into box-like units by a series of immense monoliths forming severely rectan- 67 gular pillars and lintels.

It is understandable that the uncompromising ambitiousness of these buildings, which naturally presupposed an enormous concentration of economic and political resources, could not be maintained indefinitely. The crises that began at the end of the 4th dynasty and continued through the 5th and 6th dynasties (2480–2200 BC) were not without consequences. Unfortunately scholars have not yet

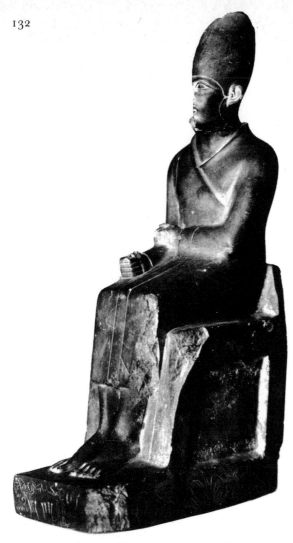

**90. Seated statue of King Khasekhem from
Hierakonpolis.** Late Second Dynasty. *c.* 2700 BC. Green slate.
h. 22 in. (56 cm.). Egyptian Museum, Cairo. The king,
wrapped in a long cloak and wearing the White Crown of
Upper Egypt is seated upon a cube-shaped throne. Together
with an almost identical limestone statue in Oxford this
representation of King Khasekhem is the earliest known
example of royal portrait statuary. The base of the throne is
decorated with sketchily incised figures of slain enemies.

discovered the origins of these crises. They are reflected
in the gradual retreat of the aristocratic and ideal concep-
tion that left its stamp on so many works of the 4th dynasty.
In architecture the great obelisk of the pharaoh Neuserre at
Abu Ghurob (5th dynasty) is clearly a variation on the
pyramid and would have been unthinkable without the
precedent of the Giza monuments. In essence, however, the
Abu Ghurob temple is not as close to the great 4th-dynasty
pyramids as it is to Zoser's 3rd-dynasty step-pyramid. It is
an eloquent example of a brilliant idea realised with
neither the remote grandeur of the 4th dynasty nor the
human scale of Zoser's monument.

OLD KINGDOM SCULPTURE

The essential features that we have observed in Old King-
dom architecture recur in other branches of art. In sculp-
ture the most intellectual work is perhaps the diorite statue
92 of Chephren in Cairo. In accordance with the established
formal conventions, the pharaoh is portrayed frontally
enthroned with the left hand flat on the thigh and the right
91 hand clenched. Compared with the figure of Zoser illus-

trated earlier, the Chephren statue lacks expressive power.
Meticulously naturalistic, it nevertheless lacks warmth, the
anatomical features and the details of dress serving only to
create symmetries, geometrical correspondences and well
placed areas of light and shade. The falcon, a symbol of
royal power, who perches behind the ruler's head and is 92
visible only in the side view, confirms the abstract and
symbolic interpretation of the work. This ideal treatment
of the human figure, presented not for its own sake but as an
emblem of the dignity of the person portrayed, is found to a
greater or lesser extent in other works; such as the so-called
'reserve heads' and the statues of Ranefer. 93,94

These formal characteristics are less faithfully observed
in the many sculptures which satisfy other more expressive
and human needs. The statue of Cheops' vizir Hemon, for
example, though it follows a scheme quite close to that of
the seated pharaoh, conveys a profoundly different feeling.
The stress on the fleshy folds of the figure produces a soft-
ness of modelling that contrasts with the rigid cube of the
chair and deprives the figure of any sense of monumental-
ity. Somewhat similar results are achieved through other
means in the magnificent statues of Rahotep and his wife **68**
Nofret. Even if the aim was for solemn monumentality, this
is diminished by the introduction of descriptive detail and
colour. This tendency is particularly evident in the expres-
sive figure of the woman whose dark mass of hair and
strands of the necklace contrast so strongly with the white-
ness of her garment. To this must be added the very subtle
modelling discernible beneath the dress and the nuances
achieved through the use of white on white. These features
help in a sense to idealise the figure, but in a softly sensuous
way that is emphasised by the pliant contour lines blurring
all sharp angles.

To this category of less abstract, more human idealisa-
tion belong such figures as the prince Ankhaf and, in the 95
last analysis, the figures of Mycerinus and his queen. A 96
place apart is occupied by the famous statue of the seated
scribe in the Louvre. The surface naturalism of the figure
combines so well with the clearly underlying geometric
scheme that the result is markedly different from the
diorite Chephren. The figure of the scribe achieves a meas- 92
ure of taut alertness, emphasised by the bright piercing
eyes, which is absent in the official rendering of the pharaoh.

These figures are paralleled, especially during the 5th
and 6th dynasties, by a large number of lively informal
statues which may be regarded as provincial art. The per-
sons represented are high state officials, not princes, but the
compositional schemes are borrowed from the court art.
These figures are governed by a different attitude; they
reflect a way of life that is more down to earth than that
conducted at the pharaoh's court. In this category we can
include the wooden statue of the 'Sheikh el-Beled', the 98
sculptured group of the dwarf Seneb and his family. 97
These are domestic portraits in which official dignity has
given place to informal ease, and individual features are
observed with clarity, even affection.

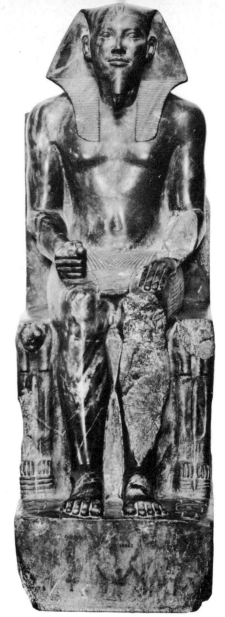

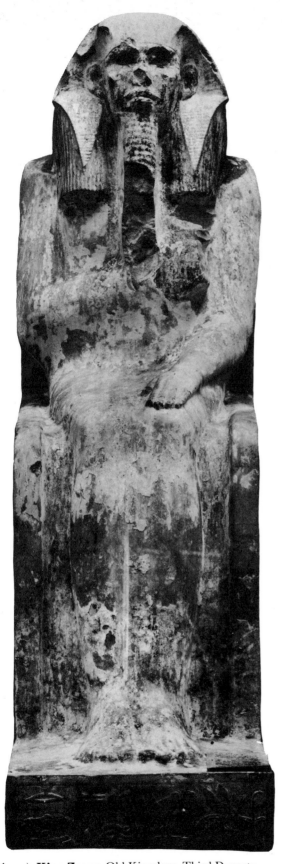

92a (above), b (below). **King Chephren.** Old Kingdom, Fourth Dynasty. *c.* 2560 BC. Dark green diorite. h. 66 in. (167 cm.). Egyptian Museum, Cairo. *(a)* This seated portrait statue was found in the Valley Temple of the king's pyramid at Giza (see plate 67). The throne has lion legs, with a maned lion's head surmounting them. Above the brow is the erect forepart of the divine serpent or *uraeus*—symbol of royal power. *(b)* In profile the falcon god Horus is clearly seen perched behind the royal figure, transmitting his strength to the ruler.

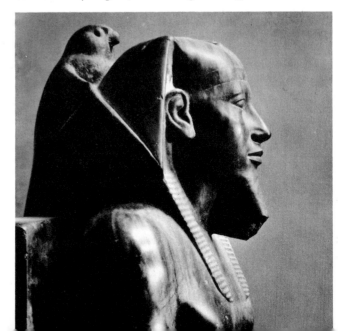

91 (above). **King Zoser.** Old Kingdom, Third Dynasty. *c.* 2650–2630 BC. Limestone. h. 55 in. (140 cm.). Egyptian Museum, Cairo. The impressively individual statue of the Pharaoh found in the statue-chamber on the north side of the step-pyramid at Saqqara still bears traces of colouring: white on the mantle, brown on the skin and black on the hair. The eyes were formerly inlaid. The title and name of the king are inscribed on the pedestal.

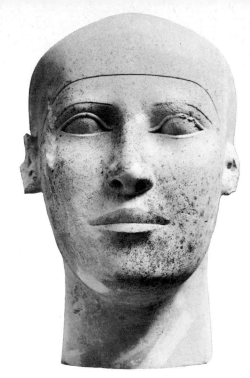

93 (above). **Reserve head of a prince from Giza.** Old Kingdom, Fourth Dynasty. *c.* 2600–2480 BC. Limestone. Life size. Museum of Fine Arts, Boston. One of a group of so-called 'reserve' heads found in the tombs of Cheops' and Chephren's families at Giza. The hair is depicted like a close fitting cap and the eyes are not inlaid. It is thought that 'reserve heads' were put into the tombs, in case the actual mummified head of the deceased was to be disturbed or damaged.

94 (right). **Ranefer, High Priest of Ptah.** Old Kingdom, Early Fifth Dynasty. *c.* 2400 BC. Limestone. h. 73 in. (185 cm.). Egyptian Museum, Cairo. One of the best examples of idealistic Memphite statuary, this figure still preserves traces of paint, and is one of two found in the priests' tomb at Saqqara.

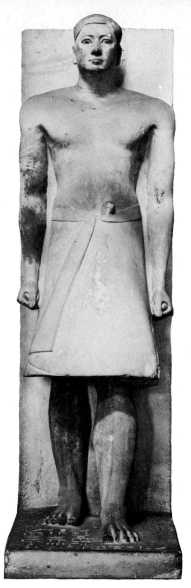

It is significant for the political and cultural history of Egypt that towards the end of the Old Kingdom this provincial tendency (which clearly constitutes the opposite pole to the formal trend of the statues of the 4th dynasty) was officially adopted by the pharaohs themselves, as in a votive statue of the kneeling Pepy I in the Brooklyn Museum. To realise the distance travelled from the 4th to the 6th dynasty it is enough to note that in an alabaster *99* statue of the same Pepy I, the traditional scheme of the *92* enthroned pharaoh is reduced to a kind of play-acting; compared to Chephren's falcon the bird that accompanies Pepy seems more like a gentle dove.

OLD KINGDOM RELIEFS

One of the art forms most typical of the Old Kingdom is relief carving. The walls of private tombs and those of the funerary temples built by the kings are embellished with narrative reliefs accompanied by inscriptions. Royal monuments emphasise the public and religious acts of the king with the aim of recording his glory for all time to come. In the non-royal tombs, however, one finds scenes from daily life in which the deceased, shown in larger scale than other men, seeks to comfort himself during his residence in the tomb. The reliefs, always very low, are often coloured. The absence of depth and chiaroscuro means that there is no real difference between relief and painting, both being simple two-dimensional renderings.

Egyptian funerary scenes aimed at narrative and this explains their exclusion from the royal funerary temples of the 4th dynasty. An art directed towards the grandeur of absolute abstraction could not be reconciled with the incidents of everyday life. Reliefs existed as early as the third dynasty (one shows Zoser competing in a jubilee ritual) and during the 4th dynasty some appear in private tombs. The reliefs of the tomb of Khufukaf and his wife display a fine sensibility. To the beginning of the fifth dynasty belong the reliefs of the funerary temple of the pharaoh Sahure at Abusir; together with representations of hommage there are battle scenes showing rows of prisoners, fallen enemies, etc. These scenes convey a sense of human participation in the events (though this does not imply pity for the vanquished) and a stylistic flexibility that departs from the somewhat chilly perfection of the preceding phase. The provincial and realistic trend seen in the sculpture of the 5th and 6th dynasties recurs in many reliefs showing work in the fields and other scenes of daily life. In such tombs as those of Akhhotep, Ptahhotep and Mereruka (all at Saqqara), where the scenes are arranged in rows, there is no lack of vivid incidents. None of these, however, reaches quite the level of refinement of the decorations of the tomb of Ti at Saqqara (5th dynasty). *100*

If the Egyptians drew no hard and fast distinction between relief and painting, inasmuch as the reliefs were normally fully painted, the Old Kingdom does offer a few

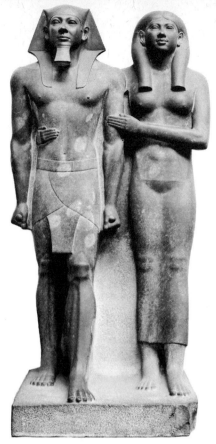

95. King Mycerinus and Queen Chamerernebti.
Old Kingdom, Fourth Dynasty. *c.* 2510 BC. Schist. h. 56 in.
(142 cm.). Museum of Fine Arts, Boston. This appealing group
portrait is finely modelled, though the surface is only partially
polished. It was found in the king's Valley Temple at Giza.
The appearance of the queen at the side of the monarch gives
the sculpture a more informal, intimate quality contrasting
with the solitary grandeur of the Chephren piece.

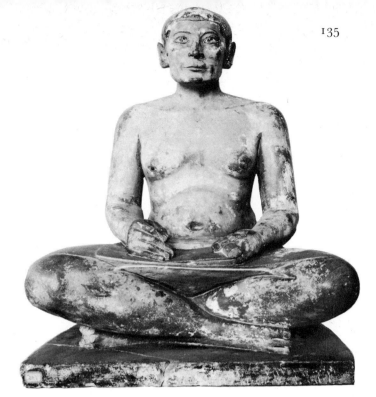

96. Statuette of a noble from Saqqara. Old Kingdom,
Fifth Dynasty. *c.* 2470 BC. Limestone, painted. h. 21 in. (53 cm.).
Louvre, Paris. The nobleman depicted as a scribe holds a
papyrus scroll in his left hand, and his finely detailed right hand
once held a reed writing implement. Many other statues of
this type have been found, all in the same cross-ledged
position. The inlaid eyes of this statue give an impression of
alert intelligence.

examples of pure painting. Of these the delightful frieze of
85 geese from Medum is perhaps the best known.

THE MIDDLE KINGDOM: HISTORICAL BACKGROUND

The end of the 6th dynasty (*c.* 2200 BC) signals the begin-
ning of more than a century of civil strife in Egypt. During
this so called First Intermediate Period (7th–10th dynas-
ties) the power of the pharaoh gave way to the precarious
authority of local chieftains who were constantly fighting
among themselves. This crisis was finally overcome by the
energy and determination of the Theban ruler Mentuhotep
I, who reunified Egypt and founded the Middle Kingdom.
Although political stability was assured for a long period
(11th–13th dynasties, *c.* 2080–1640 BC), the total confidence
of the Old Kingdom could not be regained. The earlier
attitude, which was based on a robust faith in the stability
of the existing order as incarnated and sustained by the di-
vine pharaoh, had been shattered by the violence that swept
Egypt. Thus it seemed that the old order was not exempt
from decay and destruction. But in reality, the feudal period
—and the First Intermediate Period was just this—saw the
peak of a crisis already latent in the 5th, and especially the
6th dynasty. The social conflicts that were to wreck the Old
Kingdom gradually emerged as the court nobility began to
usurp political and religious prerogatives that formerly be-
longed to the pharaoh alone. Once a climate of self-seeking
came to be accepted it was inevitable that men from social

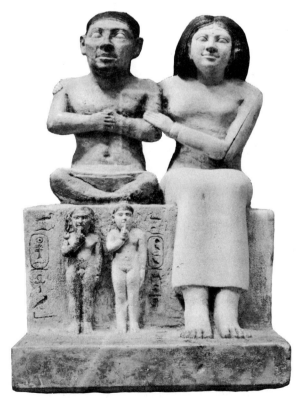

97. The dwarf Seneb with his family. Old Kingdom, Sixth
Dynasty. *c.* 2350–2200 BC. Limestone, painted. h. *c.* 13 in.
(33 cm.). Egyptian Museum, Cairo. Found in the dwarf's tomb
at Giza, this family group shows the tendency towards realism in
sculpture. A person of standing at court, Seneb was buried in a
mastaba tomb, a privilege accorded to few private persons.

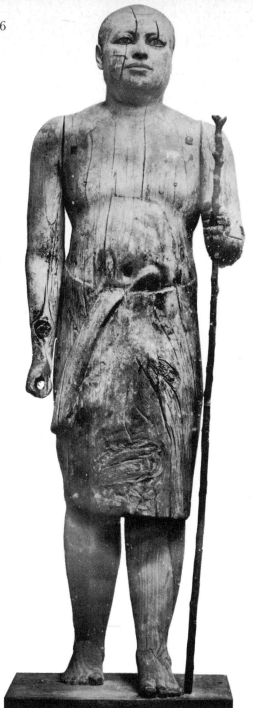

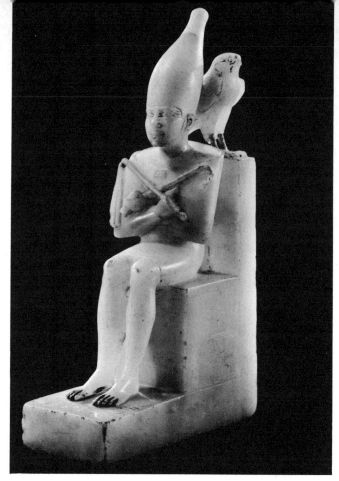

99 (above). **Statuette of Pepy I.** Old Kingdom, Sixth Dynasty. *c.* 2350–2200 BC. Alabaster. h. 10 in. (25 cm.). Brooklyn Museum, New York. The seated figure of Pepy I holds the crook and the flail of kingship in his crossed hands and wears the jubilee cloak and the White Crown of Upper Egypt. The falcon, perched on the back of the simple cube-shaped throne, is symbolic of the royal god Horus. This statuette incorporates the conventional attributes of statues of Egyptian rulers, but without the power and with more gentleness than the earlier works (see figure 92).

98 (left). **Kaaper, priest and high state official.** Old Kingdom, Fifth Dynasty. *c.* 2480–2350 BC. Wood. h. 43 in. (109 cm.). Egyptian Museum, Cairo. Commonly known as the 'Village Magistrate' or 'Sheikh el-Beled' because of the resemblance to the former headman of the modern village, this corpulent figure is a magnificent early example of sculpture in the round in wood. Both feet and the fore-part of the legs have been restored, and the knotted staff is not original. Of the original layer of stucco nothing remains, but the eyes are strikingly realistic, set in copper lids, now green in colour.

100 (below). **Relief from the tomb of Ti at Saqqara.** Old Kingdom, Fifth Dynasty. *c.* 2480–2350 BC. Limestone, painted. This is one of many brilliantly executed scenes in the tomb of Ti illustrating episodes from everyday life. The figures begin to overlap and the gestures are more lifelike than in earlier reliefs.

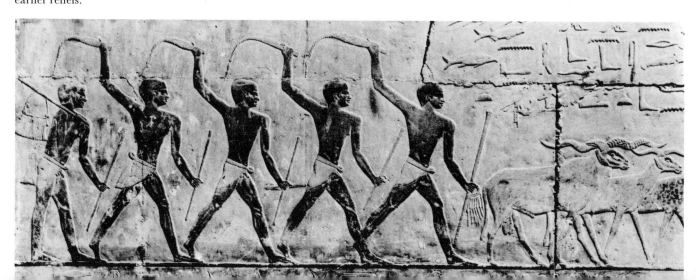

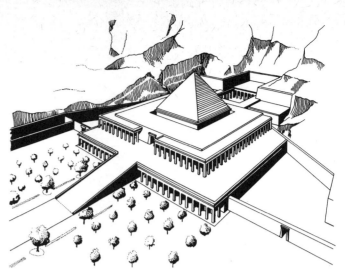

strata other than the high bureaucracy of the court would rise to prominence. The pessimism that runs through the literature of the Middle Kingdom, echoing the earlier time of crisis, points to the disillusionment of a nobility deprived of its privileges rather than to a widely felt need to create a new order. Nonetheless, there was one inescapable outcome; the loss of confidence in the divine stability of the world order led to a preoccupation with human weakness and changeability. Egypt's awareness of a superhuman dimension in life was replaced by an immediate confrontation with the realities of the human predicament. It is obvious that this new attitude could not serve as the basis for a harmonious civilisation comparable to the Old Kingdom world view nor, to cite a non-Egyptian parallel, the heroic humanism of 5th-century Greece. The inner contradictions of the Middle Kingdom, which were only apparently overcome during the long and successful reign of Sesostris I, the son of Amenemhet I the founder of the 12th dynasty, were ultimately to provoke a new crisis in the Second Intermediate Period.

THE ART OF THE MIDDLE KINGDOM

Art mirrors these changes quite faithfully. The meagre finds from the feudal period herald some of the features of the Middle Kingdom recovery. Iconographically, steles and funerary paintings still move within the bounds of the Old Kingdom tradition, with the banquet of the dead and scenes of life in the countryside. But the balanced harmony of narrative and structure conveyed by the older works yields consistently to a new sensibility in which love of vivacity and colour join with a naive story-telling. The attractiveness of the result is undeniable, but it lacks the integration that marks a solidly based style. Still, the naive experiments of the First Intermediate Period left their mark: descriptive detail was to be one of the main features of the style developed in the Middle Kingdom.

In the reign of Mentuhotep I of the 11th dynasty the foundations were laid for the creation of a viable artistic idiom capable of expressing the new aspirations of the court and of serving as a model for the country as a whole. But unlike Old Kingdom art, the central idea of the Middle Kingdom is hard to identify: its elements are highly complex and some features seem to be in open conflict with others. In fact the forces that shape the art of this period are very varied. The variety is not explained by invoking the existence of separate artistic 'schools' in north and south. Nor is it enough to emphasise the predominantly southern character of the new dynasty—this would be over-simplifying. We can, however, try to pick out some of the recurrent traits of the art of the Middle Kingdom.

In the first place, there is a real and lasting respect for the positive achievements of the Old Kingdom tradition, displayed both outwardly in the imitation of iconographic types and inwardly in the approach to an earlier stylistic manner. But these backward-looking trends could not yield results that were really satisfying. The Old Kingdom ex-

101. **Reconstruction of the funerary temple of Nebhepetre Mentuhotep,** at Deir el-Bahri, Thebes. Middle Kingdom, Eleventh Dynasty. *c.* 2070–2019 BC. The funerary complex of Mentuhotep consisted of a pyramid surrounded by a columned hall and ambulatory, the whole raised on a platform fronted by porticoes, and approached by a ramp. Behind the pyramid and on the same level was a colonnaded court and a columned hall cut into the rock, beneath which was the tomb of the king. This building served as a model for the temple of Hatshepsut (see plate 74).

102. **The Lady Sennuy.** Middle Kingdom, Twelfth Dynasty, *c.* 1991–1778 BC. Grey granite. h. 66 in. (167 cm.). Museum of Fine Arts, Boston. Sennuy's husband, Prince Hapijedfai, was governor of Kerma in Nubia during the reign of Sesostris I. This statue, found in his tomb, is of a quality which shows the influence of court workshops. The finely carved wig and beautiful features are outstanding in Middle Kingdom sculpture.

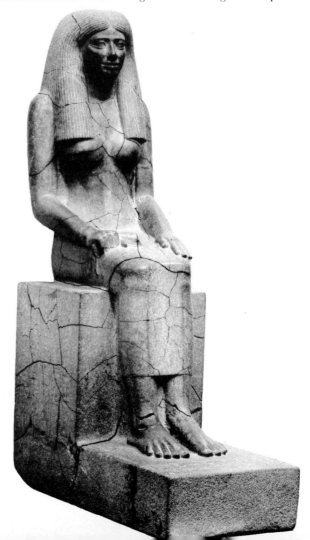

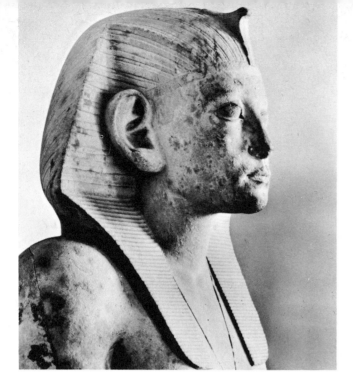

103. **Head of a seated figure of Amenemhet III.**
Middle Kingdom, Twelfth Dynasty. *c.* 1840–1792. Hard
yellow limestone. Full height of figure 63 in. (160 cm.).
Egyptian Museum, Cairo. This magnificent figure of
Amenemhet III executed in the Memphite tradition has a
serene, but almost sorrowful expression. The peculiarly large
ears may have been an artistic feature at the time (see figure 104).

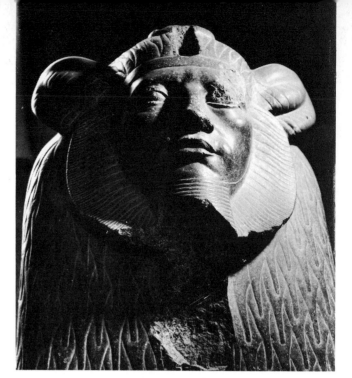

104. **Maned Sphinx of Amenemhet III.** Middle Kingdom,
Twelfth Dynasty. *c.* 1840–1792 BC. Black granite. h. 39 in.
(99 cm.). Egyptian Museum, Cairo. One of four similar
sphinxes found at Tanis, this has the best preserved facial
features. The face is framed by a stylised lion's mane, instead
of the usual royal headdress.

celled in its perfect dovetailing of particular modes of ex-
pression to a particular range of feeling. Now if there is any
single underlying theme in the Middle Kingdom it lies in
the tragic awareness of the inability to regain the serenity
which was typical of the Old Kingdom. The crisis of the
feudal period had destroyed forever a world that regarded
itself as perfect and unchanging. The sense of precarious
exposure and of human suffering is the new contribution of
the artists of the Middle Kingdom.

Unlike the earlier work, the portraits of the pharaohs and
the people of the Middle Kingdom seem almost to deceive
us by their physical reality. But in fact they are just as styl-
ised as their Old Kingdom predecessors: only the ideal has
changed. No longer do we have the pharaoh-god or the
man who feels confident of being able to maintain his vital
essence even in the tomb. Rather we are confronted with
the pharaoh-king, bravely militant or humanly wise, or
the subject who anticipates with serenity an after life very
much like the present. As long as the new content was
clothed in the representational forms of the Old Kingdom
the results were undistinguished and weak. But when the
new content acquired a more adequate form masterpieces
resulted.

In seeking to understand Middle Kingdom sculpture in
particular it is important to grasp that form is modelled
primarily to receive the light, which now assumes a dom-
inant role. Thus the self-contained volumes of the Old
Kingdom were eroded through greater modelling, and
softened by the play of light and shade. As in other phases
of the history of art—one instance is the Roman Empire in
the 3rd and 4th centuries of our era—contrasts of light and
shade provide a very effective means of dramatising the
nervous awareness of an age of anxiety.

THE ELEVENTH DYNASTY

The 11th dynasty has left few works of art and most of them
are linked with the name of pharaoh Mentuhotep I. Al-
though his funerary monument at Deir el-Bahri across the
river from Thebes is largely destroyed, its main elements
can be reconstructed. There were two large porticoed *101*
courtyards, one above the other; a pyramid stood in the
centre of the upper courtyard. Before the building complex
lay an open space planted with trees from which one could
ascend by a ramp to the first terrace. At the back, the sec-
ond porticoed courtyard opened in the rock face. The
Middle Kingdom favoured tombs carved out of the rock
with inner pillared corridors imitating those of free-stand-
ing buildings. The pharaohs continued to build pyramids,
but they were smaller and more often employed as an
adjunct than a main theme. An important work of sculpture
is the funerary statue of Mentuhotep I. The bright **72**
colours—white garments, red crown, brown flesh-tones—
and the squat proportions distinguish it from Old Kingdom
works. This statue which apparently found no real succes-
sors, irradiates a tremendous force achieved by simple
means freed from traditional bonds.

THE TWELFTH DYNASTY

The most important works of the Middle Kingdom come
from the succeeding 12th dynasty. The colossal statue of
Amenemhet I amounts to a stylistic compromise between
imitation of the Old Kingdom and the new feeling for sur-
faces modelled in light and dark. With Sesostris I, however,
the several trends are clearly revealed. There are some
figures of Sesostris I, standing or enthroned, that go back
directly to Old Kingdom models; they remain cold and un-
integrated, inasmuch as their preoccupation with effects of

light and shade destroys the massive quality so essential to the Old Kingdom. Other figures, however, such as a headless one in New York and one in the British Museum, are more successful in integrating the two stylistic aspects. The London statue provides an ensemble of vibrant planes and light, in which the sculptor has caught the features of the ruler, in a state of pensive repose. In the New York figure the fine modelling goes hand in hand with the calligraphic detail of the garments, recalling what is possibly the finest work of this phase, the statue of Sennuy in the Boston Museum of Fine Arts. In the Boston figure there is again an emphasis on broken lines and sharp angles in the profile, but in the front view the body almost dissolves in the delicacy of the modelling, while the head with its heavy wig treated in soft and regular grooves expresses an ideal beauty that reminds one of Greek art. Not all the works of this period achieve this high standard of course, but it is significant that one of the rare architectural monuments to have survived, the Chapel of Sesostris I at Karnak, is conceived according to the same human scale. The reliefs decorating it—the hieroglyphs as well as the figure scenes—are strikingly lively.

The prevailing spiritual climate shifted in the reign of Sesostris II. Several portraits of this pharaoh and one of his wife Nefret convey an impression of monumentality in terms of full-bodied forms and heavy volumes, but a certain monotony emerges. What is stressed is not the king's humanity, but his strength and power. The rich and detailed handling of the wig of Nefret and the slight upward tilt of her face reflect the same motive. In these statues the balance achieved in the time of Sesostris I is gone. These imitations of Old Kingdom works show even more clearly the inability on the part of the sculptor to express genuine feeling, while those which are not in imitation of Old Kingdom works are hampered by an empty striving after lost grandeur.

The reign of Sesostris III witnessed a partial return to the level of quality established under Sesostris I and the innovations of this period were to be more fully exploited under Amenemhet III. Again the sculptors manipulate light to break up surfaces and accentuate the plastic modelling. But now, in the reign of Sesostris III, the chisel digs deeper and what had been a mere groove joining the luminous planes becomes a furrow that marks a brow, giving the face a scowling, tragic quality. The serene humanity of Sesostris I is now as far away as the stern implacability of the Old Kingdom pharaohs. This dramatic handling of light is accompanied by a wealth of surface detail, as can be seen in a statue in the British Museum. Here the model is once more Sesostris I, but the style has changed: whereas earlier there was a softness to the modelling there is now a rigid linearity, the firm planes of the surfaces lending the sculpture drama by means of strong chiaroscuro rather than through subtle curves.

These characteristics are further developed in the figures of Amenemhet III, the last great ruler of the 12th dynasty

105. **Sesostris III.** Middle Kingdom, Twelfth Dynasty. *c.* 1878–1841 BC. Granite. h. 59 in. (149 cm.). From Deir el-Bahri. Now in the Egyptian Museum, Cairo. The most striking features of this figure are the naturalistically furrowed brow, enormous ears and arms, and the ornament suspended from the king's neck. Sesostris is otherwise conventional in his dress with the *uraeus* on his hood and apron.

and of the Middle Kingdom as a whole. Some of his portraits follow in the same line as those of his predecessor, with the features of the face hollowed out and the expression tragic. Others, such as the Cairo figure in priestly costume and the portrait as a sphinx, with its careful handling of the accoutrements, add to the other qualities a baroque heaviness that emphasises its drama. A heightened sense of tonal contrast turns the ruler's features into a tragic mask.

In the latter part of the 12th dynasty a new style of painting made its appearance, a style that owed little to Old Kingdom precedents. In the tomb of Ukhotep at Meir, for example, the pattern of local colour areas is enlivened by changes of tone produced by a technique of stippling. A

106 particularly well preserved specimen of such work is the coffin of Djehuty-nekht, now in Boston.

The deep-seated insecurity of this period, which seemed to recede only during the long reign of Sesostris I, was manifested as we have seen in a variety of stylistic trends in the field of official art. The classic quality of Middle Kingdom art is the product of an unstable fusion of a glorious past, now almost mythical, and a present filled with uncertainty, despite the long period of peace and security.

THE SECOND INTERMEDIATE PERIOD

The end of the 12th dynasty brought a new reign of anarchy in Egypt, the Second Intermediate Period. It was then that the Hyksos, a largely Semitic people with a Hurrian admixture, invaded Egypt, establishing a state in the Delta with their capital at Tanis. The expulsion of the Hyksos from Egypt by a Theban dynasty led to a new reunification of the country and the founding of the New Kingdom (c. 1570 BC). Although this looks at first sight like a repetition of the events that ushered in the Middle Kingdom, the reality was rather different. The feudal period of the First Intermediate Period entailed the crisis of a society and its most cherished values, but the crisis could be overcome through a purely internal process. Guided by past events, the society of the Middle Kingdom felt a profound ethical obligation to renew, even if on a reduced scale, its inherited spiritual patrimony according to principles dictated by changed times. In the Second Intermediate Period, however, a new factor appeared, for the Hyksos invasion seems to have given Egypt her first true awareness of cultures other than her own. While a characteristic Egyptian reaction might have been one of chauvinism and national pride, at this period there was in fact a genuine desire for foreign values. This new receptivity was ultimately to lead to an infusion of new strength into an organism in which two deep and lengthy crises had left little room for adjustment. For the first time since the late predynastic period, Egypt began to play an active role in the politics and cultural life of the eastern Mediterranean and western Asia. This cultural interchange enriched both sides. In due course we shall see what Egypt gave to Asia, but here it is necessary to emphasise that, though remaining essentially faithful to her own nature, Egypt would have been unable to achieve what she did in the New Kingdom without the fresh currents from the east and north, that is from western Asia and the Aegean.

NEW KINGDOM COSMOPOLITANISM

These considerations bring us to a problem that is of central importance for the New Kingdom. We have mentioned the entry of Egypt into the lively international scene of the second half of the second millennium BC and the resulting exchange of ideas and techniques. Now in a period in which Egyptian religion, culture and language welcomed many ideas, inventions (such as the battle chariot and the cuirass), and words adopted from neighbouring countries,

it would be odd if art did not follow suit. But in fact, apart from a few instances of conscious imitation of Cretan fresco painting, Egyptian art was largely immune from foreign influence. This resistance can be understood if one thinks both of the way in which the art of the New Kingdom was formed in conscious reversion to the models of the 11th and 12th dynasties and of the strength of Egypt's age-old artistic traditions as a whole. But when, as in the Deir el-Bahri reliefs and the later historical scenes of the 19th-dynasty kings, we find something that is completely foreign to Egyptian tradition, though inserted in an otherwise completely Egyptian setting, we must ask whether some aspects of the art of the New Kingdom are not ultimately grounded in developments in Asia and the Aegean. This concerns not so much actual models, which in any case have not so far been found, as a new current of feeling that was diffused in Egypt. This new feeling amounted to greater freedom of expression, less rigidly tied to pre-established schemes. In Asia, of course, this freedom came into being because of the absence of a solid tradition such as Egypt enjoyed. In a new and freer Egypt the pharaoh's activity could be considered from a less abstract and symbolic standpoint. In this way a more human and consequently more historical approach became possible. The new trend can be traced from its first appearance in the reliefs at Deir el-Bahri to its culmination in the explosive novelty of the artistic and religious revolution created by Amenhotep IV (Akhenaton), which paved the way for the integration of this new trend into the traditional heritage in the court art of the 19th dynasty. This development did not necessarily imply the continuing presence of Asiatic models, whether or not they were available, but there can be little doubt that something new had entered the stream of Egyptian art in the New Kingdom.

THE EARLY NEW KINGDOM

The first artistic manifestations of the New Kingdom still moved in the wake of the latest works of the Middle Kingdom, a fact that is partially explained by the common Theban origin of the 12th and 18th dynasties. This continuity signifies, however, mainly that the long hiatus of the Second Intermediate Period had not removed any of the problems inherited from the Middle Kingdom. The best statues of the period, with their delicate modelling and studied effects of light, may recall the Amenemhet III and similar pieces, but they lack the dramatic urgency of their predecessors. Formal beauty goes along with an expression of serenity that evades difficulties rather than solves them.

The true point of departure for the art of the New Kingdom is the reign of Queen Hatshepsut (1501–1480 BC), which was crowned by the completion of her great funerary temple at Deir el-Bahri. The first thing to notice 74, 75, 76 about the temple is the site itself. Designed by the architect Senmut, the vast complex stands beside Mentuhotep's 101 Middle Kingdom funerary temple. The latter must have served as the model, but in the course of building operations

106. **Painted coffin of Djehuty-nekht.** Middle Kingdom, Twelfth Dynasty. *c.* 1991–1778 BC. Wood (probably cedar). Museum of Fine Arts, Boston. The inside of the lid of the outer coffin of Djehuty-nekht, from el-Bersheh. The outlines of the figures are unusually fine, the hieroglyphs neatly ordered, and the matting patterns of the false door on the left minutely detailed. The door with the eyes above is repeated in the same position on the outside of the coffin, and on the less decorated inner coffin, so that the mummy had a magical means of leaving and entering the burial place.

107. **Queen Hatshepsut.** New Kingdom, Eighteenth Dynasty. *c.* 1501–1480 BC. Black granite. Life size. Metropolitan Museum of Art, New York (Rogers Fund, 1930). Many of the statues of Queen Hatshepsut depict her as a man with the attributes of royalty. This piece, found in her mortuary temple at Deir el-Bahri, shows her in a long cloak, wearing necklaces and the hood with the *uraeus* on the front.

the plans were changed. The great temple of Hatshepsut follows that of Mentuhotep in its basic structure, though the pyramid is omitted. The scale, however, is much more vast and the two terraces are preceded by a third huge terrace with its own access ramp. What had been for Mentuhotep a kind of experiment without immediate consequences, became in the hands of Hatshepsut's brilliant architect a superb instrument for a dramatic reshaping of landscape on a colossal scale. This concept necessitated the sacrifice of the pyramid, for the presence of its geometric shape (which in any case was obsolete) on a scale so much larger than that of Mentuhotep's monument would have spoiled the contrast of horizontal planes standing out sharply against the rough cliffs of the background.

Although the relief decoration on the piers and walls of the temple bears the stamp of court inspiration, reverting back to Old Kingdom traditions, there are important indications of a new trend. The attractive realism of some of the profiles, such as that of the queen mother Ahmes, and the narrative vivacity of scenes such as those depicting the Expedition to the Land of Punt are certainly innovations. The scenes of the Punt Expedition are particularly important: in addition to their freedom and liveliness, which permit a vein of gentle satire in the portrayal of the fat African queen, these reliefs represent the first appearance in Egyptian art of a fully individual theme treated on a generous narrative scale. Up to this time artists had restricted historically verifiable events to allusion, condensing the episode in one or more basic scenes and executing these in fixed schemes of symbolic character.

SCULPTURE IN THE REIGN OF QUEEN HATSHEPSUT

It is not surprising that the point of departure for the numerous statues representing Queen Hatshepsut is the court tradition harking back to models of the Middle Kingdom. This involves both the dress and the attitude of the sovereign, even extending to the artificial beard. Increasingly evident, however, especially in the face, is a predilection for modelling and for delicacy and refinement of expression; this is due partly to the queen's personal feminity and partly to a new interest in grace as a positive quality. A good example is provided by a seated figure in New York in which the artist has captured the sharply feminine features of the small face, emphasising also the breasts, despite the solemnity of the official mode in which he was working. Allowing for the great differences in historical setting, this work recalls the *galant* atmosphere of 18th-century France. The interest in formal novelty is also evident in a group of figures representing the vizier-architect Senmut with the little princess Nefrure. The established types of Egyptian statuary form the starting point for various attempts to integrate a second figure in schemes created for one figure alone. From what has already been said it should come as no surprise that the most successful solutions were the ones which used a flowing rhythm to escape from the constraint of tradition.

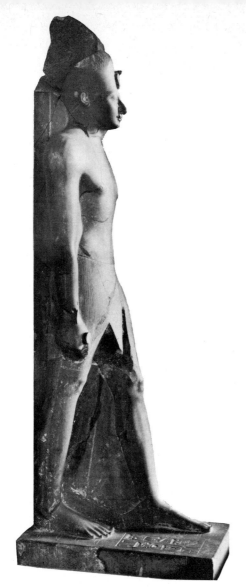

108. **Standing figure of Tuthmosis III from Karnak.**
New Kingdom, Eighteenth Dynasty. *c.* 1502–1448 BC. Hard
grey-green slate. 79 in. (200 cm.). Egyptian Museum, Cairo.
Comparison with the mummy indicates that this is a striking,
if stylised likeness to Tuthmosis III, with his distinguished nose,
and short neck. He wears the White Crown of Upper Egypt. The
base is carved with nine bows symbolising foreign nations.

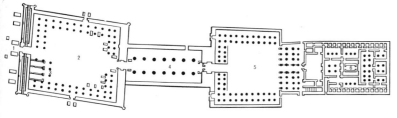

109. **Plan of the temple of Amon-Mut-Khons at Luxor.**
New Kingdom, Eighteenth Dynasty. All the buildings of the
temple constructed under Amenhotep III are disposed along a
single cardinal axis. The sanctuary of Amon (6) surrounded by
smaller halls and vestibules was approached through a great
court (5) (see plate 77) and a later colonnade of papyriform
columns (4) (see plate 78). The large first court (2) and pylon (1)
were constructed in the reign of Ramesses II and are on a line
7° east of the axis of the rest of the temple. This is partly because
Amenhotep's temple entrance was slightly askew, but probably
because Ramesses wanted to preserve the three earlier
sanctuaries of the sacred bark (3) and the columns of
Tuthmosis III.

THE REIGN OF TUTHMOSIS III AND AFTER

The tendency of the artists of Hatshepsut's reign to infuse a
refined grace into traditional forms increased under her
successor Tuthmosis III. The statues of this pharaoh dis- *108*
play a refined elegance obtained through a careful hand-
ling of light. They follow the lines established in the Middle
Kingdom, but the heavy shading yields to a subtle treat-
ment that seems to caress the rounded surfaces. A striking
example is the huge relief of the pharaoh destroying his
enemies which is carved on a pylon of the Temple of Amon
at Karnak; the figure of Tuthmosis III, set off by a shadow-
filled channel, stands out clearly from the other figures out-
lined in soft contours. Contrasts of light and shade and the
use of picturesque settings characterise the architecture of
this period, of which the temple of Amon at Karnak is one **79**
of the most typical and imposing examples.

The years between 1448–1377 BC, (corresponding to the
reigns of Amenhotep II, Tuthmosis IV and Amenhotep III),
were to witness a gradual stylistic development along the
lines suggested above. This was a period of ambitious build-
ing programmes. Under Amenhotep III the great temple
of Amon was constructed at Luxor. Because of its fine state **77, 78**
of preservation, this impressive complex gives us a good
idea of temple architecture at the height of the New King-
dom. The first thing which strikes the observer is the dis-
position of the buildings along a single cardinal axis. The
religious procession would enter the great court through
pylons, or towers with sloping faces, and proceed through
successively smaller enclosed spaces to the inner sanctuary,
the smallest chamber of all, to which access was limited to
a select few. The progression from large airy courts, **78**
through shadowy hypostyle halls to small confined spaces
is paralleled in the passage from light to shadow, from the
open to the confined, from the known to the secret. This
process can clearly be observed in studying the ground plan *109*
of the temple at Luxor.

The 'Colossi of Memnon', also erected by Amenhotep III **73**
to embellish his funerary temple again reflect his love of
grandeur. These statues, over fifty feet in height, were
carved from solid blocks of quartzite transported from over
four hundred miles away. Their very size is an indication of
how vast the temple must have been.

Sculptors, especially official sculptors, did not alter their
styles significantly until the last years of the reign of Amen-
hotep III; they were content with rather academic repeti-
tions of the elegant forms of official portraits of the early
rulers of the dynasty. An exception to such repetitious
sculpture is the head of Queen Tiy, together with a further
head in wood, perhaps portraying the same queen, where *110*
the graceful style of the court is suddenly abandoned in
favour of a more austere treatment. The important stylistic
advances of this period, however, are to be observed not in
its sculpture, but in painting.

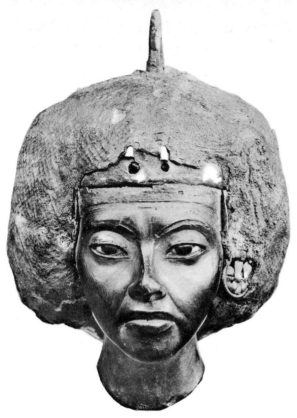

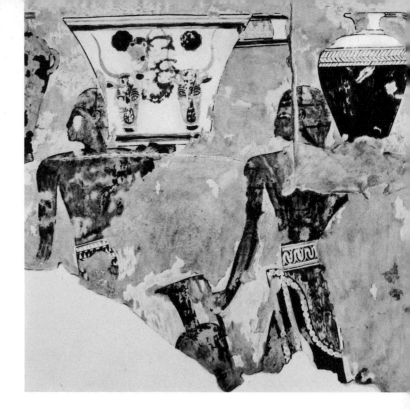

110. **Head of Queen Tiy.** New Kingdom, Eighteenth Dynasty. *c.* 1440 BC. Painted yew-tree wood, gold and inlays. h. 4¼ in. (10·7 cm.). From Medinet Gurob in the Faiyum. Now in the Staatliche Museen zu Berlin. This royal face has a disdainful, almost contemptuous expression. Queen Tiy was a commoner, the daughter of a priest of Min at Akhim, who became the chief wife of Amenhotep III. The eyes are inlaid, the earring is of gold and lapis lazuli, and the headcloth was covered by plaster and linen set with small blue beads.

111. **Tribute bearers.** Detail from a wall-painting in the tomb of the architect Senmut at Deir el-Bahri. New Kingdom, Eighteenth Dynasty. *c.* 1490 BC. During the Second Intermediate Period, and the first years of the New Kingdom, Egypt became increasingly aware of cultures other than her own. A new receptivity to foreign influences is reflected in this painting which shows tribute bearers carrying vases which are clearly Minoan. The decoration has been carefully and faithfully observed.

NEW KINGDOM PAINTING

Painting is one of the most important contributions of the art of the New Kingdom, not merely because of the large body of work that has been preserved, but because of the high level of artistic achievement. It is represented by illustrated papyri, painted sarcophagi and particularly by paintings decorating the tombs carved out of the living rock in the neighbourhood of Thebes. There were, of course, tomb paintings in the preceding periods, but the dominant form was the painted relief in which the essential form was set by the relief itself; paint, which was often worn away by time, merely added liveliness. In the cases where true paintings were executed, they were resorted to as substitutes for reliefs, which they imitated. But the physical conditions of the Thebes area, where the friable limestone was not well suited to relief carving, happily coincided with the development of new trends in the taste of the New Kingdom, which came to prefer lively narrative scenes, unhampered by tradition. Thus a new category of art came into being; the art of painting was emancipated from relief and became endowed with values of its own. The painting of the 18th dynasty shows the rapid development of an art that started from premises substantially the same as those of the Middle Kingdom, but that ultimately acquired the polished virtuosity of the works of the early Ramesside period.

The great Theban necropolis lies on the left bank of the Nile opposite the temples at Karnak and Luxor, from which the mummified bodies of the dead were rowed across in elaborate ceremony. It is here that the funerary temples of Deir el-Bahri and Medinet Habu are situated, and, in the famous Valley of the Kings, the royal tombs of the New Kingdom pharaohs. Nearby are the private cemetaries of the high officials of the court, at Deir el-Medina, Sheikh-abd-el-Qurna and el-Asasif. The paintings of the royal tombs were governed by rigid canons of iconography, and, while they were technically of the first order since the most accomplished artists were employed upon them, little scope was left for personal expression and descriptive freedom. This is why the private tombs are generally of greater interest to us, in the wealth of invention and narrative detail which they offer.

In the course of the two hundred and fifty years of the 18th dynasty, painting went through a number of stylistic phases, not always in a line of direct progression, a particularly manneristic period being followed by a resumption of formal order, with more than a glance backward to the code of conduct sanctified during the Middle Kingdom. Up to the reign of Queen Hatshepsut, paintings derive directly from traditional Middle Kingdom work. The colours are opaque, the gestures carefully measured and conventional, the composition symmetrical. In the tomb of Senmut, however, we see signs of Minoan influence. A scene of Cretan tribute bearers shows vases from Crete observed with scrupulous accuracy. The whole atmosphere

of the painting is a tasteful evocation of the Minoan style with the narrow-waisted figures familiar to us from the Knossos frescoes.

During the reign of Tuthmosis III a development occurred in the use of colour. Instead of flat areas of colour, variations of the same tint are used, and the figures show traces of modelling. The tomb of Rekhmire, vizier to the King, contains a variety of lively scenes depicting craftsmen of every trade—brickmakers, blacksmiths, metalworkers. Yet the draughtsmanship is still a little stiff, even if the composition is skilful.

By the second half of the fifteenth century BC, the liberation of the Egyptian painter was complete. If the earlier phases had been on the one hand formal, and on the other, tentative, by the time of Amenhotep II and Tuthmosis IV, the painter had left behind the conventional technique which had faced his predecessors. Brushwork shows signs of a true painters' concern with form as well as outline. Figures are grouped freely and informally, without regard to any established rule. If the subject-matter is repetitive—funeral banquets, dancers, workmen in the fields, its interpretation is personal and infinitely varied. An interest in landscape, new to Egyptian art, is reflected in a fragment from the tomb of Nebamun, now in the British Museum. Here a garden pool is depicted, with birds and fishes formally disposed upon its surface, as if from an aerial view, and the pool is surrounded by decorative flowering trees. The **88** famous tombs of this period, of the Scribe Nakht, of Menna, and of Horemheb are full of lively scenes to entertain the dead man in reminding him of the pleasant pursuits of his natural life. A favourite subject for illustration is a hunting scene in the marshes. The dead man, usually accompanied by his wife and daughters, propels a punt along a stream, which is prolifically occupied by fish and waterfowl. Spears and snares are used, and in one detail from the tomb of **87** Nakht we see a rare example of a clap net, sprung to, and full of duck. In a further scene in the same register the duck are being plucked and drawn to be preserved in tall vessels which stand ready. In another hunting scene from **89** the tomb of Menna a young girl stands at the stern of a boat, grasping her father round the waist to keep her balance, while in the other hand she holds a bunch of lotus flowers. An incredible richness of brown tones is set off by an off-white background, and the two extremes of the colour range are limited to the white of the girl's garment and the black of her hair. It is as if the dead man were invited to recall with almost sybaritic pleasure the good things of his life. A change was to occur, however, under Amenhotep III. There was undoubtedly a danger that the naive charm of the narrative scenes just mentioned could sink into academic insipidity. Artists were now to calculate problems of proportion, volume, line and colour, and the paintings and especially the reliefs, while showing the refinement characteristic of the New Kingdom are in danger of being frozen by the formal schemes imposed upon them. An example of this new phase is the painting in the tomb

of Ramose, vizier to Amenhotep III and during his early years, to Akhenaton. A scene of female mourners is strictly **91** limited in its colour range to shades of grey, with black and brown as the only other colours. This is a formal, elegant expression of grief.

Our survey of painting in the New Kingdom has revealed first a cautious advance of a new taste still concealed beneath the traditional iconography, and then works in which the new trends appear more openly and vigorously. Obviously there was during this period a kind of bubbling undercurrent which was sometimes quite apparent and at other times merely tinged the surface of traditional art. The first warning signs of an approaching crisis were to be followed in the reign of Amenhotep IV by a violent explosion in which all the new forces, suppressed until this point were joined.

THE AMARNA REVOLUTION

Amenhotep IV is an altogether unique figure in Egyptian history. This 'heretical' pharaoh, who was implacably opposed to official religion revolving around the Theban god Amon, founded and zealously propagated the cult of the sun god Aton. The complex tangle of Egyptian religion was to be replaced by the worship of one god alone. The pharaoh's new allegiance was symbolised by his change of name from Amenhotep, which incorporated the hated word Amon, to Akhenaton, 'the instrument of Aton'. Akhenaton's revolution made a violent break with the past inevitable. With its all-embracing claims the new religion was necessarily committed to rooting out many of the traditional manifestations of Egyptian civilisation. In an effort to escape from the atmosphere of the Theban court, the capital was moved to Akhetaton ('the Horizon of Aton'; the modern el-Amarna); a city that Akhenaton carefully laid out on a new site supposed to have been chosen by Aton himself. After Akhenaton's reign, however, his more orthodox successors abandoned the new capital.

The religious revolution of the Amarna period (so called after the capital of el-Amarna) had powerful consequences in the field of art, which effectively mirrors the revolutionary character of the age. The break with the past, which had been foretold in the previous reign and which the reforms of Akhenaton pressed to its logical extreme, appeared at first in art as a kind of direct challenge to the motifs and ideals of earlier official art.

The colossal figures of Akhenaton set up in the temple of *112* Aton at Karnak represent the first phase of the new art. The courtly grace of official sculpture is completely gone and the pharaoh's individual features—the narrow elongated face with its thick lips and the waspish body, its sunken chest and protruding hips—are rendered with such ugliness as to suggest caricature. It is important to recognise, however, that the Amarna art did not reject the rules of the preceding tradition out of hand, it only replaced some of the old rules with new ones. In fact the colossal

(Continued on page 161)

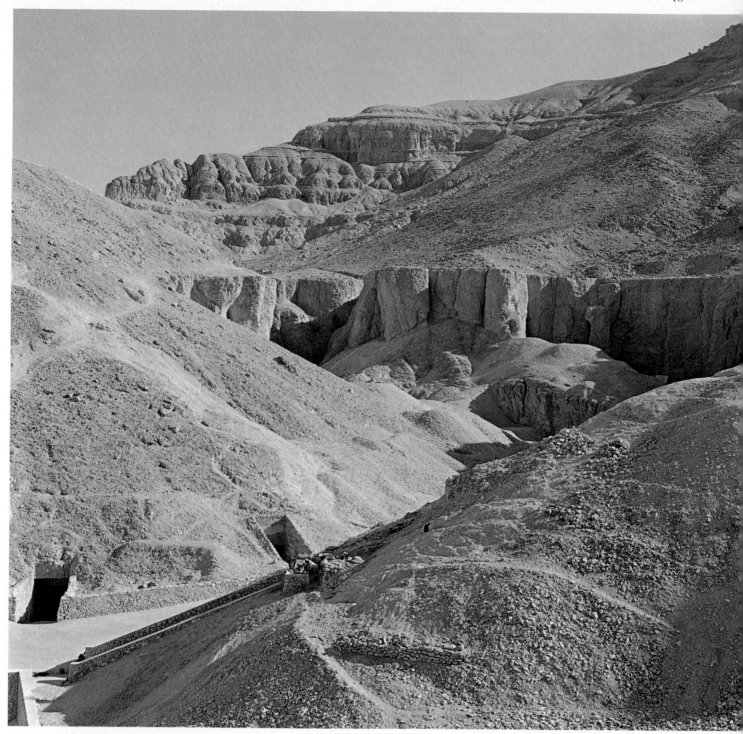

84 (above). **The Valley of the Kings at Thebes.** The tombs of the kings of the eighteenth, nineteenth and twentieth dynasties were channelled into the rock in a defile in the mountains behind Thebes. This 'Valley of the Kings' is dominated by the natural rock pyramid of the summit of El-Qorn (right). The tombs were cut into the rock in a straight line, often more than six hundred and fifty feet, and had a large number of pillared halls and small chambers. Behind the temple at Medinet Habu a similar valley concealed the tombs of queens and members of the royal family.

85 (above). **Geese in a marsh** (detail).
From the tomb of Itet at Medum, now in
the Egyptian Museum, Cairo. Fourth
Dynasty. *c.* 2600–2480 BC. Painting on
plaster. h. *c.* 8 in. (20 cm.). This rare
example of Old Kingdom painting shows
six geese in a frieze, three walking to the
right and three to the left. Although
somewhat stiffly posed, the geese are
carefully observed, and the details of
their colouring is most lifelike.

86 (below). **Servants trussing a dead
cow and bearing offerings.** Eleventh
Dynasty. End of First Intermediate
Period. Painting on plaster. 39 × 57 in.
(100 × 145 cm.). From the tomb of Ity,
now in the Egyptian Museum, Turin.
Ity's chapel at Gebelein was of simple
brick construction with a plastered barrel
vault. At the corners of the room slender

wooden columns were painted to suggest
that the scenes were taking place on the
walls beneath a canopy. The colouring
shows a change from the Old Kingdom,
being cruder and more violent in its
contrasts. The figures are more elongated
and diverse, though still rather stiff
in their attitudes.

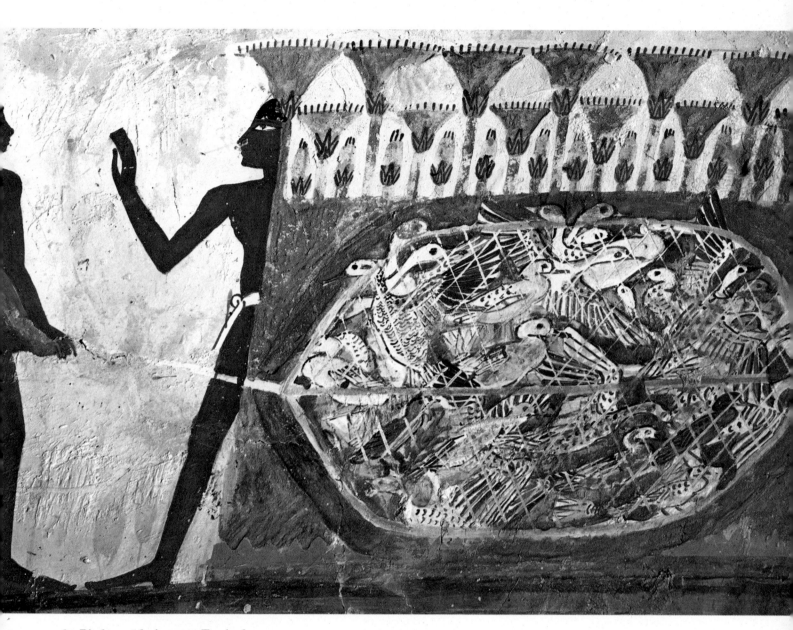

87. **Birds caught in a net.** Tomb of
Nakht, Sheikh-abd-el-Qrnah, Thebes.
Mid-eighteenth Dynasty. Painting on
plaster. This detail from a fowling scene
shows birds caught in a clap-net in the
marshes. The water is indicated by a line
of blue around the net, and the catch is
being drawn to the bank by a group of
servants. The ducks, heaped one upon the
other in convincing disarray are observed
with an impressionistic freedom far
removed from the rendering of the geese
in plate 85.

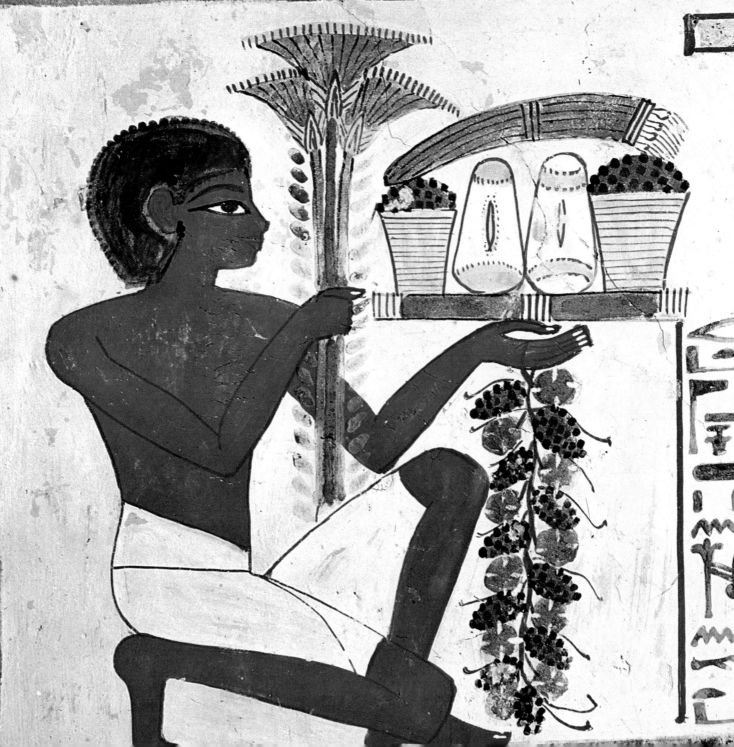

88 (opposite). **Offering bearer.** Detail from the south wall, tomb of Nakht, Sheikh-abd-el-Qrnah, Thebes. Mid-eighteenth Dynasty. Painting on plaster. In preparation for their life in the next world, the dead are plentifully supplied with food and drink, both literally and in painted representation. Here an offering bearer, one of a series of such figures decorating the south wall of the tomb, presents flowers and fruit.

89 (below). **Head of a girl with a lotus bud in her hair.** Tomb of Menna, Sheikh-abd-el-Qrnah, Thebes. Mid-eighteenth Dynasty. Reign of Tuthmosis IV (*c.* 1425–1415). Painting on plaster. The tomb of Menna contains some of the finest examples of New Kingdom painting. A field scribe to the Pharaoh, his tomb is suitably decorated with scenes of agricultural activity. This delicate portrait of a young girl forms part of a painting depicting a fishing expedition in the marshes, always a favourite subject.

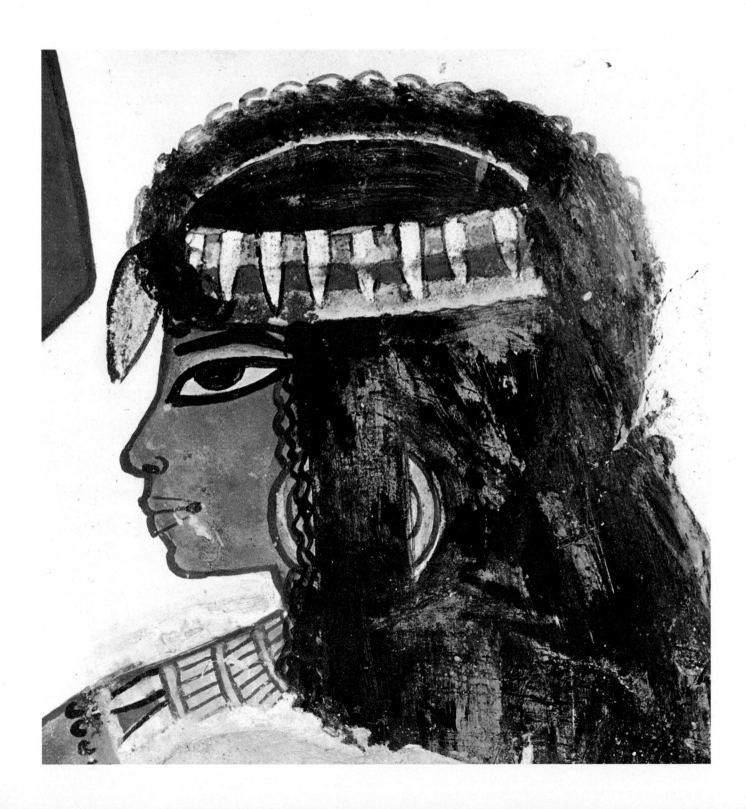

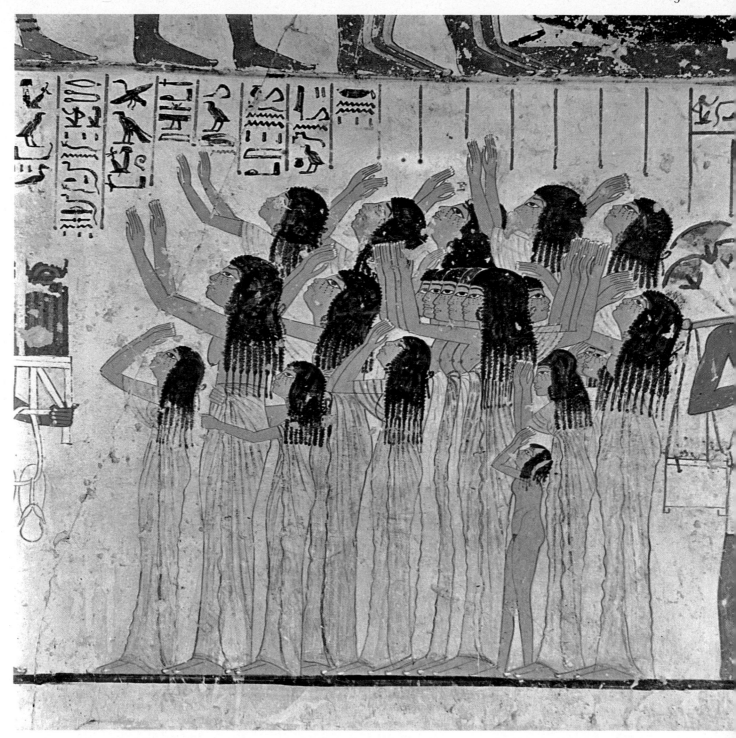

90 (opposite). **Ceiling painting with birds, butterflies and locusts.** Tomb of Khonsu, Sheikh-abd-el-Qrnah, Thebes. Mid-eighteenth Dynasty. Reign of Tuthmosis IV (*c.* 1425–1415). Painting on plaster. Even in the private tombs the painter was subject to certain icono-graphical strictures in his rendering of the human figure. In his observation of nature however, he was able to paint in a spontaneous and personal manner, as in this ceiling decoration of birds and insects which achieves an almost impressionistic immediacy.

91 (above). **Group of mourning women.** Tomb of Ramose, Sheikh-abd-el-Qrnah, Thebes. Eighteenth dynasty. Painting on plaster. Ramose was the last vizir to Amenhotep III and the first in the reign of Akhenaton. This painting belongs to the phase immediately preceding the Amarna period. It is distinguished by its linear clarity and is markedly different from, for example, the style of the tomb of Nakht. The figures are more slender and austere. Colours are restricted to greys browns and blacks, and black outlines are limited now to the eyes alone.

92 (following pages). **Two of the daughters of Akhenaton.** Amarna period (*c.* 1370–1350 BC). Painting on plaster. h. of left figure 9 in. (23 cm.). Ashmolean Museum, Oxford. This fragment of painting was taken from a wall of a palace at Amarna. It is part of what was a family group. The princesses have the elongated skulls, full hips and slender legs which mark the Amarna manner. In spite of the exaggerations inherent in the style, the affectionate communication between the two sisters is suggested in a charming way.

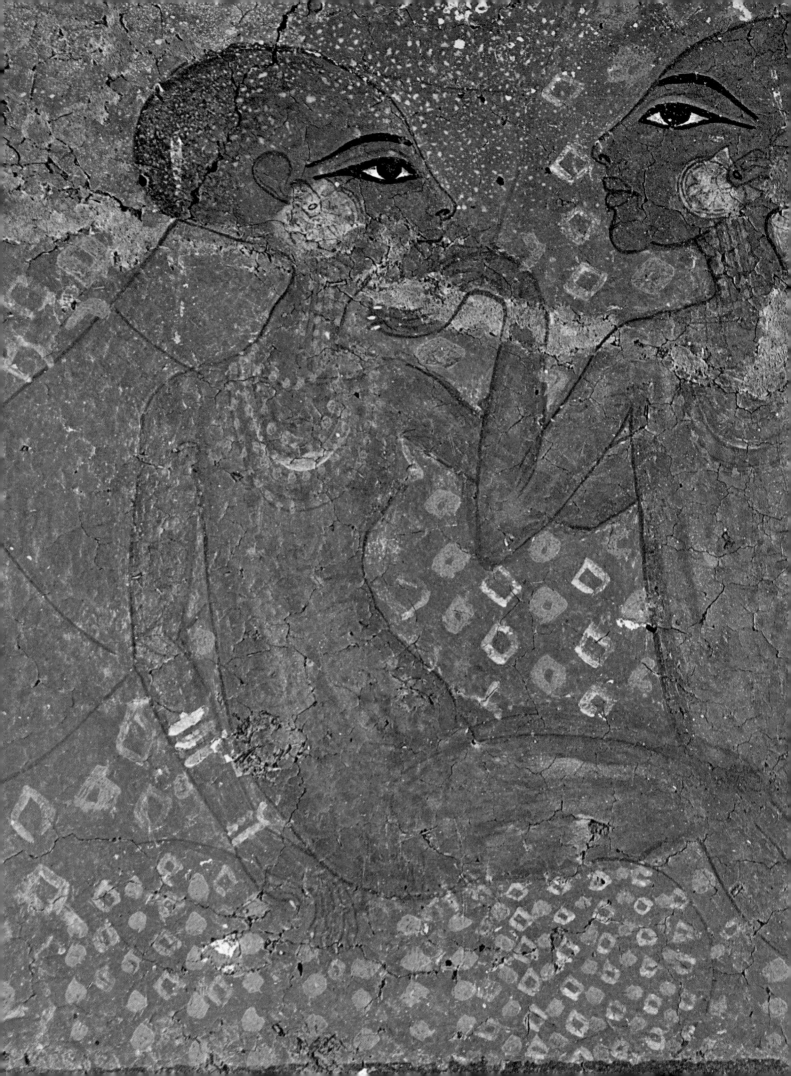

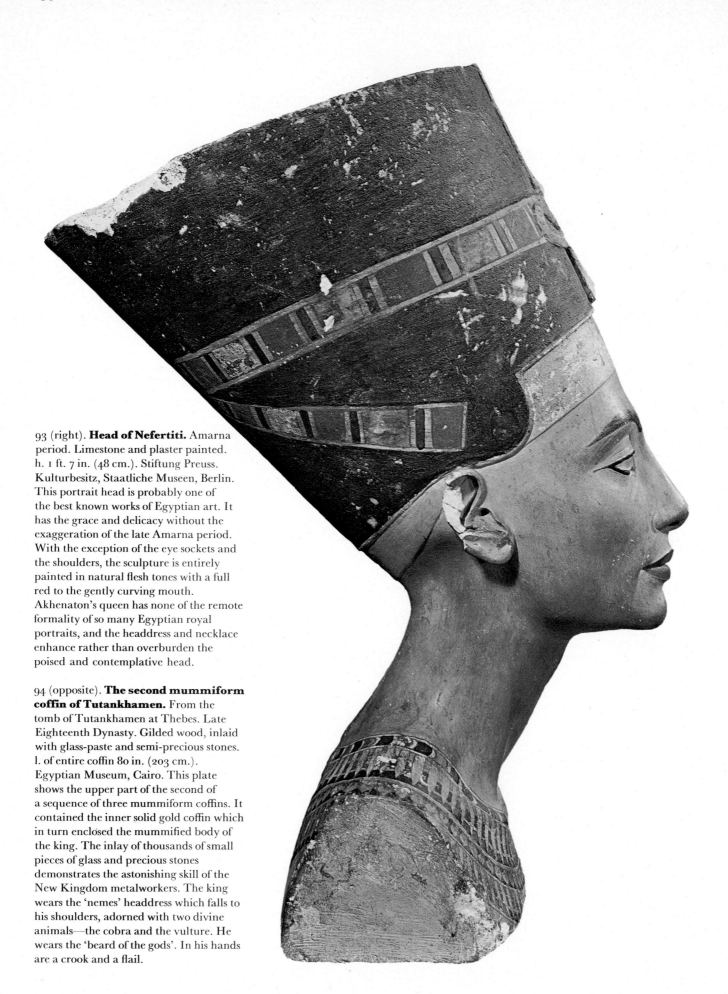

93 (right). **Head of Nefertiti.** Amarna
period. Limestone and plaster painted.
h. 1 ft. 7 in. (48 cm.). Stiftung Preuss.
Kulturbesitz, Staatliche Museen, Berlin.
This portrait head is probably one of
the best known works of Egyptian art. It
has the grace and delicacy without the
exaggeration of the late Amarna period.
With the exception of the eye sockets and
the shoulders, the sculpture is entirely
painted in natural flesh tones with a full
red to the gently curving mouth.
Akhenaton's queen has none of the remote
formality of so many Egyptian royal
portraits, and the headdress and necklace
enhance rather than overburden the
poised and contemplative head.

94 (opposite). **The second mummiform
coffin of Tutankhamen.** From the
tomb of Tutankhamen at Thebes. Late
Eighteenth Dynasty. Gilded wood, inlaid
with glass-paste and semi-precious stones.
l. of entire coffin 80 in. (203 cm.).
Egyptian Museum, Cairo. This plate
shows the upper part of the second of
a sequence of three mummiform coffins. It
contained the inner solid gold coffin which
in turn enclosed the mummified body of
the king. The inlay of thousands of small
pieces of glass and precious stones
demonstrates the astonishing skill of the
New Kingdom metalworkers. The king
wears the 'nemes' headdress which falls to
his shoulders, adorned with two divine
animals—the cobra and the vulture. He
wears the 'beard of the gods'. In his hands
are a crook and a flail.

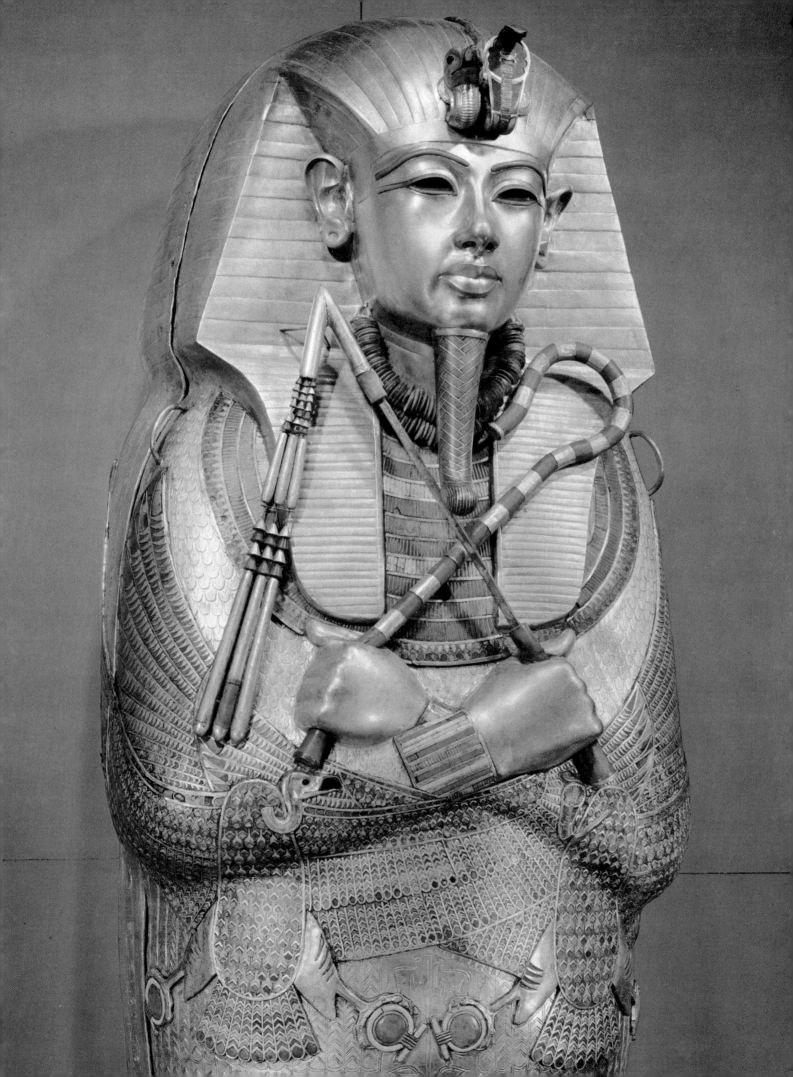

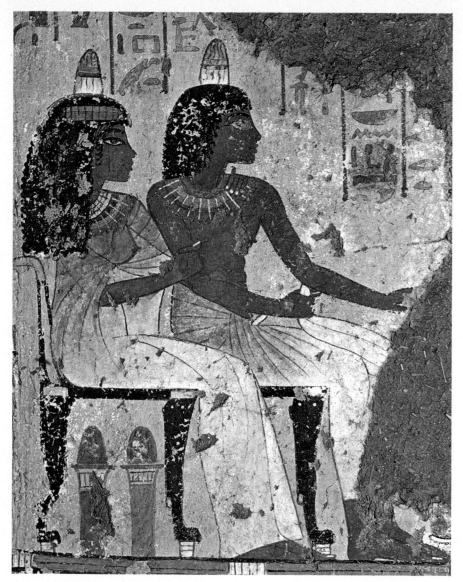

95 (left). **The parents of Meye.**
96 (below). **Funerary voyage.** Both from the tomb of Meye, Deir el Medina, Thebes. Now in the Egyptian Museum, Turin. End of the Eighteenth Dynasty. In paintings of the post-Amarna period, there is a new concern with modelling which can be observed in plate 95. The flesh colour can be seen through the dress where the material is tightly drawn across the body. Below, a ritual voyage is painted with a careful eye to the composition of the picture.

97 (opposite). **Ladies beneath a sycomore-fig.** Tomb of Userhet, Thebes. Nineteenth Dynasty. c. 1301–1234 BC. Painting on plaster. 26¼ × 18 in. (66 × 45 cm.). This detail shows the wife and mother of Userhet sitting beneath a sycomore-fig, holding decorated gold cups in their hands. The details of their garments and jewellery are exquisitely painted. Their hair is elaborately dressed and on their heads are cones of perfume. One of the finest examples of early Ramesside painting, this work has a technical brilliance that was not to be surpassed.

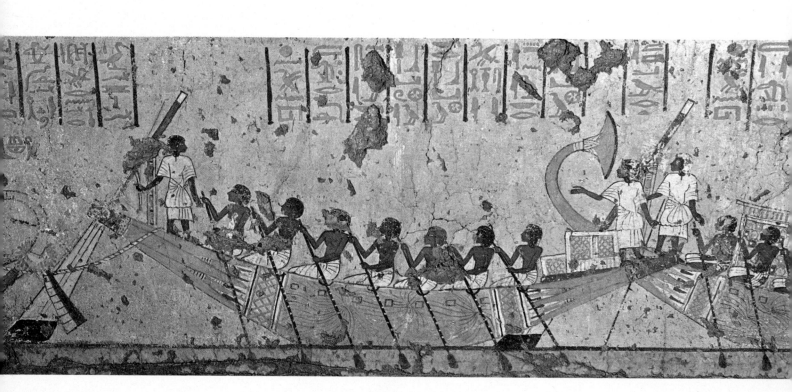

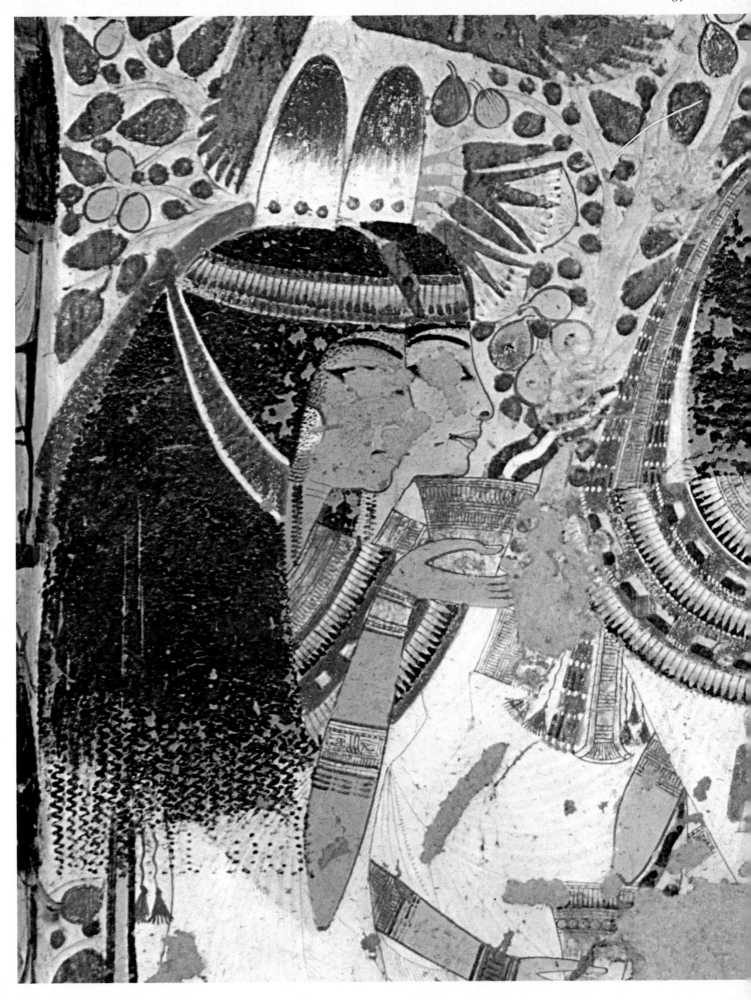

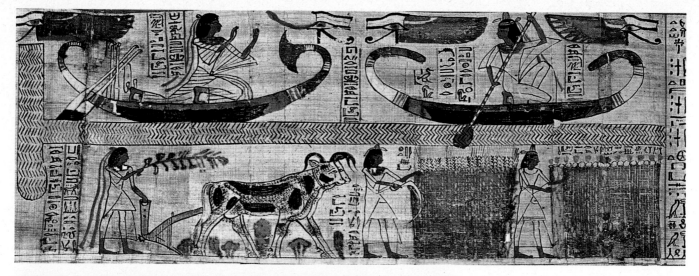

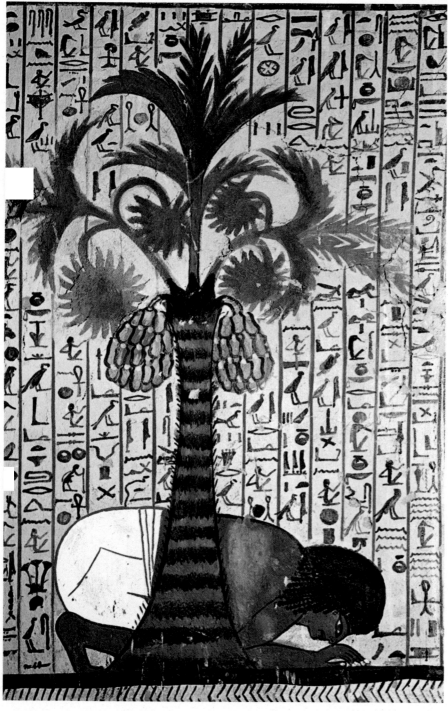

98 (above). **Detail from a 'Book of the Dead'.** Twentieth Dynasty. Papyrus. $7\frac{7}{8} \times 17\frac{3}{4}$ in. (20 × 45 cm.). Egyptian Museum, Turin. The papyrus rolls of the Book of the Dead, which were buried in the sarcophagus with the dead man (in this case Oneru), while providing invaluable religious data are often in themselves works of art. Here a funerary voyage and a ploughing scene are illustrated. Such illustrations were often enlarged and elaborated to form wall paintings as was the case with plate 100.

99 (left). **Pashedu, beneath a date-palm.** Tomb of Pashedu, Deir el Medina, Thebes. Twentieth Dynasty. Painting on plaster. In this attractive detail the dead man crouches to drink the water of a stream. The use of a yellow ochre background, and the careful outlining of each separate detail of the composition are characteristic features of the Ramesside period.

100 (opposite, above). **Gathering flax.**
101 (opposite, below). **Table with offerings.** Both from the tomb of Sennedjem, Deir el Medina, Thebes. Twentieth Dynasty. Painting on plaster. The tomb of Sennedjem a 'servant of the Necropolis', is the best preserved in the artisan's village of Deir el Medina and is covered with religious scenes showing the dead man and his wife encountering the gods and goddesses of the underworld. Above, in a delightfully observed detail we see the couple harvesting flax. Below, a bouquet of lotus blooms is placed with food and drink on a table.

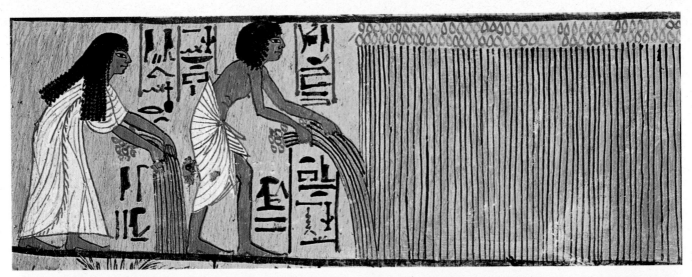

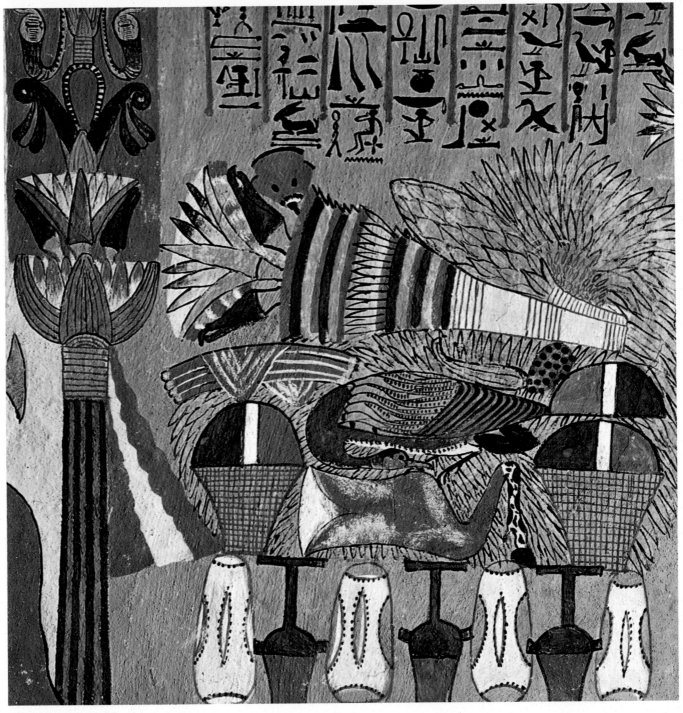

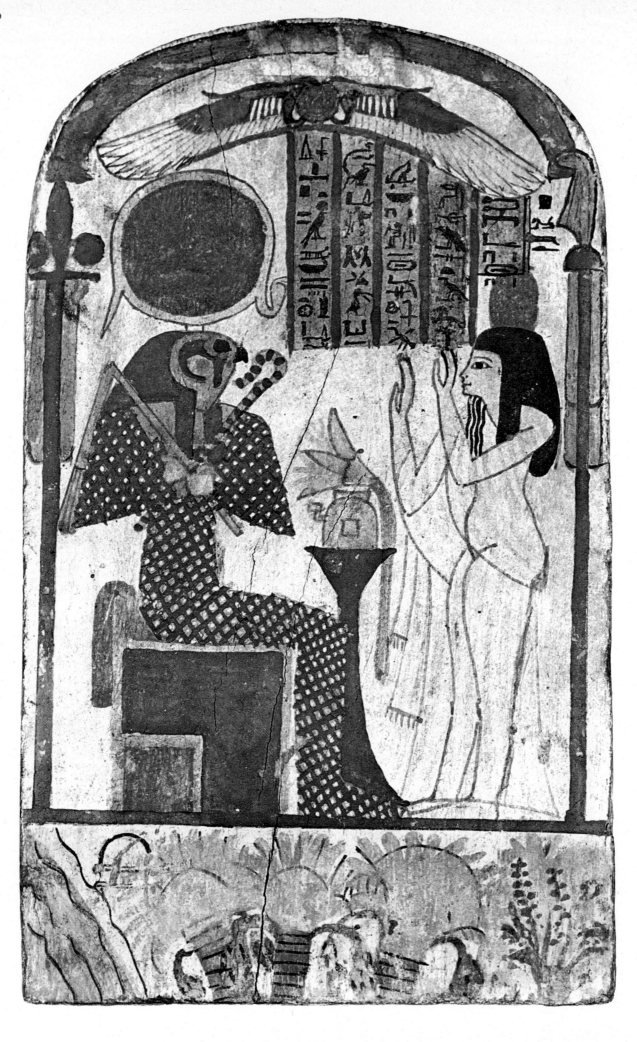

figures of Akhenaton are just as stylised as those of his predecessor Amenhotep III. But instead of employing the usual academic idealisation, Akhenaton's sculptors were at pains to observe the physical features of the King, even exaggerating them and thus arriving at a kind of expressionistic distortion. Amarna art is no less attached to the court than its predecessor, but it is a court in which the atmosphere had radically changed. Moreover, it is obvious that no one, not even Akhenaton, could create a whole new school of artists overnight; significantly, Bek, Akhenaton's head sculptor at Amarna, was the son of Men, who had been the head sculptor of Amenhotep III.

THE LATER AMARNA STYLE

After the shift of the capital to el-Amarna the works of art acquired greater maturity, being executed in an independent style designed to reflect the spiritual trends of the age, or at least those in favour at the court. If we turn to the magnificent series of portraits, those of the pharaoh, his *93, 115* family (including the famous queen Nefertiti) and the members of his court, we find in them particular stylistic features and certain special iconographic conventions. In the last analysis, however, it must be admitted that there is no essential difference, apart from the shift in stylistic emphasis, between a figure of the heretical pharaoh and, say, that of Sesostris III in New York. Once more, as in the Middle Kingdom, light is the essential element of this sculpture, but the different planes are more sharply delineated despite the very delicate modelling, and the depressions of the mouth and the eyes are more marked. The novelty, which is perhaps more apparent than real, is the appearance of portraiture as such. Unlike all other periods of Egyptian art, the Amarna figures show an attentive reproduction of the actual physical traits of the persons represented. Although these may not be portraits in the sense that we know them in western art, in other words the sculptor may not be trying consciously to capture the totality of the personality, there is no doubt that individual characteristics were observed and recorded in Amarna sculpture for the first time.

Another revealing example of the new interest in por-*114* traiture is the existence of plaster cast heads. Whether these were made from plaster moulds actually taken from the face of the living person or whether they were cast from heads modelled in clay is a matter of conjecture. What is certain is that their appearance is unprecedented. They are astonishingly lifelike, and the modelling of the eyes and

102 (opposite). **Funerary stele of Nes-khonsu-pa-Khered.** 20th–21st Dynasty. Painting on wood. 116 × 69 in. (295 × 175 cm.). Egyptian Museum, Turin. The dead woman is shown in worship before the sun god Re-Harakhte-Aton, who is seated holding the crook and flail (see plate 94). Above the falcon head is the sun disk encircled by the *uraeus* or sacred serpent. In the lower register is a landscape with a garden at the entrance to the tomb of Nes-khonsu-pa-Khered.

throat show a subtlety and an understanding of physical reality absent even at this date from formal sculpture.

An attractive fragment of painting, excavated at Amarna and now in the Ashmolean Museum, Oxford, *92* shows the two daughters of Akhenaton seated on cushions in what was probably part of a family group. The artist has finally overcome the schematic rigidity of parallel figures in a composition. The children turn to face one another and the pattern of curve and answering curve of the composition is wholly satisfying. The relief illustrated shows the *113* ruler and his family in adoration before the sun disk, seated at ease in the intimacy of the palace. Here the manneristic exaggeration of the period reaches its height in the distortion of the figures, and the acute observation of a domestic scene verges on sentimentality.

Having departed from the path of the earlier court art, the late phase of Amarna art was nevertheless capable of effects of refinement and pleasing elegance that are all its own. The break with tradition was the only means of realising a new artistic need within the court. Up to this time the new trend had only emerged marginally, mostly in settings less bound by tradition, as in certain details of tomb paintings (especially in scenes of daily life with figures of slaves) and in some narrative reliefs. The short reign of Akhenaton was an effort, whose effects could not be lasting, to legitimise a revolution that had been brewing beneath the surface. Less fortunate than a later religious reformer, Constantine, Akhenaton was not only denied the epithet of 'great' but his very name was cut out of all the monuments.

TRANSITION TO THE NINETEENTH DYNASTY

The reaction that ensued upon the death of Akhenaton, though initially peaceful, was soon to lead to the stifling of all the new possibilities opened up by Amarna art. Tutankhamen was the youthful successor of Akhenaton whose great fame rests on the fact that of all the New Kingdom his was the only tomb to have been found intact. His reign and the period in which the military leader Horemheb prepared to take power saw an enfeebled continuation (at least in court circles) of the artistic trends developed under Akhenaton, though with a certain backward glance at the more traditional art. The scenes on wooden panels with incrustations of gold and ivory found in Tutankhamen's *94* tomb display this backward-looking reliance on the traditional reliefs of the pharaohs, though the force of the mannerism of the time of Akhenaton is evident. More lively are the scenes painted on other wooden panels showing scenes *116* of hunting and warfare. In these scenes compositional freedom results in a chaotic jumble of figures, arranged in dramatic disorder, set against a background thickly strewn with landscape motifs (interest in landscape settings had been a principal feature of Amarna art). These motifs recur, more skilfully handled, in the reliefs of Horemheb's tomb at Saqqara; here compositional liveliness is always held in check by a careful design that isolates and groups the figures in a conscious rhythm.

117 The reign of Horemheb marks the transition from the 18th to the 19th dynasty and at the same time the definitive rejection of the Amarna heritage. This rejection took the form of an attempt to eradicate the name of Akhenaton. Artists were required to return to the court art of the earlier part of the 18th dynasty. Outside of the court, in fact, one could hardly speak of a return, for the wave of Amarna innovation had not been able to penetrate very far into the lower strata of society.

THEBAN PAINTING AT THE END OF THE NEW KINGDOM

The reaction against Amarna—or the lack of knowledge of it—was reflected in the private tomb paintings of the late 18th and early 19th dynasties. One of the finest of the period is that of the two sculptors Nebamun and Ipuky. It has all the interest of transitional works, bearing witness to the technical achievement of the past, and adding a feeling of vivacity which was a specifically Ramesside contribution. The scene in which the widow caresses the feet of the mummy case before the tomb door is described with a poignant depth of feeling. In the tomb of the priest Userhet *97* the group of the mourning wife and mother reaches a level of grace and refinement which it would be hard to match.

The polished elegance of the private tombs contrasts strongly with the reliefs in the royal tombs, such as that of Queen Nefertari, wife of Ramesses II. The painted reliefs are academic to a point of chilliness, a quality which occurs also in the reliefs of Seti I.

The 20th dynasty saw a gradual decline in the art of tomb painting. The early Ramesside period had seen the final flowering of the art of the New Kingdom. In the later nineteenth and twentieth dynasties, while the output of tomb paintings continued unabated, they lacked innovation. The scenes are painted in bright, almost garish colours and every available surface is carefully covered. The subjects *101, 100* remain the same: offering scenes, agricultural pursuits, the *98* funerary voyage of the dead. The richness of the colour and the confidence with which the scenes are executed reflect the prosperous life of the imperial period. But something is missing. However decorative, there tends to be a mechanical quality about them which one associates with repetition rather than invention.

THE SCULPTURE OF THE RAMESSIDE ERA

The nostalgic return to the past pursued by the Ramesside kings of the 19th and 20th dynasties despite the irrevocable disappearance of that past, could not avoid some tacit concessions to the experience of the Amarna period. This can *118* be seen to some extent in the statue of Ramesses II in the Egyptian Museum in Turin. Although it clearly harks back to the ideals of Tuthmosis III, the figure is noteworthy for the stress laid upon certain virtuoso tricks of style (note the sleeve of the raised arm) and for the novelty of the royal insignia. But if we examine closely the treatment of the mouth and the eyes, the Amarna heritage is clearly evident,

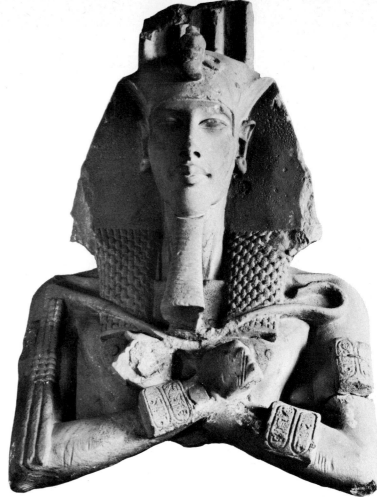

112. Amenhotep IV, later known as King Akhenaton. New Kingdom, Eighteenth Dynasty. *c.* 1375 BC. Sandstone. More than twice life size. Original site, Karnak. Now in the Egyptian Museum, Cairo. This fragment from a colossal statue was found in the temple of Aton, near the temple of Amon at Karnak. Still bearing the name Amenhotep, it depicts the ruler during the years before he moved his capital to Amarna. The almost decadent stylisation of the features are typical of the sculpture of Akhenaton's reign. Akhenaton was the son of Amenhotep III and Queen Tiy.

113. Akhenaton, Nefertiti and three of their daughters. New Kingdom, Eighteenth Dynasty. Amarna period. *c.* 1370–1350 BC. Limestone. h. 17 in. (43·5 cm.). Egyptian Museum, Cairo. This stele, carved in sunk relief and painted, was probably designed as a private altar. An unconventional subject, the informal portrayal of the royal family shows them beneath the extended rays of the sun disk, the Aton.

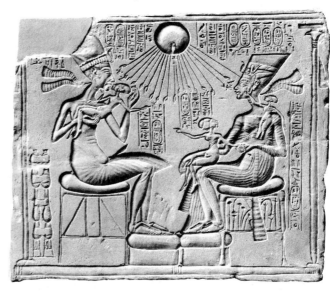

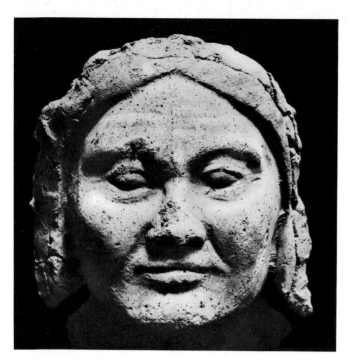

114. **Plaster mask of an old woman from Amarna.**
New Kingdom, Eighteenth Dynasty. Amarna Period.
c. 1370–1350 BC. h. 10⅝ in. (27 cm.). Staatliche Museen zu
Berlin. The wrinkles round the eyes and on the forehead of this
old woman and the suggestion of a hairline beneath her
headcloth are more realistic than anything previously seen in
Egyptian sculpture. There is some uncertainty as to whether
these masks were taken from living persons, and for what
they were finally intended.

115. **Statuette of Queen Nefertiti.** New Kingdom,
Eighteenth Dynasty (Amarna period). *c.* 1370–1350 BC.
h. 15¾ in. (40 cm.). Staatliche Museen zu Berlin. This
exquisite portrait of Queen Nefertiti is one of the finer examples
of sculpture from the reign of Akhenaton. Her narrow waist and
large hips follow the exaggerated fashion of the time.

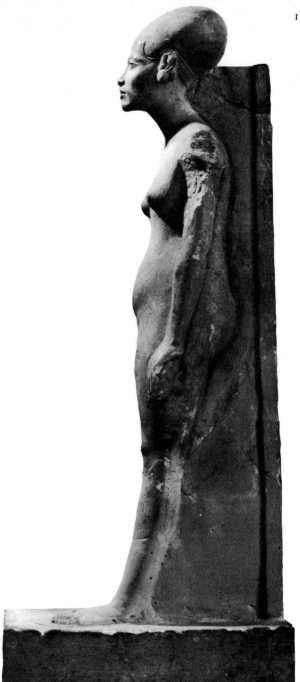

if only in a superficial way. In one field, however, this heritage proved to be decisive, even though the roots of the
development go back to the early 18th dynasty: the field of
historical relief. This branch of art constitutes the most
significant achievement of the 19th dynasty. Although it
partly reverted to the stage of the narrative reliefs of Queen
Hatshepsut, the new relief art could not have reached its
characteristic form without the experiments (in the direction of liveliness and freedom of design) and the ideas of
Amarna, which were imbued with a human interest in the
deeds of the pharaoh and his ways of self-expression. With
the natural exception of the details of the vanquished
enemies, the historical reliefs of Seti I and Ramesses II show
a wholly courtly conception of the king. The coincidence of
the sudden flowering of this artistic genre, which had its
own specialised iconographic schemes, with the Syrian
campaigns of Seti I makes it pertinent to ask (even if no
definite answer can at present be forthcoming) whether
perhaps the impetus for this kind of art, if not unknown in

Egypt, cannot have stemmed from the art of northern
Syria, where Hittite influence was strong.

The last works of the New Kingdom, like the earliest
ones, are imbued with an ideal of colossal grandeur. In this
final period of Egyptian glory in the 19th dynasty, immense
buildings were set up all over Egypt—from the temple of
Seti I at Abydos to the temple of Ramesses II at Thebes (the
Ramesseum) and the temple of Amon built by the same *120*
king at Luxor. The predilection for colossal building ensembles culminates in the stupendous rock-carved temple
of Abu Simbel in Nubia erected by Ramesses II. With the
great 19th-dynasty funerary temple of Ramesses III at
Medinet Habu near Thebes the art of the New Kingdom **80, 81**
came to an end.

TRANSITION TO THE LATE PERIOD

The period from the death of Ramesses III (1165 BC) in the
middle of the 20th dynasty until about 720 BC is a low
point in the history of Egyptian art and culture. Deprived

of its colonial empire in western Asia and weakened by the Theban priests' struggle for power with the Pharaoh, Egypt underwent a prolonged crisis. This phase is comparable to the First and Second Intermediate Periods, though it did not reach the same depths of anarchy. Still there was to be no real and lasting recovery from this crisis. The reasons for this are partly economic: the ancient world was shifting from the use of bronze to the use of iron as a basic metal and although Egypt had plentiful resources of copper for making bronze she had no iron. During the first three centuries of the first millennium BC, no large building projects were undertaken; sculpture and relief carving continued fitfully in the wake of the late New Kingdom, producing work that was sometimes refined and elegant, but increasingly academic. The crafts were able to escape some of the effects of this cultural stagnation; metalwork objects found in the royal tombs of Tanis in the Delta (21st–22nd dynasty) show an astonishing skill in workmanship, continuing the high standards set earlier in this field.

A change for the better began when the Nubian king Piankhy set out from his capital at Napata in the far south to conquer Egypt, where he founded the 25th dynasty. Nubia had long been subject to Egyptian cultural influence and the new rulers were prepared to devote their full energies to an effort towards recovery. This is the beginning of the Late Period, the fourth main age of Egyptian civilisation. The Nubians were unable to open new paths in Egyptian culture, but they promoted a determined reaction against the lifeless forms inherited from the New Kingdom by striving to return directly to the classic sources of the Old Kingdom. It is not surprising, therefore, that the Nubian kings built pyramid tombs in their native town of Napata. Piankhy carefully restored many Egyptian temples and others benefited from the attentions of his successors. The more creative aspects of the process of artistic renewal are evident in sculpture, where the artists rejected the effete taste so long dominant, reverting to ancient models. The sense of volume reappeared in sculpture, after having almost vanished in the Ramesside enthusiasm for the effects of light, though the attractions of the play of light on broad surfaces were not scorned altogether, as can be seen in a group of statues of Taharqa from the temple of Amon at Napata. Similar tendencies can be observed in the art of relief. At Kawa in Nubia Taharqa commissioned reliefs that imitated Old Kingdom compositions. But the oldest reliefs of Piankhy at Napata betray a harsh realism that seems to be a distinctive Nubian contribution. Among the realistic features is a stress on the details of the leg muscles, recalling contemporary Assyrian reliefs.

83

THE SAITE DYNASTY

The accomplishment of the Nubian dynasty in Egypt were cut short by the invading armies of Assyria, which for a short time annexed Egypt to her empire (671–663 BC).

The Nubian kings then retired to Napata once more,

where they established an independent state that survived for almost a thousand years to transmit Egyptian culture to the south. Because of troubles at home the Assyrians were unable to consolidate their conquests and Psammeticus, a governor of Sais in the Delta, succeeded in freeing the country and establishing a new dynasty, the 26th (663–525). In the Saite period (as the 26th dynasty is often called after the capital at Sais) the backward-looking attitude developed in the Nubian period was strengthened. The revival of the past was not just a question of inspiration but a conscious attempt to reproduce the forms and ideals of the past. Although some successful and interesting works were produced, the usual result was a kind of 'archaeological' art. One must not, however, underestimate another factor which was inherited from the Nubian period. This was the feeling for naturalistic detail displayed in portraiture and reliefs, where it was combined with a firm sense of volume. These features are evident in some works from the beginning of the 26th dynasty, such as the reliefs in Theban tombs; here the locale suggested a recourse to Middle Kingdom precedents. In statues the main emphasis falls on volume, which is conceived in terms of geometrical masses, while in relief the taste for descriptive detail comes to the fore, favouring a strong linear contour. Some of the relief carvers were unable to escape the lingering influence of New Kingdom work; they sometimes turned this to good advantage, achieving a sensual effect, as in the Brooklyn Museum fragment of a woman nursing. Saite works from northern Egypt lack this creative spark and the formal polish that weakened Ramesside tradition tended to persist despite the new fashion of imitating and copying the ancient models.

THE END OF EGYPTIAN ART

Despite its internal weaknesses, late Egyptian art showed a surprising resistance to temptations coming from the outside. Neither the short Assyrian domination nor the more stable Persian occupation (525–404 BC) left any appreciable traces in Egyptian art. The four centuries of contact with the Greeks that preceded Alexander's conquest and the founding of the Ptolemaic dynasty in the late 4th century BC had only a superficial effect. Differences between the two cultures ran too deep to permit a true synthesis. Works like the 'small green heads' in Berlin and Boston and the relief of Nectanebo in the British Museum still belong in the Egyptian tradition, though the figures in the relief do show a certain amount of understanding of Greek art. The Greek influence is more marked in such works as the reliefs of the Petosiris Tomb (late 4th century BC), where one figure is actually shown frontally in defiance of the whole Egyptian tradition. But cases of true fusion are very rare even in the Ptolemaic period; more common is the simple insertion of a Greek motif in an indigenous setting, as for example when the Ptolemaic kings are shown presiding over traditional ceremonies. Egyptian artists were bent on following a path of formalism, bound by a tradition that

119

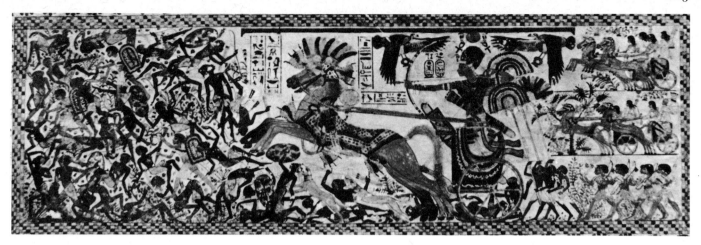

116. **Battle scene on painted chest of Tutankhamen.**
New Kingdom, Eighteenth Dynasty. *c.* 1358–1349 BC.
Length of whole scenes *c.* 20 in. (50 cm.). Egyptian Museum,
Cairo. This dramatic composition with the striking figure of the
king in his chariot and the confusion of warriors and hounds
on the left is more lively than much of the painting produced at
this time. The lid of the chest is decorated with hunting scenes.
Comparison with the Oxford and Narmer palettes (figures 87
and 88), and the relief of Ramesses III at Medinet Habu
(plate 81) shows a similarity in the treatment of hunting and
battle scenes over thousand of years.

had long since become incapable of self-renewal. By con-
trast the new capital of Alexandria on the Mediterranean
Sea became the centre of a well patronised school of Helle-
nistic Greek art. The mummy portraits of the Faiyum
type from the succeeding Roman period (after 30 BC) are
essentially a reflexion of earlier Hellenistic painting.

Architecture presents a somewhat brighter prospect. If
there were no parallels in other periods of human history—
Achaemenian Persia, the declining Roman empire, and the
late Gothic period of medieval Europe—it would seem sur-
prising that in its last days Egyptian civilisation was cap-
able of creating architectural monuments that fused tradi-
tion with contemporary needs in a way that made them the
best achievements of the period. The temples at Edfu,
82 Kom Ombo, Denderah, and (most famous) Philae stay
close to the hallowed temple type with its hypostyle halls
supported by decorated columns and relief-carved pylons.
The architects of this period were definitely inclined to-
wards the picturesque. The fine papyrus capitals, together
with the carefully balanced formal relationships of solids
and voids, columns and piers, and of open and closed space,
that are found in the temple of Horus at Edfu and in
Trajan's kiosk at Philae give this architecture a quality of
great sophistication. At times it almost seems as if only the
restraints of tradition saved it from rococo prettiness.

The final break in Egyptian cultural tradition came only
with the adoption of Christianity in the 4th century of our
era. With the closing of the temples and the dispersal of the
priesthood, knowledge of the hieroglyphic script, the in-
dispensible key to the understanding of Egypt's past, dis-
appeared entirely. Champollion's decipherment of the
Egyptian script in the early 19th century opened the
modern era of Egyptian archaeology and the story of her
4000 years of civilisation was gradually reconstructed.

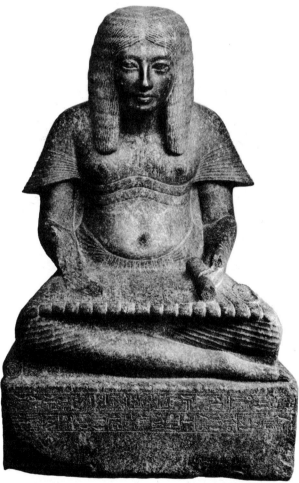

117. **General Horemheb as a scribe.** New Kingdom,
Eighteenth Dynasty. *c.* 1355 BC. Grey granite. h. 46 in. (116 cm.).
Metropolitan Museum of Art, New York. (Gift of
Mr and Mrs Everit Macy, 1923). This work dates from the
time when Horemheb was still Commander-in-Chief of
Tutankhamen's army and not yet king. He is depicted as a
military scribe writing a long hymn to Thoth, god of learning.
The style echoes that of the reign of Amenhotep III in the
traditional posture, gestures and dress, but the Amarna period
has left its mark in the softened facial expression, the folds and
flares of the drapery and the generally less formal approach.

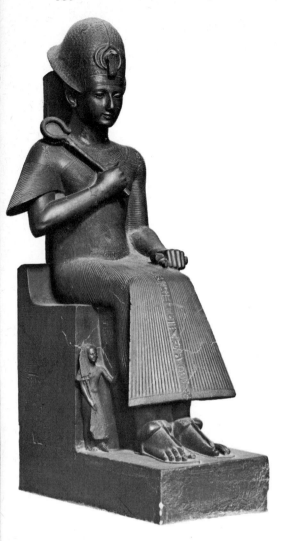

118 (left). **Statue of Ramesses II.** New Kingdom. Nineteenth Dynasty. *c.* 1301–1234 BC. Black granite. h. 76½ in. (194 cm.). Probably from Thebes. Now in the Egyptian Museum, Turin. Although the king is here portrayed in a conventional manner, wearing the Blue Crown with *uraeus* and holding the royal crook, his dress is contemporary rather than traditional. The figure of the queen, in a smaller scale, stands by his left leg, and that of his son by his right.

119 (right). **Green head of an old man.** Ptolemaic Period. *c.* 200 BC. Schist. h. 4 in. (10·5 cm.). Museum of Fine Arts, Boston. This remarkable portrait head seems to be conceived in the traditional style. In common with other sculptures of this type it has been variously ascribed to the Twenty-sixth or Twentieth Dynasty, but the later date is now regarded as more probable. The plastic treatment of the eyebrows, foreheads and eyelids is especially noticeable.

120. **Pillars from the hypostyle hall of the Temple of Amon at Karnak.** New Kingdom, Nineteenth Dynasty. *c.* 1318–1200 BC. This unusual view of the sixty-nine foot high pillars from the central aisle of the great hypostyle hall shows clearly the enormous open papyrus capitals and elaborate reliefs dating from the reign of Seti I and Ramesses. In the background can be seen the tops of the papyrus bud capitals of the pillars of the innermost of the six northern side aisles, and the architrave and cornice supporting the remains of the clerestory and its windows.

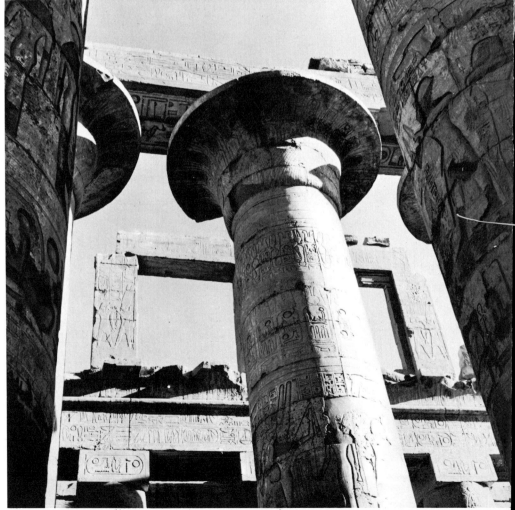

The Expansion of the Art of the Ancient Middle East

Our survey of the history of the art of the ancient Middle East would be incomplete without a brief discussion of some of the outlying cultures dependent on the central traditions. Sometimes artistic motifs spread across vast areas such as the Iranian pottery forms which influenced the Neolithic Chinese culture of Yang-shao. We will leave aside irradiations of this kind which are always to be expected with any major artistic tradition. There are more immediate and pervading ones which demand our attention.

NUBIA

In the late period, Egyptian culture gained a southern satellite. When the Assyrians drove the Ethiopian dynasty from the throne of the pharaohs, Ethiopian culture survived in Nubia, where it long remained faithful to Egyptian tradition. In the 4th century BC, however, the capital moved southwards from Napata to Meroë and this brought a shift of cultural focus. The northern part of the country, lower Nubia, continued in the orbit of Ptolemaic Egypt, though as a marginal dependency, and upper Nubia, including the capital, while not closed to influences coming from the north, was in more direct contact with the primitive cultures of central and eastern Africa. For approximately seven hundred years until the destruction of the kingdom of Meroë by the Ethiopian state of Aksum in about the middle of the 4th century AD, the Sudan was the home of a flourishing culture inspired by Egypt but endowed with enough strength to establish its own character.

As at Napata, the kings continued to build temples and pyramidal tombs of Egyptian type. But Hellenistic ideas also filtered in: a thermal building at Meroë, its façade covered with sculptured figures, clearly reveals Greek influence. The most interesting aspect of Meroitic art lies in the originality of its handling of the Egyptian iconographic tradition, which had formed the basis of all its achievements. A frequent theme of court reliefs is that of the king striking bound captives on the head. Such melodramatic themes appealed to Meroë, partly because it offered possibilities for decorative invention. In a relief in the Worcester Art Museum, Massachusetts, we recognise the Egyptian origin of the scene, but almost nothing else Egyptian is left—only some minor details of iconography and even less of style. The elegant and unusual arrangement of the captives and the figure of the king is a distant echo of Indian art, while the little figure with the ceremonial fan by the king's shoulder recalls a Nike (personification of victory) in Parthian guise. Another interesting rock carving at Gebel Qeili dating from the first half of the 1st century AD, shows a king flanked by bound captives. The bust of the sun god in Hellenistic form holds out a flower to the king with one hand while in the other he holds a rope to which are attached the separate cords binding a group of captives. While the figure of the king is formally rendered, a group of slain enemies falling down a cascade are shown more naturalistically. The composition is certainly effective and one cannot help recalling that this late Nubian relief is the ultimate descendent of the relief on the base of the early dynastic statue of Khasekhem. It seems as if Egyptian tradition had come full circle to fuse once again in its most spontaneous expressions with the underlying African base that had given it birth.

In the context of cultural history the Meroitic civilisation has great importance as an exporter of Egyptian elements, especially the obelisk, to the more southerly civilisation of Ethiopia with its capital at Aksum. But since two different cultural streams mingle here—one coming from the north, the other from the east—it seems best to postpone the discussion of Ethiopia until later.

SOUTH ARABIA

While the Assyrian conquerors were laying waste to Syria, a tradition that owed much to that country was growing up far to the south in the fringe of the Arabian desert. The long chain of oases connecting the cities of Syria with the Yemen was already a flourishing trade route before the Assyrian conquest and it carried techniques and ideas from north to south. We still know too little of the art of pre-Islamic Arabia to be able to assert very much with certainty, but it seems that this latest and most remote province of the ancient Middle Eastern world owed much to the mediation of traders. The dominant Syrian influences were joined by others from Mesopotamia, Iran and India. As often happens in border regions in which an aptitude for culture is promoted by favourable political conditions these influences were used to create something new.

Towards the middle of the 1st millennium BC, rock-carved tombs flanked by lions in high relief appeared in the middle of the Arabian desert at el-Ula (ancient Dedan). A connection with the somewhat earlier North Syrian figures seems undeniable. The appearance of rock tombs of pure Nabataean style half a millennium later at another oasis, Medain Salih (ancient Hegra), suggests a continuous flow of culture from north to south.

The Yemen, the Arabia Felix of the ancients, was the centre of a flourishing school of religious art from the beginning of the 1st millennium BC. This religious basis contrasts with the more usual political focus in the art of the Middle East. In the large building complexes found at Marib and Sirwah a number of temples have been identified. They point to Achaemenian models. Recently another temple has come to light at Khor Rori in Oman in southeast Arabia. The sanctuary of Awwam at Marib, the most characteristic of these temples, has a big elliptical precinct wall with a pillared peristyle building attached to one side. This building recalls an Achaemenian temple recently discovered in Afghanistan by an Italian archaeological expedition. The casemate construction of the precinct wall points to the architecture of Syria and Palestine. A particular feature of south Arabian architecture is the wall with niches of progressively increasing depth; apparently this device comes from Mesopotamia,

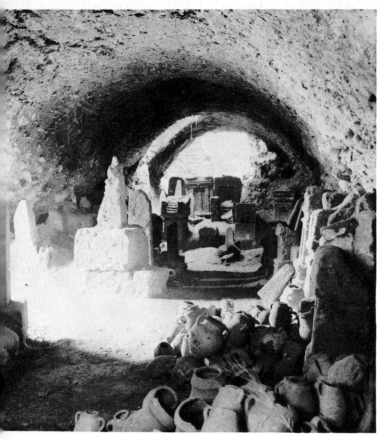

121 (left). **The tophet of Salammbo, Carthage.** This is the most important surviving *tophet* or sacred precinct. The pottery urns contained the ashes of sacrificed children or animals. The small steles date from the 5th–2nd centuries BC, and are decorated either with a niche surmounted by an architectural cornice, or with pilasters in the Egyptian style.

122 (centre). **Punic terracotta head.** Bardo Museum, Tunis. This small head with columnar base is strongly expressionist in feeling. Such heads had quasi-magical healing powers, and were often highly coloured.

123 (right). **Demon mask.** Bardo Museum, Tunis. In the Punic world demon masks had healing powers, and were placed both in tombs and tophets. Demon masks, used to foretell the future, occurred also in Mesopotamia and were later imitated by both the Greeks and the Phoenicians.

where such walls have a history that stretches from Sumerian times to the Neo-Babylonian period. Moreover Mesopotamia (perhaps via Syria) is the source of the stepped pinnacle commonly used to crown buildings. Sculpture —mostly votive statues and reliefs carved on steles and altars—is rather rudimentary. A fifth-century bronze statue of Marib, though of indifferent quality, is important for its Phoenician iconography. The pose recalls Cypro-Phoenician statuary of the 5th century BC, and the lion skin is a Greek element. Reliefs commonly show offering scenes and figures of camels. Although this is basically folk art, foreign motifs appear in the reliefs: the use of the Greek vine trail as an ornament is very frequent while the goat motif seems to come from Iran. The ornamental use of the latter, which must have originally had some symbolic meaning, is exemplified by a fine relief now in Marseilles in which two superimposed rows of goats carved in high relief flank a handsome inscription surmounted by an architectural frieze. It is interesting to observe that the south Arabian script was often used for decorative effect, paralleling the North Syrian treatment of the Hittite hieroglyphic and Aramaic scripts at the beginning of the first millennium. Both countries preferred relief script to the incised version.

ETHIOPIA

In the first half of the first millennium South Arabia gained a cultural colony of its own when the Yemenites emigrated across the Red Sea to Ethiopia. There they encountered a culture of Egyptian origin that had been transmitted by Meroë. The little-known works that emerged from this meeting merit attention for their own sake. Perhaps the most characteristic monuments are the obelisks of Aksum, which succeeded in combining an obviously Egyptian

architectural form with ornament derived from south Arabia.

The art of pre-Christian Ethiopia seems to have been made up of a series of ingredients which are as yet imperfectly known, and uncertainly dated. Some works, such as the 'thrones' of Aksum consisting of a platform on piers with curved corners, and the obelisks just mentioned seem to belong to the latest phase of Aksumite history and show a good deal of independence. Other monuments resemble Yemenite art, as for example the little square temple of Yeha, a throne decorated with bas-reliefs, a statue from Haulti, and a statuette from Hawila Assaraw. The relatively early date of these last works—about the 5th century BC—makes it hard to determine whether this Ethiopian tradition is the contribution of an autonomous south Arabian art coloured by local and Meroitic influences, or whether it really amounts to a parallel stream of culture which in turn exercised an influence on the Yemenite works. Another difficulty occurs when we try to specify the route taken by certain Egyptian motifs in reaching Ethiopia. Does a piece like the sphinx of Cascase owe its form to Meroitic influence or to something coming from Syria?

It should be obvious that the general development of south Arabian art and that of pre-Christian Ethiopia needs further classification. In this recently-added chapter of archaeological history, exploration in depth has only just begun. Future scholars may establish the place of this last manifestation of the culture and art of the ancient Middle East.

THE PHOENICIAN CIVILISATION OVERSEAS

The Phoenician migrations into the western Mediterranean established a bridge linking East and West. In time the colony of Carthage surpassed the parent cities of old

64

124. **Punic stele.** Bardo Museum, Tunis. This stele dates from the 3rd–2nd centuries BC. A Phoenician inscription gives the name of the offerer, Ammat-Melqart, i.e. servant of the god Melqart, and the names of the gods to whom the sacrifice was offered, Baal Hammon, and Tanit. At the side is an open hand signifying blessing.

Phoenicia in importance. One might expect that when the Phoenicians settled in the west, their culture would resemble that of the homeland, but this was not the case. The larger share of the new Carthaginian or Punic civilisation springs from Cyprus where the Phoenicians were present in strength from the end of the second millennium. Although Cyprus, especially the eastern part centering upon the city of Kition, had been deeply imbued with imported Phoenician culture, it also preserved some native and Mycenean elements in both religion and art and some of these were transmitted to the western colonies. Thus these colonies received a highly mixed culture: a genuinely Phoenician stream mingled with a Cypriot-Phoenician one, both having been penetrated by Egyptian and Minoan-Mycenean elements during the last centuries of the second millennium. Moreover, most of the immigrants to the West were not settling in culturally virgin lands, though this was sometimes so in North Africa. Thus we must make allowance for local elements—Sicilian, Sardinian, Iberian—which were soon to be overwhelmed by the tide of Greek expansion. The outcome of this complex intertwining of historical factors was a culture in which only the language, and to some extent the religion, remained faithful to the original sources. In other fields, especially in art, much was derived from the new environment, and especially from Greece.

PUNIC ART

To grasp the peculiar character of Punic art we must bear in mind that the migration of the Phoenicians to the West occurred at a time unfavourable for art in the mother country, which in any case was primarily concerned with commerce. The mercantile base of Carthaginian power did not permit the growth of a court art, nor was it suited to a civic art such as that of the Greeks. When it was not utilitarian (though the Carthaginians imported many luxury goods from the Greeks), Carthaginian art was religious. But it was a religion based chiefly on the sacrifice of infants who were buried in open sanctuaries, and was therefore not suited to the building of monumental temples. When these did exist—no archaeological remains have yet been found, but explicit descriptions occur in ancient texts—they must have repeated Phoenician types. (Cadiz was reputed to have had a temple preceded, as at Jerusalem and Tell Tayanat, by two columns).

The most characteristic feature of Punic art is still the *123,124* carved stele. Placed in sacred areas (called *tophets* by archaeologists) they record infant sacrifices. At first imitating simple steles of Syrian origin, in the 6th century they began to assume the form of the Egyptian shrine enclosing a male or female sacred figure, or else a *baetyl*, a sacred pillar. At the end of the 6th century, as a result of the new wave of Egyptian motifs entering Phoenicia the art of the colonies felt an influence which manifested itself in the elaboration of the Egyptian shrine and in the adoption of

some Egyptian iconographical elements. But towards the beginning of the 5th century Carthage underwent a reaction against anthropomorphic representations of the gods and replaced these with various symbols. This reaction spread to the colonies that were dependent on Carthage, except for southern Sardinia. Still later Greek influence penetrated this type of monument, and thus one finds steles in the form of a Greek aedicula, or columned niche, with an occasional human figure; thus these steles evolved from a Cypriot to a Hellenistic type.

Stone sculpture in the round is rare and reflects local styles, but terracottas are common, being generally of oriental type with a cylindrical base. Unfortunately they *125* are mostly of poor quality. More interesting are the clay half figures made from moulds; these are of Ionic derivation even when they represent an Egyptian type of figure. The most important are the grotesque masks following *126* bronze prototypes. The manufacture of terracottas seems finally to have come to an end in the 5th century BC.

In the minor arts the ivories should be mentioned, which follow in the wake of the Phoenician ones and generally belong to the orientalising current; also the coloured glass, the scarabs (with the usual representation of Egyptianising and Syrian figures and hieroglyphs) and the gold and silverwork. In this last category the Punic workers found a congenial field for the exploration of their interest in ornament.

Punic art, which never developed a distinctive character of its own, gradually retreated before the increasing fashion for things Greek. From the monumental temple of Tharros **66** in Sardinia to the steles and clay statuettes of Hellenistic type found throughout the area of Phoenician culture, the art of the last centuries of the pre-Christian era demonstrates the progressive eclipse of Punic forms and motifs. The process was achieved in the Roman period when spiritual forces alien to the classical world permeated various ethnic groups who had previously possessed only a rudimentary culture of their own. A primitive folk art arose which preserved some traces of Punic influence. The funerary steles of Roman Sardinia, the votive steles of Ghorfa and some monumental tombs erected in North Africa in Roman times represent the twilight of Punic art.

A Glossary of Peoples and Cultures

Achaemenians (or *Achaemenids*). Persian dynasty, named after its founder Achaemenes, of whom Cyrus (546 BC) was the first king to reign over the whole country. The dynasty ended in 330 BC with the death of Darius III Codomannus.

Akkadians. Name applied to the kings of the Semite dynasty founded by Sargon 24th century BC; also to the subjects of their state, centred at Agade (Akkad) in central Mesopotamia. The dynasty ended in 23rd century BC.

Amorites. Semitic people of the region west of Mesopotamia who infiltrated into Mesopotamia from the north at the end of the third and the beginning of the second millennium, later to found the Amorite kingdom of Babylon in about 1900 BC which eventually fell to the Kassites c. 1540 BC.

Amratian. Name applied to a distinct prehistoric Egyptian culture found at the site el-Amra near Abydos, from which came the first known stone vases c. 3800 BC.

Aramaeans. Semitic people of central and northern Syria, their three main cities being Damascus, Hama and Aleppo. They appeared in the Near East in the 12th century BC, spread into Mesopotamia and later established their rule in Babylon, (Chaldaean dynasty).

Assyrians. Inhabitants of Assyria, in the middle course of the Tigris, with successive capitals at Assur Kalah and Nineveh. Assyria was an Amorite kingdom (20th century BC). Towards the beginning of the 13th century BC Shalmanesar I moved his capital from Assur to Kalah. This middle Assyrian period, to which Tiglathpileser 1st belonged, ended c. 1000 BC. Then a brilliant period of expansion followed with Assurnasirpal II (883–859), Tiglathpileser III (745–727 BC) and Sargon II, 722–705 BC, and later Assurbanipal 668–626. The Assyrian kingdom fell c. 610 BC to the Medes and Babylonians.

Babylonians. Semitic Amorites who unified Mesopotamia in the Isin-Larsa period at the end of the third millennium introducing the Semitic language to the area. During the Old Babylonian period (end of third to middle of second millennium) the Babylonians erected important buildings at Mari and Ishchali. They were overcome c. 1540 by the Kassites. Following the defeat of the Assyrians by the Medes and the Babylonians in 612 BC, the Neo-Babylonian period came into being and the city of Babylon was built under Nebuchadnezzar II (see *Chaldeans*) The Neo-Babylonians were overcome by the Achaemenians in the 6th century BC.

Badarian. Egyptian prehistoric culture named after the el-Badari site, c. 4000 BC.

Canaanites. Large ethnic group of Semitic origin which lived in the western part of the Near East from late prehistoric times and whose culture, with the many Amorite features introduced c. 2000 BC, lasted until the Phoenician and Israelite period.

Carthaginians. Inhabitants of Carthage, a town founded in north Africa (near Tunis) by the Phoenicians, according to classical writers, in 814 BC.

Chaldeans. (Biblical name for the Babylonians). Name incorrectly used in many books to designate the Sumerians and also the peoples of Mesopotamia in general. Strictly speaking it only applies to the ruling tribes of Aramaean descent that settled in Lower Mesopotamia and founded the Neo-Babylonian dynasty in the 7th and 6th centuries BC.

Cimmerians. Tribe of skilful bowmen living southeast of the Black Sea, who penetrated into Urartu at the end of the 8th century.

Elamites. Inhabitants of Elam, with their capital at Susa, from the first half of the third millennium continually in contact with the inhabitants of Mesopotamia. Their language was, with Persian and Babylonian, one of the official languages of the Empire of Darius. They had a system of writing of their own as early as the third millennium BC.

Gerzean. Culture named after the northern site of el-Gerza in Egypt, a prehistoric culture which seems to have superseded the Amratian culture c. 3300 BC and lasted into late predynastic times.

Gutians. Nomads from the highlands east of Mesopotamia who put an end to the Akkadian dynasty in the 22nd century BC, and ruled the country for nearly a century.

Hittites. People of Indo-European tongue who settled in Anatolia in the early 2nd millennium superseding a non-Indo European people called the Hattites. From their capital of Hattussas (modern Boghazköy), they ruled over an empire which during the 19th and 18th centuries BC extended as far as Babylon and was overthrown by the 'Peoples of the Sea' c. 1200 BC.

Hurrians. See *Mitannians*.

Hyksos. Mistakenly called 'Shepherd kings', these people of mixed but predominantly Semitic origin advanced from Syria and Palestine into Egypt in the 18th and 17th century BC and dominated the country for over a century.

Kassites or *Cossaeans*. People originating from the north-eastern highlands of the Zagros mountains, who ruled the whole of Mesopotamia for about three hundred and fifty years after the fall of the first dynasty of Babylon in 1540 BC.

Lullubians. People inhabiting the Zagros mountains, related to the Elamites who made incursions on the Mesopotamian borders c. 2300 BC. Naram-Sin erected a stele in honour of a victory over them (see figure 25).

Lydians. Indo-European people from the western province of Anatolia (called Lydia by the Greeks), its capital at Sardis, who took over power from the Phrygians in 7th century BC and were in turn vanquished by Cyrus in 546 BC.

Lycians. An Indo-European speaking people from the south-westernmost peninsula of Anatolia.

Medes. Indo-European people who, under King Cyaxares destroyed the Assyrian Empire c. 610 BC.

Mitannians. Indo-European speaking tribes (Aryans in the strictest sense), who ruled the Arianic people called Hurrians or Hurrites and created an independant kingdom in Syria, Mitanni, centred on the Khabur river. They were particularly powerful during the second millennium down to the 14th century BC, when they were conquered by the Hittites.

Neo-Sumerians. See *Sumerians*.

Persians. Federation of agricultural and nomadic tribes of Indo-European tongue, of which the Achaemenians formed one clan. Inhabiting Persia (modern Iran) they conquered the Medes, Babylonia and Asia Minor in the 6th century BC under Cyrus and reached their apogee under Darius I (521–486). The fall of the Persian empire came in 331 BC with Alexander's conquest of the East.

Philistines. People of Anatolian origin inhabiting the southern coastal district of Palestine after the invasion of the 'Sea Peoples', among whom they numbered.

Phoenicians. Ancient Semitic people of seafarers and traders, inhabiting the north-west coastal district of Palestine and Syria. They were the inventors of alphabetic writing and had an extensive influence throughout the Mediterranean at the beginning of the first millennium BC.

Phrygians. Indo-European people whose capital was at Gordium in western Anatolia. They spread east across the central plateau displacing the Hittites from their capital at Hattusas (Boghazköy), and were usurped by the Lydians in the 7th century BC.

Samaritans. Inhabitants of the town of Samaria, capital of the northern Israel kingdom. Later came to be a general description of the mixed population of Israel after most of the original inhabitants had been deported into captivity by the Assyrians, (722 BC) and after colonists from the east had been introduced.

Scythians. Nomadic horsemen originating in the district north of the Caspian Sea, who at the end of the 7th century penetrated deep into Palestine.

Seleucids. Hellenistic dynasty founded by Seleucus I which ruled a large part of the Near East for 175 years from 312 BC. They were expelled from Mesopotamia by the Parthians penetrating from Persia.

Semites. Linguistic group of several peoples among whom numbered the Babylonians, Assyrians, Hebrews and Arabians who from prehistoric times lived in the 'Fertile Crescent' and later entered into Arabia and Ethiopia.

Sumerians. Non-Semitic people who settled in Lower Mesopotamia in the middle of the fourth millennium BC, probably during the al'Ubaid period, and created one of the two oldest known civilisations. They disappeared at the beginning of the second millennium. The Neo-Sumerians were the Sumerians who regained political control of the country between the overthrow of the Gutians 23rd century BC and the fall of Ur 2061 BC.

Tasian. Prehistoric Egyptian culture named after the site Deir Tasa near Hierakonpolis, c. 5000 BC.

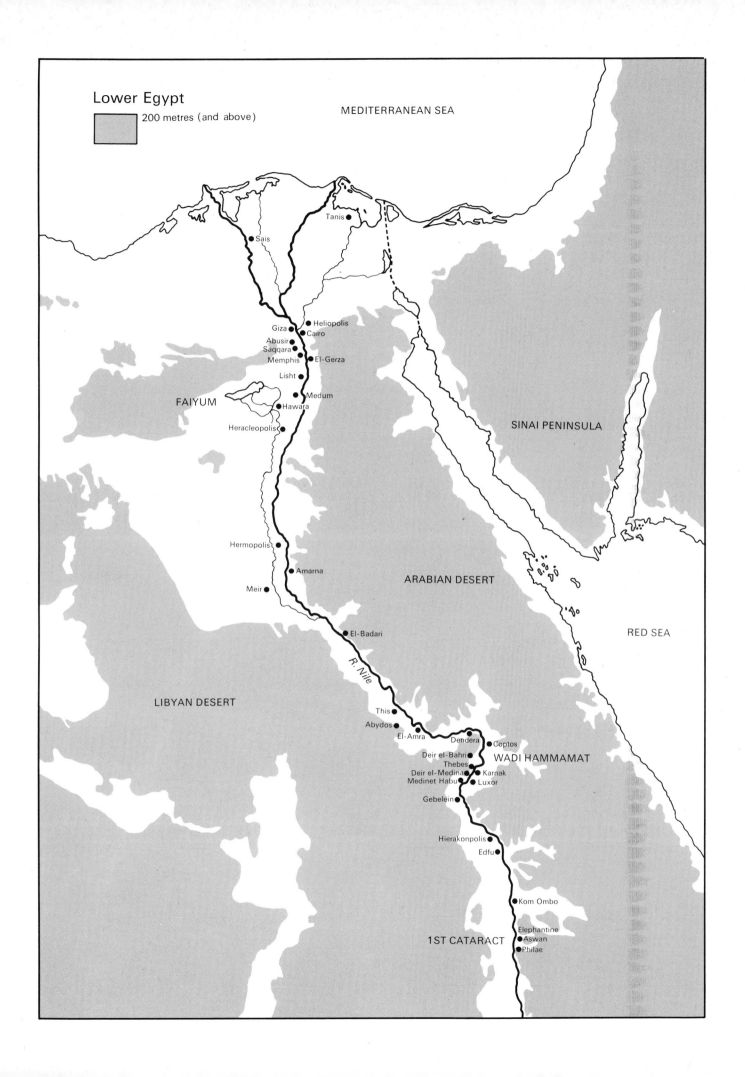

Lower Egypt

200 metres (and above)

MEDITERRANEAN SEA

Tanis

Sais

Heliopolis
Giza
Cairo
Abusir
Saqqara
Memphis
El-Gerza
Lisht

Medum
Hawara
FAIYUM
Heracleopolis

SINAI PENINSULA

Hermopolis

Amarna

ARABIAN DESERT

Meir

RED SEA

El-Badari

R. Nile

LIBYAN DESERT

This
Abydos
El-Amra
Dendera
Coptos
Deir el-Bahri
Thebes
WADI HAMMAMAT
Deir el-Medina
Karnak
Medinet Habu
Luxor
Gebelein

Hierakonpolis
Edfu

Kom Ombo

Elephantine
Aswan
1ST CATARACT
Philae

Further Reading List

General

Delaporte, L. *L'Art de l'Asie Antérieure*, 1932 (Paris)
Frankfort, H. *The Art and Architecture of the Ancient Orient*, 1954 (Penguin Books, Pelican History of Art)
Frankfort, H. *Cylinder Seals*, 1939 (London)
Groenewegen-Frankfort, H. A. *Arrest and Movement*, 1951 (Faber)
Lloyd, Seton *The Art of the Ancient Near East*, 1961 (Thames and Hudson; Praeger)
Moortgat, A. *Alt-Vorderasiatische Malerei*, 1959 (Berlin)
Moortgat, A. *Vorderasiatische Rollsiegel*, 1940 (Berlin)
Moscati, S. *Historical Art in the Ancient Near East*, 1963 (Rome)
Potratz, J. A. H. *Die Kunst des Alten Orients*, 1961 (Stuttgart)
Schäfer, H., and Andrae, W. *Die Kunst des Alten Orients*. 1925 (Berlin)
Wiseman, D. J. *Cylinder Seals of Western Asia* (Batchworth Press)
Woolley, L. *Mesopotamia and the Middle East*, 1961 (Methuen)

Mesopotamia

Frankfort, H. *Sculpture of the Third Millennium B.C.*, 1939 (University of Chicago)
Frankfort, H. *More Sculpture from the Diyala Region*, 1943 (University of Chicago)
Gadd, C. J. *The Assyrian Sculptures*, 1934 (British Museum)
Garbini, G. *Le Origini della Statuaria Sumerica*, 1962 (Rome)
Moortgat, A. *Frühe Bildkunst in Sumer*, 1935 (Leipzig)
Parrot, A. *Nineveh and Babylon*, 1961 (Thames and Hudson)
Parrot, A. *Sumer*, 1960 (Thames and Hudson)
Strommenger, E., and Hirmer, M. *The Art of Mesopotamia*, 1964 (Thames and Hudson; Abrams)
Woolley, L. *The Development of Sumerian Art*, 1935 (London)

Peripheral Areas

Akurgal, E. *Phrygische Kunst*, 1955 (Ankara)
Akurgal, E., and Hirmer, M. *The Art of the Hittites*, 1962 (Thames and Hudson)
Albright, W. F. *The Archaeology of Palestine*, 1960 (Penguin Books)

Barnett, R. D. *A Catalogue of the Nimrud Ivories*, 1957 (British Museum)
Cecchini, S. M. *La Ceramica di Nuzi*, 1965 (Rome)
Dussaud, R. *L'Art Phénicien du 2ᵉ Millénaire*, 1949 (Paris)
Ghirshman, R. *Iran*, 1954 (Penguin Books)
Grohmann, A. *Arabien*, 1963 (Munich)
Harden, D. B. *The Phoenicians*, 1962 (Thames and Hudson)
Kenyon, K. M. *Archaeology in the Holy Land* (Praeger 1960; Benn 1964)
Lloyd, Seton *Early Anatolia*, 1956 (Penguin Books)
Matthiae, P. *Ars Syra*, 1962 (Rome)
Mellaart, J. *Earliest Civilizations of the Near East* 1965 (Thames and Hudson)
Pope, A. U. (ed.) *A Survey of Persian Art*, Vol. I, 1938 (Oxford U.P.)
Porada, E. *Seal Impressions of Nuzi*, 1947 (New Haven)
Pottier, E. *L'Art Hittite*, 2 vols, 1926–30 (Paris)
Van den Berghe, L. *Archéologie de l'Iran Ancien*, 1959 (Leiden)
Vieyra, M. *Hittite Art 2300–750 B.C.*, 1955 (Tiranti)

Egypt

Aldred, C. *The Development of Ancient Egyptian Art, 3200–1315 B.C.*, 1962 (Tiranti)
Aldred, C. *The Egyptians*, 1961 (Thames and Hudson; Praeger)
Badaway, A. *A History of Egyptian Architecture*, vol. I, 1954 (Giza)
De Wit, C. *La Statuaire de Tell el Amarna*, 1950 (Antwerp)
Donadoni, S. *Arte Egizia*, 1955 (Turin)
Harris, J. R. *Egyptian Art*, 1966 (Spring Books)
Hornermann, B. *Types of Ancient Egyptian Statuary*, 3 vols, 1951–7 (Copenhagen)
Lange, K., and Hirmer, M. *Egypt: Architecture, Sculpture, Painting*, revised ed. 1961 (Phaidon)
Mekhitarian, A. *Egyptian Painting*, 1954 (Skira)
Petrie, W. M. F. *The Arts and Crafts of Ancient Egypt*, 1923 (London)
Smith, W. S. *The Art and Architecture of Ancient Egypt*, revised ed. 1965 (Penguin Books, Pelican History of Art)
Smith, W. S. *A History of Egyptian Sculpture and Painting in the Old Kingdom*, 1949 (London)

Index

Aannepadda *12*
Abu Ghurob 132
Abu Ireyn 99
Abu Shahrein *see* Eridu
Abu Simbel 163
Abusir 134
Abydos 129, 163
Achaemenian 46, 69, 73, 107–8, 110, 165, 167, *78, 80, 81,* **55–8, 60, 62, 63**
Adab 34
Adad, temple of, Assur 44
Adadnirari I 46
Aedicula 169, **39**
Aegean Sea 76, 80, 101, 140
Aeolic, proto- 105
Afghanistan 167
Africa, North 111, 112, 169; West 112
Agade 37, 80
Ahiram sarcophagus 101, *69*
Ahmes 141
Ahura Mazda 107, *78*
Akhenaton 140, 144, 161, 162, *112, 113*
Akhhotep tomb, Saqqara 134
Akkad dynasty 9, 39, 73, 107
Akkadian 35, 37–9, 40, 41, 44, 48, *24, 25, 26*
Aksum 167, 168, **64**
Alaca Hüyük 76, 77, 79, *60, 61,* **27, 28, 29, 35, 36**
Alalakh 80, 98, 99, 101, **40**
Aleppo 101
Alexander the Great 107, 164
Alexandria 165
Alishar II ware 77, **30**
Almeria 77
Amarna period 144, 161–2, 163, *113–5,* **92, 93**
Amenemhet I 137, 138
Amenemhet III 99, 139, 140, *103, 104*
Amenhotep II 142, 144
Amenhotep III 98, 142, 161; Court and Colonnade of, Temple of Amon, Luxor, **77, 78**
Amenhotep IV *see* Akhenaton
Amenophis *see* Amenhotep
Amman 105
Ammenemes *see* Amenemhet
Amon 144, **70, 71**; Temple of, Karnak 142, *119,* **79**; Temple of, Luxor 142, 163, *109,* **77, 78**; Temple of, Napata 164
Amorites 40, 41, 43, 67, 68, 75, 77, 98
Amratian culture 112, *84*
Amurru 41, 43
Anatolia, Anatolian 9, 44, 45, 46, 48, 70–2, 73, 76, 77, 80, 98, 101, 104, 106, 108–9, 110, *51–3,* **27–30**. *See also* Hittite
Anghelu Ruju culture 77
'Animal style' 76, 107
Ankhaf 132
Antiochus I of Commagene 109
Anu, temple of, Assur 44
Anu ziggurat 10, 11, **8**
Arabia 44, 167–8
Aramaeans, Aramaic 69, 102, 168
Araras, King 103
Arcevia *see* Conelle
Architecture:
　Achaemenian 97, 107, **55–8, 62–3**
　Arabian (South) 167
　Assyrian 44, 45, 46, 67–8, *45*
　Egyptian, Predynastic 112; Early Dynastic 129–30, *9*; Old Kingdom 131–2, **10, 11, 12, 67**; Middle Kingdom 138, 139, *101,* **69**; New Kingdom 140–1, 142, 163, *109, 119,* **74–81, 84**; Late Period 165, **82**
　Elamite **54**
　Ethiopian 168
　Hittite 77, 79, *59,* **32–7**
　Isin-Larsa period 41, *28*
　Kassite 43, *32*
　Neo-Babylonian 69, *49,* **52, 53**
　Neo-Sumerian 40, **13**
　Old Babylonian 41, *28*
　Palestinian 98, **5, 6**
　Phoenician 104–5, **65, 66**
　Punic 169
　Sumerian, Predynastic 10, 11, *3, 4, 7,* **8**; Early Dynastic 16, 33, *15, 16,* **13**
　Syrian 98, 103, *45, 75,* **45, 46**
Argishi, King 109
Artaxerxes II, tomb of **63**

Artemis, temple of, Ephesus 79
Aryans 74
Asasif, el- 143
Assur 34, 38, 44, 48; Temple of, Kar-Tukulti-Ninurta 44
Assurbanipal 68; Stele of *13*; Palace of, Nineveh 66–7, *43, 44*
Assurnasirpal 45, 46, 48, *35*; Palace of, Nimrud 46, *36–9,* **48**
Assurnasirpal II 48, 65, 67
Assur-nirari I 44
Assyrian, Neo-Assyrian 44–8, 65–9, 77, 80, 98, 104, 106, 107, 108, 109, 110, 164, 167, *34–46,* **50, 51**
Atarlukas 104
Athens 107
Aton 144, *116*; Temple of, Karnak 144
Ay 98
Azerbaijan 107

Babylon 9, 68, 69, *49,* **4, 52, 53**
Babylonia, Babylonian 41, 43, 68, 73, 80, 107
　Old Babylonian 9, 41–3, 44, 69, *28–31,* **25, 47**
　Neo-Babylonian 9, 68–9, 167, *47, 48*
Baetyl 169
Balawat 48, *40*
Bavian 45
Bedouin 11
Beersheba 74
Bek 161
Bersheh *106*
Beth Shean 98
Beycesultan 76, 77, 98
Bit-hilani 68
'Black Obelisk' 48
Boghazköy 77, 109
'Book of the Dead' **98**
Boundary stones, Kassite 43–4, *33*; Neo-Babylonian 69, *47*
'Brocaded style' seals 16, 36, *10*
Broken Obelisk 48
Bronze age 76
Bronze gates, Balawat 48, *40*
Bronze work:
　Alaca Hüyük 76, **28, 29**
　Akkadian 38, *24*
　Babylonian 10
　Luristan 106–7, *77*
　Sumerian 35
　Urartu 109, *83*
Bull motifs 37, 71, 97, *46b, 80, 83,* **16**; Human-headed 46, 67, 107, *36,* **55**
Bull-man 57, *68b, 88*
Byblos 98, 101, **45, 46,** Colossus of 99

Cadiz 169
Canaanites 75
Canidae 87
Capitals, Achaemenian 108, *80*; Egyptian 130, 165, *119,* **77, 78, 82**
'Cappadocian' ware 77, *58*
Carchemish 80, 103, 104, *70*
Carthage 169, *121*
Cascase 168
Castelluccio 76
Çatal Hüyük 71, *51*
Caucasus 76, 106
Chalcolithic period 74, 101, 112
Chaldean dynasty 69
Chamerernebti, Queen *95*
Champollion 165
Cheops 131, 132, **10**
Chephren, King 132, *92*; Pyramid of 131, **10**; Sphinx of **11, 12**; Valley Temple **67**
Choga Zambil 97, **54**
Christianity 165
Cimmerians 107
City-planning, Assyrian 67, *45*
'Code of Hammurabi' *30*
Coffins, painted Egyptian 140, *106*
Colossi of Memnon 142, **73**
'Colossus of Byblos' 99
Conelle 76, 77, **31**
Confronted animal motif 107, 109, 129, *46b, 79*
Constantine, Emperor 161
Crete 76, 98, 140, 143

Cuneiform script 16, *12, 13*
Cybele 109
Cycladic culture 76
Cylinder seals:
　Akkadian 38–9, 40, *26*
　Assyrian 44, 45–6, *34, 46*
　Egyptian 112
　Kassite 44
　Mitannian 80, *62*
　Old Babylonian 42–3, 101, *31*
　Proto-Elamite 73, *54*
　Sumerian 10, 13, 14, 16, 36–7, 73, 76, 101, *9, 10, 22*; Neo-Sumerian 40–1, 42, 44, *27*
　Syrian 76, 97, 98, 101, 103, 109, *68*
Cypro-Phoenician 168, 169
Cyprus 101, 105, 106, 110, 169
Cyrus 107

Darius I, Palace of, Persepolis **55–8**; Palace of, Susa 80
Darius III 107
Dead Sea 70
Dedan 167
Deir el-Bahri 138, 140, 141, 143, *101, 105, 107, 111,* **72, 74–6**
Deir el-Medina 143, **95, 96, 99–101**
Denderah 165
Diodorus Siculus 69
Disks, Sun disks 80, 107, *34, 71, 78, 113,* **29**
Diyala river 34, 35
Djehuty-nekht, coffin of 140, *106*
Djet, stele of 131
Dur-Kurigalzu 43
Dur-Sharrukin 65
Dur-Untashi *see* Choga Zambil

E-anna precinct, Uruk 10, 11
Eannatum, King 36, 41, *21*
Early Dynastic *see* Egypt, Sumerian
Ebih-Il *19*
Edfu 165
Egypt 10, 16, 39, 41, 42, 48, 68, 70, 72, 74, 77, 79, 101, 102, 107, 110, 111–69
　Predynastic period 13, 112, 167, *84–7, 89*
　Early Dynastic period 129–31
　First Dynasty 129, *88*
　Second Dynasty 130, *90*
　Third Dynasty 130, 132, *91, 9*
　Old Kingdom 39, 112, 131–5, 137, 138, 139, 164
　Fourth Dynasty 131, 132, 134, *92, 93, 95,* **10, 11, 67, 68, 85**
　Fifth Dynasty 132, 134, 135, *94, 96, 97, 100*
　Sixth Dynasty 134, 135, *98, 99*
　First Intermediate Period 135, 137, 140, 164
　Middle Kingdom 39, 99, 112, 135–40, 141, 142, 143, 161
　Eleventh Dynasty 138, *101,* **72, 86**
　Twelfth Dynasty 137, 138–40, *103–6,* **69–71**
　Second Intermediate Period 137, 140, 164
　New Kingdom 48, 101, 112, 140–61, 163–4, 164, 167
　Eighteenth Dynasty 140, 143–4, 161–2, *107–17,* **73–9, 87–96**
　Amarna Period 144, 161–2, 163, *113–5,* **92, 93**
　Nineteenth Dynasty 140, 161–2, *118–9,* **97**
　Twentieth Dynasty 162, *80, 81,* **98–102**
　Ramesside Period 143, 162–3, 164
　Twenty-fifth Dynasty 164, **83**
　Late Period 112, 163–4
　Ptolemaic Period 69, 164, 167, *120,* **82**
　Roman Period 165
Elam, Elamite 38, 43, 45, 67, 70, 73, 77, 97, 106, 108, *63*; Proto-Elamite 73, *54*
En 10
Ensi 10
Entemena, silver vase of *23*
Ephesus, temple of Artemis 79
Eridu 11, 73, *3*
Eshnunna 42. *See also* Tell Asmar
Etana 39
Etemenanki ziggurat 69, *49*
Ethiopia 167, 168, **64**
Etruria 109
Euphrates river 9, 10, 35, 41, *70*

Faiyum 111, 112, 165
Falcon symbol 132, 134
'Flower bunch' capitals **82**
'Flowing vase' *32*
Frankfort, Henri 10
Funerary paintings *see* Paintings
Funerary steles *see* Steles

Gaudo culture 76
Gebel el-Arak 129, *86*
Gebel Oeili 167
Gebelein **86**
Genii, winged 46, 108, *46b*, eagle-headed *34, 37*
Gerzean culture 112, 129, *85*
Ghorfa 169
'Gilgamesh motif' 16, 36, 39, 67, 107, 112, *86*
Giza 130, 131, *93, 95, 98*, **10, 67**
Goldwork *see* Metalwork
Gordion 108
Gothic 165
Greco-Oriental 79
Greece 106, 109, 110, 137, 139, 164, 165, 169
Gudea of Lagash 40, **24**
Guilloche motif 101, *62, 68*
Gutians 39, 77

Hadad 104
Hacilar 71, 72, *52, 53*
Hama 104
Hammurabi 42, 43, 107, *30*
Hanging gardens of Babylon 69
Harappa 73
Hasanlu 107, 109, **61**
Hathor *88*, **75**
Hatshepsut, Queen 112, 140, 141, 142, 143, 163, *107*; Funerary temple, Deir el-Bahri 140-1, **74-6**
Hattusas 77, 79, 80, *59*, **32-4**
Haulti 168
Hawila Assaraw 168
Hazor 101
Hebrews 102
Hegra 167
Hellenism 107, 110
Hellenistic 69, 165, 167, 169
Helmet of Meskalamidug 37, **17**
Hemon 132, **10**
'Herald's Wall', Carchemish 103
Herodotus 69, 111
Hierakonpolis 112, 129, *85, 87, 88, 90*
Hieroglyphs 129, 139, 165, *88, 106*
Hilani 68, 98, 103
Hittites 44, 77-80, 98, 102, 103, 104, 108, 109, 163, 168, *59-61*, **32-9**
Homer 76
Horemheb, General 144, 161, 162, *117*
Horus *88, 92, 99*; Temple of, Edfu 165
Humbaba 97
'Hunters' palette 13, 129
'Hunting stele' from Uruk 11, 13, *5*
Hurrians 77, 80, 102, 140
Hyksos 41, 77, 101, 140

Idi-Ilum 42
Idrimi, King 99, *64*
Imdugud 37, *17, 23*, **22**
Imhotep 130, **9**
Inanna 13, 41, 73; Temple of, Uruk 43, *32*
India, Indian art 44, 167
Indus valley 73-4
Intarsia work, Sumerian 37, **14, 15**
Ionian 109, *78*
Ipuky and Nebamun tomb 162
Iran 9, 46, 70, 71, 72-4, 76, 97, 106, 107-8, 110, 164, 167, 168. *See also* Achaemenian, Proto-Elamite
Iraq 9
Ischali, Ishtar-Kititum temple 41, *28*
Ishtar 41, 46, *46a, 48*, **25**
Ishtar Gate, Babylon 69, **52**
Ishtar-Kititum temple, Ischali 41, *28*
Ishtup-Ilum 42
Isin-Larsa Period 41-3, *28, 29*
Israel 74
Itet tomb, Medum **85**
Ity tomb, Gebelein **86**

Ivories:
 Assyrian **59**
 Egyptian 129, *86, 87*
 Phoenician 104, 105, 169, **48**
 Punic 169
 Syrian 101, 104, **49**

Jabbul 99, *66*
Jehu 48
Jericho 70, 98, *50*, **5, 6**
Jerusalem 104, 169
Jewellery from Alaca Hüyük 76
Jordan 74, 105
Jordan river **2**

Kaaper, statue of 97
Kalkhu *see* Nimrud
Kar-Tukulti-Ninurta 44
Karaindash, King 43; Temple of, Uruk 97, *32*
Karatepe 103, *73*
Karmir-Blur 109
Karnak 139, 142, 143, 144, *108, 112, 119*, **69-71, 79**
Kassites 9, 43-4, 68, 69, 77, 97, *32, 33*
Kawa 164
Khafajah 10, 33, 34, 35, *15, 16*, **26**
Khasekhem, King 130, 131, 167, *90*
Khonsu, tomb of Sheikh-abd-el-Qrna **90**
Khor Rori 167
Khorsabad 65, 67-8, *41, 45*
Khufakaf tomb 134
King's (or Warrior) Gate, Hattusas 79, *59*
Kish 33, *11*, **47**
Kition 169
Knossos 144
Kom Ombo 165, **82**
Kuban 76
Kudurrus 43-4, *33*
Kulli 73
Kültepe 77, *58*, **30**
Kurigalzu, King 43
Kurlik 35, **21**

Lachish 98
'Lady of Warka' 13, *8*
Lagash 10, 34, 35, 36, 39, *20, 21*, **24**
Lebanon 74, **3**
Limestone Temple, Uruk 10, 11
Lion motifs 46, 103, 104, *69*, **60**
Lion-headed eagle motif 37, **22**
Lion Gate, Hattusas 79, **33, 34**
Lion Gate, Malatya 104, *75*
Lion rhytons 108, *58*, **60**
Loftus Group of ivories from Nimrud 104, **49**
'Long Wall of Sculpture', Carchemish 103
Lugal 10
Lugalzaggisi, King 36, *75*, 107
Luristan bronzes 106-7, *77*
Luxor 142, 143, 163, *109*, **77, 78**
Lycian 109
Lydian 109

Maces, Sumerian 36
Maeander river 76
Maikop 76
Malatya 44, 80, 102, 104, *75*, **41**
Malta 76
Maltai 45
Manetho 111
Manishtusu 38
Marathos 110
Marash 104, *74*
Marduk 41, 69
Marduknadinakhe boundary stone *33*
Mardukpaliddina, stele of *47*
Mari 33, 34, 35, 37, 41, 42, *75*, 98, *19, 25*
Marib 167, 168
Masks, Egyptian plaster 161, *114*
Masks, Punic grotesque 169, *123*
Mastabas 130
Medain Salih 167
Medes 68, 106
Medinet Gurob *110*
Medinet Habu 143, 163, **80, 81**

Mediterranean 102, 106, 165, 168
Medum 135, **85**
Megaron 76
Megiddo 98, 99, 104, **42**
Meir 139
Melidi *see* Malatya
Mellaart, James 71
Memnon, Colossi of 142, **73**
Memphis 129, 130
Men 161
Menes 129
Menna, tomb of, Sheikh-abd-el-Qrna 144, **89**
Mentuhotep I, King 135, 137, 138, **72**; Funerary temple, Deir el-Bahri 140, 141, *101*
Mereruka tomb, Saqqara 134
Meroë 167, 168
Mesilim of Kish 36
Mesilim style 34
Meskalamidug, helmet of 37, **17**
Mesopotamia 9-69, 70, 71, 72, 74, 76, 77, 79, 97, 102, 110, 112, 167. *See* Akkadian, Assyrian, Babylonian, Sumerian
Metalwork:
 Achaemenian 108, *79*, **60**
 Alaca Hüyük 76, **27-9**
 Assyrian 46
 Egyptian 164
 Elamite 97, *63*
 Luristan 106-7, *77*
 Phoenician 105
 Punic 169
 Scythian **61**
 Sumerian 35, 37, *23*, **16-19, 22**
 Syrian 76, 99, 101-2, *56*, **42, 43**
 Urartu 109, *83*
 Ziwiye treasure 107, **44**
Meye, tomb of, Deir el-Medina **95, 96**
'Midas City' 108
Min **70**
Minoan 80, 98, 143-4, 169, *111*
Mitannian 44, 46, 80, 97, 102, *62*, **40**
Mongolia 107
Monneret de Villard, Ugo 107
Moortgat, Anton 10
'Mountain peoples' 77, 80, 97, 102
Motye **65**
Mummiform coffin of Tutankhamen **94**
Mummy portraits 165
Mycenaean 102, 109, 169
Mycerinus, King 132, *95*; Pyramid of 131, **10**

Nabataean 110, 167
Nabonidus 69
Nabuapaliddin 69
Nakht, tomb of, Sheikh-abd-el-Qrna 144, **87, 88**
Napata 164, 167
Napirasu, Queen 97, *63*
Naqsh-i-Rustam 108, *62, 63*
Naram-Sin, stele of 38, *73*, 97, *25*
Narmer palette 129, 131, *88*
Narrative reliefs *see* Relief carving
Nebamun 144
Nebamun and Ipuky tomb, Thebes 162
Nebhepetre Mentuhotep *see* Mentuhotep
Nebuchadnezzar 69, 107
Nectanebo 164
Nefertari, Queen 162
Nefertiti, Queen 161, *113, 115*, **93**
Nefret 139
Nefrure, Princess 141
Neo-Assyrian *see* Assyrian, Neo-
Neo Babylonian *see* Babylonian, Neo-
Neo-Sumerian *see* Sumerian, Neo-
Neolithic 112, **6**
Nes-Khonsu-pa-Khered funerary stele **102**
Neuserre obelisk, Abu Ghurob 132
Nike 167
Nile river, valley 102, 111, **1**
Nimrud 46, 65, 104, 105, *35-9*, **48, 49**
Nineveh 38, 40, 68, 69, *24*; Palace of Assurbanipal 66-7, *43, 44*; Palace of Sennacherib 66, *42*
Ningirsu 36
Ninurta, temple of, Nimrud 46
Nippur 34, 35
Niqmepa 98
Nofret 132, 139, **68**

Nomes 111, 112
Nubia, Nubian 163, 164, 167, **83**
Nuzi 80, 97

Obelisk temple, Byblos **45**
Obelisk of Neuserre, Abu Ghurob 132
Obelisks, Aksum 167, 168, **64**
Old Babylonian *see* Babylonian, Old
Oman 167
'Orientalising' art 106
Orthostats:
 Alaca Hüyük 79, 80, *60*
 Carchemish 103, *70*
 Karatepe 103, *73*
 Malataya **41**
 Tell Halaf 103, *71*
Oxford palette 129, *87*
Oxus treasure *79*

Painting:
 Anatolian 71
 Egypt, Predynastic 112, 129, *85*; Old Kingdom
 134–5, 137, 139, **85**; Middle Kingdom 137,
 139–40, 143, *106*, **86**; New Kingdom 143–4,
 161, 162, *111*, *116*, **87–102**
 Mitannian 97
 Neo-Assyrian 67, **50, 51**
 Old Babylonian 41, **25**
Pakistan 73
Palace F, Khorsabad 68
Palestine 11, 44, 70, 77, 98, 101, 102, 104, 109–10,
 167 *see also* Syro-Palestinian
Palettes 129, *87, 88*
Palmyra 110
Papyrus motif 130, 165, *119*, **77, 78**
Parthian 107, 110, 167
Pasargadae 107, 108
Pashedu, tomb of, Deir el-Medina **99**
Pazarli 109, *82*
Pazyryk 107
'Peoples of the Sea' 102, 110
Pepy I 134, *99*
Persepolis 107, *78, 81*, **55–8**
Persia *see* Iran
Petosiris tomb 164
Philae 165
Phoenician 102, 104–5, 109, 110, 168–9, *69, 76*, **48,**
 65, 66
Phrygian 108–9, *82*
Piankhy, King 164
Piano Conte 76
Pictographs 16, *11*
Plaster masks, Egyptian 161, *114*
Plastered skull from Jericho 70–1, *50*
Pottery:
 Alishar II ware 77, **30**
 Amratian 112, *84*
 'Cappadocian' ware 77, *58*
 Gerzean 112, 129
 Halicar ware 71, 72, *53*
 Mitannian 80, **40**
 Phoenician 76
 Phrygian 108
 Pre-Appenninic **31**
 Samarra ware 72, *1*
 Sumerian 72, *6*, **18, 23**
 Susa I style 72, 73, **20**
 Tepe Siyalk 72
Predynastic *see* Egypt, Sumerian
Psammeticus 164
Ptahhotep tomb, Saqqara 134
Ptolemaic Period 69, 164, 167, *120*, **82**
Punic 169, *122–4*
Punt Expedition reliefs 141, **76**
Puzur-Inshushinak, King 73
Puzur-Ishtar 42
Pyramids 40, 164; Giza 130, 131, 138, **10**; Step
 pyramid of Zoser, Saqqara 130, **9**

Qorn, el- **84**
Quetta 73
Quyunjik *see* Nineveh

Rahotep 132, **68**
'Ram caught in a thicket' **19**
Ramat Rahel 104, 106, *76*
Ramesses II 98, 162, 163, *118*
Ramesses III 163; Temple, Medinet Habu 163,
 80, 81
Ramesseum, Thebes 163
Ramose, tomb of, Sheikh-abd-el-Qrna 144, **91**
Rana Ghundai 73
Ranefer, High Priest of Ptah 132, *94*
Ras Shamra *see* Ugarit
Re-Harakhte-Aton **102**
Red Sea 70, 168
Rekhmire tomb 144
Relief carving. *See also* Cylinder seals, Orthostats,
 Steles
 Achaemenian 107–8, *78, 81*, **58**
 Anatolian *71*
 Arabian 168
 Assyrian and Neo-Assyrian 44, 45–6, 48, 65–7,
 108, 164, *34, 36–44, 46*
 Egyptian, Early Dynastic 131, *87, 88*; Old King-
 dom 134, *100*; Middle Kingdom 139, 164,
 70, 71; New Kingdom 140, 141, 142, 161, 162,
 163, *119*, **75, 76**; Late Period 164
 Ethiopian 168
 Hittite 77, 79–80, *59*, **33–9**
 Meroitic 167
 Neo-Babylonian 69, *47, 48*
 Neo-Sumerian 40, *27*
 Old Babylonian 42, *30*, **47**
 Phoenician *69*
 Phrygian *82*
 Sumerian, Predynastic 11, 13, *5, 6*; Transitional
 Period 14, *14*; Early Dynastic 36, *20–2*, **22**
 Syrian 48, 103–4, *70*, **41**
 Syro-Palestinian *75*
Remedello culture 76
Repoussé work 107, 109, **43, 61**
'Reserve' heads 132, *93*
Rhytons, Achaemenian 108, **60**; Phoenician *58*
Rinaldone culture 76
Rock carving:
 Hittite 73, 77, 79, **37–9**
 Meroitic 167
 Phrygian 108
Rock tombs:
 Achaemenian 108, **62, 63**
 Arabian 167
 Egyptian 138, 143, **84**
Roman Empire 165
Rome 69
'Royal Buttress' Carchemish 103
Russia 76, 107

Sahure 134
Sais 164
Saite dynasty 69, 164
Sakçegözü 103, 104
Salambo, *tophet* of, Carthage *121*
Samaria 104
Samarra 9, 72, 73, *1*
San Michele culture 77
Saqqara 129, 131, 134, 161, *94, 96, 100*, **9**
Sarcophagi 101, 143, *69*
Sardinia 169, **66**
Sargon I 36, 37, 39, 75
Sargon II 65, 107; Palace, Khorsabad 65, 67–8, *41*
Sassanian 73, 107, 108
Scarabs, Punic 169
Scaraboid seals 101, 105
'Scarlet ware' **26**
Sculpture. *See also* Cylinder seals, Orthostats, Relief
 carving, Steles
 Achaemenian 107–8, *78, 80, 81*, **62**
 Akkadian 37–9, *24–6*
 Anatolian 71, 76, *51*
 Arabian 168
 Assyrian, Neo-Assyrian 44, 45–6, 48, 65–7, *34–44,*
 46
 Babylonian, Old 42–3, *29, 30*, **47**; Neo- 69,
 47, 48
 Egyptian, Predynastic 130, 131, *87, 89*; Early
 Dynastic 130–1, *88, 90*; Old Kingdom 33,
 132, 134, 138, 139, *91–100*, **68**; Middle Kingdom
 138–9, 141, 142, 161, *102–5*, **70–2**; New Kingdom

140, 141–2, 144, 161, 162–3, *107–8, 110, 112–5,*
 117–9, 73, **75–9, 93**; Late Period 164, *120*
Ethiopian 168
 Hittite 77, 79–80, *59–61*, **33–9**
 Isin-Larsa Period 42–3, *29*
 Kassite 43–4, *33*
 Mitannian 97
 Palestinian 70, 105, *50*
 Phrygian 108, 109
 Proto-Elamite 73
 Punic 169, *122, 124*
 Sumerian, Predynastic 11, 13, 14, 34, 35, *2, 5–8*;
 Transitional Period 14, 16, 75, *14*; Early
 Dynastic 33–7, 38, *17–22*, **21**; Neo-Sumerian
 40–1, 42, 27, **24**
 Syrian 75, 98–101, 103–4, *55–7, 64–67, 70–5*, **42**
Scythians 76, 106, 109, **44, 61**
Seals *see* Cylinder seals, Stamp seals, Scaraboid seals
'Seated Scribe' 132, *96*
Semitic peoples 9, 11, 14, 33, 36, 37, 39, 40, 41, 75,
 102, 140
Seneb 132, *98*
Senmut 140, 141, **74–6**; Tomb, Deir el-Bahri 143,
 111
Sennacherib 45, 66, 67, *42*
Sennedjem, tomb of, Deir el-Medina **100, 101**
Sennuy 139, *102*
Serpo-pards *88*
Serraferlicchio culture 76
Sesostris I 137, 138, 140; Jubilee pavilion 139,
 69–71
Sesostris II 139
Sesostris III 99, 139, 161, *105*
Seti I 162, 163; Temple, Abydos 163
Sevan, Lake 109
Shalmaneser III 45, 48–9
Shamash *30*; Temple of, Assur 44
Sharma **39**
Shechem 98
Sheikh-abd-el-Qrna 143, **87–91**
'Sheikh el-Beled' 132, *97*
Shutruknakhunte, King 97
Siberia 107
Sicily 169
Sidon 104
Silverwork *see* Metalwork
Sin, temple of, Assur 44; temples, Khafajah 33, *15*
Sinai 70
Sirwah 167
Skulls, plastered 70–1, *50*
Solomon, King 104
Sphinx motif 43, 105, 107, *68*, **35, 36, 79**
Sphinx of Amenemhet III 139, *104*
Sphinx of Chephren **11, 12**
Sphinx Gate, Alaca Hüyük 79, *61*, **35, 36**
Spiral motif 42, 77, 80, *53*
Stag standard, Alaca Hüyük **28**
Stamp seals 76, 80, 105
'Standard of Ur' 37, **14, 15**
Standards from Alaca Hüyük 76, **28, 29**
Statuettes *see* Sculpture
Stele of Assurbanipal *13*
Stele of Djet 131
Stele of Eannatum (Stele of the Vultures) 36, 39,
 41, *21*
Stele of Hammurabi 42, 43, 73, *30*
Stele of Mardukpaliddina *47*
Stele of Naram-Sin 38, 73, 97, *25*
Stele from Uruk ('Hunting Stele') 11, 13, *5*
Stele of the Vultures 36, 39, 41, *21*
Steles:
 Egyptian 131, 137, *113*
 Funerary 104, 169, *74*, **102**
 Punic 169, *124*
 Syrian 99, 101, *67*
 Victory 36, *21*
 Votive 67, 169
Stepped pinnacles 44, 107, 168
Step pyramid of Zoser, Saqqara 130, 132, **9**
Sudan 111, 167
Sumeria, Sumerian 9–41, 45, 68, 72, 73, 74, 77, 80,
 98, 108, 112, 129, 167
 Predynastic Period 9–14, 16, 34, 35, 36, 73, 112,
 2–9, **7, 8, 23**; Transitional Period 14, 16, *10, 14*
 Early Dynastic Period 9, 14, 16, 33–7, 38, 39,
 10–13, 15–22, **14–22**
 Neo-Sumerian 39–41, 42, 69, *27*, **13, 24**

Sun disks *see* Disks
Sun disk standards 76, **29**
Susa 37, 42, 43, 67, 72, 73, 97, 107, *29, 63, 80,* **20**
Syria, Syrian 9, 33, 34, 35, 41, 42, 44, 45, 46, 68, 70, 71, 72, 74–6, 77, 80, 97, 98–104, 105, 109–10, 163, 167, 168, *45, 55–7, 64–8, 70, 72, 75,* **41–3, 49**. *See also* Hittite
Syro-Hittite 79, 101
Syro-Palestinian 70, 71, 74–6, 77, 98, 101, *57*

Taharqa, King 164, **83**
Tanis 140, 164, *104*
Tarhunpiyas *74*
Tarxiens 76
Teleilat Ghassul 74
Tell Agrab 34, 35
Tell Ahmar *48*
Tell Asmar 33, 34, 35, *17, 18*
Tell-i-Bakun 72
Tell Beyt Mirsim 98
Tell Brak 75, *55*
Tell Gat 98
Tell Halaf 9, 73, 97, 103, 104, *71*
Tell Harmal 41
Tell Hassuna 9, 72, 73
Tell el-Judeydeh 76, *56*
Tell Khuera 34, 35, 75, 98
Tell Mardikh 75, *57*
Tell Sulaymiyya 98
Tell Tayanat 103, 104, 169
Tell al-'Ubaid *see* 'Ubaid
Telloh *see* Lagash
Temples *see* Architecture
Tenaille gates 77, 98, 105
Tepe Giyan 73
Tepe Siyalk 72, 73
Teshebani *see* Karmir-Blur
Textiles, Phoenician 105
Tharros 169, **66**
Thebes 143, 162, 163, 164, **84, 97**
This 129
Ti, tomb of, Saqqara 134, *100*
Tiglathpileser III 65, 66, 67
Tigris river 9, 41, 48, 65, 70

Til Barsip 67, **50, 51**
Tiles, Assyrian 46; Babylonian 107
Tiy, Queen 142, *110*
Tomb paintings *see* Painting, Egyptian
Tophets 169, *121,* **66**
Toprakkale *see* Tushpa
'Tower of Babel' 11, 69, *49*
Trajan's kiosk, Philae 165; column, Rome 38
'Treasure of Hasanlu' **61**
'Treasure of Priam' 76
Triplyon, Persepolis *81*
Troy 76
Tudhaliyas IV **39**
Tukulti-Ninurta I 44
Turkey 70, 71
Tushpa 109
Tutankhamen, King 161, *116,* **94**
Tuthmosis III 142, 144, 162, *108*
Tuthmosis IV 142, 144
Tyre 48, 101, 104

'Ubaid 13, 34, 35, 37, 72, 73, 112, *2,* **21–3**
Ugarit 98, 99, 101, 102, 104, *67,* **43**
Ukhotep, tomb of, Meir 139
Ula, el- 167
Umma 34
Untash-Khuban, King 97, **54**
Ur 9, 10, 14, 34, 37, 39, 40, 75, **13–19**; Standard of **14, 15**
Uraeus 92, 105, 107, 118, **102**
Urartu 109, *83*
'Urban Revolution' 70
Urkisal 35, 38
Urnammu 40
Urnanshe 20
Uruk 9, 10–11, 13, 14, 34, 43, 97, 112, *4–9, 14, 32,* **7, 8**
Userhet, tomb of, Thebes 162, **97**

Valley of the Kings, Thebes **84**
Vases:
 Assyrian 46
 Khafajah **26**

Mitannian 97, **40**
Pre-Appenine **31**
Samarra *1*
Sumerian 13, 14, *6, 14*
Susa I style **20**
'Village Magistrate' 97
Votive Plaque of Urnanshe 20
Votive steles *see* Steles

Wall painting *see* Painting
Warka *see* Uruk
Warrior (or King's) Gate, Hattusas 79, *59*
Washukkanni 80
Weather gods 99, *67*
'White Obelisk' 48
White Temple, Uruk 10, 11, *4,* **8**
Writing, development of 16, 70, *11–13*

Xerxes 69

Yang-Shao 167
Yarim-Lim, King 99, *65*; Palace of, Alalakh 98, 103
Yazilikaya 73, 77, 79, 103, **37–9**
Yeha 168
Yemen 167, 168

Zagros mountains 71
Ziggurats:
 Assyrian 44, 67
 Babylon 69, *49*
 Choga Zambil 97, **54**
 Ur 40, **13**
 Uruk 10, 11, **8**
Zincirli 80, 103, 104, *72*
Zirimlim palace, Mari 41, **25**
Ziwiye treasure 107, **44, 59**
Zoser, King 130, 132, 134, *91*; Pyramid of, Saqqara 130, 132, **9**

Acknowledgements

The publishers gratefully acknowledge the consent of the following to reproduce subjects illustrated in this book: Mrs Enriqueta Frankfort for figure 71, from the late Professor Henri Frankfort's book *The Art and Architecture of the Ancient Orient*, figure 71; Professor Seton Lloyd, from his book *Early Anatolia* (Penguin Books) figure 83; Professor M. E. Mallowan, figure 55; Professor P. Matthiae, figure 57; The Oriental Institute, University of Chicago, figure 111. Photographs were provided by the following:

Colour: Ashmolean Museum, Oxford 47; British Museum, London 14, 15, 19, 21, 22, 23, 24, 40, 48, 49; J. Allan Cash, London 3, 80; Werner Forman, Prague 9, 12, 64, 68, 74, 75, 76, 83, 89, 91; Professor G. Garbini, Rome 2, 5, 6, 45, 46, 65, 66; Giraudon, Paris 20, 25; Hirmer Verlag, Munich 4, 7, 8, 13, 16, 17, 18, 26, 30, 43, 50, 51, 72; Michael Holford, London 27, 29, 41, 92; F. L. Kennet © George Rainbird, London 94; A. F. Kersting, London 73, 78, 79; Oriental Institute Museum, Chicago 42; A Perissinotto, Padua 36, 37, 38, 39, 54, 57, 62, 63; Josephine Powell, Rome 28, 44, 55, 56, 58, 59, 60, 61; Mavis Ronson/Picturepoint, London 10; Foto Rosso, Turin 86, 95, 96, 98, 102; Scala, Florence 31, 32, 33, 34, 35; Scala/Werner Forman 85; Staatliche Museen zu Berlin 52, 53; Stiftung Preuss. Kulturbesitz, Staatliche Museen, Berlin 93; Roger Wood, London 1, 11, 67, 69, 70, 71, 77, 81, 82; Joseph Ziolo/André Held, Paris 84, 87, 88, 90, 97, 99, 100, 101

Black and White: Alinari/Giraudon, Paris 118; Archives Photographiques, Paris 21, 23, 29, 30b, 80; Ashmolean Museum, Oxford 11, 87, 89; Bildarchiv Foto Marburg 32, 116; Boudot-Lamotte, Paris 41, 42, 64, 121; British Museum, London 2, 12, 13, 22a, 22b, 26, 27, 31, 33, 34, 35, 36, 37, 38, 39, 40, 43, 44, 46a, 46b, 54, 55, 62, 68a, 79, 105; Brooklyn Museum, New York 99; Directorate General of Antiquities, Iraq 8, 9a–e, 16, 26b, Egyptian Museum, Cairo 104, 113; Werner Forman, Prague 115; Giraudon, Paris 77, 86; Hatay Museum, Turkey 65; Hirmer Verlag, Munich 5, 6, 7, 14, 24, 60, 70, 75b, 88, 91, 92a, 92b, 94, 97, 98, 100, 103, 108, 112; Michael Holford, London 19, 20, 25, 30a, 48, 51, 52, 53, 63, 66, 67, 74, 111; Louvre, Paris 10, 69, 96; Professor P. Matthiae 57; Metropolitan Museum of Art, New York 107, 117; Musée du Bardo, Tunisia 122, 123, 125; Museum of Fine Arts, Boston 84, 93, 95, 102, 106, 119; Oriental Institute, University of Chicago 17, 18, 56; Penguin Books, London 83; A. Perissinotto, Padua 59b, 61, 73, 75a, 78, 81; J. Powell, Rome 82; Ramat Rahel Expedition, Jerusalem 76; Service de Documentation Français, Versailles 58; Staatliche Museen zu Berlin 1, 47, 49, 59a, 68b–d, 72, 110, 114; Thames and Hudson, London 50, 85, 90; Warburg Institute, London 71; Roger Wood, London 120

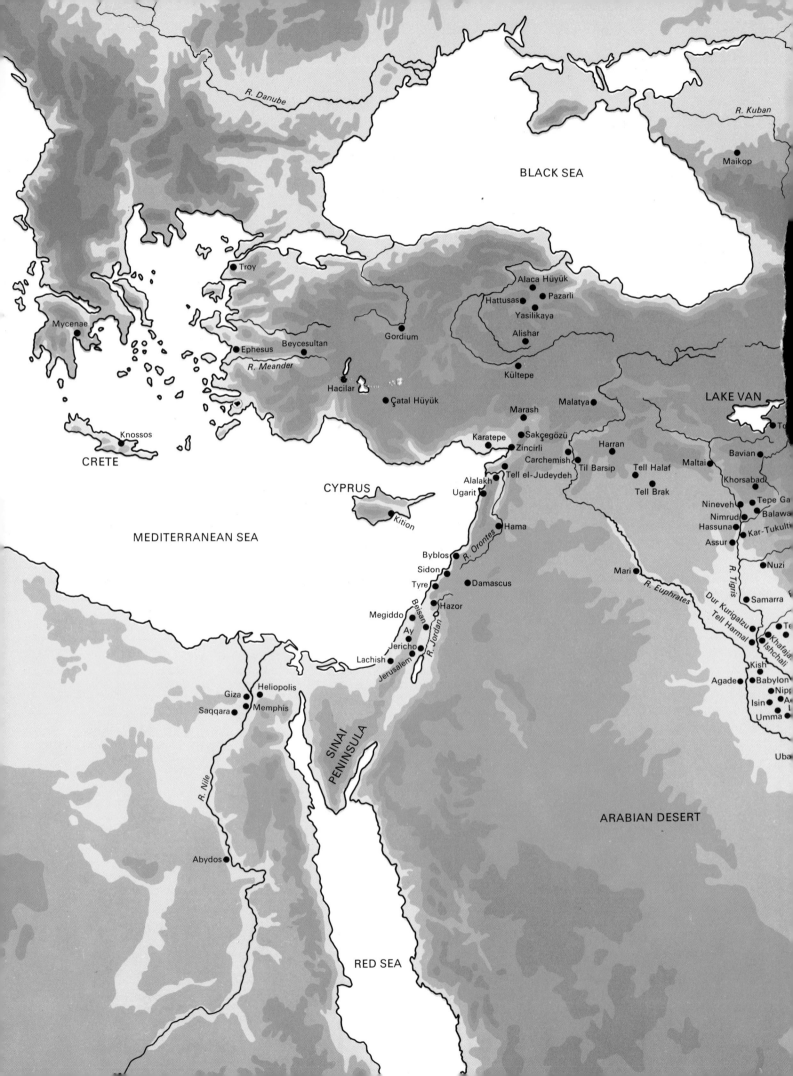